TEOTIHUACAN

TEOTIH

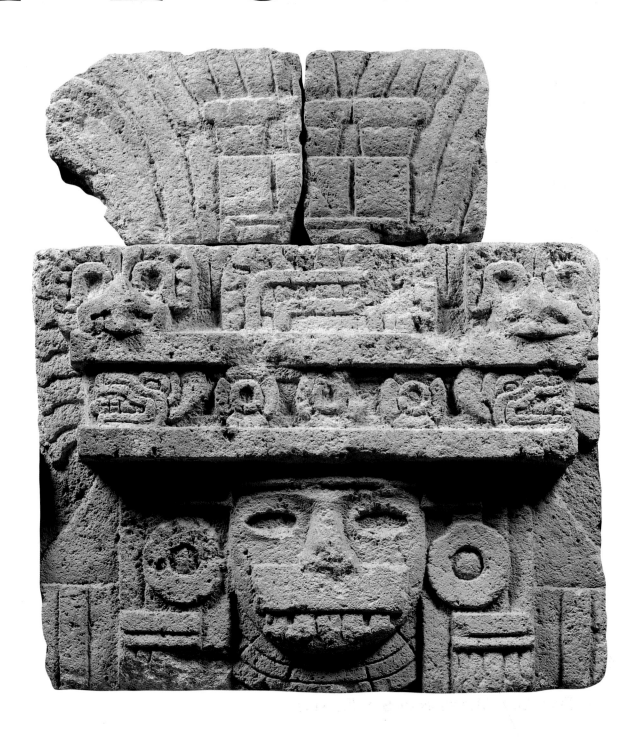

U A C A N

ART FROM
THE CITY
OF THE GODS

Edited by

KATHLEEN BERRIN

AND ESTHER PASZTORY

 THAMES AND HUDSON

THE FINE ARTS MUSEUMS OF SAN FRANCISCO

TEOTIHUACAN: CITY OF THE GODS

The Fine Arts Museums of San Francisco
M.H. de Young Memorial Museum
26 May through 31 October 1993

This exhibition is organized by The Fine Arts Museums of
San Francisco. Support for the catalogue is made possible
by generous grants from the National Endowment for the
Humanities and the National Endowment for the Arts, Fed-
eral agencies. The Wayne J. Holman., Jr., 1963 Charitable
Trust is providing additional funding for the catalogue.

First published in the United States of America in hard-
cover in 1993 by Thames and Hudson Inc., 500 Fifth
Avenue, New York, New York 10110

First paperback edition in 1994

ISBN 0-500-27767-2

Library of Congress Catalogue Card Number 92-62139

FRONT COVER
POLYCHROME MASK (cat. no. 67)

BACK COVER
A SERPENT HEAD
Side view from the Temple of the Feathered Serpent,
showing the Pyramid of the Sun

FRONTISPIECE
Detail, FRIEZE REPRESENTING A DEITY (cat. no. 4)
CNCA-INAH-MEX, Zona Arqueológica de Teotihuacan

Printed and bound in Hong Kong

Contents

Preface

Teotihuacan: City of the Gods is the first comprehensive exhibition ever to focus on the arts of this great ancient civilization. It has been over eight years in the making, and contains over two hundred objects drawn from collections in Mexico, Europe, and the United States. The overwhelming majority of these works have never been seen outside of their home institutions. Many of them will be surprising, because Teotihuacan was a unique ancient Mesoamerican civilization, and Teotihuacan, though vastly important to Mexico, is poorly understood in the United States.

The approximately sixty works from national Mexican collections are, of course, priceless cultural patrimony and among the greatest treasures Mexico has to offer. Many of these works have only recently been discovered by Mexican archaeologists. The concept and evolution of numerous aspects of the exhibition have always been the result of a close collaboration between The Fine Arts Museums of San Francisco and Mexico's cultural leaders. We are exceedingly grateful to the many people in Mexico who, over the years, have contributed so much to this important project, and to Mexico's leaders who allowed these treasured works to travel to San Francisco.

Our deepest thanks, also, to many lenders in the United States and Europe who have worked closely with us in order to allow stellar pieces in their collections to travel to San Francisco for this exclusive showing, and to the sponsors who have generously contributed toward the presentation. The exhibition and this publication are made possible by generous grants from the National Endowment for the Humanities and the National Endowment for the Arts, Federal agencies. Air transport from Mexico was graciously provided by United Airlines. Additional support for the exhibition was provided by Corona & Corona Light Beers and Hotel Nikko of San Francisco. Public programs were made possible in part by a grant from Metropolitan Life. The Wayne J. Holman, Jr., 1963 Charitable Trust provided additional funding for the publication.

Though over the years countless individuals have been involved in select aspects of the planning for Teotihuacan: City of the Gods, the curatorial work has been the collaborative effort of Kathleen Berrin, Curator of Africa, Oceania, and the Americas at The Fine Arts Museums of San Francisco, and Esther Pasztory, Professor of Art History, Columbia University, New York. The concept of the exhibition, the themes chosen, and the intellectual content were developed by Pasztory, who is an important art historian specializing in Teotihuacan and who has dedicated much of her life to the study of Teotihuacan art since her 1971 pioneering doctoral thesis on the murals of Tepantitla. The myriad museological and administrative tasks of the exhibition and catalogue were the province of Berrin, who was curator in charge of the Teotihuacan murals project, which was ongoing between 1978 and 1985. Assisted by many members of the Museums' staff, she supervised all aspects of the exhibition, from loan requests, display, publicity, and education, to shaping it to fit the needs and tastes of a general audience.

The objects in the exhibition were selected by both Pasztory and Berrin, who were aided in their efforts by the suggestions of dozens of advisers throughout the United States and Mexico over the course of five years. Loans from Mexico required Berrin, Pasztory, and others to partici-

pate in lengthy discussions with cultural leaders in Mexico between 1988 and 1993 regarding the exhibition's scope, interpretation, and content. Key agencies in Mexico were the Instituto Nacional de Antropología e Historia and the Consejo Nacional para la Cultura y las Artes, Relaciones Exteriores, and of couse the individual museums, especially the Museo Nacional de Antropología and the Museo de la Zona Archaeológica de Teotihuacan.

Teotihuacan: City of the Gods was conceived in 1986, following nearly ten years of cooperation between The Fine Arts Museums of San Francisco and Mexico's Instituto Nacional de Antropología e Historia inivolving the joint care and preservation of a large bequest of Teotihuacan wall fragments. In 1985, after conservation work was complete, over half the mural collection was voluntarily returned to Mexico and celebrated there in the form of a special exhibition at the Museo Nacional de Antropología. The good will resulting from this unprecedented model for the care and treatment of cultural patrimony laid the foundation for this exhibition and publication on the arts of Teotihuacan.

Teotihuacan: City of the Gods is an extraordinary artistic and cultural event which we celebrate in San Francisco. It reflects the continued collaboration of our respective institutions, which has stretched over fifteen years. We are proud that this exhibition has been the catalyst for so much new and original scholarship.

HARRY S. PARKER III
Director
The Fine Arts Museums of San Francisco

Foreword

TEOTIHUACAN WAS THE FIRST GREAT CULTURE to appear in central Mexico. It produced splendid art during the seven centuries of its existence. Its mural painting, ceramics, and sculpture express a vigorous style that has been slowly uncovered.

The Aztecs, who settled in the Valley of Mexico hundreds of years after Teotihuacan had been destroyed and abandoned, were the first ones to seek clues of their creators in the ancient city. Important examples of this are the objects from Teotihuacan found in offerings in the Templo Mayor in Tenochtitlan.

For the Aztecs the importance of Teotihuacan was paramount; they mythicized the old city and transformed it into one created by the gods. The rise of the Fifth Sun, one of the most important myths that can still be found in the cosmogonic vision of our native groups, was attributed to the site.

The Consejo Nacional para la Cultura y las Artes, through the Instituto Nacional de Antropología e Historia, is pleased to lend selected works, which contribute to what is undoubtedly the most complete exhibition that has been put together on the Teotihuacan culture.

The Fine Arts Museums of San Francisco has participated with its interest and selected the objects that today allow us to appreciate part of the cultural expressions of a civilization whose presence was felt all over Mesoamerica, one of which all Mexicans are proud and part of the patrimony of humanity.

We would like to emphasize that The Fine Arts Museums of San Francisco in 1986 returned to Mexico some of the murals from Teotihuacan that had left our country illegally. This gesture is the example to be followed and greatly honors its authors. It also contributed greatly to this exhibition's having had the full support of our country.

One of the best ways to promote understanding between people from different countries is through the shared knowledge of their histories and culture. This exhibition, whose success is assured, must serve as a link between two neighbor countries respectful of each other. We hope those who visit it find out about one of the most important civilizations in the so-called New World.

MARÍA TERESA FRANCO Y GONZÁLEZ SALAS
General Director
Instituto Nacional de Antropología e Historia

Acknowledgments

T HE DEVELOPMENT of *Teotihuacan: City of the Gods* has been a collaborative undertaking involving countless individuals, to all of whom we extend our profound thanks.

First, we would like to express our gratitude to Harry S. Parker III, Director of The Fine Arts Museums of San Francisco, a man of vision and creativity with the ability to move from the pragmatic into the ideal. Without his complete and wholehearted support this project never could have been realized. He is to be commended for recognizing the project's complexity but being willing, in these difficult times for museums, to make it work.

Because virtually all of the most important Teotihuacan works of art are in Mexican national collections, we must exphasize that without the support of the many cultural leaders in Mexico this exhibition would not have been possible. From Relaciones Exteriores, we are especially grateful to Fernando Solana, Secretary of Foreign Relations; Rosario Green, Subsecretary for International Cooperation; and Jorge Alberto Lozoya, Director of Cultural Affairs; as well as former Subsecretary for International Cooperation Javier Barros Valero and former Director of Cultural Affairs Alfonso de Maria y Campos. Warm expressions of gratitude go to Rafael Tovar y de Teresa, President of the Consejo Nacional para la Cultura y las Artes; former President Victor Flores Olea; Jaime García Amaral, Coordinator of International Affairs; Miriam Kaiser, Director of International Exhibitions; and Celia Chávez, Subdirector of International Exhibitions. María Teresa Franco y González Salas, the current Director of the Instituto Nacional de Antropología e Historia (INAH), has been wonderfully supportive of the project as have two former INAH directors, Enrique Florescano Mayet and Roberto García Moll. Others from INAH we wish to thank are Cristina Payán, National Coordinator for Museums and Exhibitions; Ana Coudourier, Subdirector of International Exhibitions; Angel García Cook, Director of Archaeology; Mario Vásquez Rubalcava, former National Coordinator of Museums and Exhibitions, and his assistant, David Aceves; Miguel Angel Fernández, former Director of Museums and Exhibitions; and Joaquín García-Bárcena, former Director of Pre-Hispanic Monuments.

The two people who have been integral to this project and to whom we owe deepest gratitude are Mari Carmen Serra Puche, Director of the Museo Nacional de Antropología, and Eduardo Matos Moctezuma, Director of both the Zona Arqueológica de Teotihuacan and the Museo Templo Mayor. Without their endorsements of the loans of national treasures from their institutions, there would be no exhibition. Warmest thanks also go to Felipe Solis Olguin, Subdirector of the National Museum, and Clara Luz Díaz, Curator of the Teotihuacan Hall, both of whom have been hardworking and special friends to the project. We also wish to acknowledge the gracious help of Leonardo López Luján from the Museo Templo Mayor and Rubén Cabrera Castro, Eduardo Villa, and Juan Mendez from the Zona Arqueológica de Teotihuacan.

The assistance of the United States Embassy in Mexico City has been central to the project. We are grateful to Ambassador John Negroponte; William Dieterich, Minister Counselor for Cultural Affairs; and especially John Dwyer, Cultural Attaché. Bertha Cea Echenique (Senior Cultural Af-

fairs Specialist), a close friend and colleague, has provided indispensable help throughout the years with grace and good humor.

There have been many people in Mexico whose support and friendship have been important. Deborah Nagao has served as our Museums' Mexico City liaison over the last eight years, performing every possible type of curatorial task as well as aiding with translations. Other friends whose support we would like to acknowledge are Jaime Abundis, Jorge Angulo, Michele Beltran, Luis Cue, Ann Geyer, Beatriz de la Fuente, Doris Heyden, Robert Littman, Druzo Maldonado, Linda Manzanilla, Carlos Margáin, Noel Morelos, and Evelyn Rattray. Michel Zabé and Enrique Franco Torrijos are to be especially noted for their outstanding photography; Mario Diez de Urdanivia was the very talented producer of the exhibition's video.

We are especially grateful to Consul General Rodulfo Figueroa and Amalia Mesa-Bains, the distinguished and exceptionally hard-working co-chairs of the Teotihuacan Exhibition Committee in San Francisco. From the office of the San Francisco Consulate special thanks go to Esther Larrios, Deputy Consul General, and Daphne Roemer, Press Attaché. We would also like to acknowledge the assistance of two former Consul Generals, Enrique Loaeza, and Marcelo Vargas, as well as the help of Sandra Calderon, former Cultural Attaché.

We are immensely grateful for support from the National Endowment for the Humanities during the planning and implementation phases of this project, and would like to acknowledge from the Division of Public Programs Marsha L. Semmel, Assistant Director, and Andrea Anderson, Program Officer. For this publication we appreciate major support from the National Endowment of the Arts, and we would especially like to thank Andrew Oliver, Jr., Director, and David H. Bancroft, Program Specialist, both from Museum Programs.

In addition to the many scholars in Mexico, a number of others in the United States have been vital to the project. René Millon has been an important friend and a major advisor as have George Cowgill and Warren Barbour. Janet Berlo and Hasso von Winning were important consultants early in the project. Special thanks go to Julie Jones, Jane Day Stevenson, Richard Townsend, and Steven Vollmer for providing many insights in negotiating Mexican loans, and to James Langley for extraordinary efforts in producing the drawing of the mural *Los Glifos*, which appears in this volume for the first time. Other specialists who over the course of time have contributed their expertise, endorsed the importance of the project, and helped in many other ways are Marie-Therese Brincard, Oralia Cabrera, Michael Coe, Clemency Chase Coggins, Cynthia Conides, Diana Fane, Nancy Fee, Virginia Fields, Anne Gallagher, George E. Harlow, Mary Hopkins, Stacy Goodman, Nicholas Hellmuth, Aldona Jonaitis, David Joralemon, Justin and Barbara Kerr, Ed Merrin, Gail and Alec Merriam, Mary Ellen Miller, Clara Millon, David Pendergast, Merle Greene Robertson, William Sanders, Anne Schaefer, Linda Schele, Sue Scott, Ed Shook, Robert Sonin, Rebecca Storey, the late Robert Stroessner, Spencer Throckmorton, and Javier Urcid. Students of Esther Pasztory who have provided inspiration to her are Sue Bergh, Shirley Glazer, Alisa La Gamma, Judith Ostrowitz, Joanne Pillsbury, Patricia Sarro, and Andrew Shelton. Thanks go also to expert model makers Frank Tucci, Jonah Margulis, and Sumner Nunley, who worked with Warren Barbour and René Millon to perfect the models of the Zacuala Palace Apartment Compound and the Pyramid of the Sun, which were prepared especially for the exhibition, and to John C. McKendry, who kindly provided the transportation for the models to come to San Francisco. We also owe special thanks to Merle Greene Robertson for her generous assistance with plans for displaying her superb Maya rubbings, and to Guillermo Nánez Falcón, Director of the Latin American Library at Tulane University, for facilitating loans.

Many museum professionals provided significant help in the selection, preparation, and lending of the objects — American Museum of Natural History, New York: Charles Spencer and Belinda Kaye; The Cleveland Museum of Art: Margaret Young-Sánchez and Delbert Gutridge; The Denver Art Museum: Gordon McEwen and Inga Calvin; Denver Museum of Natural History: Jane Day Stevenson and Laura Brown; Duke University Museum of Art: Dorie Reents-Budet and Jessie Petcoff; Dumbarton Oaks Research Library and Collections: Elizabeth Boone and Carol Callaway; Field Museum of Natural History, Chicago: Janice Klein; Indiana University Art Museum, Bloomington: Diane Pelrine; Los Angeles County Museum of Art: Virginia Fields and Renée Montgomery; The Metropolitan Museum of Art; National Museum of the American Indian, Smithsonian Institution, New York: Nancy Rostoff and Molly Heron; Natural History Museum of Los Angeles County: Margaret Harden and Karen Wise; Peabody Museum of Archaeology and Ethnology, Cambridge: Rosemary Joyce and Genevieve Fisher; Peabody Museum of Natural History, New Haven: Michael Coe and Martha Hill; The Art Museum, Princeton University: Gilette Griffin and Ann Gunn; The Saint Louis Art Museum: John Nunley and Jeanette Fausz; The University Museum of Archaeology and Anthropology, University of Pennsylvania, Philadelphia: Lucy Fowler Williams; Yale University Art Gallery, New Haven: Susan Matheson and Susan Frankenbach; Folkens Museum-Etnografiska, Stockholm: Director Per Kaks, Staffan Brunius, Lars-Erik Barkman, and Anita Utter; Museum für Volkerkünde, Vienna: Christian Feest and Heide Leigh Theisen; Hamburgisches Museum für Volkerkunde: Corinna Raddatz; Marian White Anthropology Research Museum, State University of New York, Buffalo: Warren Barbour, Joyce Sirianni, and Margaret C. Nelson.

At The Fine Arts Museums of San Francisco, the production of *Teotihuacan: City of the Gods* was a tremendous effort for the entire staff, requiring a colossal spirit of cooperation, creativity, resourcefulness, and the ability to orchestrate complex tasks under conditions of extreme pressure. There are five individuals who must be singled out for extraordinary efforts. Kathe Hodgson served as coordinator for the project, and must be acknowledged, above all, for her competence, good humor, and profound common sense in guiding all aspects of the project and coordinating complex in-house operations and team meetings. Karen Kevorkian, the editor of this publication as well as the exhibition's guidebook, dealt undaunted with deadlines and the complexities of work by eighteen authors. William White, Exhibition Designer, deserves recognition for creating a sensitive and beautiful installation that does justice to the glory that was Teotihuacan. Lesley Bone, Objects Conservator, with her combined understanding of the preservation of archaeological objects and sensitivity to Latin American countries, was invaluable in many aspects of the negotiations, going far beyond the parameters of her job. And finally, Deborah Small, our very talented grants officer, worked with dedication on four intricate proposals to the National Endowments that have resulted in most of the support for Teotihuacan projects over the years.

Others on The Fine Arts Museums staff to whom we are especially grateful include Steven A. Nash, Associate Director and Chief Curator; Stephen E. Dykes, Deputy Director of Administration; James Forbes, Deputy Director of Development; Ann Heath Karlstrom, Director of Publications; Connie King and Ron Rick, Graphic Designers; Paula March, Manager of Corporate Relations and Membership; Renée Dreyfus, Curator of Ancient Art and Interpretation; Lois Gordon, Director of Education, and her entire staff; Therese Chen, Director of Registration; Michael Sandgren, Packer; Kate Schlafly, Coordinator of Special Events; Pamela Mays McDonald, Director of Audience Outreach; and Pamela Forbes and Barbara Traisman

of *Triptych* magazine. Special thanks also to Ellen Werner of the Department of Africa, Oceania, and the Americas, and to volunteers Hopemary Key, Catherine Docter, Vilma Toebert, as well as to the exhibition's entire technical crew, engineers, graphic design staff, development staff, and to individual members of the conservation, registration, information services, and accounting departments.

We are also grateful to Thomas K. Seligman, former Deputy Director at The Fine Arts Museums, who was so instrumental in the earlier Teotihuacan murals negotiations. Other special friends we wish to thank are Judith Teichman and Ben Flores for assistance on legal points, and Debra Pughe, former Director of Exhibitions.

Finally, we wish to thank our families and closest friends for their patience throughout the years as the project has unfolded. We will always be grateful to them for their unwavering support and encouragement.

Kathleen Berrin and Esther Pasztory

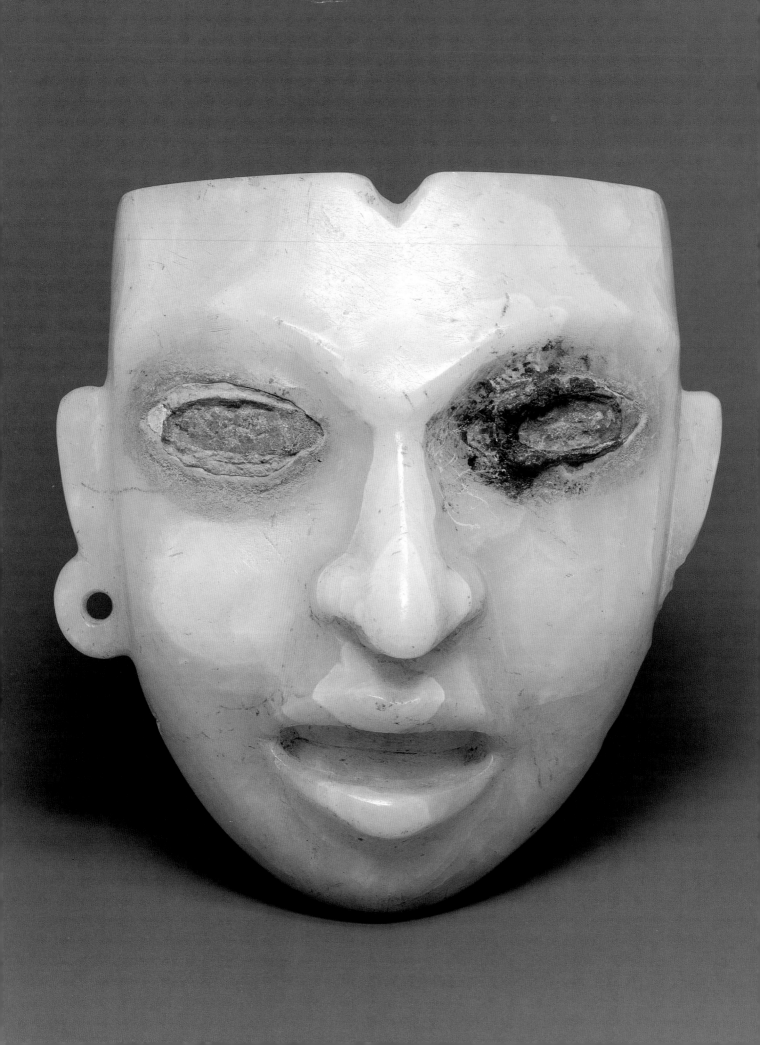

Envisioning a City

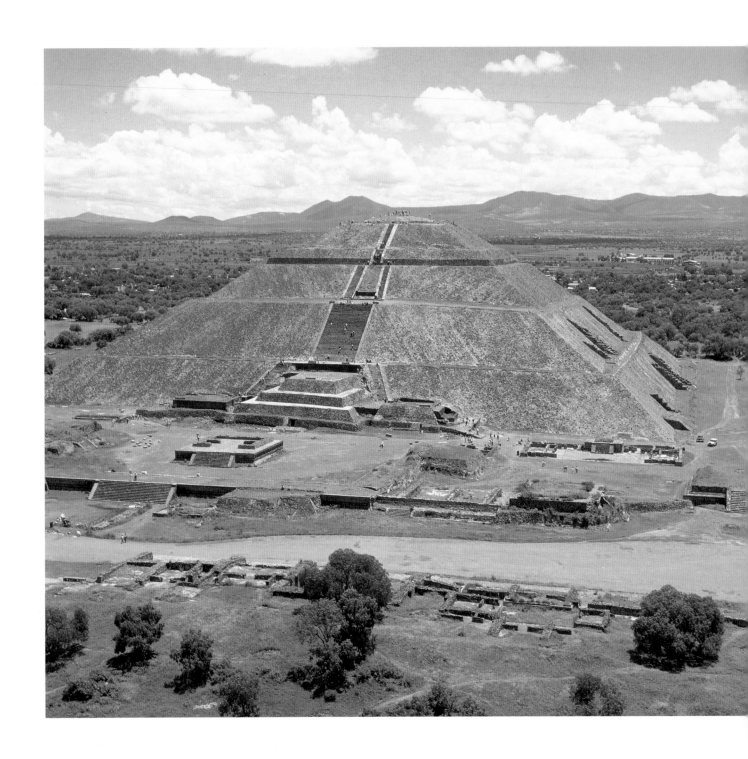

Fig. 1
Pyramid of the Sun

The Place
Where
Time Began

An Archaeologist's Interpretation of
What Happened in Teotihuacan History[1]

René Millon

Teotihuacan was an unusual city. It exploded into being as central Mexico's dominant urban center with the sometimes forcible concentration in the city of tens of thousands of people, the overwhelming majority of the surrounding population. It was the sixth largest city in the world in A.D. 600.[2] It housed its heterogeneous, multiethnic population for most of its history in some two thousand state-sponsored one-story stone and adobe apartment compounds designed for urban living. Its rulers were so determined to demonstrate their power through colossal public works, and its populace was so effectively mobilized and so suffused with religiosity, that they erected in the city center the greatest expanse of monumental public architecture of its time in the New World.

Teotihuacan's urban milieu fostered unprecedented economic activity and intellectual ferment. The results were manifold — the development of Central Mexico's most prosperous economy and wide-ranging exchange network; the development of an origin myth centering on the belief that Teotihuacan was where the cosmos and the present cycle of time began; the development and inculcation of a belief that the city's populace was specially honored and favored and collectively charged with the responsibility to maintain the viability of the cosmos through properly executed ritual from city center to individual household; the development of a cult of war-and-sacrifice governed by an eight-year cycle on which the well-being of cosmos, city, and citizen depended; the development of a military so renowned for its prowess and its victories that its cult of war-and-sacrifice, called "Star Wars" by some, was adopted by the Maya; the florescence of a culture, economy, and society of such power and prestige that Teotihuacan became the most influential city of its time in Mesoamerica and continued to play that role for hundreds of years; and the development during a time of collective leadership of distinctive art forms in which the individual was

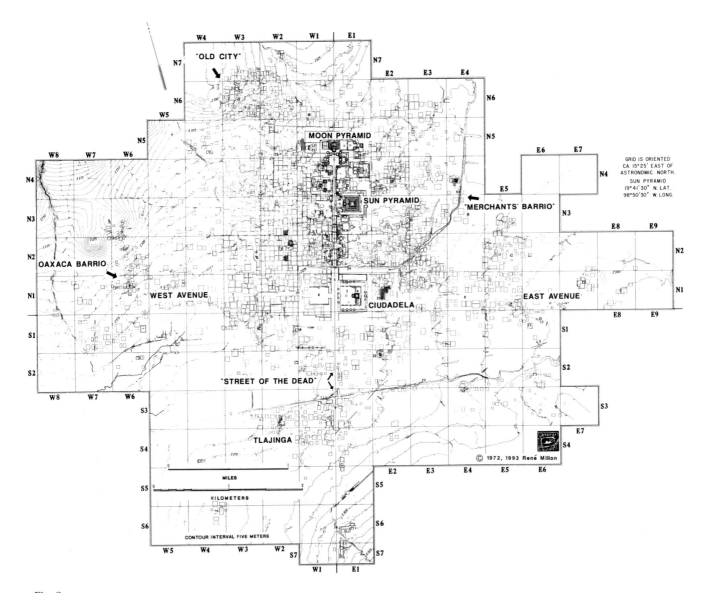

Fig. 2

Archaeological and topographic map of ancient Teotihuacan as it would have appeared ca. A.D. 600 when its population is estimated to have been at least 125,000, making it one of the most populous cities of its time. The construction shown extends over 20 square kilometers (8 square miles), an immense area for an early nonindustrialized city. The city's north-south axis was the "Street of the Dead." This great avenue, together with East and West Avenues, divided the ancient urban center into quadrants. For reasons directly related to a turning point in its political history, there was much less construction in the southern half of the city than in its northern counterpart. The "Street of the Dead" was more than 5 kilometers long (3 miles). The map shows partially or completely excavated structures, primarily on the "Street of the Dead," together with some 2,000 hypothetical reconstructions of high-walled, windowless, single-story apartment compounds, and temples, platforms, and other structures in the rest of the city that are based on Teotihuacan Mapping Project surveys and collections made on the surface in agricultural fields and modern towns on the site of the ancient city. Apartment compounds so reconstructed are shown as open rectangles on the map. The Teotihuacan apartment compound was an unusual residential structure because there were so many that were so large. Many were 50 to 60 meters (150 to 200 feet) on a side and housed 60 to 100 persons. Excavated compounds reveal rooms clustered around networks of courtyards with underfloor drains. The city was divided into many barrios or neighborhoods, at least two of which were occupied by foreigners, the Oaxaca barrio on the west, and the "merchants' barrio," occupied by people from Veracruz, on the east. Tlajinga, in the southwest quadrant, was a potters' barrio. The city had no outer defensive walls but neither was it an open city. See comments in fig. 3 caption.

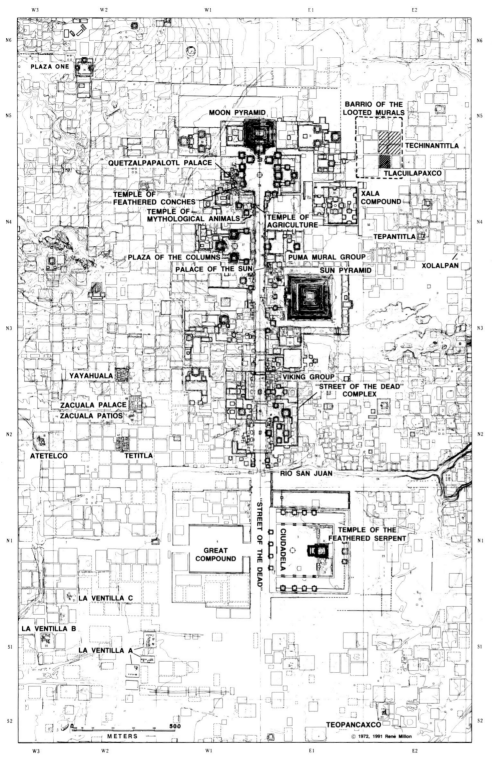

Fig. 3
Central Teotihuacan, an area of 7 square kilometers (3 square miles). Beyond the temples, public buildings, palaces, and other structures on and adjoining the city's main street, the "Street of the Dead," were the buildings occupied by most of the city's inhabitants. The basic residential structure was a one-story apartment compound. Open rectangles on the map represent unexcavated apartment compounds mapped in Teotihuacan Mapping Project surface surveys. Yayahuala, Zacuala Palace, and Tetitla, left center, are completely excavated apartment compounds, with high windowless walls and rooms clustered about courtyards. Atetelco, Zacuala Patios, and the five La Ventilla compounds, left, and Teopancaxco, Xolalpan, Tepantitla, Tlacuilapaxco, and Techinantitla, right, are partially excavated apartment compounds. The northern half of the "Street of the Dead" shown here is 2 ½ kilometers long (1 ½ miles). The Mall in Washington, D.C., is almost 3 kilometers long (2 miles). The "Street of the Dead" Complex, center, a large, walled administrative, political, and temple complex, covers an area of more than 30 acres (the area of the Pentagon in Arlington, Virginia, is 34 acres). The Ciudadela compound, bottom right, the city's political and religious center, covers 38 acres. The Great Compound, bottom left, was still larger; its area was 48 acres. A case can be made that the great central plaza of the Great Compound was the city's principal marketplace. The compounds on its two great platforms probably served bureaucratic ends. As noted in fig. 2, Teotihuacan was not a walled city. But some areas of the city are partially or completely walled, for example, the "Street of the Dead" Complex and other structural complexes on the "Street of the Dead." The Ciudadela's great platforms provided protection against assaults. There are also wall complexes north and west of the Moon Pyramid that may have served to separate the "Old City" (fig. 2) from the city center. If the city came under attack, its apartment compounds would have been defensible from the flat roofs atop their high walls. That is why it is misleading to think of Teotihuacan as an open city, although it is probably true that throughout most of its history its power was unchallenged and it needed no outer defenses.

19

deemphasized, rulers were not identifiably portrayed, domination and conflict were absent, and human sacrifice and ritual bloodletting were shown indirectly.[3]

The center of the city was dominated by its avenue, the "Street of the Dead," and its major pyramids, the pyramids of the Sun and Moon (figs. 1, 6) and the Temple of the Feathered Serpent. The last-mentioned is the principal temple in the Ciudadela, the great precinct in the center of the city (figs. 2, 3).[4] In addition to these constructions a critically significant cave is located beneath the Sun Pyramid.[5] The "Street of the Dead" has a distinctive orientation — 15.5 degrees east of north. I contend that this orientation was based on astronomical observations related to the cave. These observations also determined the location of the "Street" and explain why the pyramids are where they are. This mile-and-a-half stretch of the "Street of the Dead" is one of the most arresting concentrations of monumental architecture in the world. It overwhelms the viewer today, even in its present bare, skeletal form, without the white and red plaster that once covered its scores of platforms, without the ornate temples that once topped them.

Visitors and others who think about the layout of Teotihuacan wonder not only why the "Street of the Dead" has an unusual orientation but also why the Sun Pyramid, the city's largest pyramid, is on the east side of the avenue instead of at its head, and what started all this monumental construction. To answer these questions we have to begin in the second century B.C. when the first major settlement began to grow on the site of the later city.

BEGINNINGS

Teotihuacan grew up in the central part of the Teotihuacan Valley in the northeastern part of the Basin of Mexico (fig. 4), a high plateau in central Mexico over seven thousand feet in altitude with a temperate semiarid climate and a system of shallow lakes in its center. An island in one of those lakes was the site of the later Aztec capital. Mexico City was built on the ruins of the Aztec city and today extends widely over a now largely drained lake bed.

The Teotihuacan Valley was intensively settled in the second century B.C., long after most of the Basin of Mexico. It was not intensively settled earlier because it has less rainfall than the rest of the Basin. But it had resources with the potential to compensate for this. Among these resources were deep alluvial soils and many adjacent springs. The potential for irrigation as well as obsidian deposits and a key geopolitical position in the Basin made it a region of exceptional promise. The realization of that promise brought the Teotihuacan state into being and transformed the Teotihuacan Valley into the Basin's most productive economic area for most of a millennium.

Arable land would have been divided among founding kin groups, with some of the best lands set aside for public purposes, including the support of communitywide ritual. Kin groups with high-status members would have been favored in gaining access to alluvial lands in the lower valley (fig. 4). Their increasing prosperity would have contributed to the intensification of stratification in early Teotihuacan society as the original community was transformed into a thriving urban center in the space of a century or so, with priests and other religious specialists becoming increasingly prominent. An important outgrowth of this

20

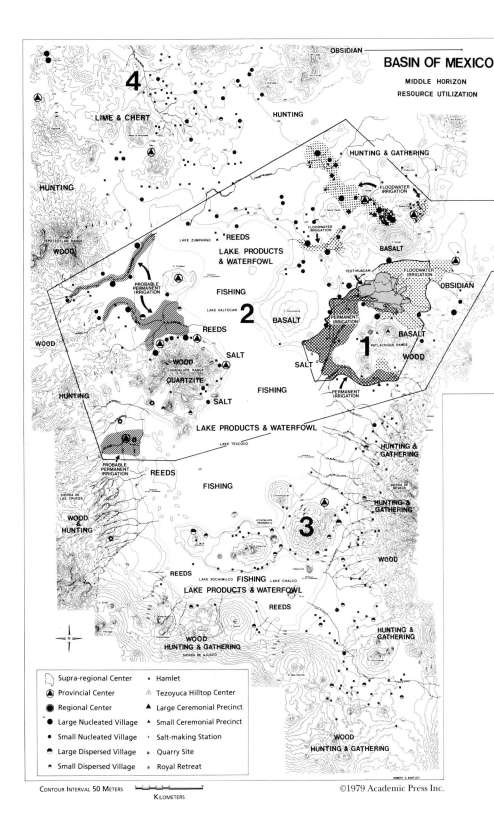

Fig. 4
The Basin of Mexico showing the resources used and zones exploited during the time of Teotihuacan ascendancy in the first millennium A.D. From Sanders, Parsons, and Santley 1979.

Zone 1 is the Teotihuacan Valley. Zone 2 includes the area immediately adjoining the Teotihuacan Valley, including the irrigable lands directly across the lake. Zones 3 and 4 were much less intensively occupied, despite the fact that Zone 3 was potentially the most productive part of the Basin and was much more intensively exploited both before and after this area came under Teotihuacan control. The southern zone was virtually depopulated when the Basin's population was removed and concentrated in the city in the first century A.D. Moving the Basin's population into the city made it easier for the city's rulers to maintain direct control over the vast majority of the people who had been living in other parts of the Basin. Maintaining this control was evidently so important to the city's leaders that the vast majority of the Basin's population remained concentrated in the city for centuries. The price paid for this was the dramatic underutilization of the rich resource potential of the southern Basin, which persisted throughout the centuries of Teotihuacan dominion.

BASIN OF MEXICO

MIDDLE HORIZON
RESOURCE UTILIZATION

Supra-regional Center
Provincial Center
Regional Center
Large Nucleated Village
Small Nucleated Village
Large Dispersed Village
Small Dispersed Village

Hamlet
Tezoyuca Hilltop Center
Large Ceremonial Precinct
Small Ceremonial Precinct
Salt-making Station
Quarry Site
Royal Retreat

CONTOUR INTERVAL 50 METERS

KILOMETERS

©1979 Academic Press Inc.

ROBERT S. SANTLEY

Fig. 5a

Pyramid of the Sun, height 63 meters (210 feet). Cross section showing cave 20 feet beneath it and archaeological tunnels at and near ground level (1933 and 1920, respectively) and near its summit (1962).

The Teotihuacan Mapping Project excavation (1968) in the floor of the 1962 tunnel exposed a great sloping wall (*talud*) of earth faced with mud plaster, which was part of a platform on the summit of an earlier Sun Pyramid (not illustrated) that was almost as large at the base as the present one. See enlarged plan of cave in fig. 5b.

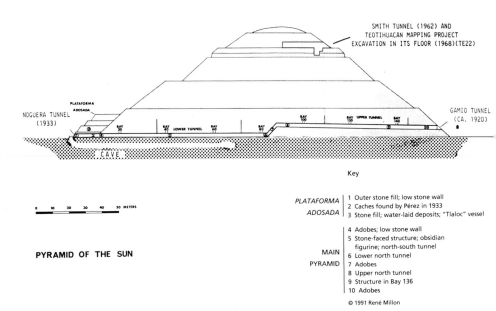

PYRAMID OF THE SUN

0 10 20 30 40 50 METERS

Key

PLATAFORMA ADOSADA	1 Outer stone fill; low stone wall 2 Caches found by Pérez in 1933 3 Stone fill; water-laid deposits; "Tlaloc" vessel
MAIN PYRAMID	4 Adobes; low stone wall 5 Stone-faced structure; obsidian figurine; north-south tunnel 6 Lower north tunnel 7 Adobes 8 Upper north tunnel 9 Structure in Bay 136 10 Adobes

© 1991 René Millon

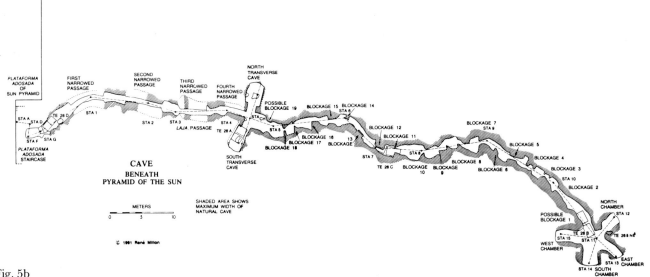

CAVE
BENEATH
PYRAMID OF THE SUN

METERS
0 5 10

SHADED AREA SHOWS MAXIMUM WIDTH OF NATURAL CAVE

© 1991 René Millon

Fig. 5b

Sun Pyramid cave. Enlarged plan of the cave beneath the Sun Pyramid shown in schematic cross section in fig. 5a. Plan shows the natural width of the cave and the various ways it was modified by the Teotihuacanos in the first century A.D. and earlier to produce a passageway much more sinuous and serpentine than the natural cave. The cave must have been centrally important in Teotihuacan religion because its entrance determined the locus and center line of the Sun Pyramid. Every aspect of the modified cave manifests ritual. The western section of the cave, between its entrance and the transverse cave, was altered four times by narrowing and by the construction of low, slab-covered ceilings, so that those penetrating the cave would have had to repeatedly alternate between standing and crouching and kneeling. In the second century A.D. the eastern section of the cave was sealed by a succession of seventeen to nineteen blockages of stone, most of which were faced with standard Teotihuacan mud concrete. These barriers were penetrated in Teotihuacan times, probably during the fourth century A.D. Teotihuacan Mapping Project explorations and excavations in the floor of the cave in 1978 disclosed evidence of first-century A.D. rituals involving fire and water and offerings of shell and tiny fish spines and bones in association with distinctive ceramic forms (a plate, a bowl, and a jar) found in quantity only in the cave.

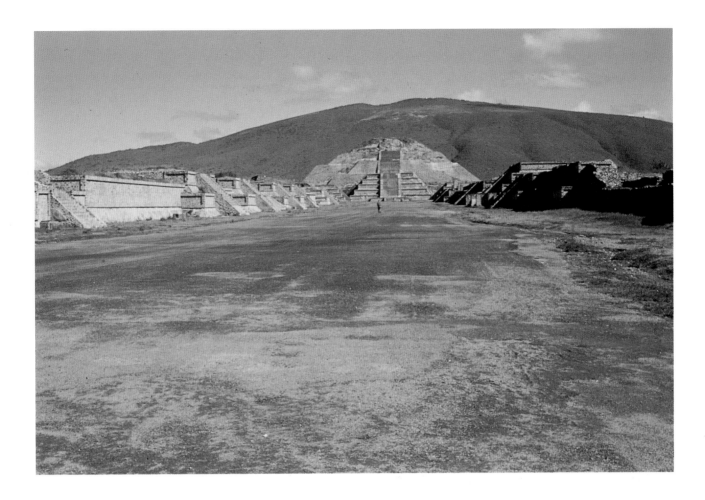

process would have been the development of a group of prospering leaders, from whose number would have come the city's early rulers.

The exploitation of workforce and ecological potential to produce a powerful expanding economy is only part of the story. The key to understanding the phenomenon that was Teotihuacan is the way religion and ideology were used in a context of economic strength and military might to transform the city into the seat of the most powerful single state in Mesoamerica, one that had an unequaled influence for more than five hundred years.

The City Transformed

The story begins with one of the many caves underlying what was to become the city of Teotihuacan — the cave that now lies beneath its great pyramid, the Pyramid of the Sun (figs. 5a-b). At the time the Teotihuacan Valley was intensively settled, caves in Mesoamerica were considered to be potentially sacred — entryways to the underworld — places of emergence.

The Sun Pyramid cave came to be seen as the focus of a creation myth in which it was portrayed as the place where the present era began, where humankind came into being, and where the present cycle of time was born.[6] A sightline from the cave's entrance to the western horizon was related to astronomical phenomena (the setting sun and the Pleiades constellation) with calendric associations (day counts, beginning dates) that would have been profoundly significant to other

Fig. 6
The Pyramid of the Moon at the north end of the "Street of the Dead," framed by Cerro Gordo and centered on the notch at its summit. The *talud-tablero*, the architectural form symbolizing the sacred at Teotihuacan, decorates the facades of temples on both sides of the avenue as well as the five-tiered platform abutting the base of the Moon Pyramid.

Mesoamericans.[7] Teotihuacan's leaders, headed by a powerful, probably charismatic, ruler, decided to put Teotihuacan on the map with a bang. They would commemorate the importance of the cave and relate it to their principal deity with a program of monumental construction that would forever memorialize the cave's significance, while dramatizing the exercise of the leaders' power. To carry this out they used the control that by this time they had gained over the other communities in the Basin, through conquest or other means, to round up their populations and concentrate them in the city, using force where necessary.[8]

Ideology would have played a critical integrative role, supporting the state in the maintaining of order in a city now swollen with thousands of ethnically diverse newcomers, and at the same time dampening the need for repressive action. A powerful source of integration would have been the requirements of state ritual celebrating Teotihuacan's creation myth and the honored position this myth accorded the city and its inhabitants.

A half-mile-long avenue perpendicular to the cave sightline, with three-temple complexes on both sides, was built north from the plaza in front of the cave and the temples associated with it toward what had been regarded from the outset of settlement as the Valley of Teotihuacan's sacred mountain, centering on the notch at its crest. The avenue ended with a pyramid, the earliest Moon Pyramid, framed by the sacred mountain (today unflatteringly called Cerro Gordo) dedicated to the city's principal deity, the Great Goddess (our designation), who was associated with both the mountain and the new pyramid (fig. 6).

Seventy-five to a hundred years later the avenue was extended another half-mile to the south, the Moon Pyramid underwent a major enlargement, and the first Sun Pyramid, almost as high as the Sun Pyramid we see today, was built, centered on the cave's entrance and dedicated to the Great Goddess and a god of storm, lightning, and rain whom we call the Storm God (still misleadingly called Tlaloc by some, after the later Aztec god). The city's third principal deity was the Feathered Serpent. Temples in the city's many three-temple complexes presumably were dedicated to these deities. The Great Goddess was celestially associated with the sun; the Feathered Serpent, with the planet Venus.

Another fifty to seventy-five years later (ca. A.D. 150-225), the Sun Pyramid was built, whose facade we see today; the avenue was extended more than two miles to the south; and a new center of the city was created three-fourths of a mile south of the Sun Pyramid. Two immense enclosures were built there — the Ciudadela, the city's new political and religious center, and opposite it the even more extensive Great Compound, which was to serve as the city's main marketplace and bureaucratic center. The Moon Pyramid was enlarged almost to its present size and sophisticated form (fig. 6). East and West Avenues were laid out centered on the Ciudadela and Great Compound, dividing the city into quadrants. The southern quadrants were never developed as the northern quadrants had been, because with these megacompounds great monumental construction in the city came to an end.[9] The Rio San Juan was canalized in the city center to follow the Teotihuacan orientation in its flow to the west (figs. 2, 3).[10]

The Ciudadela is the most sophisticated architectural entity and expression of monumentality at Teotihuacan. Its platforms and temples bore the characteristic elements of Teotihuacan temple architecture,

the *talud-tablero* (see fig. 6 and Matos-López, fig. 3). Both the Temple of the Feathered Serpent, completed ca. A.D. 225, and the earlier platform abutting the Sun Pyramid, completed ca. A.D. 175, bore cut-stone *talud-tablero* architecture.[11] The architect of the Ciudadela did not try to surpass the Sun Pyramid. Instead of the emphasis on verticality and volume, on height and mass in the earlier pyramids, horizontality was stressed, with the *talud-tablero* form accentuating the long horizontal expanses.[12] Here the onlooker is separated from the palaces and major temples, not by overwhelming height and mass, but by architecturally expressed distance that is horizontal rather than vertical.

In addition to the other ends that these monuments served, the expenditures of energy manifest in the pyramids of the Sun and Moon, the Ciudadela, and the "Street of the Dead" are dramatic demonstrations, dramatic realizations of the exercise of power[13] during a time of strong rulers, when Teotihuacan society became increasingly stratified and the gulf between the top and bottom of Teotihuacan society widened.

With the building of the Ciudadela compound and the complex of constructions within it, the focus shifted away from the recently enlarged Sun Pyramid and the newly enlarged Moon Pyramid. To me the most persuasive explanation for this shift is that an ambitious new ruler with a passion for immortality wished to build a colossal new seat of power and authority. It was to be embedded in a ritual setting of such transcendent significance in the Teotihuacan belief system that it would become a major focus of citywide ritual in what would become the new center of the city.

CROSSROADS OF THE COSMOS

The core of the newly emphasized ritual was a cult of sacred-war-and-sacrifice ("Star Wars") associated with the Feathered Serpent deity, the Storm God, and the planet Venus and its cyclical motions.[14] Conquests to the east by the new ruler, accompanied by some population resettlement in the city, may be part of what was being celebrated in the macabre dedication of the Temple of the Feathered Serpent. It must have been a time of unparalleled prosperity in which there were few checks on the power of the new ruler.

The fundamental significance of the symbolism of Teotihuacan's sacred cave as passageway was preserved and emphasized in the imagery of the Temple of the Feathered Serpent, for its sculpted serpent heads are portrayed as emerging from "a great facade of feathered mirrors"; mirrors represented caves as passageways in Mesoamerican iconography.[15] The cult of war-and-sacrifice was given cardinal significance through the mass sacrifice of Teotihuacano soldiers in the temple dedication. Celebration of the cult through sacrifice in the Temple of the Feathered Serpent had become an essential ritual in the city center. Its primary concern became the maintenance of the cosmos and human well-being through the sacrifice of war captives.[16] Whether or not this was part of the original ritual, it soon came to center on heart sacrifice.[17]

Teotihuacan's ruler had endowed the new seat of power and authority with cosmic significance. The new east-west axis and the southern extension of the "Street of the Dead" placed the Ciudadela in the geographic center of the city. The celebration in this new center of sacrificial ritual perceived as essential to survival placed its perfor-

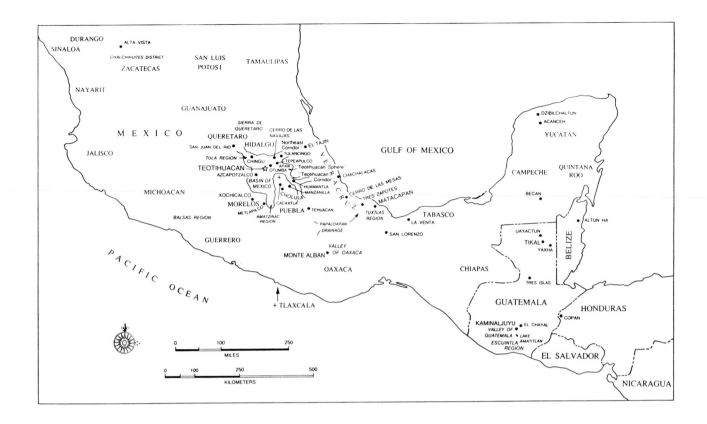

Fig. 7
Ancient Mesoamerica. The area directly controlled by Teotihuacan is outlined at center, left. Other places identified were related to Teotihuacan in one or more ways — through economic links, religious and other cultural influences, or political ties.

mance at the crossroads of the cosmos (as many centers in the Old World and the New were believed to be). It would have served as the axis around which the cosmos moved,[18] the place where ritual had to be performed to ensure the world's continued existence.

Teotihuacan rose to its position of dominance in Central Mexico and beyond in the two centuries from the time of population concentration to the building of the Ciudadela because of the way its ecological potential was exploited, because it had a vigorous, expanding, and diversified economy, and because it had developed a novel, highly effective political system and military. But essential to its success as the power of consequence it became in Mesoamerica was the instrumental way its leaders used the attraction of its holy places and the prestige of its religion to make it so significant to so many for so long a time.

The city had been led by a succession of powerful rulers, two of whom may have been buried in the Moon and Sun Pyramids respectively. The ruler under whose regime the Ciudadela precinct was built and the Temple of the Feathered Serpent was dedicated appears to have been the last great ruler.[19] The dedication of the Temple of the Feathered Serpent was accompanied by perhaps as many as two hundred human sacrifices,[20] most of them soldiers guarding the temple in death, all of them apparently Teotihuacanos. Human sacrifice, including the sacrifice of Teotihuacanos, was a part of Teotihuacan ritual both before and after this, in the dedication of the Sun Pyramid, for example, but not on this scale. This mass immolation has no known precedent and was not repeated.

REACTION AND REFORM

A period of reaction and enduring reform set in. It appears that the domination of Teotihuacan society by increasingly powerful rulers[21]

26

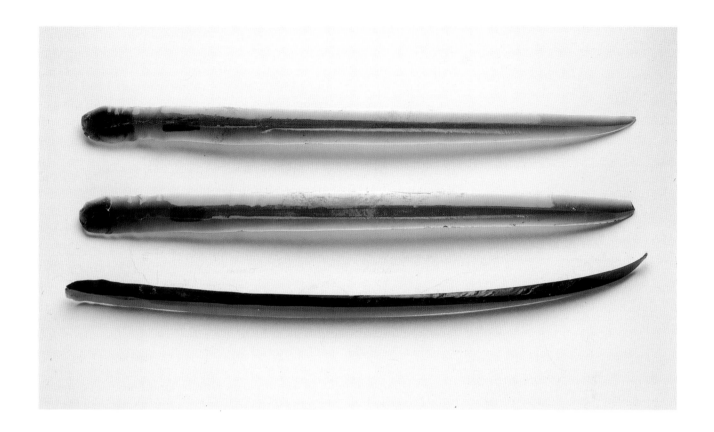

had become so onerous that permanent checks were placed on the exercise of arbitrary power, checks so effectively institutionalized and so firmly embedded in ideology as to make possible their persistence for most of the rest of Teotihuacan's history as a dominant power.[22] The regime established by the collective leadership of the ruling bureaucracy precedes or roughly coincides with the coming into being of what are recognized to be at once the best-known, most characteristic, and most distinctive aspects of Teotihuacan society. It remains to be seen how much of this transformation relates to political reform, how much to the prior regime, and how much to currents not derivable from either.

The political reform endured for at least four hundred years until the last century of the city's existence as a great power, when it appears that there was at least a partial restoration of personal rule. The reputation of Teotihuacan's victories in war and of its military prowess,[23] as well as the associated prestige of its cult of sacred-war-and-sacrifice, persisted after the power of Teotihuacan's rulers had been curtailed. The expansion of the Teotihuacan state into regions surrounding the Basin of Mexico, begun in the first or second century A.D., was continued after the political reform had taken hold. It included the incorporation of a subtropical cotton-producing region south of the Basin (in present-day Morelos) and obsidian- and lime-producing regions to the north (in present-day Hidalgo).

It is reasonable to infer that the collective leadership would have sought to shore up its authority by intensifying the religiosity that had for so long pervaded Teotihuacan society. This effort likely entailed an increased emphasis on the ritual calendar and the proliferation of ritual performances centered on both domestic and state concerns. All of Teotihuacan's deities are likely to have played roles in the celebration

Cat. no. 170
THREE PRISMATIC BLADES
CNCA-INAH-MEX, Centro de Investigaciones Arqueológicas de Teotihuacan.

of war-and-sacrifice ritual, which emphasized the military and ritual obligations and responsibilities of those in the hierarchy. Political activity would have been embedded in ritual performances and have derived legitimacy from them. Indeed, the power of rulers may have been kept in check by accentuating their sacredness and enveloping them in ritual requirements, as has been done in other times and places.

Heart sacrifice was the ultimate sacrifice. Captives taken in war or in lesser conflicts would have been the most common victims. But there also must have been occasions when the sacrifice of a Teotihuacano was demanded. Much more common would have been ritual blood-letting performed in public and private at every level of Teotihuacan society — in public by persons of high rank and in domestic settings at the compound level by compound leaders and others, depending on circumstances.[24]

Teotihuacan Abroad

The area dominated by Teotihuacan was never vast, probably about ten thousand square miles, about the size of Sicily.[25] The population under its control probably did not exceed 500,000. Incursions continued into distant regions. This was the case in Guatemala beginning in the third century A.D. Ties between Teotihuacan and lowland Petén Tikal continued for two hundred years or more, involved the adoption of the distinctive Teotihuacan temple form (talud-tablero) for a time, but apparently never entailed domination or conquest.[26] Tikal adopted Teotihuacan's sacred-war-and-sacrifice cult about A.D. 375 and used it to justify the conquest of surrounding cities.[27]

Teotihuacan's relations with other parts of Guatemala were blunter. The highland capital of Kaminaljuyú (fig. 7) appears to have been conquered and held for perhaps a century. The Pacific coastal region of Escuintla may have been held for a longer period. The attraction of these regions were their exotic products, including tropical feathers prized for headdresses, jade, and other greenstone minerals coveted for jewelry, cacao beans esteemed for their use in beverages and as a medium of exchange, Pacific Ocean shells treasured for use in ritual and personal decoration, copal valued for its use as incense in ritual, and probably rubber which would have been required for the ritual ball game and perhaps for other ritual purposes. All of these were also obtained from other regions such as Yucatán and Veracruz on the Gulf of Mexico and in Guerrero on the Pacific side, both in the highlands and on the coast.

Teotihuacan's exports included an obsidian particularly well suited to the making of prismatic blades (cat. no. 170, this essay); ceramics, including a prized tradeware not locally made but distributed from Teotihuacan known as Thin Orange (cat. nos. 148-164); cloth; raw materials and finished products derived from maguey and nopal; and, mainly in central Mexico, ritual paraphernalia. The impact of Teotihuacan on other regions of Mesoamerica was highly variable but in most instances appears to have been economic, ideological, and cultural, rather than political.[28] There was no Teotihuacan empire. Nevertheless, no other single city had so widespread and far-ranging an impact in the history of Mesoamerica prior to the time of the Aztecs.[29]

Teotihuacan's prosperity fostered growth in the arts. The archae-

ologist sees this manifested primarily in the visual arts (cylindrical tripods, Thin Orange, censers, masks, figures, figurines, and sculpture). But musical instruments, including multitubed flutes, ocarinas, drums, and rattles, also abounded. Mural painting began a development in the third century that made it one of the city's principal art forms for five hundred years.

THE TEOTIHUACAN APARTMENT COMPOUND AND ITS SIGNIFICANCE

Teotihuacan had been an urban society with a population approaching 100,000 for two centuries when existing agglomerations of dwellings of perishable materials began to be razed and replaced by large permanent dwellings of stone and adobe, whose walls and floors were surfaced with concrete and plaster. Such structures for general residential use were without precedent in Mesoamerica; the intent was to create order from increasing urban disorder. These high-walled, windowless apartment compounds (Manzanilla, figs. 1-3) were apparently designed to accommodate the needs of populations beset by the problems of crowded urban living in a nonindustrialized setting. Their many interior patios made it possible to gain a measure of privacy in open-air settings.[30] In time about two thousand of the compounds were built, eventually housing virtually all of the city's population, which at its maximum was perhaps 125,000 to 150,000.

Apartment compounds were occupied by kinship units, often numbering fifty to one hundred people in a compound. The state must have sponsored the building of apartment compounds by organizing the supply of building materials. This was a political decision that resulted in administrative units of some fifty to one hundred people at the base of Teotihuacan society. But a fundamentally political end received strong religious backing in the ritual requirement that apartment compounds conform to Teotihuacan orientations.[31] Apartment compounds were not built to uniform plans. With the partial exception of the Ciudadela palaces, all apartment-compound layouts thus far excavated differ from each other. The system of underfloor drains in each meant that construction of the compound had to be planned from the outset. Each was evidently built to accommodate the particular needs of the group that was to occupy it. With the passage of time demographic changes would have made apartment-compound layouts increasingly inappropriate and inflexible. This is why we have inferred that the kin units occupying them must have been flexible and adaptable.[32] Apartment compounds served as the city's basic political units with neighborhood or barrio headquarters standing between groups of compounds and the central hierarchy.

When the "Street of the Dead" was laid out in the first century A.D., many three-temple complexes were built on or near the "Street of the Dead" and in the city's northwest quadrant. The early political role these temple complexes appear to have played may indicate that they subsequently formed part of the city's administrative structure.[33]

Apartment-compound dwellers would have formed the city's basic economic and social units, serving as the source of labor in state workshops and on state lands, public works, and other state enterprises, and furnishing the population from which military units were formed.

These exactions and requirements would have been levied from above and passed through the hierarchy to the barrio or neighborhood level and from there to compound leaders.

The rights of apartment-compound dwellers as kin-unit members would have been the fundamental source of whatever rights they had in the city and state. Most compound kin groups would have had rights to work lands of differing quality at varying distances from the city, both within and bordering the Teotihuacan Valley. Subordination of the individual to the group and obedience to authority[34] are likely to have received great emphasis. Most of the time of compound dwellers is likely to have been at the disposal of compound heads, whether in agriculture, crafts, or any of the various kinds of obligatory service work assigned to compounds in the city.

A great deal of internal variation in status existed among the occupants of apartment compounds,[35] whatever the compound's level in the social hierarchy. The same seems to have been true of apartment compounds within a barrio. Contiguous barrios could also vary widely in the status level of their occupants. This gave the city a mosaic quality, with no simple gradation in status from center to periphery. The basic problem of survival remained for those at the bottom of Teotihuacan society even after the transfer of the city's population into permanent apartment compounds. Apartment compounds that were not in the city center varied greatly in the quality of construction. A small number were palatial and were decorated with murals. But the vast majority of the compounds so far explored in all the city's quadrants have been simple, unadorned, and often of shoddy construction.[36] Even when the city was at its most prosperous, conditions for those at the bottom of Teotihuacan society were so harsh, infant mortality so high, and life expectancy so low that the city could not maintain its population without attracting to it newcomers from the countryside and beyond.[37]

Foreign Barrios

Teotihuacan's complex urban society was able to accommodate at least two foreign enclaves on a long-term basis — one from Oaxaca to the south, the other from Veracruz to the east. Foreigners from the southern highlands, from Monte Albán, the capital of the Valley of Oaxaca, were allowed to settle near the city's western edge (fig. 2, left). The inhabitants of the Oaxaca Barrio lived in apartment compounds in one of which we exposed a standard *talud-tablero* temple.[38] As a means of retaining their ethnic identity these outsiders maintained many of the customs and beliefs they had brought with them, including the use of funerary urns and Oaxaca-style tomb burials. They were not people of high status in the city and may have been engaged in the extraction of lime in the Tula region[39] and its marketing in the city.[40]

A second foreign barrio, the "Merchants' Barrio,"[41] was established on the city's eastern margin in the fifth century by people from coastal Veracruz who built a unique cluster of round structures. These structures, whose walls obviously could not follow the Teotihuacan orientation, nevertheless were aligned in north-south rows that follow the Teotihuacan orientation rather than the riverbank they adjoin.[42] In addition to quantities of Veracruz and Maya pottery, excavations suggest that barrio residents were importing other materials, including cotton, cinnabar (used in funerary ritual and pottery decoration), and

fine plumage (such as the long feathers used in Teotihuacan head-dresses). The evidence also suggests that the cinnabar was processed in the barrio and that textiles were produced there.[43] Structures in the barrio built in the sixth century were rectilinear and conformed to Teotihuacan orientations.[44]

CITY AND COUNTRYSIDE

Teotihuacan's foreign barrios stand out sharply but are only its most obvious neighborhoods. Other barrios have been identified in the city, some because their boundaries are so clear, others because of what has been found within clusters of adjoining compounds, and still others for a combination of reasons. Among those identified are barrios of craftworkers (such as obsidian knappers, potters, and lapidaries) and one or perhaps two military barrios.

Although craft production was more important at Teotihuacan than anywhere else at the time in Mesoamerica, there may have been relatively few full-time craft specialists in the city.[45] Most craftworkers probably also had to do other work in the city or in the fields.

Two social districts[46] in the city stand out because of the relative prosperity of some who lived there. Many of the city's most famous mural paintings are in these districts. One district, encompassing several barrios west of the "Street of the Dead," includes the Atetelco, Tetitla, Zacuala Palace, and Zacuala Patios compounds (figs. 2, 3). The other cluster includes the barrio in which Tepantitla is located and the Barrio of the Looted Murals. Each of these districts include military compounds — Techinantitla, headquarters of a military barrio, and Atetelco.[47]

Several hundred years after the concentration of most of the Basin of Mexico's population in the city, a planned resettlement of selected parts of the Basin occurred. It was centered in areas where agricultural production and resource exploitation could be maximized, as in the irrigable lands to the west of the Teotihuacan Valley (fig. 4).[48] Even with this resettlement, the great majority of an estimated Basin population of 200,000 during the A.D. 200-750 time span continued to live in the city. The price paid by the hierarchy for direct control over so much of the Basin's population for so long was the underutilization of much of the Basin's resources compared to what was done earlier and later.[49]

Prescribed rituals and associated religious beliefs were used effectively to reinforce the ideology of the state.[50] The successful performance of ritual was necessary to keep the cosmos in motion, to keep life going, and to ensure fertility and future life. To be a Teotihuacano was to be honored and favored because Teotihuacan was the center of the world and where the world began.[51] But this honor carried with it an obligation to participate in state ritual in order to ensure the continued existence of the cosmos. The celebration of rituals, such as those associated with the cult of war-and-sacrifice, united a heterogeneous, multiethnic population whose members had diverse interests.[52] At the level of the household the performance of ritual was enhanced by the sacred orientation of the walls of the compound in which it was being carried out. The legitimation accorded the state in its ritual role provided support for its labor exactions and corvée labor requirements, as well as for its role as enforcer of state requirements, and as the guardian of public order.

FIERY DESTRUCTION

During the last century of the city's existence as a major power center, its exchange networks and trading relationships began to experience problems.[53] It was a time of increased prosperity for some and increasing problems for many, and a time when a partial restoration of personal rule seems to have occurred. The collective leadership that had so successfully carried out the initial reform and maintained the checks on the power of rulers may have undergone factional disputes severe enough to undercut its effectiveness and allow rulers to reassert powers previously denied them. Pressures from below may have been exerted to ease state requirements and restrictions and so serve as a safety valve in Teotihuacan's hierarchical society. But those at the top may have been unable to respond to changing circumstances. Economic and social conditions may have deteriorated,[54] perhaps exacerbated by repressive actions of the state.

A sharpening and widening of status differences in the middle range of Teotihuacan society may have taken place. The apparent increase in the prominence of the military in the final century (ca. A.D. 650-750) may have been accompanied by an increase in the obtrusiveness of the state and its repressive activities and in an erosion of its legitimacy.[55] A more significant contributor to the problems that led to the state's demise is the likelihood that Teotihuacan suffered from long-term mismanagement.[56] Policies that may have made political sense when inaugurated (the population concentration) may have been continued long after they began to create economic problems (the underutilization of the Basin's resources). Possibly related to these circumstances was the marked "unevenness" in development at the end — productivity and prosperity in some sectors, deterioration and decline in others. But however serious these problems were, the evidence we have now does not prepare us for the cataclysm that put an end to Teotihuacan as a major power.

Deepening conflict at the top between the collective leadership and rulers who had reassumed old powers may have weakened the power of the state and demoralized its repressive arm. The centuries-old role of the collective leadership had been called into question by even a partial restoration of personal rule, as had the legitimacy of the hierarchical structure of the city and state. A stalemate in this conflict could have interfered with the effective operation of the city's administrative structure, leading to breakdowns in public order. Deepening resentments against the city's ruling establishment among influential leaders in various parts of the city, resentments that might have been defused by modest accommodations, instead may have been bitterly resisted because the hierarchical structure was rigid and inflexible. These resentments could have turned to hatred if the state's military arm, riven by internal conflicts, allowed factional struggles to turn into repressive actions against the citizenry.

Tensions must have mounted intolerably, because in a sudden explosion of fury the Ciudadela was attacked. People in its palaces were slaughtered. The palaces were burned. Temples were reduced to rubble. This was not commonplace destruction. It was not solely a manifestation of fury and rage, not simply a violent, murderous attack on hated rulers, such as has occurred many times in many places. What is most strik-

ing is that those who led this assault did not allow matters to rest with the storming of the Ciudadela. Perhaps fearing that new rulers would rise from the ashes, as perhaps had happened in the past, these leaders set in motion a systematic process of ritual destruction that led to the dismantling and burning of structure after structure on the "Street of the Dead," because to destroy Teotihuacan politically meant to destroy it ritually. Temple and state were one and symbolized as such. The Teotihuacan polity was sacralized. Political acts were embedded in sacred acts. Ritual permeated the political.

The center was not simply consumed in a spreading fire. Temples and public buildings were not merely destroyed — they were cast down, dismantled, burned, reduced to rubble, again and again and again, on both sides of the avenue for more than a mile. I have called this destruction Carthaginian and it has that quality. It does because those who started this process wanted to be certain that no powerful Teotihuacan state ever again would rise from these ruins. Because religion and the state were fused and inextricable, the state could not be destroyed without destroying its temples, and destroying its temples meant ritually demolishing each of them in a process of fiery destruction.[57] This is what happened to all the temples in the Ciudadela, to temples on the "Street of the Dead," to temples in outlying parts of the city. A process of ritual destruction and desacralization unprecedented in scope and scale in Mesoamerica was carried out until the heart of the city was in flaming ruins, until most of its other temples were destroyed and burned.

Even though few of its apartment compounds had burned, the city apparently was abandoned for a short time, perhaps fifty years, before a new city arose in its place, a new community with a different cultural tradition, and with new dwellings, smaller and unlike apartment compounds.[58] The ruined Street of the Dead, now no longer a misnomer, remained a wasteland. But Teotihuacan's legacy endured in other times and places. We see it among the later Toltecs and the still-later Aztecs, We see it in Teotihuacan today. We see it in this exhibit.

René Millon is Professor Emeritus of Anthropology at the University of Rochester.

1. This brief overview of Teotihuacan for the general reader represents my current understanding of what we know or can infer about the ancient city. Supplementary information and observations appear in the notes. Space limits make it impossible to present the evidence for many of my statements or to convey how fragile particular interpretations may be. The interested reader should consult the citations in the notes and other sources for fuller explanations of the evidence and of my interpretations. George Cowgill's essay in this catalogue should be read in conjunction with this essay, for he stresses what is *not* known about Teotihuacan — how much critically important information we still need to learn to gain an adequate understanding of the most basic questions about Teotihuacan society and history.

2. Constantinople was the largest with an estimated population of 500,000. Second and third were the Chinese cities of Changan and Loyang. Ctesiphon, the Persian capital, twenty miles south of Baghdad, was fourth. (The vulnerability of its renowned arch was the subject of much concern in 1991 during the Persian Gulf War.) Alexandria was fifth with an estimated population of 200,000. Teotihuacan was sixth with an estimated population of 125,000. Tertius Chandler and Gerald Fox, *3000 Years of Urban Growth* (New York: Academic Press, 1974), 82, 305, 368.

3. Schele and Freidel apply the term "Star War" to the Teotihuacan cult of war-and-sacrifice adopted by the Maya of Tikal. Linda Schele and David Freidel, *A Forest of Kings: The Untold Story of the Ancient Maya* (New York: William Morrow, 1990), 130. Carlson (1991) refers to it as "Star Wars." While Teotihuacan was a city of economic opportunity, it differed fundamentally from medieval and later cities in western Europe largely because of the pervasive role of the state in its economy. In some respects Teotihuacan may have resembled an early Near Eastern or Chinese city except that marketplace trade became important early in its history. The marketplace as a milieu where many could come together repeatedly would have created a setting where intellectual activity could have flourished,where new ideas might have had a hearing, perhaps in some measure approaching the ambience of the ancient Greek agora, under admittedly quite different circumstances. This milieu also may have played a role in the city's ultimate violent fall.

4. The names of the "Street of the Dead" and the two pyramids come from the sixteenth-century Aztecs, more than seven hundred years after Teotihuacan ceased to be a politically dominant force in the eighth century. The other two names were bestowed by archaeologists. We do not know if the Teotihuacan names for the pyramids were the same as those used by the Aztecs, whose language was Nahuatl. Teotihuacan is a Nahua word. There are several interpretations of its meaning (R. Millon 1992b, 359). The most persuasive is that of the Nahua scholar Thelma Sullivan (personal communication, 1972) — "The Place of Those Who Have The Road (or Avenue) of the Gods." We do not know what the dominant language of Teotihuacan was. But I find it difficult to believe that a Nahua language was not being spoken at Teotihuacan well before its fiery destruction (R. Millon 1992b).

5. Many of the underground formations in the Teotihuacan Valley, including the cave beneath the Sun Pyramid, took the form of lava tubes often in association with volcanic scoria, the light porous stone that was mined later in Teotihuacan's history to form a major ingredient in "Teotihuacan concrete." When the cave beneath the Sun Pyramid came to be regarded as the most sacred place in the Teotihuacan world, it already would have been cleared of any volcanic debris it might once have contained.

6. Murals depicting creation myths are on the "Street of the Dead" and to the east in the Tepantitla compound (fig. 3). The stone sculpture on the Temple of the Feathered Serpent in the Ciudadela also has been related to creation myths, e.g., Michael D. Coe, "Religion and the Rise of Mesoamerican States," *The Transition to Statehood in the New World*, eds. Grant D. Jones and Robert R. Kautz (Cambridge University Press, 1981), 157-171; López-Austin, López, and Sugiyama 1991, 93-105. In 1966 Clara Millon pointed out that the then newly discovered Mythological Animals murals on the upper "Street of the Dead" (fig. 3) might represent a creation myth in which the feathered serpent was the dominant figure, along with other mythological animals, jaguars, and fish (C. Millon 1972, 7-8). One feathered serpent is shown confronting another beast. Taube argues that these murals portray a myth of the watery creation of humankind from fish. Taube 1986, 54, 76. For photos of these murals, see Miller 1973, figs. 89-91; *Flor y Canto del Arte Prehispánico de México* (Mexico: Fondo Editorial de la Plástica Mexicana, 1964), pls. 175-178. Taube believes the offerings of fish found in one of our excavations in the cave support the view that the Teotihuacanos saw the cave as the place of origin of humankind (Taube 1986; R. Millon 1981, 234). Michael Coe comments on the significance of the cave as a "place of emergence" and couples this with his hypothesis that the stone carvings on the Temple of the Feathered Serpent celebrate a myth of "the creation of the universe from a watery void through a series of dual oppositions" (Coe, "Religion," 167-168). Murals in Tepantitla, one of which portrays streams of water issuing from a cave in a mountain, may refer both to the creation of the sun and moon and of humankind. Juan Vidarte de Linares, "Teotihucan, la ciudad del quinto sol," *Cuadernos Americanos* 158(1968): 133-145; Heyden 1975b; Heyden 1981, 1-39; Pasztory 1976; and Taube 1986, 76. For illustrations see Aveleyra Arroyo de Anda 1963, fig. 12; Pasztory 1976, figs. 36, 39. For considerations of the cave itself, see Heyden 1975b; Heyden 1981; R. Millon 1981, 231-235; R. Millon 1992b, 385-391; Taube 1986. (Much information was lost after the cave was discovered. See R. Millon 1981, 233-234.) The later Aztecs believed that the present cycle of time, the Fifth Sun, came into being when the sun and moon were created at Teotihuacan in a conclave of the gods.

Bernardino de Sahagún, *The Florentine Codex, General History of the Things of New Spain*, book 7, trans. Arthur J. O. Anderson and Charles E. Dibble. Monographs of the School of American Research no. 14, pt. 8 (Santa Fe: The School of American Research and the University of Utah, 1953), 3-8, 42-59. When the Aztecs came into the Basin of Mexico in the fourteenth century, the center of ancient Teotihuacan had been in ruins for many centuries. This is one reason the Aztecs called Teotihuacan's then-desolate central avenue the Street of the Dead.

7. What appears to have happened is that early in the first century A.D. the Teoti- huacanos related a sightline from the cave entrance to a spot 15.5 degrees north of west on the western horizon where the sun was seen to set on two days of the year, 12 August and 29 April. These two days were separated from each other by counts of days — 260 and 105 (52+1+52) — other Mesoamericans would have regarded as charged with meaning.

The Pleiades star cluster set on the same spot on the western horizon at Teotihuacan and in addition made its first yearly appearance in the east (heliacal rising) before dawn in the spring on the first of the two days of the year that the sun passes directly overhead at noon (zenith passage of the sun), around 18 May, when spring rains should be making it possible to begin planting. See Anthony F. Aveni and Sharon L. Gibbs, "On the Orientation of Pre-Columbian Buildings in Central Mexico," *American Antiquity* 41, no. 4 (1976):510-517; Anthony F. Aveni, *Skywatchers of Ancient Mexico* (Austin: University of Texas Press, 1980); John B. Carlson, "America's Ancient Skywatchers," *National Geographic* 177, no. 3(March 1990):76-107.

The setting sun on 12 August also celebrated the legendary day the pre- sent era began —"the day that 'time' began" in the Maya calendar (Vincent Malmström, "A Reconstruction of the Chronology of Mesoamerican Calendrical Systems," *Journal for the History of Astronomy* 9, pt. 2, no. 25 [June 1978]:105-116). Depending on how it is calculated that legendary date is 11, 12, or 13 August in 3114 B.C. Schele and Freidel, *Forest of Kings*, 81, 82; Floyd G. Lounsbury, "Maya Numeration, Computation, and Calendrical Astronomy," in *Dictionary of Scientific Biography* 15, suppl. 1, *Topical Essays*, 759-818 (New York: Charles Scribner's Sons, 1978), 760, 809-810, 815-816; R. Millon 1981, 239, 240. Since the sacred cave at Teotihuacan was believed to be *where* time began, the fact that a sightline from its mouth to the western horizon commemorated *when* time began must have been seen as having extraordinary significance.

Consequently, the sightline from the cave to the western horizon (15.5 degrees north of west) commemorated the birth of the cosmos at Teotihuacan, the begin- ning of the present era, the day that time began, and the zenith passage of the sun at Teotihuacan and in part of the Maya area, as well as two sacred counts — the 260-day ritual calendar and the 52-year calendar round. The importance to the Teotihuacanos of the orientation formed by the sightline to the western horizon is demonstrated by the location in later times at two places within the city a mile and a half apart of the same distinctive marker, a pecked cross. One was on a floor on the east side of the "Street of the Dead," a short distance south of the cave, the other on a stone on a hill far to the west. The sightline joining them forms a right angle with the "Street of the Dead" accurate to within less than .25 degrees (R. Millon 1973, figs. 57a-b).

The critical day counts were 260 (the Mesoamerican ritual calendar consisting of 13 months of 20 days each) and 365 (260+105)(our term for this 365-day year is *the vague year*). When permutated, these counts — 260 and 365 — produced a calendar round of 52 vague years which repeated endlessly. Both 13 and 20 were regarded as highly significant numbers, the latter because Mesoamericans used a vigesimal number system. There is a zone in the Maya area where 12 August and 29 April, separated from each other by 260 and 105 days, were the two days of the year when the sun was at the zenith. It has been argued that these intervals in that zone were the source of the 260-day ritual almanac. See Zelia Nuttall, "Nouvelle lumières sur les civilisations américaines et le système du calendrier," in *Atti del XXII Congresso Internazionale degli Americanisti* 1 (1926):119-148; Ola Apenes, "Possible Derivation of the 260-Day Period of the Maya Calendar," *Ethnos* 1(1936): 5-8; R. David Drucker, "The Shortest Day of the Year at Teotihuacan and the Solution to the Problem of the Orientation of the Ancient City and the Location of Its Major Structures," paper presented at joint meeting of Consejo Nacional de Ciencia y Tecnología and the American Association for the Advancement of Science, Mexico, 1973; Drucker 1974; Drucker 1977, 277-284; Vincent H. Malmström, "Origin of the Mesoamerican 260-Day Calendar," *Science* 181 (1973):

939-941; R. Millon 1981, 239). The cyclical motions of Venus also were of great concern to Mesoamericans, including the Teotihuacanos, as discussed below. Central to this concern was the fact that five Venus years of 584 days coincided with eight vague years of 365 days and that 13 of these eight-year cycles totaled 104 years or two 52-year calendar rounds.

8. At least 85% of the Basin's population was concentrated in the city; two-thirds of the rest were concentrated within a radius of ten miles from the city in a hundred small communities. See William T. Sanders and Robert S. Santley, "A Tale of Three Cities: Energetics and Urbanization in Prehispanic Central Mexico," in *Prehistoric Settlement Patterns: Essays in Honor of Gordon Willey,* eds. E.Z. Vogt and Richard M. Levanthal, 243-291 (Cambridge. Mass.: University of New Mexico Press and Peabody Museum of Archaeology and Ethnology, Harvard University, 1983), 260; Sanders, Parsons, and Santley 1979. Then, as in the rest of Teotihuacan's history, authority would have been exercised not through force alone but through a combination of coercion and consent. See discussion in Maurice Godelier, *The Mental and the Material: Thought Economy and Society,* trans. Martin Thom (London: Verso, 1988), 156-164, and R. Millon 1992b, 381. Although the population concentration was at least partly forced and was an extraordinary step for Teotihuacan's leaders to have taken, it may have parallels in critical transformation episodes in the early history of two other areas of early civilization in the Old World — Mesopotamia and Egypt. See Robert McC. Adams, *Heartland of Cities: Survey of Ancient Settlement and Land Use on the Central Floodplain of the Euphrates* (Chicago: University of Chicago Press, 1981), 82-85; Michael A. Hoffman, "The City of the Hawk: Seat of Egypt's Ancient Civilization," *Expedition* 18, no. 3(1976):32-41. The Indus Valley, West Africa, and North China were other areas of early civilization in the Old World. The Central Andes was the other New World area of early cvilization.

9. The few temples on the southern extension of the "Street of the Dead" are not comparable to temple complexes on its northern half, and the southern half otherwise was only partly developed. Nor were comparable monuments built on or at the ends of East and West Avenues. A great deal of construction occurred during the following five hundred years of Teotihuacan history, but none approached the scale of the earlier programs of monumental construction. Never again was a ruler's reign memorialized in monumental construction comparable to that carried out before the reform curbing personal rule. The only partial exception was the "Street of the Dead" Complex between the Sun Pyramid and the Ciudadela (fig. 3), built for the collective leadership after the reform. See also note 22.

 The basic unit of measurement at Teotihuacan may have been 83 cms or very close to it (Saburo Sugiyama, "Worldview and Society at Teotihuacan," paper presented at the 57th annual meeting of the Society for American Archaeology, Pittsburgh, 8-12 April 1992; Saburo Sugiyama, "Worldview Materialized in Teotihuacan, Mexico," *Latin American Antiquity,* in press). The location of the Sun Pyramid was determined by the cave, but the locations of the Moon Pyramid and the Ciudadela in relation to the Sun Pyramid may have been determined at least in part by multiples of the putative 83-cm unit (e.g., 260, 584, 1,040) that would have been regarded as significant by Mesoamericans (Sugiyama, "Worldview and Society"; "Worldview Materialized," fig. 3).

10. The river course was changed because its natural course cut across part of the area on which the Ciudadela precinct was to be built. But canalizing it so that it made three right-angle turns as it still does (figs. 2, 3) emphasizes the importance the Teotihuacanos placed on the city's cosmologically significant orientation, even for a river course. In subsequent years other stream courses within the city were similarly altered.

11. The *talud-tablero* appears early for a brief time in western Puebla, east of the Basin of Mexico, but is abandoned there early in the first century A.D. See Angel García Cook, "The Historical Importance of Tlaxcala in the Cultural Development of the Central Highlands," in *Archaeology, Supplement to the Handbook of Middle American Indians* 1, eds. Victoria Bricker and Jeremy A. Sabloff (Austin: University of Texas Press, 1981), 244-276; Angel García Cook, "Dos elementos arquitectónicos 'tempranos' en Tlalancaleca, Puebla," *Cuadernos de Arquitectura Mesoamericana* 2 (1984):29-32 (Mexico: Facultad de Arquitectura, Universidad Nacional Autónoma de México). Third-century A.D. temples bearing *talud-tablero* decoration at Tikal cannot plausibly be derived from Puebla rather than from Teotihuacan, as has been argued, e.g., Juan Pedro Laporte Molina, "Alternativas del clásico temprano en la relación

Tikal-Teotihuacan: Grupo 6C:XVI, Tikal, Petén, Guatemala," doctoral diss., Universidad Nacional Autónoma de Mexico, 1989; Pedro Laporte Molina and Vilma Fialko C.,"New Perspectives on Old Problems: Dynastic References for the Early Classic at Tikal," in *Vision and Revision in Maya Studies*, eds. Flora S. Clancy and Peter D. Harrison (Albuquerque: University of New Mexico Press, 1990), 33-66.

12. R. Millon 1992b, n.66. Beginning with the construction of the Ciudadela, an east-west orientation was adopted that differed from the north-south by 1.5 degrees, that is, it was 17 degrees south of east and north of west. Explanations for this orientation have been sought, e.g., Chiu and Morrison 1980; Cynthia W. Peterson and Bella C. Chiu, "On the Astronomical Origin of the Offset Street Grid at Teotihuacan," *Archaeoastronomy*, suppl. *Journal for the History of Astronomy* 11 (1987): S13-S18. It is possible that it represents a correction to accommodate changes in astronomical observations on the western horizon in the two hundred years or so since the observations were first made.

13. Bruce G. Trigger, "Monumental architecture: a thermodynamic explanation of symbolic behavior," *World Archaeology* 22, no. 2(1990):119-132. With regard to the Ciudadela, George Cowgill (1983, 335) proposed that it was "the physical realization of the vision of an extremely powerful ruler."

14. Carlson 1991; Taube 1992a; Sugiyama 1992; Sugiyama, "Worldview Material-ized." There are two heads that alternate repeatedly on the *tableros* of the Temple of the Feathered Serpent. One is a feathered serpent. The identity of the other is the subject of much current dispute, although there is agreement that it represents a headdress rather than a head. It has been variously identi-fied recently as a headdress representing a feathered serpent (Sugiyama 1992), a fire serpent (Taube 1992a), the Storm God (Carlson 1991), or a Teotihuacan antecedent of the Aztec god Cipactli (López-Austin, López, and Sugiyama 1991). In foreign contexts Teotihuacan's cult of war-and-sacrifice was associated with both the serpent and the Storm God (Taube 1992a; Carlson 1991). The Great Goddess, on the other hand, while also associated with heart sacrifice, was a deity of and for Teotihuacanos (Clara Millon, "Coyote with Sacrificial Knife," in Berrin 1988, 206-217).

15. Taube 1992a, 55-59; Taube 1993. A recent interpretation sees in this serpent-mirror imagery the emergence of the Feathered Serpent as Venus (Carlson 1991 [57]).

16. Carlson 1991; Sugiyama, "Worldview Materialized." The reader will note the similarity of this belief to that of the later Aztecs.

17. Séjourné 1956; Séjourné 1959; Pasztory 1976; Esther Pasztory, "El poder militar como realidad y retórica en Teotihuacan," in Cardós de Mendez 1990, 181-201; Berlo 1983; Langley 1986; Langley 1992; Clara Millon, "Coyotes and Deer," in Berrin 1988, 218-221; Clara Millon ("Coyote with Sacrificial Knife," 217) has pointed out that heart sacrifice in Mesoamerica begins in Oaxaca in southern Mexico at least as early as the middle of the first millennium B.C.

 Venus was an integral part of the war-and-sacrifice cult both because of its association with the Feathered Serpent and because the cyclical motions of the planet as Morning and Evening Star were used to determine or regulate the timing of cult celebrations (Carlson 1991). A notable cycle associated with Venus recurred every eight years because five 584-day Venus years equal eight 365-day vague years. The Venus-regulated cult was adopted in Maya centers, initially at Tikal (Carlson, "Venus-Regulated Warfare"; Schele and Freidel, *Forest of Kings*).

18. Paul Wheatley, *The Pivot of the Four Quarters: A Preliminary Enquiry into the Origins and Character of the Ancient Chinese City* (Chicago: Aldine, 1971).

19. The tomb pit on the centerline of the Temple of the Feathered Serpent may have held the body of this ruler. But that may never be known because the tomb pit was clandestinely looted hundreds of years after the tomb was built ca. A.D. 200 (Cabrera, Sugiyama, and Cowgill 1991; Cowgill 1983, 335). There is also evidence for the existence of a tomb in the center of the Sun Pyramid, where an earlier ruler may have been buried. In addition, I have suggested that the Moon Pyramid is likely to house the tomb of the ruler under whose regime the

population concentration occurred and the earliest Moon Pyramid was built early in the first century A.D. (R. Millon 1992b, 391).

20. Cabrera, Sugiyama, and Cowgill 1991; Sugiyama, "Worldview Materialized"; Sugiyama, "Rulership."

21. We do not know what principle of succession was followed. We cannot assume hereditary succession. Rulers may have been elected from eligible members of one or more lineages, for example. The suppression of personal rule may have been accompanied by changes in the principle of succession. Rulership might thereafter have been limited to a single period of years (as it is today in Mexico).

22. These permanent checks were instituted by a collective leadership whose members subsequently governed from a walled complex built between the Sun Pyramid and the Ciudadela, which we know as the "Street of the Dead" Complex (fig. 3). Cowgill (1983, 337-338) was the first to argue that after ca. A.D. 300 the power of the Teotihuacan ruler may have been circumscribed and confined largely to ceremonial activities while executive authority came to be exercised by high-ranking officials residing elsewhere. Cowgill (1983, 339-341) was also the first to recognize the potential political significance of this complex. The existence of checks on the powers of rulership does not mean that a ruler may not ever have broken free of these restrictions. The critical point seems to have been that such reassertions of power do not ever seem to have become institutionalized and that the checks on rulership were subsequently restored. With some possible exceptions late in the city's history, Teotihuacan's rulers were not portrayed in recognizable form in its art. In this Teotihuacan contrasts sharply with other societies in Mesoamerica (as well as with early civilizations elsewhere) — before, after, and during the ascendancy of Teotihuacan. The Maya are only the most notable example, with richly attired rulers portrayed stepping on or otherwise dominating unclothed captives or individuals lower in status. There are many richly attired individuals in Teotihuacan art but they are not shown in positions of domination over others (R. Millon 1981, 212-214). Part of this difference is attributable to widely differing modes of representation in the two art traditions. The observer today reacts to what appears to be a distancing from the viewer of the subject matter of much of Teotihuacan art because the Teotihuacan art tradition is abstract, as Pasztory has persuasively argued (Pasztory 1990-1991). She describes it as a tradition in which reality is referred to in terms of projections using conventionalized forms, arbitrary signs, and decorative options. Powerful as this argument is in explaining how Teotihuacan's art tradition differs from that of the Maya and of others in Mesoamerica, it does not adequately account for some of what is most characteristic in Teotihuacan art. A principle of indirection was at work. Much of the subject matter of Teotihuacan art is represented obliquely, particularly social interaction — hierarchical relationships, domination, human sacrifice — everything that is harsh. For example, hearts are frequently portrayed, often impaled on knives, but with extremely rare exceptions, actual heart sacrifice is not. Similarly, great differences in social status are evident in dress but are not portrayed in social interaction.

 Abstraction in Teotihuacan art probably goes back at least to the first century A.D. (It is evident in the use of complementary symmetry in the disposition of individual structures in paired architectural complexes and in the disposition of design elements in pottery.) Abstraction may then have been one of several modes of representation in the Teotihuacan art tradition. Following the reaction against arbitrary rule it may have been seen as particularly suited to the needs of the time when the legitimacy of collective leadership would have required ideological support. The collective persona identifiable in various media in the fourth century and continuing thereafter may be an outgrowth of these concerns (Pasztory 1992b) (cat. nos. 24-38).

23. Cowgill cogently argues that the prestige of Teotihuacan's cult must be due in part to its association with great military victories (Cowgill 1992).

24. For discussion of heart sacrifice and its relation to the Great Goddess, the Storm God, and the military in state and compound ritual, see Clara Millon, "Coyote with Sacrificial Knife," "Coyotes and Deer" (206-221), and C. Millon 1988. For discussion of the importance of ritual bloodletting in compound ritual, see Clara Millon, "Maguey Bloodletting Ritual," in Berrin 1988, 194-205.

25. For comparative purposes the area in square miles of Kuwait is 6,177; of Wales, 8,016; of Massachusetts, 8,257; of El Salvador, 8,260; of Belize, 8,867; of New Hampshire, 9,304; of Maryland, 10,577; of Belgium, 11,781; of Switzerland, 15,941.

26. See note 11.

27. Coggins, this volume; Schele and Freidel, *Forest of Kings.*

28. The connection of Altún Ha in Belize with Teotihuacan stands out because it is so distant and so early (third century). The connection of Teotihuacan with Matacapan in southern Veracruz appears to have been both political and long- term. The interested reader may wish to consult a recent, though partly out-of-date summary in R. Millon 1988a, 114-136.

29. The Teotihuacan state was represented abroad by military figures often wearing a three-part tassel headdress (cat. nos. 43-45, 98, and Coggins, fig. 3). Representations of Teotihuacan-related figures wearing this headdress have been found in the Valley of Oaxaca and in the three previously mentioned Guatemalan regions. At Teotihuacan the tassel headdress appears in military and ritual contexts in which it stands alone or is worn by high-ranking personages and deities, principally the Storm God, and on occasion the Great Goddess. Some late representations may be of rulers. For discussion of the political significance of the contexts in which this headdress is found at Teotihuacan and abroad see C. Millon 1973; C. Millon 1988.

30. Compounds occupied by people at the lower end of the status scale may have had ragged, unbounded perimeters rather than being completely closed off by outer walls and so may not have been as private (R. Millon 1992a).

31. We can infer that there was a strong ritual component in the requirement that compound walls conform to Teotihuacan orientations because Teotihuacan orientations are found in isolated compounds far from the city center where there were no neighboring compounds to which it would have been necessary to make accommodations (for example, 16:S3E5.25) (Eugenia Lara Delgadillo, "Asentamientos teotihuacano y azteca externos al centro urbano," in Cabrera, Rodríguez, and Morelos 1982a, 329-339, plan E; R. Millon 1992a). Equally persuasive is the fact that even in the most heavily built-up parts of the city construction did not follow an orthogonal plan, did not use a grid pattern. The force and significance of this is dramatically demonstrated by contrasting the Teotihuacan map (figs. 2, 3) with the strikingly different hypothetical grid layout of Teotihuacan in Spiro Kostof, *The City Shaped: Urban Patterns and Meanings Through History* (Boston: Little, Brown, 1991), fig. 32. Even in localized areas construction only rarely follows a grid pattern with city blocks of uniform size. In crowded areas, north-south and east-west streets that follow Teotihuacan orientations can be reasonably attributed to the requirements of urban planners. But the strict adherence to these orientations in many individual compounds cannot be attributed solely to these requirements because examination of the map (figs. 2, 3) shows that many compounds could have been built with markedly different orientations without interfering with street patterns (R. Millon, Drewitt, and Cowgill 1973). The fact that such deviations are quite unusual in survey and in excavation argues that there was a ritual requirement that compound walls follow Teotihuacan orientations. The most plausible reason for this requirement is that in conforming to the requirement compound walls celebrated the ritual significance of Teotihuacan and its cave of origin and at the same time enhanced the efficacy of ritual carried out in domestic settings within compounds. There is perhaps a partial parallel here to the requirement in Islam that mosques be oriented to Mecca.

Apartment compound temples would have provided domestic settings for the celebration of both domestic and state ritual, including the cult of war-and-sacrifice. The ubiquitous Teotihuacan composite censer dedicated to the Great Goddess in her martial aspect served domestic needs as well as the needs of state ritual. The use of censers for the latter is evidenced by the military associations of so many of the portable moldmade plaques used in different combinations around the censer theater platform (Berlo 1983; Langley, "Teotihuacan Sign Clusters"; Pasztory, in press). State-sponsored workshops for the making of these plaques and other moldmade censer

elements for city-wide use were located in the large compound attached to the north side of the Ciudadela (Luis Carlos Múnera, "Un taller de cerámica ritual en la Ciudadela, Teotihuacan," thesis, Escuela Nacional de Antropología e Historia, Mexico, 1985; Langley 1992). The emphasis in censer elements on order, hierarchy, and diversity celebrates the structure of the state and the individuality of each of the city's compounds (Pasztory 1992b; R. Millon 1992b, 398).

32. For various reasons, including its existence among the Aztecs, it has seemed most likely that what social anthropologists call a cognatic descent unit would have been the city's basic unit of social organization. In a cognatic descent unit, descent is reckoned through either or both the male and female lines, thus providing a much wider range of choice than descent in a single line. The Teotihuacan evidence suggests that these presumed cognatic descent units at Teotihuacan would have tended to favor the male line. See Martha L. Sempowski, "Some Social Inferences Concerning the Social Organization of Teotihuacan," ms, University of Rochester, 1976; Martha L. Sempowski, "Mortuary Practices at Teotihuacan, Mexico," in Martha L. Sempowski and Michael W. Spence, *Mortuary Practices and Skeletal Remains at Teotihuacan, Urbanization at Teotihuacan* 3, ed. René Millon (Salt Lake City: University of Utah Press, in press); Susan M. Kellogg, "Social Organization in Early Colonial Tenochtitlan-Tlatelolco: An Ethnohistorical Study," Ph. D. diss., Department of Anthropology, University of Rochester, 1979; Spence 1974; Michael W. Spence, "Human Skeletal Material from Teotihuacan," in Martha L. Sempowski and Michael W. Spence, *Mortuary Practices and Skeletal Remains at Teotihuacan, Urbanization at Teotihuacan* 3, ed. René Millon (Salt Lake City: University of Utah Press, in press); R. Millon 1981, 208-210. Residence after marriage would have tended to be in the compound where the man had been reared, but if prospects looked better in the compound of the woman, rights to live there could have been activated.

33. Jeffrey H. Altschul, "Spatial and Statistical Evidence for Social Groupings at Teotihuacan, Mexico," Ph.D. diss., Department of Anthropology, Brandeis University, Waltham, Mass., 1981; George L. Cowgill, Jeffrey H. Altschul, and Rebecca S. Sload, "Spatial Analysis of Teotihuacan: A Mesoamerican Metropolis," in *Intrasite Spatial Analysis in Archaeology*, ed. Harold J. Hietala (Cambridge: Cambridge University Press, 1984), 154-195; Pasztory 1988, 45-77; Manzanilla 1992. The northwestern part of the northwest quadrant of the city, the northern part of what I have called the "Old City" (fig. 2), seems likely to have been where populations lived that were forcibly resettled in Teotihuacan from the countryside during the population concentration at the beginning of the first century. It would require extended discussion to present the argument for this.

34. R. Millon 1992b, 398. Teotihuacan was not a democratic society. None of the early civilizations were. See note 8. For a different emphasis, see Pasztory 1992b.

35. Martha L. Sempowski, "Differential mortuary treatment: its implications for social status at three residential compounds in Teotihuacan, Mexico," in McClung and Rattray 1987, 115-131; Martha L. Sempowski, "Mortuary Practices."

36. R. Millon 1992a.

37. Storey 1992.

38. Site 7:N1W6 was the locus of University of the Americas and Teotihuacan Mapping Project excavations (TE3, TE3A) begun in 1966. See R. Millon 1973, 41-42, figs. 58, 60; R. Millon 1981, 241n.; R. Millon 1988a, 129-130; John Paddock, "The Oaxaca Barrio at Teotihuacan," in Kent V. Flannery and Joyce Marcus, eds., *The Cloud People: Divergent Evolution of the Zapotec and Mixtec Civilizations*, 170-175 (New York: Academic Press, 1983); Rattray 1987; Sempowski, "Mortuary Practices"; Spence, "Human Skeletal." Spence has subsequently carried out excavations in the compound to the east (6:N1W6); Spence 1992.

39. Ana Mariá Crespo and Alba Guadalupe Mastache de E., "La presencia en el área de Tula, Hidalgo de grupos relacionados con el barrio de Oaxaca en Teotihuacan," in *Interacción Cultural en México Central*, eds. Evelyn C. Rattray, Jaime Litvak King, and Clara Díaz Oyarzabal, 99-106, Instituto de Investigaciones Antropológicas, Serie Antropológica 41 (Mexico: Universidad Nacional Autónoma de México, 1981).

40. Teotihuacan and Monte Albán seem to have had a special relationship. Teoti-

huacanos portrayed there are not armed as are representations of Teotihuacan-related figures at Maya centers, such as Tikal, Uaxactún, and Yaxhá. At Monte Albán the portrayed relations between Teotihuacan and that city have been interpreted as peaceful (Marcus 1983; R. Millon 1988a, 129-130). For a different interpretation of Teotihuacan-Monte Albán relations and of the Oaxaca barrio, see Coggins, this volume.

41. The "merchants' barrio" is enclosed in quotes because the existence of a neighborhood of merchants is only one of several possible explanations for the discovery in this area in 1966 of concentrations of foreign, principally Veracruz and Maya, pottery in the Teotihuacan Mapping Project surface survey and in subsequent TMP excavations (TE4, TEll). The name has been retained because it is embedded in the literature, although the area probably should be renamed the *Veracruz barrio*. Rattray conducted excavations in the barrio from 1983-1985. Evelyn C. Rattray, "The Merchants' Barrio, Teotihuacan, Mexico: Preliminary Report to Instituto Nacional de Antropología e Historia and Instituto de Investigaciones Antropológicas" (Mexico: Universidad Nacional Autónoma de México, 1987).

42. Rattray, "Merchants' Barrio," fig. 1.

43. Rattray, "Merchants' Barrio"; Harry B. Iceland, "Lithic Artifacts at the Teotihuacan Merchants' Barrio: Considerations of Technology and Function," M.A. thesis, University of Texas at San Antonio, 1989.

44. Rattray, "Merchants' Barrio."

45. James J. Sheehy, "The Organization of Ceramic Production at Teotihuacan: A Comparative Perspective," paper presented at the 57th annual meeting of the Society for American Archaeology, Pittsburgh, 8-12 April 1992; James J. Sheehy, " Ceramic Production in Ancient Teotihuacan, Mexico: A Case Study of Tlajinga 33," Ph.D. diss., Department of Anthropology, Pennsylvania State University, University Park, 1992.

46. Jeffrey H. Altschul, "Social Districts of Teotihuacan," in McClung and Rattray, 1987, 191-217.

47. R. Millon 1992a; R. Millon 1988b; R. Millon, "Descubrimiento de la procedencia de las pinturas murales saqueadas con representaciones de personajes que llevan el Tocado de Borlas," in Cabrera, Rodríguez, and Morelos 1991, 185-192; René Millon and Saburo Sugiyama, "Concentración de pinturas murales en el Conjunto Arquitectónico Grande, al este de la Plaza de la Luna," in Cabrera, Rodriguez, and Morelos 1991, 211-231; Berrin 1988, esp. Pasztory and C. Millon essays, 114-228. Atetelco's murals are dominated by military representations and heart-sacrifice ritual involving the Great Goddess, the Storm God, and the Feathered Serpent (C. Millon, "Coyote with Sacrificial Knife," in Berrin 1988).

48. Sanders, Parsons, and Santley 1979, 116; R. Millon 1988a, 136.

49. Sanders, Parsons, and Santley 1979, 128; R. Millon 1988a, 136-137.

50. Religion played a critical role in the integration of Teotihuacan society from the outset. Early Teotihuacan religion was focused on ritual celebrating the origin myth associated with the sacred cave. Although this ritual continued in later times, it was supplanted in emphasis by the cult of sacred-war-and-sacrifice associated with the Feathered Serpent, the Storm God, and cycles in the motion of the planet Venus. These and other citywide rituals played a critical integrative role in Teotihuacan's urban society because they were not only celebrated with sacrifices in the city center, but also with bloodletting in every barrio and apartment-compound temple in the city, using special ritual paraphernalia centering on the composite censer (cat. nos. 68-72). The Great Goddess would have been the focus of bloodletting and sacrificial ritual in apartment compounds and in the city center because in all her aspects, beneficent and fearsome, including her association with heart sacrifice, she was the deity of and for Teotihuacanos, whether in the city itself or in other Teotihuacano communities (Berlo 1983; Berlo 1992b; Pasztory 1988; Pasztory 1992b; C. Millon, "Coyote with Sacrificial Knife"; R. Millon 1992b). Whatever may have been her role in the Temple of the Feathered Serpent dedication,

it must have been significant after the powers of rulers were curtailed because the four-tiered platform structure subsequently built to cover most of the temple's facade was dedicated to her. Mural remnants iconographically related to her were once visible on its *tableros*.

51. Coe, "Religion," 168.

52. The accomplishments of Teotihuacan's architects and artists may evoke wonder and awe. And an ancient, multiethnic urban society very different from our own is always fascinating in its own terms. But beyond this, is there any reason why today's reader should want to undertake the serious study of a civilization with a religious tradition whose core ritual, performed for the common good, centered on war and heart sacrifice? I think there is, even though the differences between our two civilizations are so vast. We know that our wars are many times more destructive than pre-Columbian wars, but they do not involve the taking of prisoners for sacrifice. Even so, the more we learn about another way of life, the more it provides us with a perspective on our own and causes us to look at it in a fresh way. Teotihuacan was an exceptionally long-lived, multiethnic, nonindustrialized urban society. The city's population was markedly stratified, with sharp social divisions. A great gulf separated those at the top from those at the bottom of Teotihuacan society. In view of these circumstances, it might be useful to consider how urban social problems may have been confronted there and how conflicts were contained and held in check during the many centuries Teotihuacan flourished. And it also might be useful to consider how the hierarchical Teotihuacan political system apparently was able to keep in check the power of rulers for four centuries or more when it had not done so for the preceding two centuries. Although not unique in this respect in comparative political history, Teotihuacan's experience is certainly unusual. Judging from the evidence, the city's inhabitants were not subjected to cults of personality nor to rulers whose domination over others, foreign or domestic, was memorialized in monuments to their exploits. We know very little about how this reform could persist for so many centuries. But it is a sufficiently extraordinary achievement that it should make us want to learn more.

The enduring nature of the reform may be part of the explanation for the oft-noted absence of public inscriptions in stone or other media at Teotihuacan. Why this may be so is suggested by the recent analysis of Mesoamerican writing systems by Joyce Marcus. *Mesoamerican Writing Systems: Propaganda, Myth and History in Four Ancient Civilizations* (Princeton: Princeton University Press, 1992) in which Marcus persuasively argues that most Mesoamerican texts deal with propagandistic assertions about the life cycle and exploits of rulers intended to glorify them. This suggests that the checks on the power of Teotihuacan rulers thought to have been instituted in the third century by a collective leadership would have come to preclude not only the erection of monuments bearing representations of rulers but also monuments bearing texts because the expectation would have been that they would tout the exploits of rulers, as they did in Monte Albán, Tikal, and elsewhere. But if this were so, why were not Teotihuacan's powerful early rulers in the preceding two hundred years glorified in stone carvings or texts? Perhaps there was little impetus to do so because the monumental architecture created under their direction was more than sufficient to serve this purpose — the majestic expanse of the "Street of the Dead," the successive Moon Pyramids, the two early Sun Pyramids, the Ciudadela and its Feathered Serpent Temple, and the tombs thought to have been associated with each. The construction and completion of these mega-monuments were irrefutable demonstrations and dramatizations of the power of these early rulers in and of themselves. The same seems to be true of the huge early Maya pyramid-temple at Lamanai and the truly immense pyramid-temple complexes at El Mirador (Schele and Freidel, *Forest of Kings*, 26, 128-130; Ray T. Matheny, "El Mirador: An Early Maya Metropolis Uncovered," *National Geographic* 172, no. 3 [September 1987]: 316-339). El Mirador, a short distance north of Tikal, was an enormous Maya city with great and powerful rulers; its leaders dominated the region from the second century B.C. to the first or second century A.D.; its gigantic pyramid complexes, larger than anything subsequently built by the Maya, were built centuries before the earliest dated monument to a lowland Maya ruler.

53. Kenneth G. Hirth and William Swezey, "The Changing Nature of the Teotihuacan Classic: A Regional Perspective from Manzanilla, Puebla," in *Las fronteras de*

42

Mesoamérica, XIV Mesa Redonda 2:11-23 (Mexico: Sociedad Mexicana de Antropología, 1976); R. Millon 1988a, 138-142.

54. R. Millon 1988a, 142-149.

55. R. Millon 1988a, 145-147.

56. Robert McC. Adams, "Strategies of Maximization, Stability, and Resilience in Mesopotamian Society, Settlement and Agriculture," *Proceedings of the American Philosophical Society* 122, no. 5(1978): 329-335; George L. Cowgill, "Onward and Upward with Collapse," in *The Collapse of Ancient States and Civilizations,* eds. Norman Yoffee and George L. Cowgill (Tucson: University of Arizona Press, 1988), 244-276; R. Millon 1988a, 148-149.

57. R. Millon 1988a, 154-156.

58. R. Millon 1992b, n.10; Diehl 1989. A few rooms in some partly ruined apartment compounds were reoccupied for a time after the abandonment.

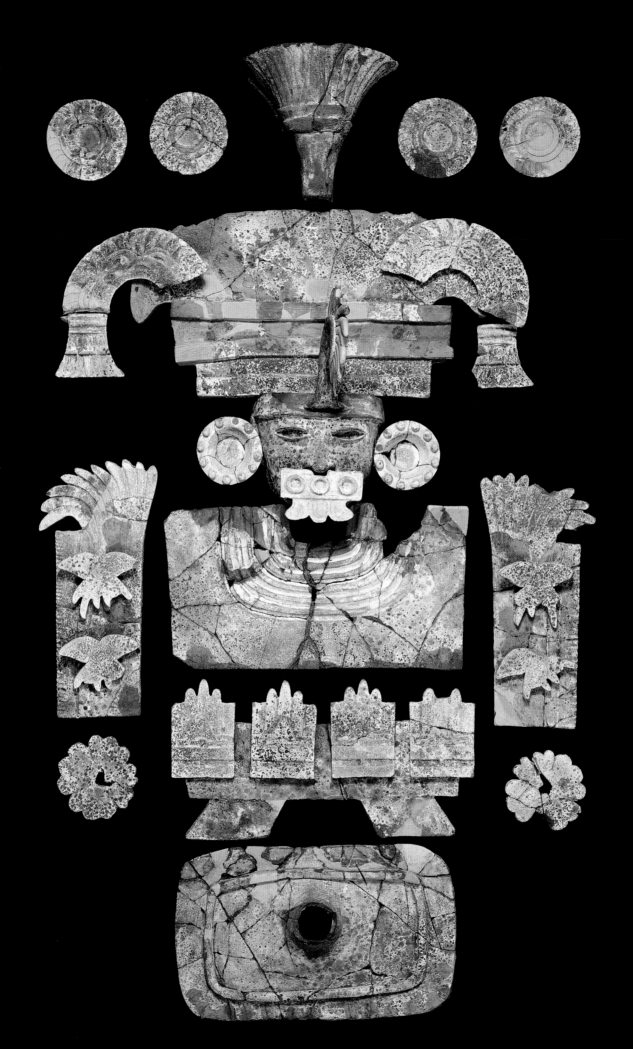

Teotihuacan Unmasked

A VIEW THROUGH ART

Esther Pasztory

IMAGINE THAT AN ANCIENT CIVILIZATION EXISTS with pyramids close in size to Egypt's, and that it is still such a mystery that the handful of scholars working on it disagree on many key aspects. Some of them think the makers of the pyramids were just like the Aztecs, only earlier, while others think the makers differed significantly from every other culture in Mesoamerica. Some think the civilization was peaceful, others think it was warlike. Some think it was a big empire, others wonder if an empire existed at all. Some think its power was vested in absolute rulers, others think the population shared in the governing.

Our presentation of Teotihuacan through its art is like the censer excavated by Sigvald Linné exhibited here in pieces (cat. no. 72, this essay). Such censers were unique to Teotihuacan in having been made in parts that apparently were put together variously, either by different families or for distinct occasions. At times they were disassembled then put together again in new ways. At other times they were taken apart and buried. The censers suggest a Teotihuacan preoccupation with the organization of many component parts.

Similarly, the exhibition *Teotihuacan: City of the Gods* is a giant puzzle: We present pieces, themes, and interpretations, but we invite the viewer to enter the mystery and participate in the reconstruction.

Any interpretation of Teotihuacan needs to address the following facts:

1. Teotihuacan lasted over seven hundred years.
2. For most of that time everyone in the Valley of Mexico lived in one compact city with a grid plan — a living pattern which did not exist before or after Teotihuacan times in Mexico.
3. Its pyramids were among the biggest in the New World and were built in the beginning of the city's history.
4. Teotihuacan devised a new astronomically related orientation.
5. Permanent multifamily apartment compounds were built to house the population for the last five hundred years of the city. The walls of many were covered with murals.
6. Hardly any art survives from the early times of pyramid building,

Cat. no. 72
DISASSEMBLED CERAMIC CENSER
Excavated by Sigvald Linné. Folkens
Museum-Etnografiska, Stockholm.

45

but a great deal from the time when the apartment compounds were built.

7. The supreme deity was a goddess.
8. The rulers were not glorified in art.
9. Little writing is found in permanent media, but a complex symbol system in art exists.
10. The art does not tell a story. It assumes a local audience familiar with its symbols and suggests no dramatic or explanatory strategies for a broader audience.
11. Teotihuacan was the greatest power in its time in Mesoamerica and had trade and diplomatic contacts, conquests, and settlements in many areas.
12. We do not know what language its citizens spoke, what ethnic group they belonged to, and what their name was for the word *Teotihuacan.*

This list can be interpreted and emphasized in various ways, and it is possible to construct other, similar lists. I am going to tell my version of the story of Teotihuacan. It may be that, as in the film *Rashomon*, there is no one truth, that we each have our own stories.

It is helpful to contrast the people of Teotihuacan with the Aztecs they are so often thought to resemble. The Aztecs described themselves as barbarian nomads who conquered the Valley of Mexico through military prowess and with the help of their patron war god, Huitzilopochtli. Because they had no other legitimate source of power they always felt insecure in their rule. They were awestruck by the ruins of ancient civilizations such as Tula and Teotihuacan, which they visited and discussed. But their chances of rivaling the past were small; most of the Aztec temple precinct is not much bigger than the Ciudadela of Teotihuacan. Partly for these reasons, the Aztecs were obsessed by the past and developed a strong sense of history.[1]

When Teotihuacan emerged in the same Valley of Mexico thirteen hundred years before the Aztecs, no great, superior, early civilizations existed. The monuments of the earlier centers, such as Cuicuilco and Tlapacoya, were modest in size and extent. The achievements of the Olmec, Izapan, and Monte Albán cultures were only known indirectly or through local sites such as Chalcatzingo. Certainly no evidence can be found that Teotihuacan was as interested in the past as were the Aztecs. Throughout its existence the city seemed uninterested in recording and monumentalizing its history. While in southern Mesoamerica writing was developed to record dynastic history for all posterity in the permanent medium of stone, Teotihuacan left no such public inscriptions.

When the people of Teotihuacan began the vast project of pyramid building in the first century A.D., they were going to create something great for which no model as yet existed. It seems they used nature itself, in all its awesome scale, as their guide. Teotihuacan is planned on such a vast scale that it invites comparison with the mountains and the plains; the imagery of its art is largely based on nature and its gods are nature gods.[2] It is as if Teotihuacan claimed that its plan for a city was more in line with the laws of nature and the cosmos than that of previous cultures.

This is a paradox, because a city of such magnitude in preindustrial times has to have had a remarkably efficient organization for creating a "built environment," one that Le Corbusier might have been proud of.

Nevertheless, this artificial world of imagery is presented as the essence of the cosmos. Thus Teotihuacan must have had a powerful ideology or religion at its core; it was not just another temporarily successful dynastic center. Nature and the cosmos were important rallying cries for other cultures as well, including the Aztecs, who claimed they supported the universe and kept it from collapsing, but Teotihuacan was extreme in seeming to invoke *only* nature and the cosmos to the almost total exclusion of everything historic or made by human beings.

It can be speculated that at about 200 B.C. the big centers of Cuicuilco and Tlapacoya were having internal difficulties. Teotihuacan, a growing village in the northeast of the valley, saw an opportunity to aggrandize itself at the expense of its neighbors. This was perhaps accomplished partly through war, using the novel tactic of well-trained groups of men functioning as a unit, rather than in hand-to-hand combat, as suggested by George Cowgill.[3] The superiority of collective organization might have proved effective, and might have affected the creation of all the rest of the city's sociopolitical structure along collective lines. Unlike most Mesoamerican cultures that were content to sacrifice captives and demand tribute from the conquered, a group of Teotihuacan "founding fathers" could have had visions of controlling and incorporating the population into a single huge center. Teotihuacan could have developed the vision of a unified empire, all in the space of one huge city, with a population organized to build, manufacture, and trade rather than just to wage constant warfare.

The glue in this new unified polity appears to have been religion. I imagine that the rulers of Teotihuacan created a powerful religious cult that either attracted, urged, or forced people to move to Teotihuacan and build its monuments. This cult was placed ahead of the veneration of the ruler, its force possibly residing in the apparent lack of ostentation in leaders who made sure to abase themselves in front of the gods.

What could have been the content of this cult? In brief, I think the gods promised that when people moved to Teotihuacan to build the great pyramids, they would be finding and creating paradise on earth. In later Teotihuacan mural art, the gods and the elite are usually shown giving — pouring seeds, jades, and flowers. Fantasies of verdant nature are ubiquitous, commonly represented by flowers, streams of water, shells, and water creatures. Unlike the threatening Aztec images, full of skulls and claws, most Teotihuacan images emphasize the gifts of the gods, and not their anger. No doubt this was a cost-effective strategy — seduction usually works better than bullying.

More specifically, recent research has revealed that this cult might have had two important features that dealt with the forces of the sky and with the earth and underworld. Research by Linda Manzanilla has shown that Teotihuacan is full of natural caves.[4] I imagine that Teotihuacan was presented as having a uniquely sacred geography, which was the home of a powerful Goddess, and perhaps also the place where human beings emerged from the ground in the beginning of creation. The home of this Goddess was probably in the caves. Her priests may have prophesied that it was unwise, unsafe, or even dangerous to live anywhere outside this sacred precinct. She was in charge of the local geography, the San Juan River, the many springs, and the high water table with its great agricultural potential. She is shown in mural paintings in paradisiacal settings, giving gifts (figs. 1-2).

Fig. 1
Mural depicting the Goddess.
Metepec A.D. 650-750. Tetitla,
Teotihuacan.

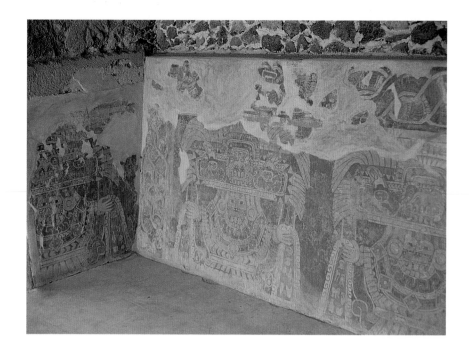

Because of the important ritual cave in the interior of the Pyramid of the Sun, I suggest that this monument could have been the shrine of the Goddess who originally brought people into the city. In late times she was the most important deity of Teotihuacan. Until the 1960s it was customary to describe Teotihuacan as a peaceful, agrarian theocracy. To correct this view, recent research has emphasized the military and sacrificial elements in art and culture. Unquestionably they are there. The Goddess often has rapacious claws instead of human hands (cat. no. 40) and human hearts may ornament her headdress (fig. 2). In fact, despite associations with bountiful nature, most persons and deities depicted in Teotihuacan art can be related to sacrificial or military themes.

One of the most common themes in Teotihuacan art is the human heart — on a sacrificial knife, in front of the maw of an animal, or by itself as a motif (cat. no. 137). In no other culture in Mesoamerica is the human heart such a common theme. Other cultures tended to represent the victims of conquest by depicting the persons conquered, who were often identified by a glyph naming them or their place of origin. This practice indicates that in most of Mesoamerica war, conquest and sacrifice were matters of ethnic identity. In contrast, the anonymous hearts in Teotihuacan art emphasize the act of sacrifice itself, without specifying the origin of the victim. Teotihuacan presents itself as a universal or cosmic place, not the home of particular ethnic group or dynasty. Sacrifice and military activity are central to the state, but removed from history and subordinated to cosmic interpretation.[5]

Additionally, murals such as two coyotes sacrificing a deer clearly represent sacrifice as part of the natural order of things (cat. no. 46). In thinking about this work, it is useful to resist the polarization of these artistic elements into representations of good and evil. Sacrificial and military imagery is not necessarily the opposite of fertility imagery. At Teotihuacan sacrifice is essential to the maintenance of the cosmic and the social world.

Nevertheless, any overview of Teotihuacan art as a whole must conclude that the images for the most part emphasize natural bounty,

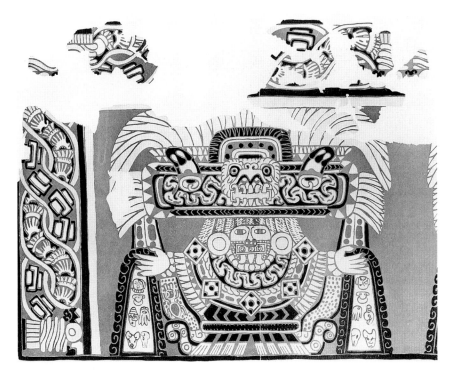

Fig. 2
Reproduction of mural depicting the
Goddess. Villagra 1971, 144, fig. 14;
by permission of the University of
Texas Press.

order, and harmony rather than violence, and that when violence is
shown it is rarely represented charged with emotional force; its force
is neutral and distanced. By contrast, the representations of verdant na-
ture have a lyricism that suggest strong emotional identification.

The second feature of the myth that had to do with the founding
of Teotihuacan relates to time and orientation. Teotihuacan is oriented
15.25 degrees east of true north, which was probably devised astrono-
mically and related to the calendar as René Millon has shown (this vol-
ume). What I find especially interesting is that it was a *new* orientation.
The Olmec used 8 degrees west of true north, and the Aztecs roughly
followed Teotihuacan and used 17 degrees east of true north. A new
orientation is significant and tells us that Teotihuacan saw itself as com-
pletely different from other cultures, a difference that was manifest in
its relationship with the cosmos and that was built literally into the plan
of the city. The new orientation is the best proof we have that Teotihua-
can consciously created itself to be different. The Street of the Dead,
looking like a gigantic arrow with the Pyramid of the Moon at its apex,
points to Teotihuacan North and dramatizes this cosmic connection.

Because the orientation relates to the gods via astronomical obser-
vations and the calendar, it suggests that Teotihuacan claimed a new,
and probably privileged, relationship to the gods. Just as Teotihuacanos
may have presented themselves as living in the one possible sacred
place, they may also have believed that the gods had imparted to them
a sacred blueprint that would allow them to create the most powerful,
sacred, beautiful, and fertile city ever known. Although I cannot prove
this precisely, I sense that the Aztec aim was military glory and staving
off the collapse of the universe, whereas the Teotihuacan aim seems to
have been the creation of paradise on earth. The Aztec vision assumed
an eventual collapse, whereas the Teotihuacan vision assumed its
people's longevity, perhaps even for eternity. Almost eight hundred
years is not bad.

The deity I see related to the Pyramid of the Moon and to the
mountain behind it, Cerro Gordo, is the Storm God, a male deity who

brings water from the sky in thunderstorms and who is associated with warfare, external relations, and the rulers of Teotihuacan.[6] He is associated with a variety of headdresses, including a tasseled headdress that seems to have imparted the most prestige. Monuments in the Maya area and at Monte Albán that show Teotihuacan-style figures are invariably related to this headdress and/or to the Storm God. As these monuments are all dynastic, they suggest that this deity in its various forms was the one associated with rulership or elite leadership at Teotihuacan. Known as Tlaloc to the Aztecs, this deity predated Teotihuacan; earlier representations exist. By contrast, the Goddess, a mysteriously masked being, seems to be entirely local, primarily involved with the city and its population at large; its image did not last much beyond the fall of the city. When she occurs outside of Teotihuacan, it is not in a dynastic context but where the people of Teotihuacan resided and brought their local cults. These two gods, like the two pyramids, seem to have been the most important.

I have suggested the Goddess as the deity of the Pyramid of the Sun and the Storm God as the deity of the Pyramid of the Moon. Equally good arguments have been presented the other way around, and neither may be true. This is partly because, strangely, very little figurative art survives from the time of the building of the pyramids. We have only modest household figurines and pottery. There is evidence for the existence of Storm God vessels and Old God incense burners, which go back to representations prior to the rise of Teotihuacan. Perhaps most art was in perishable media and no need was felt for permanent representations. Given the importance of masks in later Teotihuacan art, perhaps the deities were impersonated by masked performers in rituals in the spectacular theatrical spaces provided by the architecture.

The two great pyramids are flanked by two smaller structures that make them three-temple complexes. The Teotihuacan Mapping Project discovered that about twenty-three three-temple complexes are scattered throughout the site, many dating to early times in the old section of the city.[7] Linda Manzanilla found caves associated with most of them and considers them to be ward, or district, temples, significant in administration as well as ritual.[8] At any rate, the three-temple complexes suggest some kind of division of the city into residential districts equal in type, but unequal in importance. They might indicate that from the very beginning a balance was struck between hierarchy (with the rulers of the state symbolized by the two biggest pyramids) and the collective people, who were later symbolized by the apartment compounds.

This balance seems to have been dramatically changed by the building of the Ciudadela and the Temple of the Feathered Serpent about A.D. 150. Containing two-thirds of the material of the Pyramid of the Sun, the Ciudadela is a huge enclosure 400 square meters (440 square yards) in the south of the city. Once built, an East-West Avenue was added crossing the North-South Avenue, the San Juan River's course was changed to fit in with the grid, and a great market or some other public space was built across from it, all of which effectively shifted the center of the city away from the pyramids to this new complex in the south.

While the pyramids were probably temples to the gods and the burial places of leaders, with the overt emphasis on religion, the Ciudadela was a palace; two large habitations or administrative quarters flank the

temple. Nearby, in addition, sits a huge enclosed plaza big enough to hold the entire adult population of Teotihuacan.[9] Access, however, is restricted to a single stairway from the side of the North-South Avenue. René Millon and George Cowgill feel that this complex was a palace built by a powerful ruler who, perhaps, dreamed of creating a great dynasty at Teotihuacan. Although the Ciudadela has a temple, it is a relatively small structure within the larger edifice. A burial site was found inside the Temple of the Feathered Serpent (looted, unfortunately), which may have been that of this powerful person. The sacrifice of over one hundred young men in military dress buried in the temple suggests other royal burials in many parts of the world, where soldiers, wives, or servants accompany the illustrious dead to the underworld.[10]

Like the pyramids, the Ciudadela reveals its secrets more through its architecture than its art. The only structure with imagery from this time is the Temple of the Feathered Serpent (fig. 3), the meaning of which is far from clear. There are two feathered serpents represented with shells in their undulations on the two segments of each platform. One serpent has a simple profile serpent head, while the other has two dramatic, three-dimensional frontal heads. The one near the front is a serpent, but the other is an unidentified scaly creature unique in Teotihuacan art. Avoiding the controversy associated with the specific meaning of these two images, it is striking that if this complex is dedicated to rulership, it is done so indirectly. Even if the scaly creature should prove to be a headdress, as has been proposed by Saburo Sugiyama,[11] as symbols of rulership these are a far cry from images like the Olmec colossal heads or the Maya stelae. A broad array of cosmic meaning has been suggested for the serpents, including seasonal fertility, the calendar, and the beginning of time. If the serpents represent something like these, then even the great ruler dwelling in the Ciudadela hid behind a cosmic ideology.

The feathered serpent, however, could be a symbol of rulership. Feathered serpents in later art — at Xochicalco, Cacaxtla, Chichén Itzá, and Tula — are often represented next to important personages and are believed to be their dynastic names or titles. It is possible that at Teotihuacan this feathered serpent could have been the title of the ruler or the name of the dynasty. Even in that case, there would have been a double message — both political and cosmic.

This ornamented building was put up at great cost and effort; each serpent head weighs four tons, even without the collars of petals. No such labor-intensive structure was ever again built in Teotihuacan's history. Moreover, not long after the building of the Temple of the Feathered Serpent and the death and burial of the ruler, a simple platform was built in front of it that is so large that it effectively hides the temple from a front view. The building of this platform seemed to end the institution of powerful dynastic rule at Teotihuacan as the city put its future energies not into the building of great public monuments but into the apartment compounds of the population at large.

From A.D. 250 to 750, Teotihuacan underwent a major transformation that was social, political, economic, religious, and artistic; it has left us with censers, pottery vessels, murals, greenstone, and white-stone sculptures in surprising quantity and quality. It is as if suddenly Teotihuacan became a different kind of place, one where artistic communication was essential to its existence. The most striking archaeological

Fig. 3
Facade of the Temple of the
Feathered Serpent.

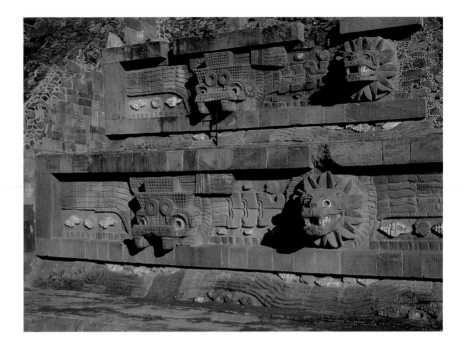

fact of the time is that energy did not go into the building of colossal
architecture. No colossal structure was built from A.D. 250 to the fall of
the city in 750. Three colossal sculptures may have been made in this
interval, but, however impressive, they cannot be compared to the pyra-
mids in magnitude of undertaking.[12]

The second surprise is that about two thousand permanent habi-
tations were built to house multiple families in what are called *apart-
ment compounds.* They range in quality from spacious, even palatial,
homes to crowded and more slumlike quarters. But their mere exist-
ence is amazing. Prior to their building the people of Teotihuacan
lived in perishable housing. What was the impetus to organize multi-
family dwellings in permanent structures? Why did so much building
activity occur around the habitations of the population rather than
on a new pyramid?

I have suggested before that Teotihuacan may have had a non-
dynastic political structure that little emphasized the personality or
family of the ruler, except for the period of the building of the Ciudadela.
The importance of the apartment compounds suggests a relatively well-
off population, perhaps having some political rights. As most of the an-
cient states we know — Egypt, Mesopotamia, and most of Mesoamerica
— were strongly dynastic, few prototypes for such a state exist. Only the
Harappan civilization of cities such as Mohenjo Daro in India seems
similar to Teotihuacan.[13] Teotihuacan could have been a low-profile
dynastic state with officials selected from certain families. The city was
divided into wards and the ward heads as well as the leaders of the apart-
ment compounds could have had some voice in city affairs.

Housing sixty to one hundred inhabitants related through the male
line, as the skeletal evidence indicates, the apartment compounds made
permanent a pattern of living in large, extended families.[14] Each family
had rooms around a patio or small atrium. The rooms were dark and
windowless, but porches on columns provided cool and shaded areas.
Sophisticated drainage drew away the water of summer downpours from

the open courtyards. Women spun, wove, cooked, and made bark cloth. Men chipped obsidian, made figurines, hunted, and worked in the fields. They all participated in their own household rituals, in the rituals of the apartment compound in general, as well as in citywide rituals.

Besides raising some fascinating questions about the political and economic status of the general population, the apartment compounds were closely linked with the invention of new art forms. The most obvious is mural painting. The building of the compounds multiplied greatly the number of walls at Teotihuacan. Even the form of apartment compounds presupposes murals; the porches facing the courts and patios on which most murals are found are well-lit but protected from rain. Although walls by themselves do not make murals, they certainly provide potential space. The quality of the murals in the apartment compounds is quite similar to murals in areas near the major pyramids, thus further suggesting a relatively egalitarian access to the work of artists. Even the comparatively slumlike apartment compound of Tlamimilolpa had mural paintings.

The Origins of Art at Teotihuacan

As far as we can speculate, the art of early Teotihuacan was mostly performance, in splendid but perishable costumes. Teotihuacan was the first culture in Mesoamerica to create wide-frame headdresses bordered by exotic and expensive quetzal feathers. Rituals consisted of burning incense in various objects, including vessels held on the head of an old man. The elite seem to have poured libations, drawn their own blood, performed sacrifices, made speeches, or sung songs. Undoubtedly processions along the avenue, on the plazas, platforms, and pyramids were important. The later importance of masks suggests frequent masked performances and deity impersonations. At least the Storm God was probably impersonated, and water poured from Storm God jars may have been thought to hasten the coming of the rains. Early Teotihuacan felt no need to make permanent images of its gods, rulers, conquests, or other activities — they turned them into instantaneous performances witnessed by everyone in the city. That was, after all, one of the advantages, if not the purposes, of living in one compact city. No other audience seemed to be important. Unlike the Aztecs, who were always concerned with impressing foreign dignitaries, Teotihuacan seemed not to care about outsiders.

Codification versus Variability

After A.D. 250, during the Tlamimilolpa period, perhaps as a result of the reorganization that seems to have occurred after the demise of the great ruler in the Ciudadela, performance art seemed to become permanent art. At the same time, everything was done to maintain its momentary, spontaneous, variable quality. We could speak of this time as a period of codification. The sociopolitical arrangements between the commoners and the elite seem to have been set and, as a result, the permanent apartment compounds were built. Just as do the works of art, the apartment compounds codify a set of social relations. New art works emerge at this time, such as the semiprecious stone figures and masks, censers, host figures, and murals. But they are all more or less standardized, as if ancient forms were being turned into permanent canonical representations. At the same time, variability remains an im-

portant value. For example, a new type of work is the "theater" censer in which a mask is framed by flat panels on which *adornos* are glued. These censers were frequently reassembled, their *adornos* changed for different events or persons.

James Langley, who has studied the Teotihuacan symbol system most extensively, found about three hundred Teotihuacan signs, which were used in all the different media.[15] These did not emerge overnight at A.D. 250. They are a codification of symbols probably used before. The beauty of these signs, which were not a system of writing, is that they could be put together either to form pictures, make diagrams, or even suggest texts. A trapeze-and-ray sign could be a year glyph or a headdress. A reptile-eye sign could be a glyph for earth or an open mouth. But then a flower could also be a mouth (cat. no. 132). Despite the process of codification and standardization, Teotihuacan never gave up the importance of individual variation and the possibility of reinterpreting signs in just about any direction. In fact, codification and variation seem to be two sides of the same coin.

FROM MASKS TO GODS

More masks survive from Teotihuacan than from any other Meso-american culture. Materials such as greenstone, calcite, an alabaster-like white stone, and many other hard or semiprecious stones were used (cat. nos. 24-37). While stone masks are usually thought to be funerary, they do not seem to have come from burials. They could have been the "faces" of perishable sculptures dressed to look like the masked spirits who were becoming gods. They could have been composite ancestor and nature spirits.

In the composite ceramic censers, the masks of the spirits are placed in what looks like a shrine or temple. The censers were found in great quantities in the apartment compounds, associated with the central platforms and the burials of important individuals,[16] whereas the stone masks and figures came from the major temples of the state near the Street of the Dead.[17] The censers made in the cheaper medium of clay may have been entire miniature household temples with the deity represented only by a mask.

The censer images are all basically alike, but with endless minor variations. This could mean that they represent one spirit or deity with a particular relationship to a compound or an event. It could also mean that they are many similar, but separate, spirits. There is no way for us to tell. What they have in common is a nosebar that covers the mouth, which is one of the characteristic features of the Goddess, who seems to have been the major deity after A.D. 250. In the representations of Teotihuacan we see the process whereby masked spirits become gods. They are already codified and represented in permanent cult objects, but they are not yet as anthropomorphic, individualized, and compartmentalized as the gods of the Aztecs.

THE GODDESS

The Goddess emerges most clearly in the mural paintings (figs. 4a-b). In the mural paintings we enter a world in which almost anything seems possible, from the representation of ritual and cult objects to fantastic creatures of the imagination. She and the Storm God are the major

deities of this realm. She is always shown frontally, her face either missing or covered with a mask, her hands outstretched and giving water, seeds, and jade treasures. In the murals of Tepantitla, still in situ, she is flanked by two elites making offerings to her. She emerges out of a body of water full of water creatures. At first she seems large, but it turns out that she is merely a bust placed on a platform. A cavelike space inside the platform, like her womb, is full of seeds. A tree grows behind her, laden with flowers and dripping with moisture, surrounded by birds and butterflies. Various plants such as maize edge the scene.

Unquestionably, this is a vision of plenty, an earthly paradise presided over by a benevolent being. In the mural painting, in contrast to the censer and the masked images, what may once have been a cult figure is turned into a being with an existence of her own. The Goddess here acquires a personality beyond the cult object. This is so, even though she is still just a masked bust. But perhaps it is the magic of translating three-dimensional things into two dimensions that gives them an imaginary reality. The ocean and cosmic tree would have been harder to render in the censer. The gods emerge literally with the new means of representing them in the mural paintings.

The Storm God is also present in this mural, but he is relegated to the borders, where his image competes with that of a watery interlace band. Both in this case and in the case of the murals of Techinantitla where the two occur together, the Goddess is always in the more important position. This leads one to believe that she must have been the most important deity of the site.

A curious feature of the Goddess is that she is often shown in parts. Some murals just represent her elegant hands giving gifts (fig. 5) or other emblematic parts. Although she presides over a terrestrial paradise, it is not one without violence and sacrifice. In one mural from Techinantitla she is only a mouth full of teeth and two menacing claws framed by her headdress (cat. no. 40). Still, streams of water emerge from her mouth. Most mysterious of all are the many representations of disembodied eyes in all images of water, as for example the stream that emerges from the mouth of the Feathered Serpent and Flowering Trees mural (cat. no. 50). These eyes are almost always in water and suggest that the water is in some ways divine or watching everything that goes on around it. It is unlikely that these are the eyes of the Storm God, because his are goggled. They seem to be the eyes of nature in general and perhaps of the Goddess in particular who presides over it. Thus this Goddess was envisioned as a personification of nature, and yet immanent *in* nature, signified by all of her body parts scattered about. In their painted apartment compounds the people of Teotihuacan were living in this paradise on earth which was, literally, the body of the Goddess.

I might have hesitated to use this metaphor, but the artists of Teotihuacan used it themselves in the curious figures that Warren Barbour has called hosts.[18] These are as remarkable as the composite censers. Little moldmade figurines are glued to the interior of a hollow ceramic figure. The hollow figure is naked and has no costume or identifying features. In the case of the Tlajinga figure (cat. no. 61), the head is really just a mask, not even attachable to the body. In the case of the figure in the Museo Diego Rivera de Anahuacalli the figure is faceless and opens up like a giant clam on the side (figs. 6a-b). We

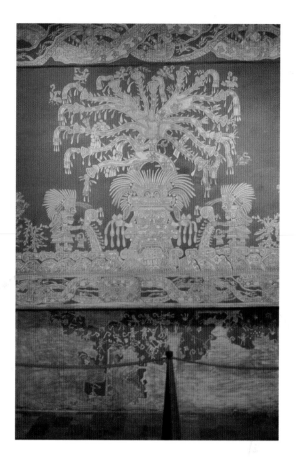

cannot identify this outer person, but the figures inside it are as if they were in its womb. The figure may represent something large — the city, nature, or the cosmos that encloses the miniature persons inside. Those miniature persons are all dressed and clearly belong to the Teotihuacan social and political world. These host figures suggest a concept of the people, or a certain segment of the people, permanently entombed within a large cosmic body. This may also be how the city was envisioned — as the sheltering body of a divinity.

Why should this important personage have been a goddess and not a god? Studies in the anthropology of gender have shown that in most cultures power is in the hands of men and not in that of women.[19] Yet some cultures create idealized images of women that transcend the values of the culturally constructed world of men. Because they are outside the usual political processes, feminine symbols can stand for large, overarching concepts. Such concepts are especially common in the West with the important cult of the Virgin Mary; Athena, the patron goddess of Athens; and even Lady Liberty, who holds the torch in New York harbor. Such supracultural female symbols are noneroticized and nonhistoric women who stand for undisputed and unpoliticized values such as love, unity, and freedom.

The Teotihuacan Goddess may have inhabited a similarly important position, underscoring some universal or cosmic value. This value was not dynastic or political in the everyday sense of the term. Yet it was political in that a feminine image seems to have been encouraged by the rulers as a symbol of neutral or higher values. As we will see, the Storm God is intimately associated with elite, dynastic, and political values, and thus seems not to have been an ideal candidate for supreme deity. Moreover, the Goddess, great though she is, seems to have been a local phenomenon and to have been involved largely with the city

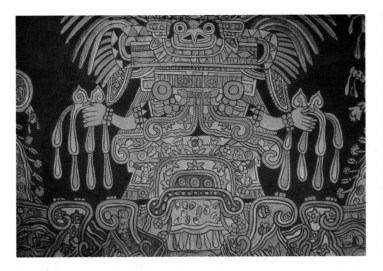

and its people. Her image was not carried outside of Teotihuacan, except in places where Teotihuacan people actually settled. We cannot discover exactly what she stood for. Perhaps her sphere was some aspect of unity or integration of the community with the cosmos.

THE ELITE — THE POWER OF SELF-EFFACEMENT

Most research has focused on the many mysterious signs and symbols and the fascinating gods of Teotihuacan. Little attention has been paid to one of the most common representations, rows of richly dressed male figures adorning many of the walls (cat. nos. 43-45). Because they are in profile, they seem less important than the frontal deities, and on various occasions they flank the frontal deities as clearly secondary figures. Moreover, because they are in profile, their eyes do not engage the viewer; one does not have a sense of communication. They go about their business of pouring libations and chanting, or dancing with sacrificial hearts on their obsidian knives. These seemingly uninteresting processions of figures are, however, our major clues to the ruling elite of Teotihuacan and what they were about. Unquestionably, as the above list indicates, they represented themselves in anonymous, secondary, and nonconfrontational ways. They are always shown performing rituals and religious services. The first point made by their representation seems to be that "we are the anonymous servants of the gods; do not focus on us, focus on them."

A second look, however, shows otherwise. Unlike the gods who are represented by their parts, these elite are the only Teotihuacan figures who are whole, complete in body, and immediately recognizable. Second, they are dressed remarkably like the gods, with the same spectacular feather headdresses, necklaces, mirrorlike back ornaments, and huge feather bustles. Third, they are shown as about the same size as the gods and much bigger than ordinary or common people who are shown as very small (note the murals of Tepantitla, fig. 4a). And fourth, there are a great many of them.

If a visitor from another city did have dinner in several of these painted compounds, he would have come away with the impression that images of the elite were on most of the walls. We cannot specify

Fig. 4b
Left, Detail, the Goddess, in the Tlalocan mural.

Fig. 5
Right, Detail, drawing of mural showing hands. Tetitla, Teotihuacan. Villagra 1971; by permission of the University of Texas Press.

Fig. 6a
Host Figure, closed. Xolalpan-Metepec
A.D. 500-750. Ceramic, H. ca. 12.5 cm
(5 in.). Museo Diego Rivera de
Anahuacalli, Mexico City.

Fig. 6b
Host Figure, open.

who these elite were; we only know that the tassel headdress signified people of the highest rank. We also see that the elite were involved in ritual evoking the gods, sacrifice, and war. The seeming understatement must have been deliberate. The way gods and humans are represented suggests that Teotihuacan chose to rule through the power of the gods. Did this idea emerge in A.D. 250 with the apartment compounds, or was it there from the beginning? It is worth pondering René Millon's comment that "Teotihuacan was not built by a committee."[20] Perhaps not, but its citizens certainly chose to give that impression. As I see it, some collective ideology of power has to have functioned from the beginning in order to explain the surprising difference of the Ciudadela from the pyramids and the dramatic way in which the experiment in absolute rule was reversed. The apartment compounds and the new arts make sense not as new ideas, but as the restoration or the reinterpretation of something old. An implicit idea and system was being codified.

Suggestive of the power of the elite is their close connection with the Storm God, who is the only deity who is shown walking in profile like the elite figures themselves.[21] In fact, it is hard to tell whether he is a deity or a human wearing a mask and performing a ritual. As important and frequent as is the Storm God, he is rarely depicted in a complex scene and has fewer manifestations than the Goddess. He is intimately tied to the elite in style of representation, close relationship to warfare, and occurrence outside of Teotihuacan in dynastic contexts. It is possible to hypothesize that while the god of the city was the Goddess, the god of the elite was the Storm God.

THE ART OF UNDERSTATEMENT

"Less is more," said the architect Le Corbusier, to which the post-modernist Robert Venturi replied, "Less is a bore." Teotihuacan's values were, in contemporary terms, firmly in the mode of the modernist aesthetic as illustrated by Le Corbusier's famous remark. This understatement proceeds, as I have tried to show, from a political strategy of elite self-effacement and the concept of a collective ideology. If we are famil-

iar with lavish Maya and Olmec jades and the theatrical effects in many Mesoamerican arts, we will not appreciate the arts of Teotihuacan. We have to bring different glasses to its art. We have to think in terms of the Bauhaus, Mies van der Rohe, and minimalism.

Any culture whose favorite pottery, made to its specifications and imported from Puebla, was Thin Orange, did not favor ostentation (cat. no. 148).[22] What, exactly, did Teotihuacan like about these objects? Mostly this is plain pottery with very little incised decoration. Perhaps it was the bright orange color and the thinness, which is often, although not always, thinner than ordinary pottery. Perhaps they liked what we like, the exquisite simplicity of the shapes. Even the effigy figures are quite generalized. It is also striking what Thin Orange is not: it is not shiny or glossy; it does not appeal to a taste for grandeur, tell stories, or display dramatic designs. An appreciation of fine material and good craftsmanship, with no desire for explicit messages, seems inherent in its aesthetic.

This simplicity is true of most Teotihuacan arts. Figures do not gesture or contort themselves; they merely exist in a self-contained, simple form. They are neither totally abstract, nor do they strive for an illusion of naturalism. There is nothing childlike or tentative about this choice; it is an unconscious reflection of who they felt they were and how they saw the world. Simplicity is remarkable in the figurines, in which garments are flat sheets of clay and eyes are merely simple slits.

In addition, repetition as a principle does not seem to be a fear. Many have commented on the "boring" repetition of *talud* and *tablero* in the architecture of Teotihuacan, but I suspect that Teotihuacan saw this monotony as orderly and harmonious. Repetition is also evident in the importance of moldmaking for the *adornos* of the censers and the later figurines. Again, rather than seeing mass production as a loss of individuality, it can be seen as a gain both for codification and variability, as mentioned above, and also for the creation of order and simplicity.

Such understatement and repetition creates an aesthetic of austerity and spareness that was revolutionary in the context of the more flamboyant traditions of most of Mesoamerica. No wonder that Teotihuacan's neighbors were impressed by this new uncompromising style (and perhaps culture) and imitated it in their arts. Teotihuacan concepts in art were influential in creating order out of the chaos of other curvilinear, naturalistic, ornate styles throughout Mesoamerica.[23]

PUZZLES, PUNS, AND THE SURREAL

If this austere art of understatement was all there was to the art of Teotihuacan, it would indeed be a minimalist bore. But this art comes to life with the body parts of deities and with flowers and glyphs turned into mouths, like the painted world of Paul Klee. The art is filled with puns and dreamlike and nightmarish combinations, such as mouths edged in flames, or serpents vomiting water full of eyes (cat. no. 50). Most of these images are on the relief vessels, frescoed vessels, and murals, where the artist is free to vary and move, open and close signs. In these realms less repetition is evident as well as a lively play of the imagination. Like the paintings of Paul Klee, these are not necessarily large, dramatic, or overwhelming works. They require decoding. They assume an audience who understands the symbols and the games that are being played. They assume the inhabitants of this city. It is not an

art to impress others, but to emotionally fulfill the inhabitants and provide for their ritual needs.[24]

Only a culture such as this could have come up with as strange a beast as the net-jaguar, a creature made up of nothing, but wrapped, so to speak, in a net (fig. 7). In a tradition in which representation is generally flat, the over- and underweaving of the net is rendered with the illusion of three dimensions; we do not miss the fact that it is a net and that there is nothing behind it except background color. This creature lines up with "real" creatures like coyotes, grasps maguey flowers, or can be anthropomorphic and walk toward a temple like a member of the elite. Although we do not know who he is and exactly what he represents, the image still tells us something about Teotihuacan — its cleverness, sense of the unexpected, and ability to take its own peculiar world as right and normal.

The feathered serpent is such a well-known image from Mesoamerica that we tend to take it for granted. In fact, however, the feathered serpent may be largely a Teotihuacan creation, a mythical creature as strange as the net-jaguar. Can one really imagine a creature stranger than a serpent covered with the green feathers of the quetzal bird? Serpents exist in the art of earlier cultures and a few have a small wing or feather attached to them. But the idea of a fully feathered composite creature first appears on the Temple of the Feathered Serpent. In later art the Feathered Serpent seems not to have its dynastic connotations but to be used as a border design (cat. no. 50). In that sense it appears to be in a protective and enveloping position. It does not seem to have been a deity as it is never worshipped by elite figures. Once we get past our familiarity with it, it emerges as a truly strange combination — an allegory, visual pun, and a play with concepts and images characteristic of Teotihuacan. Like the dragon in China, it was a positive image of transformation and fertility and may have signified *Teotihuacan* to other cultures such as Xochicalco, which also put a feathered serpent on one of its temples in a "protective" position above elite figures, probably in imitation of Teotihuacan. None of this imagery is easily accessible. All the double meanings, puns, nets, and feather coverings succeed more in hiding meaning than in revealing it, especially to another culture from another time and space.

NATURE AS MODEL

It frequently has been noted that Teotihuacan seems to prefer the representation of animal images to that of humans. Coyotes, jaguars, pumas, owls, quetzals, doves, deer, fish, and shellfish are all abundantly represented, to say nothing of mythical creatures such as the net-jaguar and the feathered serpent. These animals, too, are often anthropomorphic: felines blow conch shells and birds carry shields and weapons. It is difficult to determine if they are aspects of the gods or of the human elite, because at different times they are shown behaving like both. Perhaps most fascinating is the mural belonging to The Fine Arts Museums of San Francisco, of two coyotes sacrificing a deer, where two awesome canines rip out the heart of a slender deer (cat. no. 46). This scene, with the human-looking heart, is probably an allegory. It could represent the elite taking the heart of a human victim. At the same time, it could refer to aspects of the gods who established the necessity of the sacrifice. If we focus on the fact that the actors in the scene are animals,

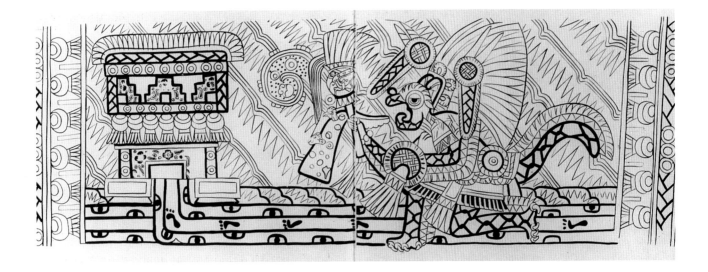

we must ask why this scene was painted in terms of animals and not gods and humans? Animals seem to be used as symbols of nature and the natural world. The sacrifice may signify that because capture is normal in the animal world it can be instituted as a ritual in the human world. The rich imagery of flora and fauna in Teotihuacan seems to place every act, every ritual, in the guise of natural or cosmic processes. The implication is that the laws of this city are not merely human constructs, but embodiments of the natural order of the universe. The picture painted of nature is one that is harsh and demanding in some ways, but bountiful and rich in others.

PARADISE ON EARTH OR GOTHAM CITY?

In A.D. 250 Teotihuacan saw a need to build masonry apartment compounds for its citizens and to invent a whole new series of works of art. These phenomena were obviously linked and I have suggested that one aspect of this link was the need to codify early systems in nonperishable media. The question still remains as to why such a wealth of art should have become necessary.

Art is a form of symbolic communication that deals in multivalent and subliminal messages. It seems that in the first few hundred years of its history Teotihuacan avoided the making of such things. It may be that the very process of settling down into permanent homes and permanent structures of social, ritual, and political life in a densely inhabited city came to require more symbolic communication. Art works also are often resorted to in situations of conflict, expressing potential confrontation that cannot be dealt with practically but that needs to be defused or sublimated symbolically. Art works do not arise spontaneously; they arise because they have work to do.

It would seem that after A.D. 250 Teotihuacan needed, if only in the forms of its masks, to make the gods more visible in the homes and temples. I presume that this was because a large, dense, heterogeneous population in the busiest city of Mesoamerica was hard to integrate into a coherent and cooperative community without such concrete images. The popular appeal of the Goddess, a kind of distant and ambivalent mother figure, might have been an ideal deity to transcend vari-

Fig. 7
Drawing, mural with net-jaguar. Tetitla, Teotihuacan. From Séjourné 1966b, fig. 13.

ous local clan, district, or status allegiances. Similarly, the references to nature suggest that the city, complex and artificial as it was, strove to reinforce the notion that everything it did was along the lines of nature and the cosmos. All the understated elite figure representations emphasize that the city was run by austere groups of men rather than contentious individuals out for fame and glory. The art works, then, paint a picture of a harmonious society. The most attractive aspect of this is the amazing emphasis on both variability and the kind of zaniness in the play with symbols. Besides gods and harmony, one also gets a spirit of fun.

Art, however, is not life. Art does not reflect life like a still pond reflecting trees on its shore. Art is an agent in the creation of a life that various segments of society want. It is a mirror, but a distorting mirror. So, what kind of place was Teotihuacan? Was it totalitarian and ruled absolutely from above with an emphasis on gods who were suffocatingly close? Or was it ruled more collectively, and did people have a certain degree of control over their lives in those apartment compounds? These are not questions that can be definitively answered; all who study Teotihuacan have their own personal views. On the basis of the art and the archaeological facts, I would say that Teotihuacan had a little of both kinds of social organization. Unquestionably Teotihuacan was a success — it lasted nearly eight hundred years. The apartment-compound phase alone lasted five hundred years.

On the other hand, Teotihuacan eventually collapsed from internal conflict that was both political and religious; there is no reason to assume that the final conflagration was the only trouble spot in its history. All that emphasis on order in its arts seems suspect, and suggests that Teotihuacan may have been a somewhat more difficult and unruly place than the images seek to suggest. Similarly, the elite protests its secondary role too much.

I imagine that the elite truly had power but chose to keep a low profile for the sake of political expedience and the appearance of a collective social contract. Life in the apartment compounds may perhaps have been delightful, but it was also harsh. Mortality rates were high in the city; overcrowding, sanitation, and poverty had to have been a problem. At the same time, city life offered a close community that developed its own ideas on things, its own vocabulary of images, and, judging by all the speech scrolls, a complex world of oral discourse. Intellectually it developed one of the most subtle and clever arts of all time. Teotihuacan may not have been paradise on earth, as the murals proclaim, but it was probably one of the most fascinating and unique civilizations that ever existed.

Esther Pasztory is Professor of Art History at Columbia University.

1. Umberger 1987b.

2. Esther Pasztory, "The Natural World as Civic Metaphor at Teotihuacan," in *The Ancient Americas: Art from Sacred Landscapes,* ed. R. F. Townsend, 135-146. (Chicago: The Art Institute of Chicago, 1992).

3. Cowgill 1992.

4. Manzanilla 1990.

5. Esther Pasztory, "El poder militar como realidad y retórica en Teotihuacan," in Cardós 1990, 181-197.

6. Pasztory 1993.

7. Pasztory 1988.

8. Manzanilla 1990; Manzanilla and Carreón 1991.

9. Cowgill 1983.

10. Cabrera, Sugiyama, and Cowgill 1991. Also see Cabrera, this volume.

11. Sugiyama 1989b.

12. There are three known colossal stone figures from Teotihuacan. One is the colossal "Water Goddess" in the Museo Nacional de Antropología, Mexico City (see Serra Puche, fig. 7). The second is an apparently very similar but very battered fragment still at the site of the Plaza of the Moon. The third is the "Tlaloc" of Coatlinchán across the street from the Museo Nacional de Antropología. Coatlinchán is near Texcoco, thirty miles from Teotihuacan.

13. I would like to thank George Cowgill for bringing Mohenjo Daro as a parallel to my attention.

14. Spence 1974.

15. Langley 1986.

16. Linné 1934 and 1942.

17. Batres 1906; Cabrera, Rodríguez, and Morelos 1982a, 1982b.

18. Warren Barbour, "Shadow and Substance: The Iconography of Host Figures Associated with Ancient Teotihuacan, Mexico," paper presented at meeting, The Society for American Archaeology, New Orleans, April 1986.

19. Sherry B. Ortner, "Is Female to Male as Nature Is to Culture?" in *Women, Culture, and Society*, ed. M.Z. Rosaldo and L. Lamphere, 67-88 (Stanford: Stanford University Press, 1974).

20. René Millon, personal communication, 1990.

21. Berrin 1988, fig. 6.18.

22. Rattray 1990.

23. Esther Pasztory, "Artistic Traditions of the Middle Classic Period," in Pasztory 1978.

24. Pasztory 1990-1991.

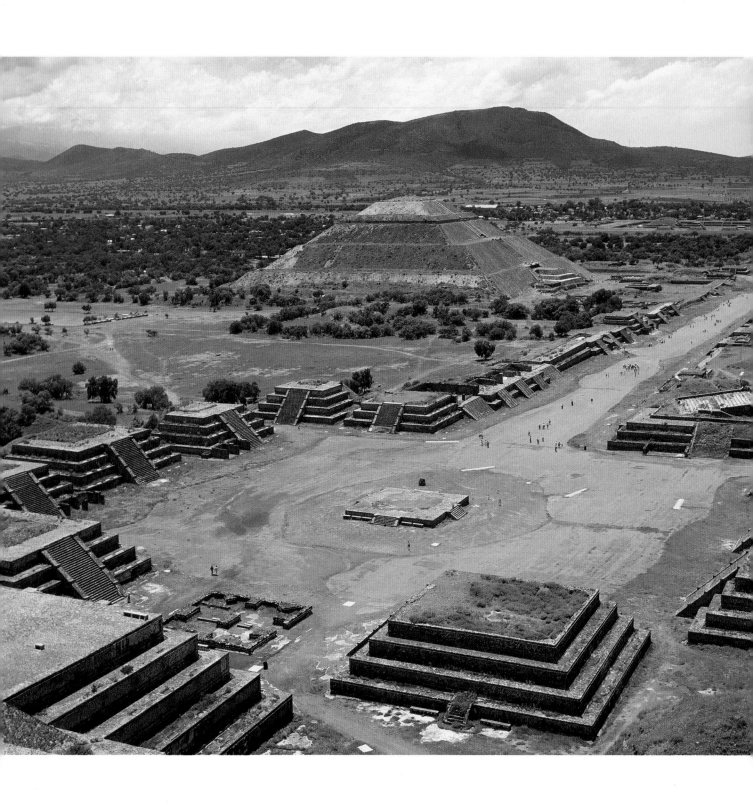

Fig. 1
Street of the Dead, view taken
from the Pyramid of the Moon.

The Role of Teotihuacan in Mesoamerican Archaeology

Mari Carmen Serra Puche [1]

Teotihuacan is without doubt the most impressive urban architectural complex of ancient America, and perhaps one of the most spectacular archaeological sites in the world (fig. 1). Teotihuacan's name, "the place where men become gods," expresses the reverence inspired by the site in the hearts of the Aztecs, who were familiar with the already abandoned, partially ruined ancient city. The names of the Pyramid of the Sun, Pyramid of the Moon, Street of the Dead, and of the apartment compounds surrounding the ceremonial core, still used today, also were given by the Aztecs.

What was once the most important city on the American continent, the focal point attracting and integrating a vast network of material and cultural exchange, continues to exert its power over the minds of scholars who now study the past. Teotihuacan is not only the location of a crucial moment in indigenous and universal history, its archaeological zone also has witnessed the development of Mexican archaeology. The great thinkers of Mexican history have strolled through its plazas and its buildings, which have felt the more or less skillful, ever-caring hands of those who have wanted to uncover its mysteries. What follows is a brief chronicle of the major studies, inspired by ongoing human curiosity, that have focused on Teotihuacan through time.

Already in 1675, during the period of Spanish domination in Mexico, Teotihuacan was the subject of one of the oldest archaeological explorations known. Carlos de Sigüenza y Góngora, a restless intellectual of the Mexican baroque period, dug a tunnel in the Pyramid of the Moon at the level of the platform attached to the front of the building. However, exploration of the site would begin two centuries later, work that would go on almost continuously until today. In 1863 Antonio García Cubas explored the Pyramid of the Moon, removing

the rubble and clearing the southeast side of the building and part of the stairway. Around that time Belgian explorer Désiré Charnay, member of the Scientific Commission accompanying Emperor Maximilian of Hapsburg, investigated a mound to the west of the Street of the Dead and a cemetery in the nearby town of San Juan Teotihuacan. A more formal study was undertaken under the direction of engineer Ramón Almaraz in 1864. Organized by the Scientific Commission of Pachuca, also under the direction of Almaraz, the project surveyed the area occupied by the ruins. The geographical coordinates of the two main pyramids and the Ciudadela compound were plotted, as well as the precise location of the Street of the Dead and several isolated monuments.

Using these reports, Gumesindo Mendoza wrote the first interpretation of Teotihuacan history. Although his effort was daring and even hasty in several respects, Mendoza proposed for the first time the existence of superimposed architectural structures, supported by evidence of successive floor layers in some parts of the site. A theory that the Ciudadela and other buildings flanking the Street of the Dead housed tombs — an idea that undoubtedly had helped to give the avenue its name — was discarded in 1895. García Cubas's interest in the site was not solely academic; he also tried to improve its appearance as an additional attraction for the eleventh meeting of the Americanists Congress to be held for the first time in Mexico.

Teotihuacan as we now know it, a great city with residential areas that had been inhabited by peasants and craft specialists, was first characterized in 1897 by William H. Holmes, curator of the Field Columbian Museum of Chicago, who published a monograph on the ancient site. With greater care than had been displayed by his predecessors, he recorded the distribution of the principal mounds and their construction techniques, based on published data and short visits to the site. With excellent detailed drawings of the ancient architecture, Holmes marked the location of the monumental sculpture of the rain goddess, called Chalchiuhtlicue by the Aztecs, behind the buildings lining the west side of the Plaza of the Moon. In spite of the lack of a historical perspective in his work, Holmes discussed the information available to him, incorporating studies on architecture, ceramics, and other materials, which enriched knowledge of the site and of its history. A study that was valuable for its illustrations of murals, which were in a better state of preservation at that time, was presented in 1900 by Antonio Peñafiel.

The research of all of these investigators, to which were added the colorful and imaginative accounts of travelers who sought adventure in the search for ancient Mexican cities, sparked public curiosity and directed attention to a topic that would later become archaeology. At the beginning this science had a positivist stamp, focused as it was on classification and description. Nevertheless, these studies are the forerunners of work that from 1914 on would be steeped in the philosophical content of the transformation brought about by the social movement of the Mexican Revolution.

It was the self-taught archaeologist Leopoldo Batres who first occupied the post of Inspector General and Conservator of Archaeological Monuments of the Mexican republic during the government of Porfirio Díaz. On 20 March 1905 Batres began exploring the Pyramid

of the Sun (figs. 2a-b), the Temple of Agriculture, the so-called Subterranean Buildings, and some parts of the Ciudadela. Batres had been charged by President Díaz with the excavation of the Pyramid of the Sun in preparation for the first Centennial of Mexican Independence celebration in 1910. During the last year of General Díaz's government, in 1910 Batres reconstructed the Pyramid of the Sun, which was to be visited by foreign diplomats and dignitaries as part of the independence celebrations.

To carry out his task, Batres dynamited the front, upper portion of the Pyramid of the Sun, destroying its topmost level. Despite such destruction, it is important to note that this work marked the beginning of archaeology as an institutional activity funded by the federal government, which was — and continues to be — the principal source of support for the discovery and preservation of ancient monuments.

It was a triumph of the 1910 revolution that the principles and objectives of Mexican archaeological research were transformed. A wider perspective developed, of archaeology in the service of the people, which was inextricably linked to the country's large rural, indigenous population. The illustrious anthropologist Manuel Gamio possessed the academic credentials and the political authority to carry out the first interdisciplinary anthropological project ever in Mexico (fig. 3). The foundations of what he called "integral anthropology," which integrated linguistics, physical anthropology, ethnology, and archaeology, were presented before the Second Pan-American Scientific Congress in Washington, D.C., in 1916. The Teotihuacan Valley was the subject of the first interdisciplinary anthropological project aimed at a comprehensive understanding of the environment and its population. Between 1917 and 1922, anthropological and demographic research was carried out, as well as studies of the characteristics of the zone — its ecology, geology, and geography, as well as reconstructions of environmental conditions from the pre-Hispanic period to the time of the project. This research paved the way for work such as Manuel Gamio's, which would permit the proposal of solutions to the future problems of the region.

Gamio's study in 1922 marked the beginning of regional anthro-

Fig. 2a
Postcard from the 1910 Centennial of Mexican Independence. Archaeologist Leopoldo Batres, with cane and hand upraised, explaining his recent reconstruction of the Pyramid of the Sun during the term of President Porfirio Díaz. Courtesy Manuel de la Torre.

Fig. 2b
Postcard from the 1910 Centennial of Mexican Independence. Entourage approaches south side of the Pyramid of the Sun. Courtesy Manuel de la Torre.

Fig. 3
Manuel Gamio leading a tour
at Teotihuacan. Courtesy Angeles
González Gamio.

pological studies, never before carried out, as well as the use of general period divisions and the definition of cultural areas, which were based on preliminary ceramic typologies. He worked on a large scale at the architectural complex of the Ciudadela (figs. 4-5) and the Temple of the Feathered Serpent while overseeing the work of José Reygadas Vertiz in the residential zone of the ancient city. The results of his research were published as *La población del Valle de Teotihuacan* [The Settlement of the Teotihuacan Valley].[2] The process of observing and comparing the physical record, which Gamio's work was based on, had not been systematically done before this time.

Again, analysis of physical evidence, in this case, ceramic types, provided an important means of identifying different cultures. In 1922 Alfred L. Kroeber examined ceramics from a tunnel dug to the east in the second tier of the Pyramid of the Sun. This study was part of a project analyzing ceramics from archaic sites in the Valley of Mexico, which enabled Kroeber to compare and thereby discover similarities and differences in forms and styles. He concluded that to explain and date Teotihuacan development it was necessary to clarify the relations of the ancient city with Maya, Oaxaca, and Gulf Coast regions, as well as with the Aztecs. Ten years later George C. Vaillant carried out a series of explorations west of the Pyramid of the Moon and near the towns of San Sebastian and San Francisco Mazapa. Vaillant identified the presence of three types of ceramics — painted, incised, and gray wares.

Returning to the ceremonial core of the site, archaeologist Eduardo Noguera dug an exploratory tunnel in the west side of the Pyramid of the Sun in search of different levels of construction. In 1935 Noguera published his results: by comparing shards found in his

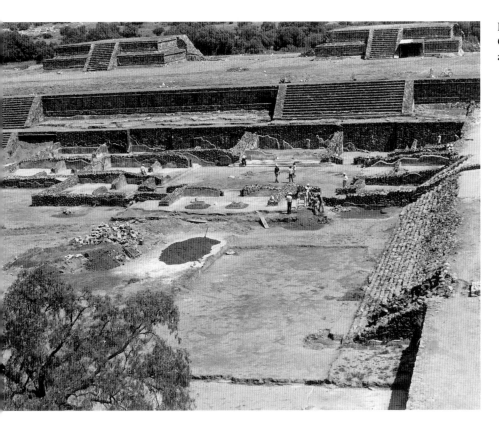

Fig. 4
Ciudadela, north interior platform
and Compound 1D. Courtesy INAH.

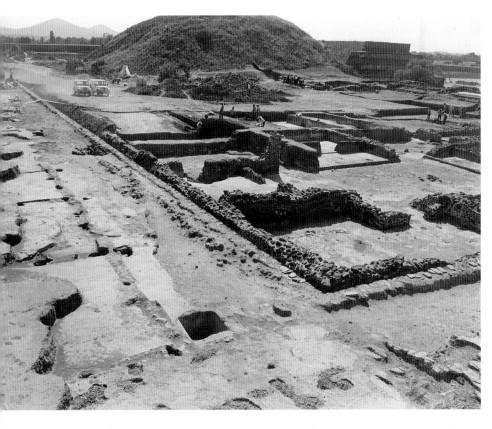

Fig. 5
Ciudadela, Compound 1C. Courtesy
INAH.

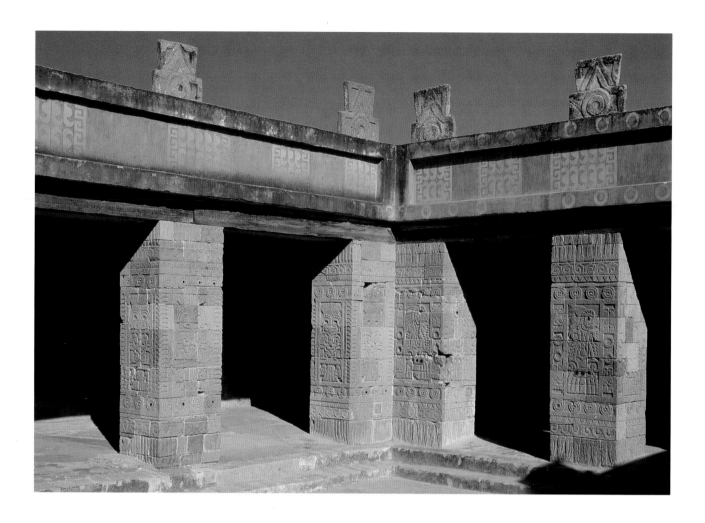

Fig. 6
Patio of the Quetzal Butterfly Palace.

excavations with those from other areas of Mexico, he noted similarities with archaeological materials from Chupícuaro, Guanajuato, and the area of Michoacán, north and northwest of the ancient city, also inferring a possible relation with more distant sites in the states of Zacatecas and Jalisco.

Around the time Noguera was excavating the Pyramid of the Sun, Sigvald Linné of the Folkens Museum-Etnografiska of Stockholm was carrying out explorations outside of the central, monumental zone. He excavated an ancient residential compound at Tlamimilolpa, as well as a habitational complex of several rooms at Xolalpan, located in the town of San Francisco Mazapa. His interest was not restricted solely to the ancient city; Linné extended his research to other sites in Central Mexico, such as Calpulalpan (in the nearby state of Tlaxcala), where he sought to identify influences from the metropolis. Based on his work, he was able to establish that the Teotihuacanos preceded another group, identified by a particular ceramic type that came to be called *Mazapa*.

In the 1940s Pedro Armillas explored other residential compounds, Atetelco (with César A. Sáenz) and Tetitla, where mural paintings would inspire him to undertake iconographic analysis and the identification of deities represented. In 1944 he excavated the Viking Group, buildings that lined the Street of the Dead, where he located artificial stratigraphy indicated by intact floors, which allowed him to associate construction stages with ceramic types. Armillas defined four

periods of relative dating, which were the basis of the general chronological sequence for the Basin of Mexico. He emphasized the importance of Teotihuacan, together with the great urban centers of the Central Highlands, as the center around which Mesoamerican cultural development revolved. Based on Armillas's work, the research focus in Mexican archaeology was no longer on the study of physical evidence, but rather the study of social institutions, their changes and the conditions that promoted their development.

Without discarding those interests, during the 1960s Teotihuacan was the scene of a great state-level project that converted the ancient city into the most important archaeological tourist attraction near Mexico City. At that time explorations focused on the discovery and adaptation of buildings, friezes, mural paintings, and entryways for public viewing. Beginning the project from 1960 to 1962 archaeologist Jorge Acosta directed three seasons of excavations, clearing buildings in the Plaza of the Moon and totally excavating the so-called Palace of the Quetzal Butterfly, the name given to fantastic representations carved in relief on the pillars of its central patio (fig. 6). In 1962 the Teotihuacan Project gained even greater force under the direction of Ignacio Bernal. It was then that the central, ceremonial, heart of the site was explored, along the Street of the Dead from the Pyramid of the Moon at its northern end, to the Ciudadela at the southern extreme (fig. 7). The area was reconstructed, leaving its latest construction stage visible. Román Piña Chán explored the zone known as La Ventilla, located at the periphery of the central monumental zone, in search of a ballcourt playing field. Laurette Séjourné explored the residential compounds of Zacuala, Yayahuala, and Tetitla, where she located an area important for the study of Teotihuacan mural painting. Florencia Müller systematically analyzed the ceramics and stratigraphy of the site, which resulted in the first ceramic chronology for Teotihuacan, indispensable for cultural comparisons.

In the same decade Pennsylvania State University began a study of the Teotihuacan Valley, aimed at obtaining a greater knowledge of the area based on human ecology; the principal research methods used included settlement pattern surveys, carrying capacity and demographic capacity studies. Later, the project would be expanded to cover the entire Basin of Mexico, its techniques and methods markedly influencing the subsequent development of research carried out by Mexican archaeologists.

In 1973 René Millon published the results of an ambitious, long-term project — the production of a detailed map of one of the major pre-Hispanic cities of Mesoamerica.[3] Millon's team defined the extent and boundaries of Teotihuacan, the site's urban planning and density, as well as construction types. They identified the main centers of the city, the great precincts, the apartment compounds and residential complexes, on the basis of which they carried out demographic estimates. The Teotihuacan Mapping Project brought together the expertise of numerous specialists, whose work was aimed at explaining and understanding the society that inhabited the ancient city. The project brought to light the process of the site's transformation from a small village to the economic and religious center of a wide region covering almost half of the territory now comprising Mexico.

Also in 1973 Arthur Miller published the book *The Mural Painting*

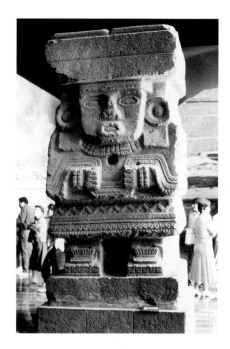

Fig. 7
Colossal Figure. Found near the Pyramid of the Moon. Probably Tlamimilolpa-Metepec A.D. 200-750 Basalt, H. 390 cm (154 in.), 22 tons. Museo Nacional de Antropología, Mexico City. Courtesy INAH.

of Teotihuacan, which is a graphic study of mural painting associated with architecture situated along the Street of the Dead and some residential areas. Soon after, Esther Pasztory provided in-depth analysis of the murals of Tepantitla.[4] These studies have enabled others to carry out further work on iconography, ideology and forms of language, as well as exchange systems and interrelations between different centers in Classic Period Mesoamerica.

The 1980-1982 Teotihuacan Archaeological Project, under the direction of Rubén Cabrera, was concerned with the presentation, maintenance, and conservation of the Street of the Dead, especially the Street of the Dead Complex and the Ciudadela.[5] As an integrated, interdisciplinary research program, it covered architectural, urban, and sociocultural aspects of the site.

The Instituto de Investigaciones Antropológicas of the Universidad Nacional Autónoma de México excavated one of the site's residential compounds. The purpose of the project was to study areas of activity within the compound and the priesthood's mechanisms of control over the production and redistribution of manufactured goods.

Virtually no archaeological technique nor methodological approach has failed to be applied to Teotihuacan. It is difficult to summarize in a few lines the tremendous diversity of analyses as well as particular studies carried out within the bounds of the ancient city. Nevertheless, we may mention, although only briefly, some of the approaches and focuses that have characterized the study of this great and complex metropolis in recent decades, the results of which will be examined in greater depth in other essays in this volume.

Today we know that Teotihuacan was the site of a process of crucial importance for an understanding of the history of Mexico — the rise of civilization and the transformation of an egalitarian society into one characterized by the separation of social classes. The rise of state societies is, in fact, the foundation of human civilization, such as we know it today. And in the history of Mexico, Teotihuacan is the location of this decisive transformation

The work carried out by archaeologists — all of the descriptive charts of ceramics, the detailed drawing of maps, studies reconstructing environmental conditions, the exploration of residential compounds beyond the ceremonial nucleus of the city, the careful excavation of burials and their analysis based on the most advanced physical and biochemical techniques — all form a long series of tedious yet fascinating labors, which when studied together may provide an even more profound explanation of social processes underlying the development of this great civilization. Understanding these processes are of utmost importance for humanity in the search for solutions to economic, social, ecological, and other challenges that face us today.

In itself, Teotihuacan stores an enormous wealth of knowledge on Mexico's past and on the origins of today's social structures. But to fully understand the role played by the site in the present-day panorama of Mexican archaeology it is necessary to emphasize another interesting phenomenon that revolves around the ancient city — its character as a cultural symbol, the privileged scenario and sanctuary of Mexican nationalism that is now considered the cultural patrimony of all humanity.

At Teotihuacan, as well as through other vestiges of its past, Mexico strengthens its roots at the same time it shares its lessons from

history with the world. By seeking knowledge of the way of life of past cultures, Mexican archaeology reevaluates its activities while it offers today's humanity a mirror showing the very essence of the clay from which humankind has been modeled.

Mari Carmen Serra Puche is Director of the Museo Nacional de Antropología, Mexico City.

1. Many thanks to Karina Rebeca Durand Velasco and Manuel de la Torre who collaborated on this essay.

2. Gamio 1979.

3. R. Millon 1973; R. Millon, Drewitt, and Cowgill 1973.

4. Miller 1973; Pasztory 1976.

5. Cabrera, Rodríguez, and Morelos 1982a-b.

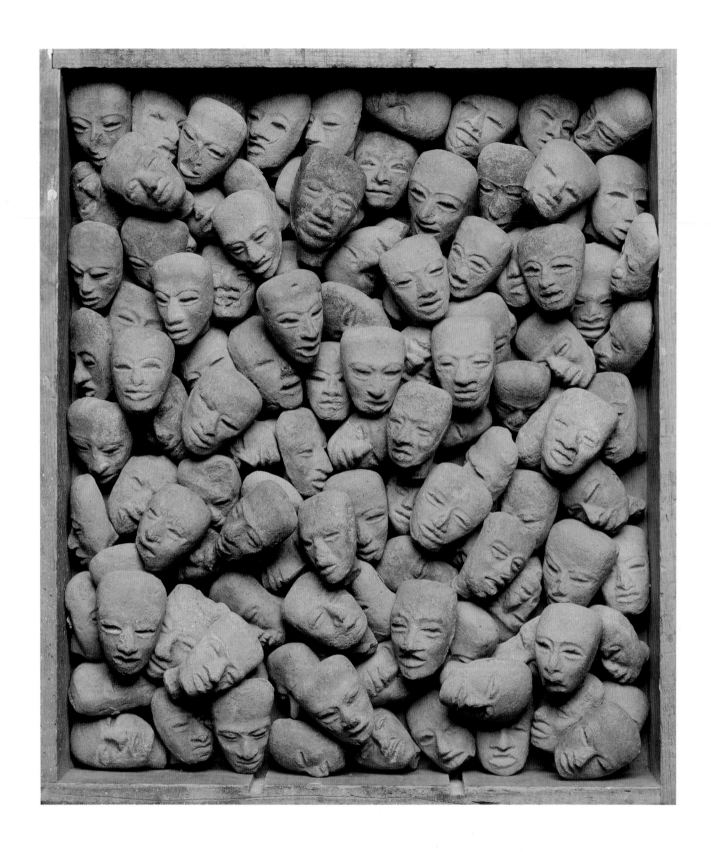

Fig. 1
Portrait heads of figurines. Xolalpan-
Metepec A.D. 400-750. Ceramic. Collec-
tion of Marian White Anthropology
Research Museum at the State Univer-
sity of New York at Buffalo.

Unknown Treasures

THE UNEXPECTED IN TEOTIHUACAN ART

Kathleen Berrin

T
EOTIHUACAN IS AN ARCHAEOLOGICAL MEGACULTURE. It ranks in importance with the ancient Maya and the Aztecs in the New World and with the ancient Egyptians, Greeks, and Romans in the Old World. Teotihuacan was Mesoamerica's greatest urban state, wielding tremendous power and influence not only in its own time but for centuries thereafter. Its massive pyramids, palaces, and temples rival those of any Old World civilization. And even today, it is no exaggeration to say that Teotihuacan is one of the most spectacular sites in the Western hemisphere.

Just being at the site of Teotihuacan is an overwhelming physical experience. After traveling from Mexico City for less than an hour, you confront the magnitude and majesty of the ruins. No experience compares to ascending the towering pyramids of the Sun and Moon, walking the mile-and-a-half-long Street of the Dead, or sensing the contrast of the site's brightness and light with the heaviness and angularity of the imposing architecture. You are also aware of the extreme horizontality of the site — the varying volumes and masses of the cadenced or staggered buildings, stacked *tableros* lifted up by their vertical *taludes*. Adding to these impressions, glimpses of brilliant white stucco remains with red-painted patterns periodically occur, subtle testimony that these sensual materials once covered the entire city and its streets. The stamina required just to see even a small portion of this great site, while all of the senses are bombarded with dazzling and often opposing sensations, distances the visitor from the ordinary. You sense you have arrived at a place that has no boundaries, no beginning, and no end, a city that has always been there and will be there forever.

Despite its significance as a culture that lasted over seven hundred years and had more impact on successive civilizations than any other culture in Mesoamerica, Teotihuacan is a place where the arts remain elusive and enigmatic. Their elusivity in part is because they

are physically unavailable. With certain exceptions, they are not well represented in museum collections. In addition, a survey of Teotihuacan's greatest art works will not yield the quantity of objects encountered when looking at the art of Maya, Olmec, or Aztec cultures.

Perhaps one reason Teotihuacan art is so little present in collections is its fragility. Many of its art forms are delicate and highly breakable. It is almost as if many of these works were created without concern for permanence. Adding to the elusiveness of many of Teotihuacan's art forms is the impenetrability of its images. These works are powerful and visually seductive, but their messages are indirectly communicated. Images are usually not narrative, and meaning is often veiled, conveyed by carefully selected signs and symbols.

A fascinating feature of Teotihuacan art is the way that it defies compartmentalization. It encompasses opposites — the large and heavy versus the diminutive and light — the understated and abstract versus the complex and iconography-packed object in which form, line, color, and texture interact in a way that affects the senses.

Why did the aesthetic preferences of such a powerful and important civilization gravitate toward the unification of opposites — creating objects that were delicate, light, or diminutive on the one hand, as well as objects that were monumental, massive, and profound? And why did such a strong and powerful culture create so many art works of great fragility?

In considering these questions, it is necesary to review six general categories of Teotihuacan art that are discussed as they occur in this volume's catalogue of objects. I emphasize what we believe are the major types of Teotihuacan objects — art works that bear significant iconography or that we know were used in important ritual contexts. I approach this discussion as someone trained to work with and evaluate objects.[1] I am particularly interested in relative size, rarity, or frequency of type, and physical aspects that contribute to fragility (fig. 1).

VOLCANIC STONE SCULPTURE

While many of the great Mesoamerican cultures such as the Olmec, Maya, Toltec, or Aztec created large numbers of monumental stone objects that emphatically declare the power of their gods, histories, or rulers, monumental stone sculpture from Teotihuacan is extremely rare. As Esther Pasztory has noted (this volume), colossal figures in stone at Teotihuacan are limited to just three known examples. The large-scale stone stelae are also virtually unknown; the over-six-foot "La Ventilla Stela" is not really a stela and is actually made in smaller separate sections that have been stacked. In addition, volcanic stone sculpture as a rule does not embellish Teotihuacan's buildings or monuments. What does exist tends to be medium in scale (five feet high or less) and very flat and heavy (cat. nos. 5-7). The great serpent heads from the Temple of the Feathered Serpent are about twenty-seven inches high and almost six feet long but much of their bulk was never meant to be seen, being tenoned inside the structure (cat. no. 3, this essay). Moreover, the ornate facade of which they were a part (Pasztory, fig. 3) was a unique cultural phenomenon. Aesthetic elaboration in stone on this scale was never to be repeated after A.D. 200.

The very well known Old God braziers (cat. nos. 9-11) often range from about fifteen to twenty-five inches in height. Fragments

exist of at least one that was significantly larger, but many more were made in smaller sizes (often in low-fired clay which did not last in the archaeological record). The medium-sized whole stone braziers that do exist are made of a dense volcanic stone and are very heavy, although the carved openwork areas on them certainly take away much of the weight but make them vulnerable to breaking. Although these pieces look sturdy, they are often found in pieces, not necessarily ritually broken, but broken due to pressure following burial.

Semiprecious Stone Objects and Masks

This general category of objects consists of greenstone, gray- or white-stone figures and masks that were found near the temples and complexes aligning the Street of the Dead. None have been found in the apartment-compound districts or burials so far, and they do not seem to have been made as trade items for use outside of Teotihuacan. The relatively few figures that have been found indicate they were made mostly for use in the ceremonial precincts of the city.

The surfaces of semiprecious stone figures and masks range from very polished to very battered, and they often have the remains of what were once mirrorlike iron pyrites in the eyes. The largest semiprecious stone figure known is a little less than thirty inches in height (cat. no. 14) and most are considerably smaller. The masks, which were never worn by humans, tend to be between seven to nine inches in height. They often have holes drilled into them that would have enabled them to have been attached to something vertical. In her essay in this volume, Esther Pasztory believes the masks could have once been tied to wooden armatures in temples, and that the stone figures were used in a similar context, dressed or decorated with perishable accoutrements appropriate for a particular ritual. It seems likely that such semiprecious stone objects, whether figures or masks, were repeatedly used rather than made for a single ritual occasion. The stone masks are surprisingly heavy for their size, and have a kind of inert quality when held.

Teotihuacan-style stone figures and masks are extremely abundant in collections and popular with collectors, but it is common knowledge that this is a problematic category. It is highly uncertain whether the majority of Teotihuacan-style figures and masks that now exist in collections were ever made or used in ancient times, but it is difficult to separate the authentic ones from the impostors based just on stylistic grounds. The great attractiveness of these objects to collectors of course provided the incentive for large numbers of them to be reproduced for the art market. The Teotihuacan style of simplicity and abstraction makes stone pieces fairly easy to duplicate and pass off as original.

Painted Wall Murals

Teotihuacan wall paintings are among the most visually complex and important artworks ever created by this ancient civilization. It is interesting that many more of them have been found in apartment compounds rather than in the ceremonial buildings along the Street of the Dead. Because less than thirty apartment compounds have been excavated (out of an estimated two thousand), it is impossible to know the full extent of painted wall murals throughout the city. The total number of mural fragments that have been removed from the site and that

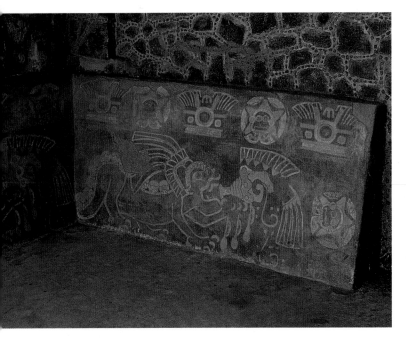

now exist in collections outside of Mexico may go as high as fifty. Working from published sources Christopher Couch estimated the total number of mural fragments in Mexico to be almost five hundred.[2]

The walls of Teotihuacan apartment compounds (figs. 2a-b) were at least seventy-eight feet high; in rough terms, compositions were generally divided into one-third lower wall and two-thirds upper wall. The sizes of the fragments that have been removed from the site, most of them by looters, are of course limited by the looter's assessment of what would make an attractive sale unit, as well as by the size that could safely be removed with a hammer and chisel. I think that Teotihuacan murals probably required considerable maintenance in their own time — one imagines people constantly brushing up against them — although examples showing ancient overpainting or repairs are limited. Since most mural fragments date from the last two hundred years of Teotihuacan's existence, it is conceivable that the old plaster surfaces were entirely removed before walls were subsequently covered with new images.

It is difficult to imagine a more fragile or unstable object than a Teotihuacan mural pried from its wall (a bizarre act never intended by its makers). The volcanic mortar backing ranges from a coarse aggregate to progressively finer particles, and the thin layer of lime stucco on which the painted surface rests is less than one-eighth of an inch deep. The mineral paints had to be applied while the lime stucco was still damp in order for bonding to occur. If the stucco dried first, its bonding to the paint would be tenuous at best, and the paint would ultimately peel off in layers. To further ensure that the painted surface would adhere to the stucco, the artist burnished the paintings by rubbing them with very smooth wood or stone tools. This produced a shiny effect and one we are sure was desired by the Teotihuacan artists. The shine of the burnishing plus the shine of the mica ilmenite and

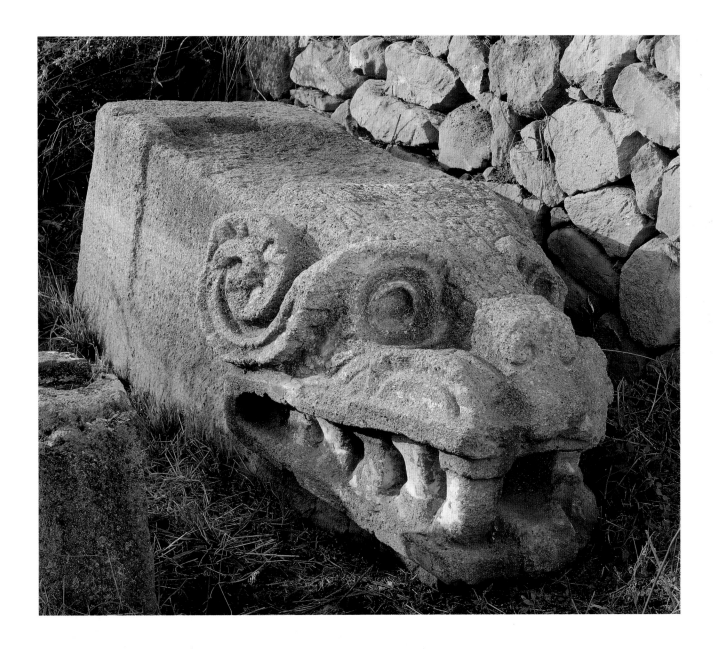

specular hematite flecks in the pigments would have made the walls glitter and reflect the white stuccoed floors and light.[3] The fragile surfaces and technology of the mural paintings seem like they would be in an uneasy relationship to the murals' images but in fact they supply a balance to their complex rendering.

If you take one fragment of a mural painting and imagine it extending floor to ceiling, and its explosion of variations on a given theme repeated around the brightly decorated walls of a room or patio, you begin to comprehend the original charm and visual splendor of these mazelike settings. Although the iconography of many murals is very complex and may have only been fully understood by certain members of Teotihuacan society, the visual experience of the murals is overridingly sensual, which allows you to enjoy the works without understanding their meaning. The murals were painted freehand, not

Cat. no 3
COLOSSAL SERPENT HEAD
Temple of the Feathered Serpent.

stenciled, and many murals have a quality of great immediacy. They look as if they truly had been a labor of love for the artist. Although their effect is decorative, these images hold the key to understanding the belief systems of Teotihuacan.

CLAY SCULPTURES

Teotihuacan very much liked the medium of clay and created some very imaginative object types from it. Most interesting for our purposes are the large, two-part composite incense burners or censers (which range from eighteen to twenty-eight inches in height) and the so-called host figures (which range from five inches or less in height to one example from the Escuintla area, cat. no. 66, whose height is nearly fifteen inches).

The censers (cat. no. 76, this essay) are generally made of coarse, low-fired earthenware clay with slip or paint on the surface, and they may once have had flat slivers of iron pyrite inlay that would have sparkled. Censers are exceptionally fragile objects for many reasons. Their hourglass-shaped bottoms, which once contained the incense, served as the base for the elaborate lift-off conical covers with appliquéd surface decoration. These large censers, in truth, actually consist of about half clay and half air because of their very fragile openwork and layered structures, and because they are made of many precariously balanced strips and pieces.

The charming and delicate *adornos*, which were generally made in press-molds and which grace censer surfaces, are vertically held in place with the most tentative sort of surface join. The *adornos*, which may have once signified prayers for healing or good fortune, were probably casually attached and removed as needed in ancient times. These objects seem almost to have been made to take apart, and were indeed taken apart in burials.[4]

Because censers are so fragile, very few have all their original pieces or have been accurately reconstructed by their finders. It is common for persons wishing to sell censers today to add new pieces or reconstruct censers in a fanciful manner to make a more attractive sale. Whether large numbers of censers ever once existed at Teotihuacan is not known. Whole examples are not plentiful in collections either inside or outside of Mexico, obviously owing to their great fragility. But a censer workshop dating from Tlamimilolpa to Xolalpan phases was recently found near the Ciudadela, yielding approximately twenty thousand parts of censers (cat. no. 77).

Another type of object that encompasses the monumental as well as the minute are Teotihuacan's host figures (cat. nos. 61-66), intriguing hollow ceramic figures that open up like cookie jars, giving the effect of an opened human body. These psychologically arresting works of art have numerous smaller figures inside them (some having extraordinary detail), which are either attached or unattached to the main body's interior chest, limbs, or stomach. Like the censers, host figures are made of extremely low-fired clay that ranges from tan to black in color. Fewer than ten host figures are known,[5] and most have not been scientifically excavated. Like the censers, they were meant to come apart and be manipulated.[6]

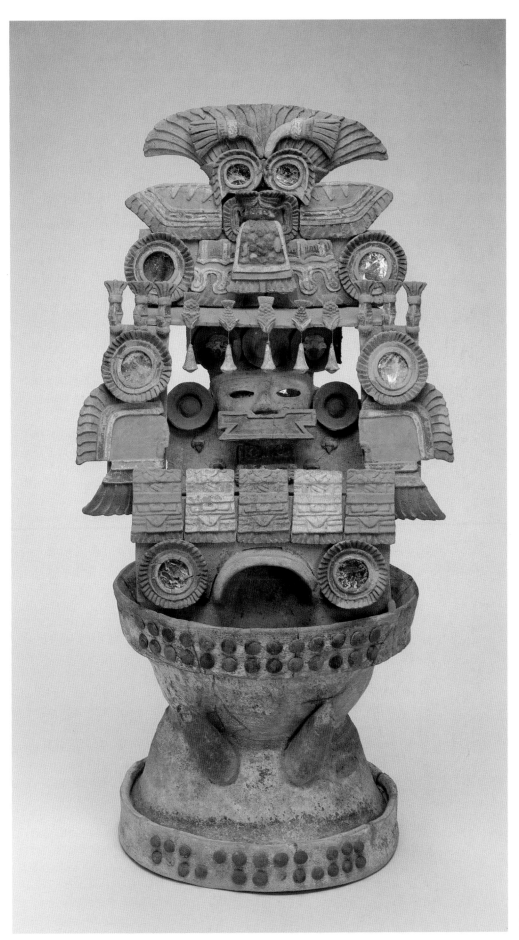

Cat. no. 76
THEATER-TYPE CENSER
Private collection.

CERAMIC FIGURINES

Five inches in height or less, ceramic figurines are the one type of Teotihuacan object that exist in unbridled abundance (fig. 1). Millions of them have been found in refuse heaps or the remains of apartment compounds (see Catalogue of Objects, Figurines). Despite their tiny size — and they can get incredibly small — some of them are made with surprising detail and expression. Others are minimalist miniatures, with their torso sections as thin as chocolate mints and the barest sketch of slit eyes.

When figurines are studied in bulk, as Warren Barbour has done, an amazing amount of information can be gleaned about the status of individuals in Teotihuacan and their daily lives, as well as stylistic changes over the centuries. Whole figurines are less plentiful than broken heads or body parts; we don't know exactly how they were originally used. They may have been intentionally broken, but it is also true that their small proportions and vulnerable necks, arms, wrists, and legs broke easily. These low-fire figurines were both hand modeled and moldmade; sometimes their heads were moldmade and their bodies handmade. They came in plain buff clay or were partially covered with a clay slip or paint.

Also in the ceramic figurine category, but slightly larger in size (about eleven inches), are the puppets or articulated figures with movable limbs. There were probably quite a few of them in ancient Teotihuacan; they seem to have satisfied the Teotihuacan aesthetic preference for variety, having smaller parts making up a larger whole that could be changed at will.

Our society tends to glorify the large, but Teotihuacan may have endorsed an aesthetic of the small. This surprised me very much when I first became acquainted with Teotihuacan art, for after experiencing the colossal site and its monumental architecture, I expected large and grandiose art forms that would proclaim this great civilization's power for all posterity. Instead, I found quite a number of little things — little figurines, little ceramics — even miniature models of things that were already little. I wondered what there was about Teotihuacan that could encompass or even embrace both the exceptionally large and the exceptionally small, finding seemingly opposing forms or the unification of opposites so essential to its society.

CERAMIC VESSELS

The very large category of Teotihuacan ceramic types ranges from utilitarian wares that were mass produced to elaborately decorated vessels, although the vast majority of ceramics seem to have been simple and unadorned. The most interesting subcategories for our purposes are the Thin Orange, plano-relief, and stuccoed and painted vessels.

Of these three types, Thin Orange was Teotihuacan's most important tradeware and the pottery type most avidly used at Teotihuacan. Evelyn Rattray has commented on how shards of it have been found in significantly greater numbers than of other pottery types.[7] The extraordinary clay, which consists of a bright orange color and a very distinctive temper, can impart a kind of bright glow that the people of Teotihuacan may have found quite pleasing (cat. no. 148). I see this quality of brightness as related to the shine of iron pyrites on figures and cen-

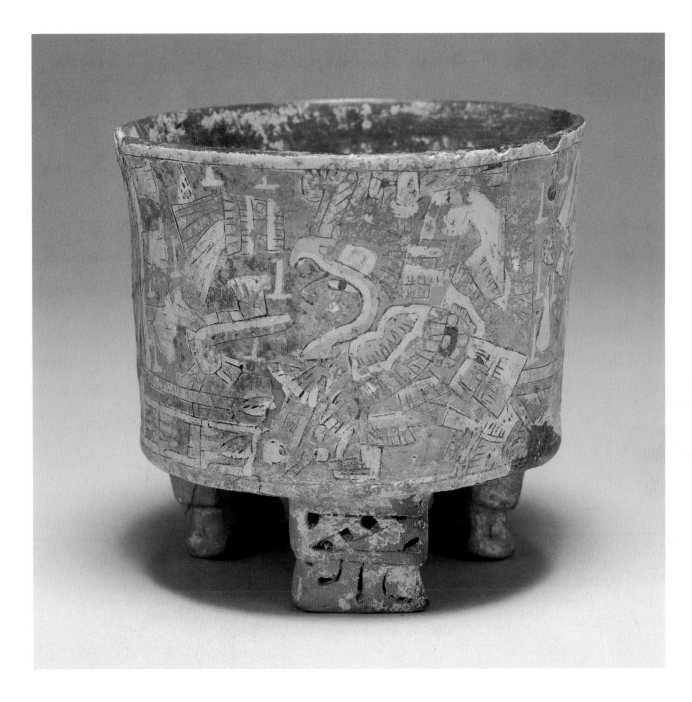

sers, to the gleam of white stucco on the buildings, and to the glittering flecks of ilmenite and hematite in the mural paintings, and have often wondered about the visual stimulus, mildly hypnotic effects, and the pleasures of brightness and sparkle.

According to Rattray, the Thin Orange clay has its source in a very limited part of southern Puebla. A unique blend of rich minerals, consisting of schists, mica, quartzite, hematite, and other elements was used to produce Thin Orange pottery.[8] It ranges from very thin to medium thickness and was used to fashion both effigy and noneffigy wares. Modern artists have tried to re-create Thin Orange but find they cannot, because they cannot find the proper combination of clays and other minerals. Thin Orange, especially fine Thin Orange, is a pottery type coveted by collectors. But fragility remains a problem, and many of the finest Thin Orange pots simply have not lasted through the

Cat. no. 138
TRIPOD VESSEL
The Fine Arts Museums of San Francisco, Gift of Harald J. Wagner.

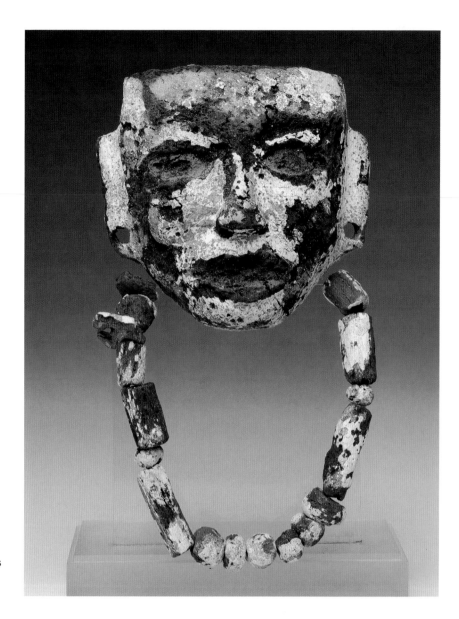

Cat. no. 38
MINIATURE MASK WITH NECKLACE
Wood, stucco, and paint. The Fine Arts
Museums of San Francisco. Purchase,
Mrs. Paul L. Wattis Fund.

ages. Thin Orange vessels I have seen are as large as fifteen inches high
(I have seen two colossal, thick Thin Orange bowls, one in Stockholm
and the other at the Museo Arqueológico de Teotihuacan). A number
of delightful Thin Orange miniatures also exist (cat. no. 156).

The elaborately decorated plano-relief vessels (cat. nos. 132-135)
are another very interesting subcategory. These were made by taking a
vessel when the clay was leather-hard and then excising it with a sharp
tool to produce raised motifs above the shallow background; these mo-
tifs were then incised with details and, after firing, filled or covered
with paint. The overall aesthetic effect of plano relief is one of extreme
delicacy and detail, and the pottery can be very brittle to handle be-
cause of the variations in surface thickness. Plano-relief pottery must
have been important to Teotihuacan because it is a difficult medium
and elaborate iconography often appears on it. Plano-relief vessels
would be highly sought by collectors today except that very few seem
to be available. We have seen only limited numbers of whole pots, even
in collections in Mexico.

The third subcategory of interest is that of stuccoed and painted vessels (cat. no. 138, this essay), which very much resemble miniature mural paintings wrapped around a cylindrical tripod, globular vessel, or bowl. They were produced in much the same way as mural paintings, but the complex iconography was painted while the stucco was dry; of course they were not burnished. The stucco was probably damp but dried as the painting progressed unless a damp cloth was kept inside the vessel. Some of the lighter colors are pigments mixed with more stucco, and these tend to be applied more thickly. It is these areas which have the poorest adhesion.

The surfaces of these delicate pots are ultrafragile, the stucco and paint on them being almost tissue-thin. If you touch them too often pressure from your hands pulls off their fragile, friable surfaces, which cannot easily be readhered or overpainted. Cynthia Conides [9] has described stuccoed and painted pots from Teotihuacan as "low-output objects" because they were not made for the masses but probably for a limited and elite ownership. This theory is certainly borne out by the limited number of whole pots or fragments that occur in collections. It is hard to imagine a more fragile type of object, and safe to assume that many of these works did not have the physical toughness to survive through the ages.

THE RAREST OF TREASURES

Teotihuacan's arts are rare and precious. With the exception of pieces in stone, all the media that Teotihuacan delighted in — low-fire clay sculptures, mural paintings, pottery, and figurines — are fragile. The ways in which these pieces were originally constructed made them fragile in their own day, let alone enabling them to survive the archaeological effects of burial. It is worth noting that Teotihuacan objects made of wood (cat. no. 38, this essay; Cabrera, fig. 5; cat. nos. 54-55), which were once probably a major category of Teotihuacan art, are now virtually nonexistent with the exception of these four examples. The same is true of textiles and objects made of feathers, which the mural paintings tell us must have once been prominent in ritual.

Teotihuacan often chose to express itself in delicate materials or in art works made up of smaller pieces. I find it fascinating that Teotihuacan art tends to come apart, either because it was designed to do just that (in the case of the censers or host figures) or because of the materials Teotihuacan artists chose and the unique manner in which they put them together. Artists took seemingly incongruous materials like clay, stucco, wood, paint, and stone and then would layer or compress several of them into a single object. They weren't necessarily concerned whether an object could survive domestic wear and tear or with its longevity beyond the lifetime of an individual owner. Otherwise they would have constructed their objects very differently.

Teotihuacan artists apparently liked to create forms that were light and delicate in feeling. Although the architecture of Teotihuacan is extremely heavy, stone objects were not often carved on a monumental scale, possibly because of an aesthetic preference for lightness, thinness, and weightlessness that may have somehow been seen as an appropriate balance to the ponderous nature of the architecture. The people of Teotihuacan liked coverings of white stucco applied to their buildings, streets, walls, and floors. They must have liked its sensuality

as a material. They painted it red or left it plain white, gleaming in the sun. They used white stucco to embellish adobe walls, volcanic stone sculptures, and architectural facades. They applied it to clay bowls, shell, or wood objects and then painted them. Somehow they must have liked the visual result, the sense that it helped relieve the mass and density of what was being covered. The application of stucco and paint must have given surfaces the appearance of weightlessness. Qualities of whitenesss and sparkle may have articulated deep and meaningful principles in Teotihuacan life.

Teotihuacan artists liked to take the weight out of objects that might otherwise be too heavy and solid. This in itself is not unusual, but the extent to which they did it is surprising because such reductions sometimes affected the stability of the object. Censers are a good example, also the openwork Old God braziers, scooped-out host figures, carved plano reliefs, tripod supports with openwork areas, and even *talud-tableros*, which were a heavy and unstable architectural form with some weight removed, but which nevertheless often collapsed under their own weight.

I often think that Teotihuacan's major arts were emphatically designed to be used in a certain place and generally kept there. The weight and fragility of many of their objects would preclude too-frequent handling or movement. The arts of the apartment compound, intended for Teotihuacan's nonelite citizenry, were probably meant to be kept small and not often moved, with the exception, of course, of the figurines. If Teotihuacan's barrios were as large and crowded as the Tlamimilolpa apartment compound, admittedly an extreme example, then perhaps there wasn't a great deal of room for too many personal possessions. Imagine hundreds of apartment compounds built side by side, their exterior walls touching and narrow passageways leading from one mazelike, one-story structure to the next, with anywhere between sixty to one hundred people inhabiting each one. Daily life in the Teotihuacan barrios would have been anything but expansive and perhaps most objects kept there would have needed to be small. A certain number of larger art works, censers and braziers, which seem to have occurred one to a compound, would be required for rituals, but those objects would likely be stationary, perhaps being used for years before replacement. The temples, palaces, and pyramids along the Street of the Dead would have had more space, of course, but the precious stone figures and masks may never have needed to be great in number and obviously could have been reused.

When we look at Teotihuacan's greatest treasures, such as those illustrated in this volume, it is important to remember how rare they are. The fact that so few remain makes those that exist so much more valuable, particularly because Teotihuacan's greatness cannot be denied but its major art works, with their hidden and opposing qualities, often leave us wondering.

Kathleen Berrin is Curator of Africa, Oceania, and the Americas at The Fine Arts Museums of San Francisco.

1. Many of the ideas expressed in this paper were inspired by conversations with Esther Pasztory between 1986 and 1993, during the course of developing this exhibition, *Teotihuacan: City of the Gods*. Although the emphasis is mine, I am

indebted to her for many insights and for comments on a first draft of this paper. I also wish to acknowledge valuable suggestions by René and Clara Millon who read an early version of this paper and who also led me to important adjustments in my perspective. And finally, I am grateful to Lesley Bone, Objects Conservator at The Fine Arts Museums of San Francisco, for assistance with some of the technical comments that appear here.

2. N.C. Couch, "Teotihuacan Murals in Mexico: A Tabulation of Murals from the City of Teotihuacan from Published Sources," paper prepared for The Fine Arts Museums of San Francisco, 1981.

3. A great many Teotihuacan murals probably have been removed by looters and not survived the trauma. The burdensome weight and vulnerable edges have caused many to crumble. Those that have endured have generally had much of their backing removed and have been neatly framed into paintings, losing contextual information that might have been important. See also Kathleen Berrin, "Reconstructing Crumbling Walls: A Curator's History of the Wagner Murals Collection," in Berrin 1988, 24-44.

4. In fact, when an important male died, a censer was taken apart and buried with him, as was the case with the censers excavated by Linda Manzanilla (cat. no. 71) and Sigvald Linné (cat. no. 70).

5. Warren Barbour, "Shadow and Substance: The Iconography of Host Figures Associated with Ancient Teotihuacan, Mexico," unpublished manuscript, n.d.

6. According to Rebecca Storey (personal communication, 1992), the Tlajinga 33 host figure (cat. no. 61) was completely taken apart, with its largest figure, chest cover, and smaller figurines all placed in various strategic locations underneath, alongside, or on top of the deceased body.

7. Evelyn Rattray (1990) and personal communication, 1991.

8. According to René Millon (personal communication, 1993) there are about eight to nine kinds of Orange pottery as distinguished from Thin Orange pottery. There is even a thick Thin Orange with the same paste as Thin Orange, which was used for making big objects.

9. Cynthia Conides, "Craft Specialization and the Development of the Stuccoed Pottery Painting Tradition at Teotihuacan, Mexico," paper prepared for the Society of American Archaeology, 57th annual meeting in Pittsburgh, symposium on Socioeconomic Perspectives on Ancient Teotihuacan, 11 April 1992.

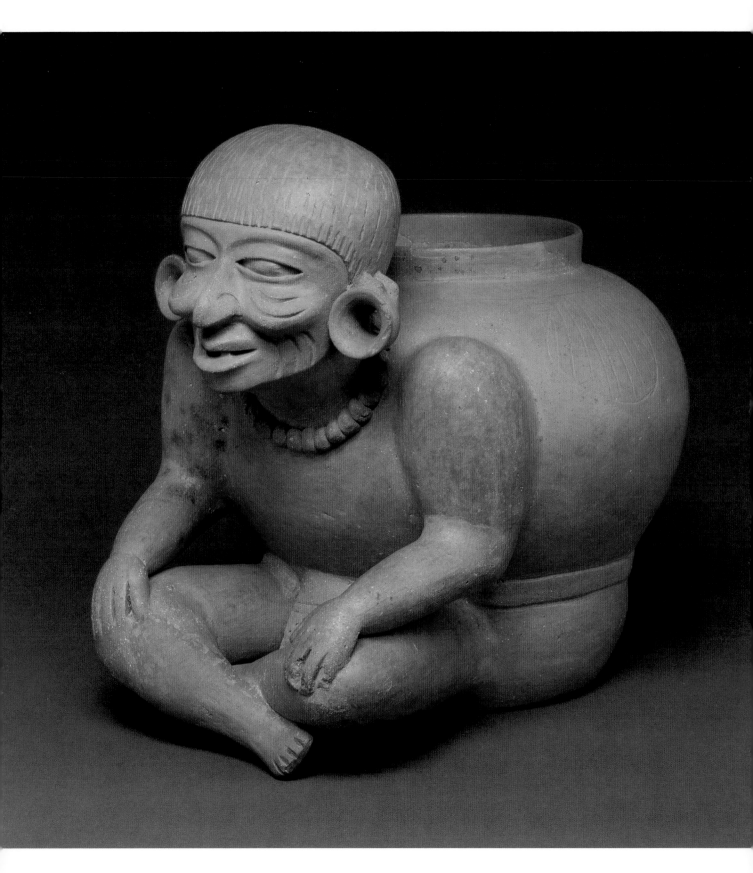

Cat. no. 160
THIN ORANGE OLD GOD EFFIGY
National Museum of the American
Indian, Smithsonian Institution.

Uncovering
the Past

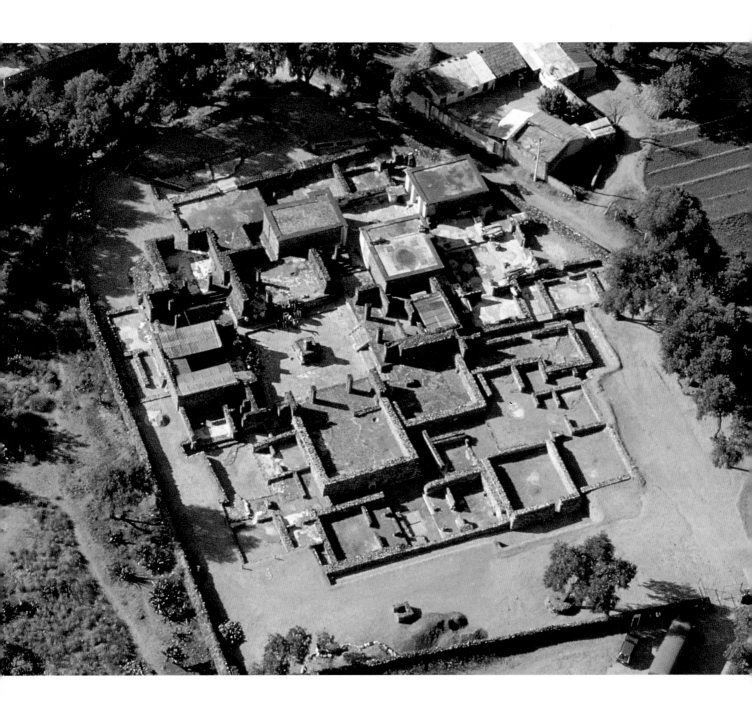

Fig. 1
Aerial view of Atetelco apartment
compound.

Daily Life in the Teotihuacan Apartment Compounds

Linda Manzanilla

T HE STUDY OF THE DAILY LIFE of pre-Hispanic peoples, a current topic of interest in archaeology, is a particular challenge when dealing with an urban center as important as Teotihuacan because we are left with only the material vestiges of the latest activities carried out at the site.

Of the some seven hundred years that Teotihuacan flourished, we know little about urban life during the Patlachique, Tzacualli, and Miccaotli phases (150 B.C.-A.D. 200). For the Tlamimilolpa phase (A.D. 200-400), elements of urban planning at the site are clearly defined, as well as domestic life in the apartment compounds.[1] During this two-hundred-year period Teotihuacan was a city with streets and well-defined areas of circulation, drinking water and a sewage system that was fed by a reservoir two hundred meters northwest of the Pyramid of the Moon. It also had a vast network of internal drainage[2] and ceremonial and administrative constructions along the Street of the Dead, to name just a few of its major features. In the rest of the city, plazas with three temples continued to be the focus of ritual and perhaps economic activity for the different sectors of the city.

APARTMENT COMPOUNDS

Some of the apartment compounds in the central area of the city have been excavated — among them, from the Tlamimilolpa phase (A.D. 250-400), structures at Tlamimilolpa, Atetelco (fig. 1), Xolalpan (fig. 2), Tepantitla, La Ventilla, Tetitla, and Zacuala, and, from the later Xolalpan phase (A.D. 400-650), structures at Atetelco. Other residential structures are partially excavated, such as those of Bidasoa[3] and San Antonio las Palmas.[4] We also have information from Tlajinga 33,[5] which lies on the outskirts of the city. More recently, Oztoyahualco, a compound located in the northwest sector of the city, was meticulously excavated in an effort to detect even the humblest traces of human activity (fig. 3).[6]

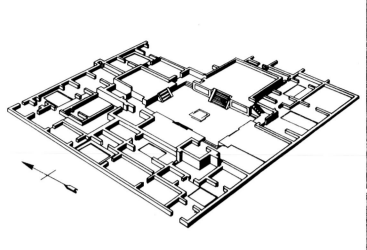

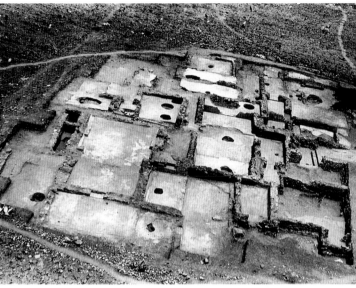

Fig. 2
Map of Xolalpan apartment compound. Redrawn from Linné 1934, 40.

Fig. 3
Aerial view of the apartment compound excavated at Oztoyahualco.

The apartment compounds consisted of different apartments joined by passages for circulation; they had domestic sanctuaries, and the entire compound was surrounded by an exterior wall. Apartments generally consisted of several rooms at slightly different levels, arranged around open patios. They were designed for maximum privacy; each construction was isolated from the street and the exterior walls had no windows; generally only one entrance led to the outside. Abundant light and air were provided by internal patios, which did not have roofs, and rainwater for building interiors was also collected here[7] and refuse disposed of. In addition, some of the patios served as ritual spaces.

The evidence of different stages of construction indicates that apartment compounds underwent changes through time. These modifications did not affect the overall plan of the structure, and repairs and remodeling were frequent.

It has been hypothesized that the Teotihuacanos used a unit of measure based on 57 meters (188.1 feet), its multiples and submultiples, as a building module. Thus, René Millon estimates there were three types of compounds that could have housed roughly one hundred, fifty, and twenty people, respectively.[8] The compounds we have surveyed or excavated vary considerably in surface area. Some are very large, such as Tlamimilolpa (less than 3,500 square meters or 11,550 square feet) while others are much smaller, such as the one excavated at Oztoyahualco (less than 550 square meters or 1,815 square feet).

It is believed that these compounds could have been occupied by corporate groups with common occupations, for it has been archaeologically observed that craftsmen dedicated to different manufactures lived in separate compounds.[9]

Outside of the center of the city, the site of Tlajinga 33 illustrates a rural residence of craftsmen that nevertheless adhered to the city's norms of urban planning. This residence was divided into groups of rooms for shelter; adobe walls were arranged around patios, while rooms

for craft specialization were located in an annex to the northwest.[10]

In the compound excavated at Oztoyahualco, the apartments for each nuclear family included a zone for food preparation and consumption, sleeping quarters, storage areas, sectors for refuse, patios for cult activities, and funerary areas. Additionally, there were zones in which the entire family group gathered to share activities, particularly those related to ritual and perhaps to the raising of domestic animals.

We suspect that members of different families participated in specialized activities, in relation to the rest of the city. In the compound that we recently studied, the family group probably specialized in the stucco finishing of the neighboring three-temple plazas, perhaps as well as other constructions at Oztoyahualco. The family group at Tlajinga was involved in ceramic activities, while the people of Tlamimilolpa probably made textiles, and those of Xolalpan painted walls, ceramics, and codices.

Agriculture

Since the beginning of the Christian era, we have evidence of the presence of corn, amaranth, beans, squash, tomatoes, and chiles, in addition to nopal cactus fruit, *quelites* (edible grasses), *epazote* (an aromatic herb), *huautzontle* (a native plant of the genus *Chenopodium*), purslane, and avocado. Cotton appeared at around A.D. 400, and *amate* (bark paper), gourds, and *huizache* (a thorny variety of acacia) at around A.D. 600 (Late Xolalpan). Even through we know that some of the plants mentioned were undoubtedly cultivated and others gathered wild (purslane, wild potato, poppy, and *huizache*), still others were perhaps semidomesticated.

Representations of tamales were found in compounds such as Oztoyahualco, so inhabitants must have been consuming some of their corn in this form.[11] Fragments were found of three species of corn — Nal-Tel Chapalote, Palomero Toluqueo, and Conical. Few remains were found of the common bean, probably because they were used so intensively that no residue of the original plants remains. The *ayocote* bean (a large, plum bean species) was also found.

Representations of squash are known from the murals of Tepantitla, dating to around A.D. 600, and remains of several species have been found archaeologically. Amaranth and *quelites* (*Amaranthus*) are found in abundance in all phases, and may be wild or a cultivated species.

The avocado was used for both food and medicinal purposes; its presence from around A.D. 400 probably indicates its importation from the south from what is now Morelos. Fragments of textiles made from cotton, which also must have come from a warmer climate, and other fibers were found in the Tlamimilolpa apartment compound. Another foreign plant was cacao; a tree of this species appears in the mural on the east wall of Tepantitla.

Several nopal cactus fruit seeds were found, in addition to representations and remains of thorny cacti. Many fruit samples were also recorded, such as the cultivated cherry and some *tejocote* (hawthorn) fruit, all local in origin.[12]

Hunting

It is generally thought that agriculture was the predominant branch of subsistence at Teotihuacan, but this idea has led to a general neglect

of information on other areas of subsistence such as hunting, which in the case of certain apartment compounds, were equally vital.

Excavations at the Formative Period village of Cuanalan,[13] located in the lower Teotihuacan Valley (where the San Juan River flows toward Lake Texcoco), have led to the belief that these early groups were already using a wide range of agricultural, as well as wild plant and animal, resources. This idea goes against David Starbuck's theory that from the Formative to the Classic Horizons (from 550 B.C. to A.D. 700) a change occurred in the type of animals hunted, shifting from those hunted locally (deer, for example) to the exploitation of the region, perhaps encompassing almost the entire Basin of Mexico (as evidenced by several species of birds, turtles, fish, and mammals).[14] At Oztoyahualco the majority of animal protein consumed by the Teotihuacanos came from rabbits, hares, white-tailed deer, and probably domesticated dogs.[15] In smaller quantities, we also found remains of ducks, domesticated turkeys, rodents, turtles, and reptiles. Eagle, falcon, and wild hen remains were found in ritual contexts at Tetitla and Yayahuala, while bear and jaguar appeared in domestic contexts at Oztoyahualco.

We know very little about hunting techniques, except that we have an abundance of obsidian arrowheads in the archaeological record (both for arrows as well as for spears). Also present are blowgun projectiles (possibly for hunting small birds) and perhaps spear throwers.

FISHING

Fish remains are extremely scarce, and the majority are concentrated in Tetitla. Because of their small size, they are believed to have come from the San Juan River, although some were lake fish. We do not know what techniques were used to obtain them, although we might guess that they were caught with nets.

GATHERING

Plant species were generally gathered for food, medicinal purposes, and fuel as well as for construction. Varieties used included hawthorn, purslane, wild potatoes, wild reeds (known as *tripas de Judas*), umbelliferous plants (called *ombligo de Venus*), white sapodilla, pine, oak, juniper, ditch reeds, and bulrushes.

As for mollusks, both land and marine species (mainly from the Pacific, but also from the Atlantic) were used. All of these were nonlocal in origin. In a mural from the Tetitla apartment compound, we see a fisherman diving to gather mollusks that he collects in nets on his shoulder. In the Tlalocan mural at Tepantitla, individuals are also seen gathering fruit, flowers, and branches. This kind of representation is the only evidence we have of the techniques used in gathering. Terrestrial mollusks were edible, while some of the marine species served ritual or ornamental purposes, as in the case of the genus *Oliva*.

Each nuclear family had a specific area for cooking that may be recognized in the archaeological record by dark, circular spots where the wood-fueled, portable stove was placed. Concentrations of phosphates may be seen around this stain that mark the area of food consumption. Grinding stones and other implements related to food preparation are also often found.

Manufactured Goods

Different craft activities seem to have taken place within each apartment compound. It is worth distinguishing between those activities that all family groups conducted to satisfy their own domestic requirements and those that they carried out as a corporate group of specialists for other sectors of the city. A variety of domestic needs were met. Prismatic blades to cut different materials for basic subsistence purposes were produced by flaking off pieces of obsidian from polyhedric nuclei. In addition, lithic instruments were retouched or sharpened, projectile points were manufactured, and some types of ceramic figurines were made with molds (for example, at Xolalpan). Baskets, textiles, and other goods were also produced.

Specialized Work

We believe that the Teotihuacan priesthood sponsored specialists who manufactured certain ritual or sumptuary goods.[16] One of the most important crafts was the production of obsidian artifacts at a super-specialized level; specialized prismatic blades were made as opposed to the more commonly produced bifacial blades.

Other workshops were dedicated to the manufacture of ceramics, figurines, lapidary arts (at Tecópac), polished stone (grinding stones at the city's periphery), slate artifacts, shell objects, textiles (to the north of the Ciudadela), and featherwork.

Excavated ceramic workshops are rare. An example is the workshop described by Paula Krotser and Evelyn Rattray in the area of Tlajinga (today San Sebastian), which produced a ware called *San Martín Orange* in the form of casserole-shaped pots for cooking and jars for storage.[17] This area shows evidence of an open-air kiln in the *tepetate* bedrock floor, solid clay artifacts for shaping vessels, molds and separators as well as the raw material itself, and obsidian knives, scrapers, and chisels.

It has been proposed that Teopancaxco ("House of the Barrios") was the site of the fabrication of Copa ware, which consisted principally of fine-paste cups. Evidence includes stone smoothers, pigments, unfired and poorly fired shards, obsidian polishers, and vestiges of a great bonfire.[18]

Finally, a workshop for theater-type incense burner appliqués was found by Carlos Múnera in the north sector outside of the Ciudadela, during the 1980-1982 Teotihuacan Archaeological Project[19] (cat. no. 77). Múnera discovered indicators of the different phases of production — the raw material (both fired and unfired clay, mica, and pigments), work implements (molds, smoothers, blades, knives, scrapers, pestles, polishers, and punchers), deformed and defective pieces, and a possible open-air kiln represented by a thick layer of ash. The bargaining among producers could have taken place in the plazas of the three-temple complexes located throughout the north sector of the city. We have suggested that each three-temple complex, which was the cult and economic center for different sectors of the city, was surrounded by apartment compounds occupied by family groups dedicated to different activities. Foreign ceramics predominate in certain sectors of the city, which has led to the belief that these represent

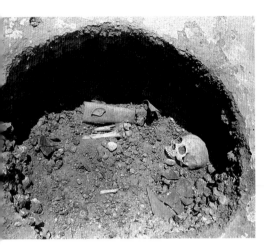

Fig. 4
View of Burial 8 with dismantled censer
(cat. no. 71).

Fig. 5
View of Burial 8 with dismantled censer
(cat. no. 71).

neighborhoods of foreigners. Examples include the Oaxaca Barrio to the southwest of the city, and the Merchants' Barrio in the eastern sector. As a cosmopolitan entity, the city of Teotihuacan housed people from other regions of Mesoamerica who maintained some of their dietary and funerary customs in these foreigners' barrios.[20]

FUNERARY PRACTICES

Burials are rich in information. However, with one exception — the case of Tlajinga 33 — the number of adults interred in each one of the compounds is too low, relative to the area of the compound, to account for most of its inhabitants, For example, seven burials are recorded for Xolalpan, thirteen for Tlamimilolpa, and seventeen for Oztoyahualco. Perhaps other adults, particularly women, were buried in other places.

Burials at certain compounds, such as Xolalpan and Tetitla, had very rich offerings (figs. 4-5).[21] Of the burials we excavated at Oztoyahualco compound, some were distinguished by their funerary effects. Burial 8 was exceptional for it contained a male adult, twenty-two to twenty-three years of age, with an intentionally deformed skull, in association with an impressive theater-type censer (cat. no. 71, this essay).[22] In what seems to represent a funerary ritual, the censer appliqués were removed from the lid, the chimney and the figure that was located above were also removed, and all were placed around the deceased. The chimney was deposited toward the west, and the lid and the figure to the east of the skull; representations of plants and sustenance (ears of corn, squash, squash flowers, cotton, tamales, and bread, perhaps made of amaranth) to the south; and four-petaled flowers, roundels representing feathers, and mica disks to the east and west.

Sigvald Linné found vestiges of another funerary ritual in Tlamimilolpa.[23] Burial 1 contained a cremated individual accompanied by fragments of several vessels that had been symbolically killed and heaped with baskets, textiles, and barkcloth that were preserved because they were protected from the fire by the ceramic vessels. A layer of pyrite was added on top of this.

DOMESTIC RITUAL

It has been proposed that a superimposition of deities on two levels occurred for the first time at Teotihuacan. Lineage gods were patrons of lines of descent, and above them was the deity Tlaloc as god of place, protector of the territory, and patron of the city and the cave.[24]

Among the deities present at Teotihuacan, the Fire God (Huehueteotl), who was known from before Teotihuacan, always appears associated with the eastern portions of apartment compounds. Another deity present in domestic contexts is the Fat God, generally represented in figurines or appliquéd on tripod vessels. The Butterfly God is represented on incense burners and is probably linked with death and fertility.

The state gods of rain and running water (who in later times were called Tlaloc and Chalchiuhtlicue, respectively) played a preponderant role at the city. On a domestic level, Tlaloc is represented in figurines with goggles and elaborate headdresses. The Feathered Serpent is sometimes present on balustrades flanking platform stairways in apart-

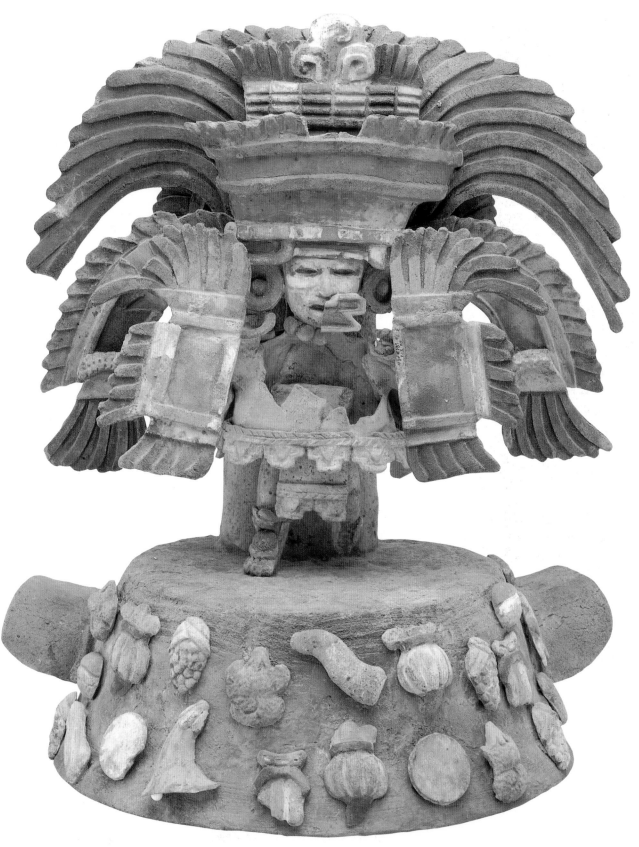

Cat. no. 71
VARIANT OF A THEATER-TYPE CENSER
Excavated by Linda Manzanilla. CNCA-
INAH-MEX, Museo Arqueológico de
Teotihuacan.

Fig. 6
Domestic altar with stucco rabbit
sculpture. Found at Oztoyahualco,
Patio 33

ment compounds; Linné found a feathered-serpent sculpture with
tenon at Tlamimilolpa.[25]

However, we also have evidence of patron gods of domestic groups.
A stucco rabbit sculpture was found on a basalt, Teotihuacan, minia-
ture temple-shaped shrine in a ritual patio at Oztoyahualco (fig. 6).[26]
Several compounds had altars in patios.

Religion should be seen as a sphere of sociopolitical integration
organized into a hierarchy in which the patron gods of family groups,
barrio and occupational deities (perhaps the serpent, bird, and coyote
of the Calpulalpan vessel),[27] the gods of specific priestly groups, and fi-
nally, state deities such as Tlaloc are superimposed.

Finally, in certain apartment compounds, such as the one that we
excavated at Oztoyahualco, spatial patterning seems to have been estab-
lished for the disposition of functional sectors, which extended beyond
the framework of nuclear families. Thus, in general, storage zones were
found to the west; those for refuse to the south; funerary areas were
concentrated in the middle of the eastern sector (although exceptions
exist); and fetus and neonate burials were located primarily on a north-
south band, in the eastern third of the compound. We wish to empha-
size that the affinity for order so patently manifest in the grid system of
the city finds its correspondence on the domestic level.

Linda Manzanilla is Professor of Anthropology at the Universidad Nacional
Autónoma de México.

1. R. Millon 1973.

2. William T. Sanders, "The Central Mexico Symbiotic Region: A Study in Prehis-
 toric Settlement Patterns," *Prehistoric Settlement Patterns in the New World*, ed. G.R.
 Willey (New York: Johnson Reprint Co., Viking Fund, 1964), 115-127.

3. José Ignacio Sánchez Alaníz, "Las unidades habitacionales en Teotihuacan:
 El caso de Bidasoa," thesis, Escuela Nacional de Antropología e Historia,
 Mexico, 1989.

4. Monzón 1989.

5. Storey and Widmer 1989.

6. Manzanilla and Barba 1990.

7. René Millon, "Teotihuacan," *Scientific American* 216, no.6 (June 1967):38-48.

8. René Millon, "Teotihuacan: Completion of Map of Giant City in the Valley of
 Mexico," *Science* 170(4 December 1970):1080.

9. Michael Spence, "Los talleres de obsidiana de Teotihuacan," *XI Mesa Redonda: El
 Valle de Teotihuacan y su entorno* (Mexico: Sociedad Mexicana de Antropología,
 1966), 213-218; René Millon, "Urbanization at Teotihuacan: The Teotihuacan
 Mapping Project," *Actas y Memorias del XXXVII Congreso Internacional de
 Americanistas* [Buenos Aires] 1(1966):105-120.

10. Storey and Widmer 1989.

11. Manzanilla and Carreón 1991.

12. McClung 1979.

13. Linda Manzanilla, "El sitio de Cuanalan en el marco de las comunidades pre-
 urbanas del Valle de Teotihuacan," *Mesoamérica y el Centro de México*, eds. J.
 Monjarás-Ruiz, E. Pérez Rocha, and R. Brambila (Mexico: INAH, 1985), 133-178.

14. David Starbuck, "Man-Animal Relationships in Pre-Columbian Central Mexico,"
 Ph.D. diss., Yale University, 1975.

15. Raúl Valadez and Linda Manzanilla, "Restos faunísticos de actividad en una unidad habitacional de la antigua ciudad de Teotihuacan," *Revista Mexicana de Estudios Antropológicos* 34, no.1(1988):147-168.

16. Manzanilla 1992.

17. Krotser and Rattray 1980.

18. Krotser and Rattray 1980.

19. Carlos Múnera, "Un taller de cerámica ritual en la Ciudadela," thesis, Escuela Nacional de Antropología e Historia, Mexico, 1985.

20. Rattray 1987.

21. Linné 1934; Séjourné 1966b.

22. Manzanilla and Carreón 1991.

23. Linné 1934.

24. Alfredo López-Austin, "1. La historia de Teotihuacan," *Teotihuacan* (Mexico: El Equilibrista, Citicorp/Citibank, 1989), 13-35.

25. Linné 1942, 122.

26. Linda Manzanilla and Augustín Ortíz, "Los altares domésticos en Teotihuacan. Hallazgo de dos fragmentos de maqueta," *Cuadernos de Arquitectura Mesoamericana,* Universidad Nacional Autónoma de México, no.13 (October 1991):11-13.

27. This is the mold-impressed bowl from a grave at Las Colinas, a Teotihuacan site near Calpulalpan, Tlaxcala, found by Sigvald Linné and published in Linné 1942.

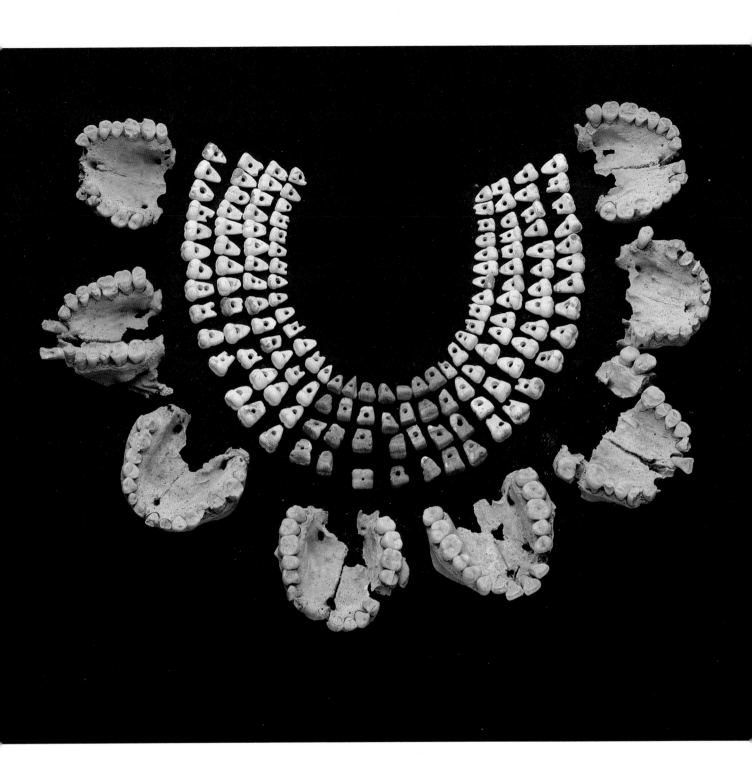

Cat. no. 172a
NECKLACE
Shell and human jaw bones. CNCA-
INAH-MEX, Centro de Investigaciones
Arqueológicas de Teotihuacan.

Human Sacrifice at the Temple of the Feathered Serpent

RECENT DISCOVERIES AT TEOTIHUACAN

Rubén Cabrera Castro

ECENT ARCHAEOLOGICAL WORK AT TEOTIHUACAN and its periphery
has touched on themes related to the core of power and to the
city as a whole.[1] It was previously believed that the Teotihuacan
government was essentially theocratic, characterized by enduring peace
that lasted throughout its duration until the time of its collapse. Govern-
ment's sacred character is evident, as indicated by numerous archaeo-
logical studies; no place in the city, nor on its periphery, fails to show
its strong presence. But the pacifistic nature of its government has been
challenged by discoveries since 1980 indicating that the Teotihuacan
state was despotic and repressive, at least during the earliest phases of
its development, when according to recent data large-scale human sac-
rifice was performed. The presence of a military caste, increasingly vis-
ible in archaeological materials, primarily in mural painting and in hu-
man burials, is evidence that "Teotihuacan peace" was not a reality.

A number of human burials, undoubtedly the remains of sacrifi-
cial victims, have been found around the lavish Temple of the Feath-
ered Serpent, located on a great public esplanade in the urban com-
plex known as the Ciudadela. One of the most prestigious buildings
at Teotihuacan because of its sacred and ideological significance, this
temple was erected between A.D. 150 and 200. These human sacrifices
were apparently carried out in two short periods, at the beginning of
its construction and when it was inaugurated (cat. no. 172a).[2]

The Temple of the Feathered Serpent stands out from the
Ciudadela, which is one of the most impressive architectural complexes
at Teotihuacan because of its urban and architectonic planning (fig. 1).
The Ciudadela was first explored between 1917 and 1922, when one of
the most important archaeological discoveries of Mexico was uncov-
ered — the splendid facade of the temple, decorated with colossal
heads sculpted in stone representing the Feathered Serpent. At that
time, the first group of human burials was found, located in the upper
part of the monument and associated with abundant offerings. Other
discoveries of burials of sacrificial victims were found at different times

Fig. 1

Plan showing the Temple of the Feathered Serpent in the Ciudadela. Drawing by Oralia Cabrera, modified from Plan 104 of the Proyecto Arqueológico de Teotihuacan 1980-1982.

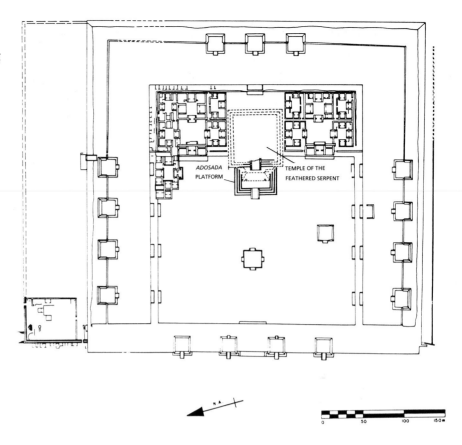

around the temple. In 1925 four human skeletons were found in deep pits at each one of its corners;[3] in 1939, at the foot of the stairs of the temple and at the foot of the annexed platform, rich offerings came to light of shell, greenstone, and obsidian carved into the form of human and animal figurines, in addition to other symbolic objects.[4] More recently, between 1980 and 1986, other groups of skeletons were unearthed, placed symmetrically at the north and south facades of the building.[5] Based on their associations and the position of their hands placed together behind their backs, indicating they had been bound, these were clearly the remains of sacrificial victims (fig. 2). Finally in 1988 and 1989 this structure was intensively excavated in order to obtain further information on the human groups sacrificed here, to determine their significance and define the repressive or pacific character of the Teotihuacan state.[6]

Archaeological excavations were carried out over the course of two consecutive years of field work approved by the Mexican government. The project involved the collaboration of Mexican and U.S. anthropologists, sponsored by several American institutions. Results of this research included the discovery of numerous human skeletons and an abundance of sumptuary objects. These data have conclusively proven the existence of large-scale human sacrifice at Teotihuacan.

In addition to the recent discoveries, and those that were reported earlier, approximately 120 human skeletons have been recorded to date at the Temple of the Feathered Serpent (fig.3). These skeletons were deposited in groups of one, four, eight, nine, eighteen, and twenty skeletons, distributed symmetrically to the north, east, and south sides of the building, both inside its massive pyramidal base and alongside its exterior.

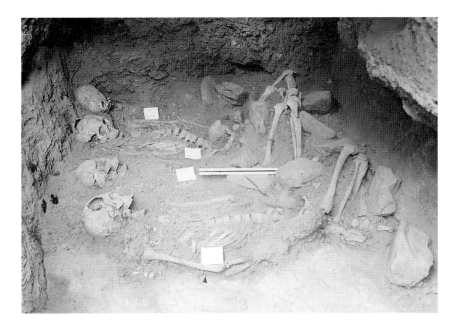

Fig. 2
Group of skeletons placed one next to the other, with the skulls placed toward the west and arms placed behind the bodies as if the hands were tied, Temple of the Feathered Serpent. Courtesy INAH.

On the east side of the building twenty-eight skeletons were unearthed, forming part of the same system of sacrificial burials. They were distributed in six groups: two of the burial sites contained a single skeleton, while four were multiple burials where groups of four and nine skeletons were distributed symmetrically toward the north and south of the central east-west axis of the pyramid.

Physical anthropologists and archaeologists collaborated in the analysis of these skeletons and of their associations, making it possible to define fundamental differences in age, sex, and costume type worn by the individuals buried here. There were fundamental differences between the groups of nine skeletons and the groups of four. The groups of nine were males, while those of four were women. The males were generally mature adults, while the women were somewhat younger.[7]

As for their costumes, the males wore elaborate necklaces of flat, rectangular, and tubular beads, as well as beads in the form of human teeth, all made from shell (figs. 5a-b). They also wore ostentatious pectorals composed of imitation human upper jaws made of shell (cat. no. 172a, this essay). One skeleton had an exceptional burial costume; instead of wearing human upper jaws imitated in shell, it bore a great necklace made of true human maxillae as insignia. They also wore disks or circular mirrors placed on their back lumbar region, used as part of their garb as clasps or medallions.

The female skeletons, on the other hand, had a much simpler costume, consisting of small shell earspools and simple shell necklaces. They were also accompanied by small projectile points.

Research carried out in the temple body also yielded valuable information. A tunnel was excavated, beginning on the south side going northward to reach the central part of the monument. Ten meters (thirty-three feet) from the tunnel entrance, a tomb was found containing eight skeletons placed one on top of the other with skulls oriented toward the center of the temple. Although they were in a very bad state of preservation because of the weight of the rocks covering them, it was clear that they had their hands placed behind their backs, as if they

Cat. no. 173
CONICAL OBJECTS
Greenstone. CNCA-INAH-MEX, Centro
de Investigaciones Arqueológicas de
Teotihuacan.

were bound. They were identified as women and they too were associated with few objects.

Further ahead a larger tomb was found, which contained eighteen skeletons with hands and body in the same position. Unlike the preceding burial, it was accompanied by a lavish offering. The skeletons belonged to males, who also wore large necklaces made of shell imitating human upper jaws, with the exception of one who wore real dog maxillae. Numerous obsidian projectile points also were found in this burial.

A large hollow area like a passageway was found about twenty-four meters (eighty feet) from the tunnel entrance, on the interior of the building, which at first created confusion. But careful analysis of this strange discovery revealed it was a pre-Hispanic tunnel dug by the Teotihuacanos themselves between A.D. 300 and 400. By way of this tunnel the ancient Teotihuacanos altered two tombs that contained abundant, elaborate offerings. One of the sacked pits still had part of the bone remains of a richly attired individual, whose hands were placed together behind his back, indicating that he too had been bound, and that therefore the two sacked pits were probably both used to deposit sacrificial victims. Among the objects recovered from these pits were jade and shell earspools, noseplugs, and beads. Of particular interest was the discovery of a unique staff of rulership, carved of wood with the representation of a feathered serpent (fig. 4).

AN UNDISTURBED TOMB

Fortunately, the Teotihuacano sackers did not reach the central tomb, located exactly in the middle of the monument at the structure's ground level (fig. 6). Composed of twenty skeletons, this multiple burial was unlike the others reported for the monument in terms of its disposition and costume elements. The bodies were not deposited in tombs, nor in pits, as in the case of other burials associated with the Temple of the Feathered Serpent. They were placed directly on the ground and then covered by the heavy foundation, only somewhat protected with semiflat stones, so that the weight of the rocks greatly

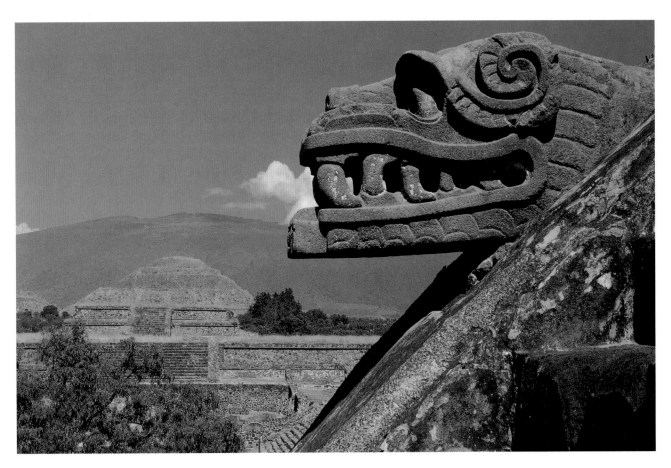

Fig. 3
Profile of tenoned serpent head,
Temple of the Feathered Serpent,
with view of the Street of the Dead
and Pyramid of the Sun in the distance.

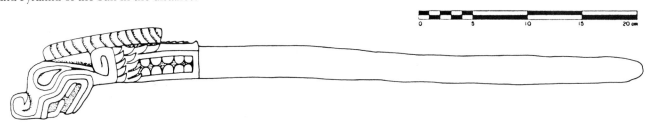

affected the bone material. Despite this destruction, a considerable amount of important data was recovered. The deceased were adults, accompanied by a wide variety of offerings scattered about without any apparent order. These consisted of many small human figures carved of greenstone; a large quantity of objects carved from obsidian, including hundreds of projectile points, prismatic blades, small knives, and objects representing human and animal figures; as well as a multitude of seashells transformed into sumptuary objects. Concentrations of different materials were found next to several skeletons, which indicates that the materials had possibly been held in bags made of coarse cloth or wrapped in some other perishable material; when the bags disintegrated, only small amounts remained of the substances that they originally contained. The majority of object types recovered from this burial were already known, but some artifacts had

Fig. 4
Wood baton with the representation of a plumed serpent. Found 1988-1989, Proyecto Templo de Quetzalcoatl. Drawing by J.R. Cid and Oralia Cabrera.

Fig. 5a
Skeleton with necklace, Temple of the Feathered Serpent. Courtesy INAH.

Fig. 5b
Detail, necklace, Temple of the Feathered Serpent. Courtesy INAH.

never been seen before in the history of Mesoamerican archaeology. Such is the case of small cones carved in greenstone (cat. no. 173, this essay), as well as the already mentioned human and canine upper jaws and their shell imitations. The function of these enigmatic pieces remains a mystery.

As already mentioned, the central burial was different in many respects from other burials at the Temple of the Feathered Serpent. The corpses lacked a precise orientation; they also did not have their hands placed together behind them as in the other burials. As for their associated offering, it was much more varied, rich, and abundant than others. Nevertheless, because it was a multiple burial consisting of people who were interred at the same time, it is believed that these individuals were offered in sacrifice. However, because of their privileged placement in the center of the building, their status as mature adults, and their rich, abundant offerings, they were probably of a higher social status than those persons of the other burials.

The evidence suggests that the other burials were not dedicated to the individuals in the central burial, as might have been initially supposed. But to whom, then, were the burials as a whole dedicated? This and many other questions have been posited based on these new data.

Depositing skeletons in groups of four, eight, nine, eighteen, and twenty, in addition to burying individuals who were symmetrically placed in the Temple of the Feathered Serpent in relation to the cardinal directions, establishes patterns that allow us to infer the existence of other interments on the still-unexplored sides of the building. An attempt to establish the original total, taking into account burials from both the interior and exterior of the structure, would yield the sum of 260 individuals sacrificed in this place, a hypothesis to be corroborated or modified by future studies.

On the basis of data available to date, it is clear that large-scale human sacrifice was practiced in the early phases of Teotihuacan, confirming the despotic character of the Teotihuacan state. Human sacrifice carried out in complex societies such as that of Teotihuacan has been considered an instrument of repression on the part of the state to consolidate and preserve its power. This act is a means of social control through the manipulation of ideology and supernatural forces in which the sacred is used as an instrument of repression.

This new data has shown not only that the Teotihuacan state was repressive, but it has also raised numerous issues and has led to new proposals that may allow a better understanding of Teotihuacan culture. For example, why was large-scale human sacrifice practiced at Teotihuacan only during the early years of its development? There is ample iconographic evidence from later periods related to sacrifice and the presence of military institutions. However, convincing evidence has not been found to indicate that human sacrifice was ever practiced on a large scale in this later era.

Also worth questioning is the significance of these acts. How were these individuals killed and what was their social status? Because of their clothing, it may be supposed at least that the males were warriors, but it is still not known if these soldiers were foreigners or Teotihuacanos.

The symmetrical location of these burials, deposited in relation to the cardinal points, indicates that this great sacrificial ceremony must have been directly related to native cosmogonic thought. The ancient

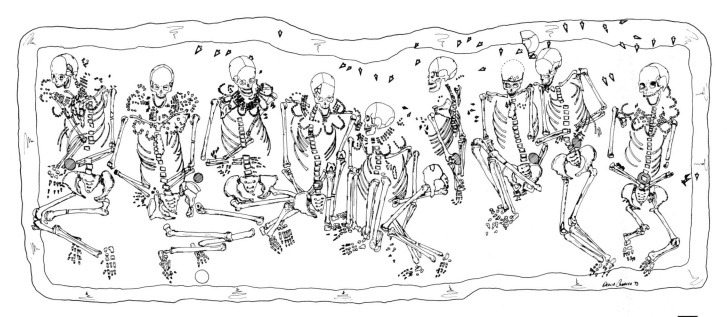

LEGEND

▲ Obsidian projectile points
♦ Obsidian eccentric
≋ Shell beads
⌇⌇ Human maxilla made of shell
⌇⌇⌇ Animal maxilla made of shell
◉ Slate disks
— Superior border of the fosa
— l imit of the bottom of the fosa
⟥ Depression

Teotihuacanos conceived of the four cosmogonic regions and a mythical central region, as reflected in the distribution of burials in the Temple of the Feathered Serpent, that were related to astronomy and the calendar, the counting of time, and agricultural cycles. For this reason it has been proposed that the Temple of the Feathered Serpent must have had a calendrical and astronomical significance apart from its political and ideological one. A great event related to the Mesoamerican calendar must have been celebrated at Teotihuacan between A.D. 150 and 200, an event that caused the colossal temple to be erected and these sacrifices to be planned and performed.

Fig. 6
Nine skeletons with necklaces, Temple of the Feathered Serpent. Drawing by Oralia Cabrera.

Rubén Cabrera Castro is an archaeologist at the Instituto Nacional de Antropología e Historia.

1. Explorations carried out at Teotihuacan from 1980 to the present — of architectural complexes, including religious, civil, residential, and rural buildings — provided new data that allows us to have a more accurate vision of the ancient metropolis. See Rubén Cabrera, "El proyecto arqueológico Teotihuacan," in Cabrera, Rodríguez, and Morelos 1982b. For recent work that refers both to the core of power and the city as a whole see R. Millon 1981.

2. Rubén Cabrera Castro, "Función, secuencia y desarrollo de la Ciudadela en Teotihuacan," paper presented at 17th Mesa Redonda of the Sociedad Mexicana de Antropología, Taxco, Guerrero, 1983; Cowgill 1983; R. Millon 1981.

3. Pedro J. Dozal, "Descubrimientos arqueológicos en el Templo de Quetzalcoatl (Teotihuacan)," *Anales del Museo Nacional de Arqueología, Historia, y Etnología* 4, no.3(1925).

4. Rubín de la Borbolla 1947.

5. Enrique Martínez, "Descripción del entierro múltiple 204," preliminary report on field work carried out in April 1986, 1987, on the north side of the Temple of the Feathered Serpent by physical anthropology students from the Escuela Nacional de Antropología e Historia.

6. Rubén Cabrera Castro, George Cowgill, Saburo Sugiyama, and Carlos Serrano, "El proyecto Templo de Quetzalcoatl," *Arqueología* 5 (Mexico: INAH, 1989).

7. Carlos Serrano Sánchez, Marta Pimienta, and Alfonso Gallardo, "Mutilación dentaria y afiliación étnica en los entierros del Templo de Quetzalcoatl, Teotihuacan, México," *Cuadernos,* in press.

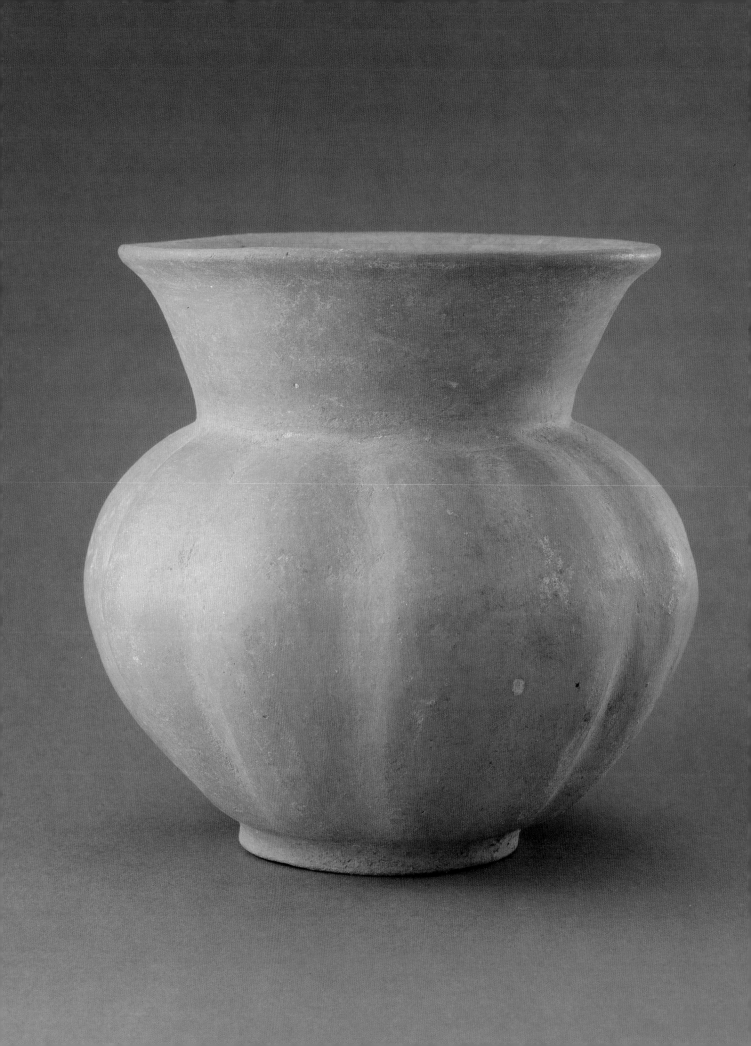

Funerary Practices
and Human Sacrifice
in Teotihuacan Burials

Carlos Serrano Sánchez

T HE STUDY OF HUMAN BURIALS from archaeological excavations al-
lows us to gain a greater understanding of the life and thought
of ancient peoples. Evidence found in the most enduring ele-
ment of the human body, its bone matter, includes not only the inher-
ited genetic determinations of physical characteristics, but also environ-
mental factors such as climate, diet, sanitary conditions, and even the
cultural practices adopted by society. By examining ancient skeletal re-
mains we may sketch an individual's personal history. Available to us
are a person's age, sex, body structure, physical characteristics, illness
and trauma, nutrition, and beautifying practices, such as intentional
cranial deformation and dental ornamentation. Given a fair range of
skeletal samples, we can analyze ancient and epidemiological character-
istics to yield information about the social development and living con-
ditions of ancient human groups. Based on the postmortem treatment
of the body and the burial context of human remains, we can recon-
struct the rules and cultural patterns governing funerary behavior.
Of significance is the way the cadaver was deposited, its orientation,
funerary attire, and associated offerings. Along with evidence of human
sacrifice and other aspects of social activity, a burial can tell us a great
deal about a people's cosmogonic and religious ideas.

In the sphere of pre-Hispanic Mesoamerican cultures, Teotihuacan
played a preeminent role as a great metropolis dominating the Central
Mexican Highlands during the Classic Horizon period (first to seventh
centuries A.D.). The archaeological zone of Teotihuacan has been sys-
tematically excavated for more than a hundred years. Because of this,
considerable advances have been made in our knowledge of the histori-
cal development and social life of this great pre-Hispanic city.

What do we know about the funerary practices of the ancient
Teotihuacanos? Nothing has been located that might be considered
a cemetery. Yet, already in 1906, based on his pioneering excavations
at Teotihuacan, Leopoldo Batres wrote that "in the chambers [of the

Cat. no. 155

THIN ORANGE GLOBULAR JAR WITH
GADROONED BODY
Los Angeles County Museum of Art,
Lent by Mrs. Constance McCormick
Fearing.

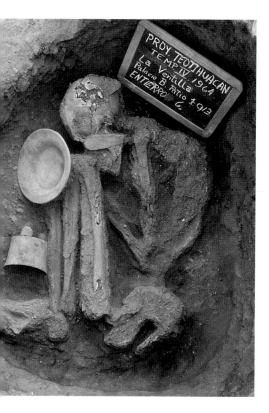

Fig. 1
Flexed burial, right lateral decubitus.
Palace B, La Ventilla, Teotihuacan.

priests' house] to one side of the Pyramid of the Sun, [he] discovered skeletons of men, women, and children in different positions and stone beads that adorned their necks...."[1] Explorations of human burials throw light on mortuary customs prevalent in Teotihuacan society. Although questions still remain and new data continue to appear, these explorations provide further evidence of the complexity of the social organization, thought, and ideological world of the great Mesoamerican metropolis.

Many finds have been made since the time of Batres. A brief survey of the data gathered to date can be divided into information on the manner of disposition of the deceased (mortuary pattern) and evidence from burials of ceremonial acts involving human sacrifice.

Teotihuacan Mortuary Practices

As noted, no special site of concentration of human burials has been located to date that might be considered a cemetery. During the development of the great metropolis, people were accustomed to burying the dead where they lived, in the so-called palaces and other habitational complexes composed of rooms and patios, which surrounded the ceremonial center and extended toward the periphery of the city.

The early sporadic discovery of cremated bones gave rise to the belief that the incineration of cadavers was the generalized practice among the ancient Teotihuacanos, and this was why very few burials had been found. More recently, it has been shown that the discovery of burials in significant numbers has depended on the extent of excavations and the stratigraphic levels reached in the archaeological site explored. Thus, burials located at compounds such as Tetitla, Zacuala, Yayahuala, La Ventilla, and Tlajinga now permit the characterization of Teotihuacan burial patterns, their internal variations and changes through time, as well as their relationship with other cultural areas.

Inhumation was carried out under floors of rooms and patios, in hollows carved out of the *tepetate* (bedrock) of sufficient dimensions to hold the mortuary bundle, which contained the human remains. Traces of circular holes have been found on stucco floors, where the floors were often patched after the burial.

Direct burial was the most common mortuary practice, and was called such because there was no intervention involving any type of construction or artificial receptacle. Pits carved out of the *tepetate* for interment of the dead have been labeled *tombs* by some authors, a misnomer since true tombs have now been found. They occur in cultural contexts where a strong foreign component is indicated, such as the Oaxaca Barrio, where tombs similar to those from Monte Albán have been uncovered.[2]

The deceased were usually deposited in a tightly flexed position, described in many published accounts as a fetal position because of the characteristic flexed position of the extremities in front of the torso (fig. 1). Nevertheless, this position may assume different variations — dorsal decubitus or lateral decubitus — (lying down in curled-up position, on the right or left side) or in vertical disposition (in a seated, flexed, or "crouching" position).

It is interesting to note the orientation of the burial, given the highly important symbolism associated with the cardinal directions in pre-Hispanic cosmology. Thus, the direction toward which the torso

110

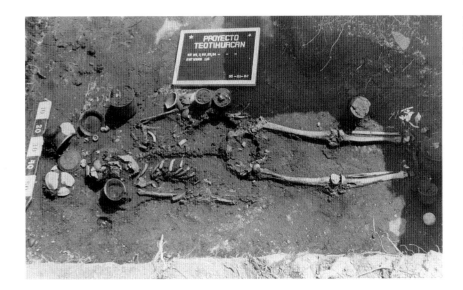

Fig. 2
Primary burial in extended position with offering. Proyecto Arqueológico Teotihuacan, 1980-1982.

area is oriented may be significant, or in the case of dorsal decubitus burials, the direction of the axis formed from the skull to feet.

The position and orientation of the deceased seems to have depended on the preferred behavior of the barrio or sector of the population involved. In burials at La Ventilla, where the largest sample of burials at Teotihuacan has been recovered, the seated, flexed position clearly predominates and the skeleton is most frequently oriented toward the east. These are mostly adult burials, with no distinction made between the sexes. Adolescents and infants were buried in flexed position in dorsal decubitus; infants who died at birth or soon after were placed on large fragments of pottery or on intentionally broken plates.[3]

This pattern of inhumation is less evident at other sites, where the lateral decubitus position is more frequent in adult burials and occasional cases are found of burials in extended position (fig. 2).

The tightly flexed position of Teotihuacan burials allows us to infer that the cadaver was tied up in this position, reducing the volume that it would occupy in the *tepetate* pit as much as possible. The mortuary bundle was wrapped in some textile material, the remains of which have been preserved in some of the burials explored.

The deceased's costume and mortuary offering were important elements in the funerary ritual. The study of offerings provides archaeological information on the rank of individuals and the social and economic structure of ancient peoples. Objects associated with the person buried reflect not only social status, but also tell about sources of materials, technology, and commerce, in addition to identifying possible religious symbolism in the funerary effects.

Objects of personal adornment are frequently discovered, including ornaments such as earspools, lip plugs, and necklace beads. In burials at La Ventilla and Tlajinga, which have been identified as the barrios of craftsmen, objects are found that symbolize the activity carried out in life by the inhabitants of these barrios (fig. 3). These include miniature vessels and other small-scale objects (tiny, fired and unfired clay receptacles containing different pigments, bundles of small clay cylinders with paint on the ends), as well as bone implements, obsidian blades, and stone smoothers (fig. 4).

Other objects associated with burials include Thin Orange ceram-

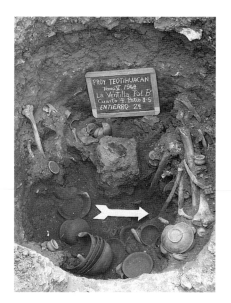

Fig. 3
Secondary burial with abundant offering.
Palace B, La Ventilla, Teotihuacan.

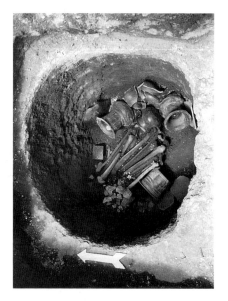

Fig. 4
Primary burial in a circular pit
in the *tepetate*. Palace B, La Ventilla,
Teotihuacan.

ics (cat. no. 155, this essay), cylinder-tripod vessels (some with relief or painted stucco decoration), jadeite beads or plaques, Tlaloc vessels, as well as shell ornaments and objects. The profusion, variety, and quality of burial objects (fig. 5) demonstrate a wide range of social differentiation between members of the same apartment compound. A study of offerings has revealed that in Teotihuacan society adults were of higher status than sub-adults, and that men had more status than women; differences in status also appear to a certain extent between inhabitants of different residential compounds.[4] These discoveries appear to speak of a nonegalitarian, hierarchically organized society. Elements of foreign origin similarly demonstrate the cosmopolitan nature not only of commercial exchange, but also of the city at any given moment.[5]

Fire was used to burn certain materials at the bottom of the pit before proceeding with a burial, which may be noted by the presence of carbon fragments under the skeleton. It is also striking that mica sheets and slate disks decorated with red and ocher lines frequently accompany a body; in some cases, as at La Ventilla, true mica beds were found on which the burial was deposited. The discovery of small agglomerations of red and ocher pigments associated with bone remains are surely other elements of symbolic significance.

Finally, other noteworthy traits associated with burials are dog bones or vessels in the shape of dogs, found for example at Tetitla and La Ventilla. A piece of jade placed in the mouth of the deceased has been found in a number of adult burials, such as at Tlajinga. This association of the dog and jade bead with burials has been described in sixteenth-century documents on the later Aztecs, for whom the dog represented a companion or guide for the deceased (cat. no. 163, this essay), while jade beads symbolized the soul.

It was common throughout Teotihuacan to move the skeleton from its original burial site, a practice that increased in later periods. During such a secondary burial, the skeleton lost its articulation. This movement of the exhumed remains to a predetermined place might be the result of a specific ritual. However, the most probable explanation was the need to use the same space for later burials, in which case the bones would have been removed while the offering objects would remain beside the recently interred subject. In other cases, the reconstruction and remodeling of apartment compounds resulted in the removal and reburial of incomplete bone remains elsewhere, or their total abandonment, which explains the modern discovery of isolated, often fragmentary bones in archaeological fill.

Several examples of incinerated burials have been found, almost always with a rich offering (at the apartment compounds of Xolalpan, Tetitla, Yayahuala, and La Ventilla). This type of funerary treatment appears to reflect high social status. In other cases, incineration is linked to ceremonial sacrifice.

EVIDENCE OF HUMAN SACRIFICE IN TEOTIHUACAN BURIALS

The theme of human sacrifice at Teotihuacan has recently attracted considerable attention because of observations made several decades ago that have gained new meaning based on recent discoveries. Tangible evidence of human sacrifice includes decapitation, represented by skulls with the first articulated vertebrae intact (the same may be

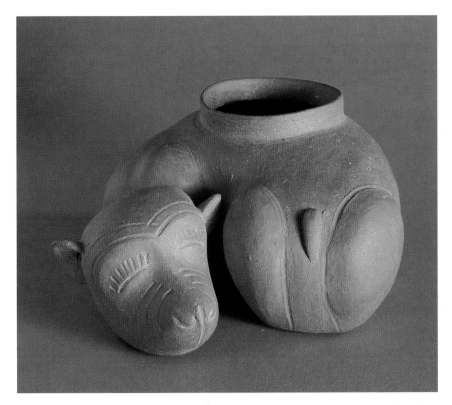

Cat. no. 163
THIN ORANGE DOG EFFIGY VESSEL
The Saint Louis Art Museum, Gift of
Mr. and Mrs. George K. Conant, Jr.

Fig. 5
Seated flexed burial with offering.
Palace B, La Ventilla, Teotihuacan.

assumed when the skeleton is found without the cephalic extremity);
dismemberment, indicated by skeletal segments and the occasionally
isolated bones with traces of cutting in the areas of muscular insertion;
and simultaneous collective burials, which may have been dedicated
to a building and the tutelary deity, whose subjects may have been
companions to a main individual. We may assume that in many of
these cases the intention was to sacrifice the immolated individual, al-
though the ideological underpinning — with its religious, social, and
political implications — still eludes our understanding.

Skeletal evidence of human sacrifice at Teotihuacan dates back to
the 1906 excavations of Batres, who found burials of children approxi-
mately six years of age at each of the corners of the four levels of the
Pyramid of the Sun. Later, Ales Hrdlicka explored two simultaneously
deposited burials of a man and a woman, placed side by side to the
southeast of the same building.[6]

These finds had no overwhelming effect at that time on percep-
tions of human sacrifice at Teotihuacan, particularly in the absence of
explicit iconographic representations of the act such as those known
from later highland cultures.

We owe the discovery of the first cases of decapitation to George
Vaillant. In his excavations at San Francisco Mazapa in 1931-1932,
nine human skulls in vessels were found, each covered with another in-
verted vessel.[7] Rémy Bastien in 1946 explored the Pozo de las Calaveras
Cave, where thirty-five skulls had been deposited in an area of one
square meter.

Since then, similar discoveries have been recorded with more
precise descriptions, confirming the practice of decapitation from the
Miccaotli phase until the end of Teotihuacan (A.D. 150-750); these
have been located at La Ventilla,[8] San Francisco Mazapa,[9] the Plaza of

the Moon,[10] Santa María Coatlan,[11] and the northern quadrangle of the Ciudadela.[12]

Cases of dismemberment have been documented in the habitational zone north of the Old Temple of the Feathered Serpent,[13] where segments of torso, vertebral column, extremities, and a pair of feet were found. The remains show traces of cutting. Furthermore, they were covered with a great quantity of ash and they showed traces of exposure to fire.

It is worth mentioning the two adult hands found as an offering at La Ventilla.[14] These bones were found articulated and placed together on the dorsa in the vertebral region of an infant burial, apparently representing an intentional mutilation of hands for funerary purposes.

Burials of newborns associated with altars, recorded at two extensively excavated sites, La Ventilla B and Tlajinga, deserve special mention. Not only the context of the discovery — their close association with these structures — but also the high perinatal mortality confirmed at these sites makes us suspect deliberate death by infant sacrifice.[15] Recent finds seem to confirm this interpretation, such as the discovery of a collective burial of eighteen skeletons of newborns simultaneously deposited in vessels in the vicinity of the site known as the "solar de Xolalpan,"[16] and a collective burial at San Francisco Mazapa of around twenty skeletons of newborns that accompanied the cremated remains of a woman, located at the bottom of a great pit in a burial with very rich offerings.[17] Recent explorations at the Temple of the Feathered Serpent yielded further evidence of a massive sacrifice. Roughly 134 individuals (plus those in unexplored sites) probably came from other regions. They were immolated when construction of the building began during the Miccaotli or early Tlamimilolpa phase.[18] Males with warrior costumes predominate. They wear ornaments imitating human jaws with teeth made from shell, on a stucco base. The position of the hands showed that they had been tied from behind. A collective burial was found below the temple, at exactly the central point of the pyramidal platform, of twenty male individuals, accompanied by rich offerings. This discovery shows the political power and the military control that the Teotihuacan state had achieved at an early date in the Mesoamerican milieu.

The study of burial sites provides ample evidence of the development of a highly integrated, complex social hierarchy at Teotihuacan. Its manifestations both preceded and foretold the funerary rites and customs that would be practiced in later times among the Mexicas, for whom abundant osteo-archaeological, epigraphic, and documentary sources exist.

The information recovered suggests, nevertheless, the need for models explaining the significance of funerary practices as social and cosmological expressions of a reality that involves economic, political, and ideological factors. Specialists from different disciplines should work together to arrive at plausible and convincing interpretations of the complex phenomena uncovered by archaeologists. The wealth of information obtained from the exploration of burials may provide major contributions to our future understanding of Teotihuacan civilization.

Carlos Serrano Sánchez is Professor of Anthropology at the Universidad Nacional Autónoma de México.

1. Batres 1906, 4-5.

2. Michael W. Spence, "Human Skeletal Material from the Oaxaca Barrio in Teotihuacan, Mexico," in *Archaeological Frontiers: Papers on New World High Culture in Honor of J. Charles Kelley*, ed. R. Pickering, 129-148, University Museum Studies, 4 (Carbondale: Southern Illinois University Press, 1976).

3. Carlos Serrano Sánchez and Z. Lagunas, "Sistema de enterramiento y notas sobre el material osteológico de La Ventilla, Teotihuacan, México," *Anales del INAH* 7a, no.4(1975):105-144.

4. M.L. Sempowki, "Differential Mortuary Treatment: Its Implications for Social Status at Three Residential Compounds in Teotihuacan, Mexico," in McClung and Rattray 1987.

5. Evelyn Childs Rattray, "Costumbres funerarias en el barrio de los comerciantes, Teotihuacan," *XIV Mesa Redonda* (Mexico: Sociedad Mexicana de Antropología, 1985).

6. Ales Hrdlicka, "An Ancient Sepulchre at San Juan Teotihuacan, with Anthropological Notes on the Teotihuacan People," *XVII Congreso Internacional de Americanistas* (Buenos Aires, 1910), Appendix 3-7.

7. Armillas 1950.

8. Serrano and Lagunas, "Sistema."

9. Enrique Martínez Vargas and Luis Alfonso Gonzáles, "Una estructura funeraria teotihuacana," in Cabrera, Rodríguez, and Morelos 1991, 327-333.

10. Z. Lagunas and Carlos Serrano, "Los restos oseos humanos excavados en la Plaza de la Luna y Zona de las Cuevas, Teotihuacan, México (temporada V, 1963)," *Notas Antropológicas* 2, no.5:28-60, Instituto de Investigaciones Antropológicas (Mexico: Universidad Nacional Autónoma de México, 1983).

11. S. Gómez Chavez, "La función social del sacrificio humano en Teotihuacan: Un intento para formalizar su estudio e interpretación," in Cardós 1990, 147-161.

12. L.A. González and M.E. Salas, "Nuevas perspectivas de interpretación que proporcionan los entierros del centro político-religión de Teotihuacan," in Cardós 1990, 163-179.

13. L.A. González Miranda, "La población de Teotihuacan: Un análisis biocultural," thesis, Escuela Nacional de Antropología e Historia, Mexico, 1989.

14. Serrano and Lagunas, "Sistema."

15. Serrano and Lagunas, "Sistema."

16. Ana María Jarquín Pacheco, "Excavaciones arqueológicas en la periferia del centro ceremonial teotihuacano," *Libro de Resúmenes* (Bogota: 45th Congreso Internacional de Americanistas, 1985), 242-243.

17. Ana María Jarquín Pacheco, Enrique Martínez Vargas, and Carlos Serrano, "Informe general de la excavación realizada en San Francisco Mazapa, jurisdicción de San Juan Teotihuacan, Estado de México," Archivo Técnico de la Dirección de Monumentos Prehispánicos (Mexico: INAH, 1989).

18. Rubén Cabrera Castro, George Cowgill, Saburo Sugiyama, and Carlos Serrano Sánchez, "El Proyecto Templo de Quetzalcoatl," *Revista de Arqueología* no.5 (Mexico: INAH, Dirección de Monumentos Prehispánicos, 1989).

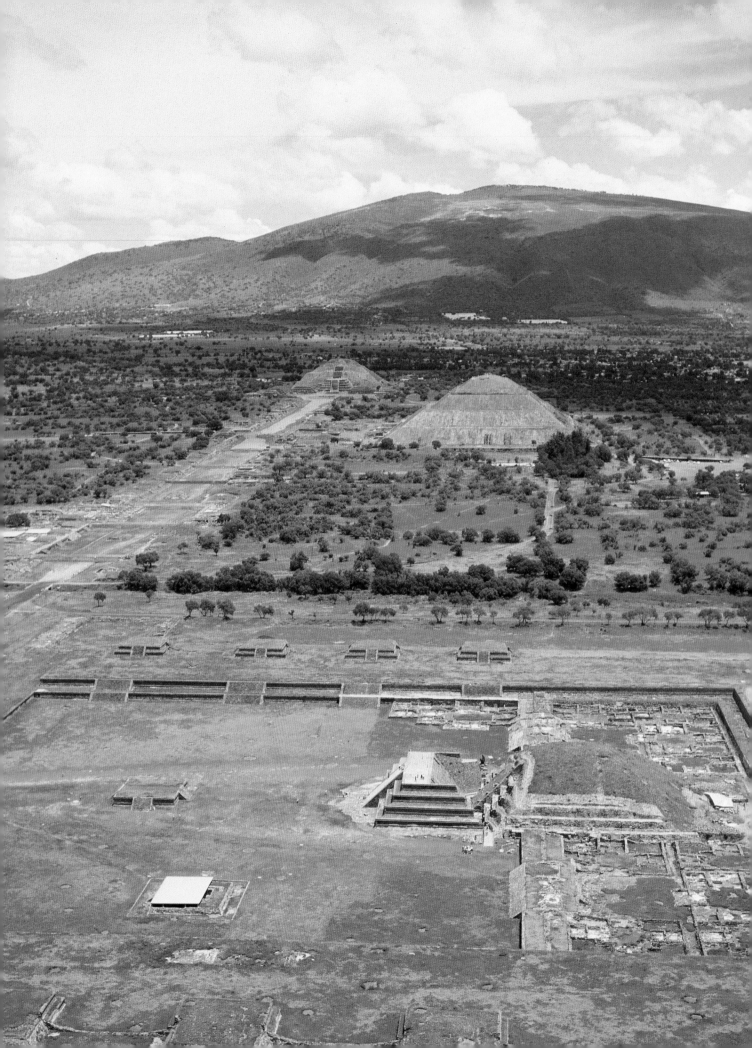

What We Still Don't Know about Teotihuacan

George L. Cowgill

THE EXTENT OF EXCAVATED AND RESTORED RUINS at Teotihuacan is overwhelming and, because the results of so much work are already visible, it is easy to assume that little is left for archaeologists to do. Nothing could be further from the truth. We are still only beginning to find out what this prehistoric city has to tell us.

What are the reasons for the apparent discrepancy between the scale of what has already been accomplished and the amount yet to be done? First, a disproportionate amount of work thus far has concentrated on the largest and most impressive structures in the ceremonial heart of the city. Second, much of this work was done decades ago, including much of the architectural reconstruction of relatively well-preserved monumental remains. A number of modern techniques of archaeology were not available and the kinds of information were not recovered that are needed to answer many of the questions that interest us today. Finally, good archaeology is expensive, and funds for archaeology are hard to come by. For all these reasons, even though the extent of restored ruins at Teotihuacan is vast, our efforts to recover Teotihuacan's history have scarcely moved beyond an exploratory stage.

Let me make these points in more detail. René Millon's Mapping Project in the 1960s showed that the city covers about twenty square kilometers (eight square miles), extending far beyond the current limits of the formally designated archaeological zone.[1] Much of this area consists of the remains of large multihousehold "apartment compounds," in which lived most of the 100,000 or so inhabitants of the city. These compounds vary greatly in size, but they are rarely much less than about thirty meters (one hundred feet) on a side and are often up to sixty meters or more on a side (about two hundred feet). When they are excavated they are found to consist of several distinct one-story

Aerial view of the Ciudadela.

apartments, of which most of the walls are solidly made of stone rubble faced with thick concrete, which in turn is coated with a thin layer of fine white plaster. Painted frescoes occur rarely. Compounds whose occupants were probably less wealthy often have walls of mud brick or adobe rather than stone rubble. Millon estimates that the larger compounds probably housed sixty to a hundred people, who were organized into several households.[2] Millon's project discovered evidence for more than two thousand of these residential compounds. Before such a site is excavated, nothing much shows on the ground except concentrations of shapeless stone rubble, shards of broken pottery, and scatters of broken implements of obsidian and other kinds of stone. Usually a slight rise in the land surface is visible, but it often amounts to no more than a foot or two, over an area whose diameter may be thirty to sixty meters. The evidence is clear enough to the trained eye of the archaeologist, and has been repeatedly confirmed by excavations in different places. However, remains of this kind are (with good reason) ignored by tour guides. Most visitors to Teotihuacan see only the most spectacular ruins and do not even suspect the existence of these thousands of other structures.

Of all these compounds that are not close to the Street of the Dead, fewer than forty have been even partially excavated by archaeologists. At best, this would be less than a 2-percent sample of the total. However, more than half of them were dug in the 1970s or earlier; many were excavated under the pressures of salvage work done in the face of imminent destruction before tracts outside the protected zone were developed for other uses; many were only partially excavated; and at several the work was dominated by specific objectives such as the recovery of mural paintings. The upshot is that by 1992 no more than three or four compounds had been excavated relatively extensively, without excessive limits on time, and taking advantage of modern techniques for recovering information about what activities were being carried out where in the residential unit. The best examples are the recent work by Linda Manzanilla and her colleagues in the far northwest of the city,[3] by Michael Spence in an enclave of people affiliated with the distant Valley of Oaxaca who lived near the western outskirts of the city,[4] by Rebecca Storey and Randolph Widmer in a neighborhood of potters in the southern part of the city,[5] and by Evelyn Rattray in a district near the eastern edge of the city where people had connections with the coastal areas of Veracruz and even the Maya Lowlands.[6] Their discoveries have been extremely interesting, but, needless to say, these sites are neither a representative nor an adequate sample of Teotihuacan apartment compounds.

I do not think a Teotihuacan apartment compound could be excavated adequately, and the materials found studied and satisfactorily published, for less than two hundred thousand dollars. At that rate, it would cost at least four hundred million dollars to excavate all of them. When costs for excavating all the pyramids and other types of structures are added in, the total to excavate all of Teotihuacan would easily exceed a billion dollars. Such a sum is, in the archaeological world, staggering. Of course, to put it into perspective, a "Teotihuacan 100-percent" project would be quite modest compared with what wealthy nations such as the United States spend on high-energy physics accelerators or space projects, and it would be a tiny amount relative to a

nation's military budget for a single year. Nevertheless, it is unrealistic to think that any society would choose to spend anywhere near that much money on one ancient city.

Fortunately, a 100-percent project is neither necessary nor desirable. It is not desirable because archaeological techniques continue to improve and our objectives change. Because excavation is destructive, the only sure way to have data available for future techniques and future questions is to leave some sites unexcavated in adequately protected parts of the city. Also, excavation of every single structure is unnecessary because we would eventually reach a point of diminishing returns, where additional digs would furnish no surprises.

How many sites, then, do we need to dig? Statistical expertise can help us to select a good sample that is likely to yield high payoffs in new and relevant information, but statistics cannot tell us when we have "enough." The only criterion that really means anything is that we will have enough when we can so well predict what we are going to find in the next excavation that we encounter no big surprises. We are still very far from that point; every new excavation yields startling discoveries.

So far I have only discussed the large apartment compounds in which most of Teotihuacan's population lived. We know even less about other kinds of sites. Millon's project found hundreds of surface concentrations of pottery fragments and other kinds of refuse left by the Teotihuacanos, but without signs of any substantial architecture. Some of these concentrations might be dumping areas, but most probably indicate where some of the poorest people lived in insubstantial dwellings, or where various kinds of special activities were carried out. I know of

Cat. no. 171
GROUP OF OBSIDIANS
Excavated by Sigvald Linné. Folkens Museum-Etnografiska, Stockholm.

Cat. no. 77

SELECTION OF MOLDS AND *ADORNOS*
From a workshop at the northwest
corner of the Ciudadela. CNCA-
INAH-MEX, Museo Arqueológico
de Teotihuacan.

none of these other kinds of sites that have been excavated in any detail.
Also mysterious are features such as the great freestanding walls that
run for hundreds of meters in parts of the city, presumably defining
large bounded districts, considerably larger than the barrios (spatial
clusters of sites), that are apparent in some places. Millon's survey
found clear evidence that these walls exist, but we are unsure of their
dates and know very little else about them.

We are somewhat better off regarding Teotihuacan's monumental
civic-ceremonial structures, especially those on or near the Street of the
Dead. Even for this category, however, a high proportion of structures
remains unexcavated. Of those that have been excavated, much of the
work was done in earlier days and concentrated on the restoration of
well-preserved late architectural stages, without having taken advantage
of either the techniques or the problems that guide modern excava-
tions. Modern excavations that have explored any sizable areas of ear-
lier architectural stages are especially scarce.

The picture is not all bleak, of course. There is a great deal that
we *do* know about Teotihuacan. We have very respectable knowledge of
architectural layouts, materials, and methods of construction of both

120

apartment compounds and civic-ceremonial structures, at least for the later stages of the city. We have a ceramic chronology that provides — when adequate samples of material excavated with careful attention to the different depositional layers are available — fairly secure dating to within intervals of two centuries or so. In a few very favorable cases, associated ceramics can date an event or a construction stage to within about a century. Although this is a worthy accomplishment, the results remain tantalizingly vague. Even if we consider a time when technological change was much slower than now, as in classical antiquity, a time resolution of about two centuries would mean that we could not tell which structures dated to the times of Julius Caesar, Nero, or Hadrian. All structures would have to be treated as essentially contemporary. In such a case, what kind of sense could we make of Roman history?

Although our present ceramic chronology is an impressive accomplishment, our ability to make secure and meaningful interpretations of what we find at Teotihuacan would be vastly improved if we could date buildings and events to within a century or less. It may not be too much to hope that eventually we can bring the resolution to within half-centuries or so, in cases where the ceramic sample is large and of high quality. Incidentally, although they are valuable supplements, radiocarbon and other archaeometric dating techniques cannot substitute for chronology based on changes in characteristics of pottery and the relative proportions of different kinds. Potshards are ubiquitous, but materials suitable for applying these other dating techniques are lacking in many deposits. Furthermore, numerous technical problems and inherent statistical uncertainties mean that the dates provided by these laboratory methods are also rarely secure to within an interval of much less than two centuries.

Another great accomplishment in the exploration of Teotihuacan has been the detailed surface survey and mapping of the entire city, carried out by René Millon.[7] Because I had nothing to do with conceiving or initiating this project, and my role in helping to carry it out was rather modest, I think it not inappropriate to point out that very few, if any, settlements of comparable size anywhere in the world have been mapped so systematically and in such detail. The great limitation is, of course, the obvious one — that even the most careful and thorough surface survey is no substitute for excavation. Surface surveys, besides making it possible to cover vastly greater areas than could conceivably be excavated, can often discover extremely powerful indications of what may be below the surface. Nevertheless, excavation invariably reveals much that could not have been guessed at from surface evidence.

Perhaps the most obvious achievement, almost too obvious to mention, is the wealth of objects that have been recovered from Teotihuacan — richly decorated ceramic vessels, figurines in fired clay and stone, both small and monumental stone carvings, and mural paintings. The very existence of the exhibition *Teotihuacan: City of the Gods* is testimony to the quantity and quality of these objects. These works have given rise to a large literature devoted to interpretation of the mental and social world of the Teotihuacanos — their iconography, religion, and ideology. Many of the other essays in this volume deal, in one way or another, with these matters. Accomplishments here are impressive, but are just the beginning of what might be achieved, and vastly more work is needed. Much of this work will more deeply

and systematically analyze objects already available, and establish fuller connections between information about Teotihuacan and the increasing body of knowledge about other Mesoamerican societies. One hopes, also, that improved models for thinking about and understanding human societies in general will help to develop better understanding of Teotihuacan.

These matters could be elaborated upon, but here it is appropriate to emphasize another limitation, that a high proportion of the fine objects from Teotihuacan are from unknown contexts. We can, to be sure, do quite well in detecting outright fakes or genuinely ancient objects that are dubiously attributed to Teotihuacan. That is, we can securely attribute objects to "somewhere" within the city of Teotihuacan (or, at any rate, to some place with essentially the same culture). But all too often we have little or no idea of the objects' exact provenance within the city. Thus, one essential and very serious limitation on our ability to interpret objects is the scarcity of information about their contexts. From what kind of structure did they come, from what period of construction, with what other objects were they originally associated, and in what kind of deposit did they occur (e.g., a burial, a dedicatory cache, a refuse midden, or undisturbed in an abandoned room)? Here, again, there is no substitute for the kind of excavations that provide us with a much richer corpus of objects *from known contexts.*

Thus, in spite of all that has been learned about Teotihuacan, from one point of view the answer to the question of what we still don't know is very simple: Everything! There is not a single worthwhile question about Teotihuacan, not a single aspect of its society, culture, and history, about which we don't feel a need to know more.

Such an answer, however true, is too general to be useful. A better idea of the possibilities for further learning can be conveyed by listing some of the topics of greatest interest. Such a list inevitably reflects my personal interests, but it also gives a fair idea of the thought of many other archaeologists actively involved in research on Teotihuacan.

While substantial amounts of work have been done on various kinds of craft industries — notably obsidian, pottery vessels, censers, ceramic figurines, shell working, and fine stone (lapidary) materials — in all cases the data bases are still extremely small and inferences are far less secure than we would like (and, indeed less secure than a few authors have claimed) (see cat. nos. 57, 77, and 171, this essay, for examples of craft-related objects). It is important to know more about these industries not only because of what they tell us about technology at Teotihuacan, but also because of what we can learn about the social relations that influenced the production and distribution of various kinds of goods. To what extent, for example, did artisans produce goods for exchange through market institutions, outside of households and various social networks? To what extent did representatives of state institutions manage or otherwise intervene in production and/or distribution processes? How was the procurement of raw materials from distant places organized? To what extent, and in what ways, did objects produced at Teotihuacan figure in the society's relationships with other societies, both nearby and distant?

Clear evidence exists that a well-defined and localized neighborhood of people at Teotihuacan had obvious ethnic connections with people of highland Oaxaca. Strong evidence also exists for another

distinct neighborhood with ties to the Gulf Coast (and, to a lesser degree, the Maya Lowlands). Yet, beyond the existence of these ethnically distinct enclaves, little is known of their reasons for being or of the roles their inhabitants played within the wider Teotihuacan society. Competing and conflicting suggestions have been made, but, at present, none can be considered very secure. More data are needed about these ethnic barrios, and we also need to search for others, especially since it seems unlikely that people from other parts of Mesoamerica (e.g., western Mexico) were not well represented at Teotihuacan.

Some work has also been done on identifying the character of different neighborhoods in the city, in other terms than ethnicity, such as socioeconomic status and the spatial concentrations of certain craft specialties. Necessarily, this work has relied heavily on such data as are available from Millon's survey, supplemented by data from a few strategic excavations. A much better understanding of these neighborhoods could come from a combination of far more intensive surface collecting from selected groups of sites, plus extensive excavations at a few sites. The results would bear on the organization of Teotihuacan society. Among many other issues, it should become possible to test the hypothesis that such things as temples or other civic-ceremonial sites were associated with specific neighborhoods. Some writers have suggested that various isolated pyramids and pyramid complexes served this role, but these structures are too scarce in some districts, too concentrated in other districts, and mostly too large and elaborate to be plausible candidates for neighborhood centers. More plausible are apartment compounds such as Yayahuala, which Millon suggests may have been a barrio temple.[8] Its main patio has a high, broad public entrance on the west, and three relatively large platforms are disposed on the other three sides of this patio. It should be noted that we know this only because Yayahuala is one of the few excavated apartment compounds. In

Cat. no. 57
MASONRY IMPLEMENT FOR APPLYING
LIME STUCCO
Folkens Museum-Etnografiska,
Stockholm.

123

its unexcavated state probably nothing — at least nothing we could see without more sophistication — would have suggested that the site might have been a special barrio structure.

We still know remarkably little about the earlier stages of the city's growth or about what preceded the establishment of the apartment compounds as the principal kind of residences several centuries after Teotihuacan's beginning. In part this may be because earlier structures seem to have been razed and dug out down to the local hard subsoil in order to provide a firm foundation for the new stone and concrete structures. Thus we find admixtures of early ceramics in later deposits, but generally no undisturbed layers pertaining to early dwellings. A concerted search, however, might reveal remains of early dwellings in the parts of the city where early ceramics are most abundant. The chances of finding very early civic-ceremonial structures are even better. Data from these earliest periods, when the city was growing most explosively, have the potential to tell a great deal about how and why Teotihuacan developed into the unique metropolis it became.

Another series of questions still to be answered concerns the kinds of lives lived by inhabitants of the city, by both the elites and those of average or low status. Modern archaeological techniques can tell much about diet, through studies of plant and animal remains, food-preparation equipment, skeletal evidence of nutritional and general health status, and chemical and isotopic markers of diet in human bone. Quantitative studies of palaeodemography (feasible only with well-excavated samples that are representative and of adequate size) can tell about average life-expectancy and the proportionate numbers of inhabitants who died at various ages. Skeletal evidence may also shed much light on marriage patterns and on whether either males or females tended to reside near the parental household after marriage. Fascinating work on all these topics has been done in the past few years or is in progress at Teotihuacan (notably by workers such as Manzanilla, McClung, Storey, Spence, and Serrano), but these are pioneering forays that need to be followed up by vastly more work.

To judge by the confidence with which some scholars write about Teotihuacan, this long recital of the uncertainties and gaps in our knowledge may come as a shock. I do not want to seem too much the skeptic. As I have pointed out, we *do* know a great deal about Teotihuacan, although many nuances exist between what is widely agreed to be very secure and matters where interpretations are quite shaky and sometimes hotly contested. Nevertheless, undeniably much less is known than we would like, and much less than we could know, given the kind of research that is feasible at the city.

It is necessary to close on an urgent note. Much of the city of Teotihuacan lies outside the protected archaeological zone. It is vulnerable to modern housing and other developments. Salvage efforts can moderate this loss of information but they cannot prevent it. Once gone, a site is lost forever. We will never know much of what we might know about Teotihuacan unless more problem-oriented excavations are undertaken very soon, on a large scale, and making full use of modern methods.

George L. Cowgill is Professor of Anthropology at Arizona State University, Tempe.

1. R. Millon 1973; R. Millon 1981; Millon, Drewitt, and Cowgill 1973.

2. R. Millon 1973, 44-45.

3. Manzanilla and Barba 1990.

4. Spence 1989; Spence 1992.

5. Storey 1991; Widmer 1991.

6. Rattray 1989.

7. R. Millon 1973; Millon, Drewitt, and Cowgill 1973.

8. Millon 1976, 225, citing Séjourné and Salicrup.

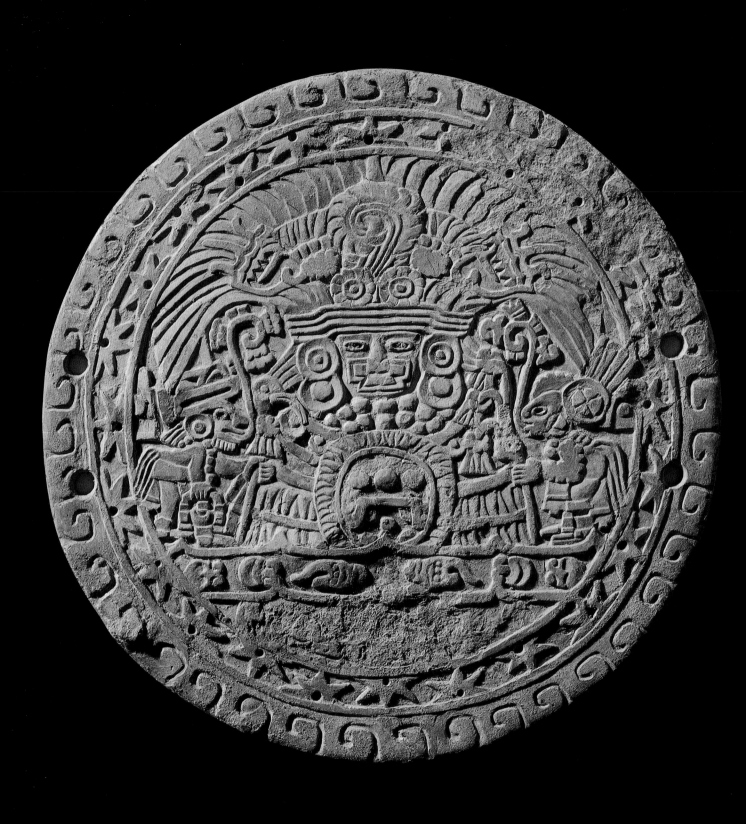

Beyond Teotihuacan

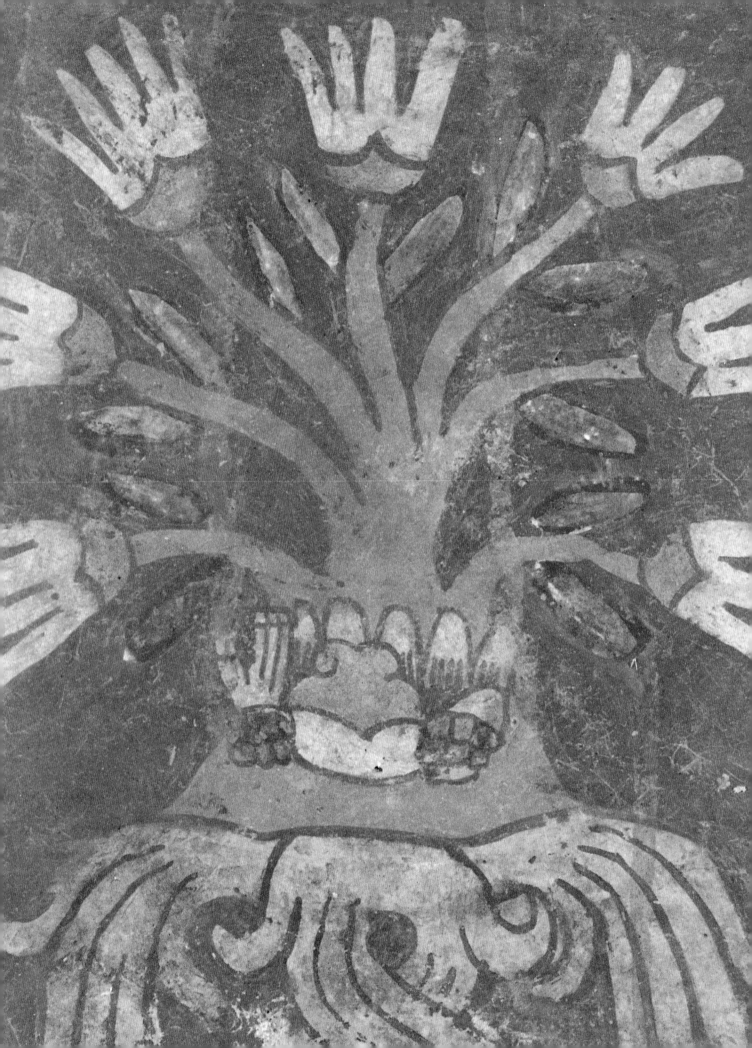

Symbols,
Signs, and
Writing Systems

J. C. Langley

S TANDING ON THE STREET of the Dead, surrounded by the massive re-
mains of Teotihuacan, it is disconcerting to reflect how little we
really know about this ancient society. There exists, of course, an
extensive literature on the excavations carried out at the site during the
past century as well as many studies of its artifactual remains. The site
has been surveyed and mapped, the rise and fall of its population has
been estimated,[1] and its economy and religious system have been the
subject of speculation.[2] Yet understanding its culture has proven elusive.
Despite the many relics of its past and the traces of its influence through-
out Mesoamerica, the political history of Teotihuacan and the daily life
of its people and what they believed, how they were governed, and how
they interacted with their neighbors are lost in obscurity. Even the eth-
nic affiliations and the languages of the Teotihuacanos are unknown.

This situation stands in startling contrast to the knowledge we
have of other Mesoamerican societies, notably the Maya and Aztecs,
and the reason is not far to seek. The Teotihuacanos left no written
records and no contemporary accounts exist of their society or history.
By contrast, a voluminous commentary was made by Spanish observers
at the time of the Conquest on many of the Mesoamerican cultures,
and several of them left their own accounts of their history and beliefs
written in their native scripts. Deciphering these works has posed many
problems but one of the most significant achievements of contempo-
rary epigraphic research is the recovery of the history of the classic
Maya from their monumental inscriptions.

Without such documentary sources, the attempt to reconstruct
Teotihuacan's past has perforce been based largely on inference from
the material remains of the metropolis and of other sites that display
traces of its influence. Archaeology has played a major role in this ef-
fort, but the abundant arts of Teotihuacan, mainly in the form of mural
paintings and decorated pottery, provide another source of information

Fig. 1
Detail, glyph from Feathered Serpent
and Flowering Trees mural (cat. no.
50). The Fine Arts Museums of San
Francisco, Bequest of Harald J. Wagner.

Fig. 2
Blowgun hunter and birds. Main motifs
on a stuccoed and painted cylinder
tripod vessel in the Hudson Museum,
University of Maine, Orono.

that has been exploited in parallel to, and to some extent independent
of, archaeological research. Their themes and motifs, and the ways they
were presented for public view, must have been significant for the
Teotihuacanos and provide us with an entrée to their society.

Unfortunately, the analysis of this visual evidence is intrinsically
difficult. Our distant cultural perspective renders the evidence strange
and enigmatic and imposes on us a set of preconceptions that distorts
our vision and prejudices our interpretations. The problem is com-
pounded by the symbolic and nonnaturalistic character of much of
Teotihuacan art that has profoundly impressed scholars and influenced
their work during much of this century. Typically, Alfonso Caso con-
cluded that the art was "par excellence a symbolic art in which every
detail has a meaning,"[3] while Arthur Miller wrote more explicitly that
"Teotihuacan painting does not refer to the real world as does repre-
sentational painting…[but] refers to a symbolic concept."[4] Scholarly
research has tended to focus on the more striking manifestations of
this symbolism, that is to say, compositions devoid of narrative content
in which human, animal, and other natural forms are compounded
into strange creatures having no counterparts in the real world.

Such symbolism on a grand scale, and the netted anthropomor-
phic jaguars, feathered serpents, fanged butterflies, and other chimera
that are so striking and recurrent in Teotihuacan art, lends itself to a
religious and mythic interpretation. Indeed, for much of this century,
Teotihuacan art has been regarded as essentially religious, and has
been characterized by terms such as "ritual" and "liturgical."[5] Scholars
have sought to elucidate the culture by decoding the symbolism and
identifying the deities and rituals thought to predominate in its subject
matter. This approach has been very much in harmony with the intel-
lectual temper of pre-Columbian studies of the period, but has pro-
duced some misleading conclusions that have not withstood the test
of time, such as an insistence on the essentially pacific and theocratic
nature of Teotihuacan society.

In addition to such a distortion of historical reality, the preoccupation with the more conspicuous kinds of symbolism has impeded our understanding of Teotihuacan society by diverting attention from other forms of symbolic usage and from the narrative and representational elements in its arts through which meaning is more directly conveyed. An illustration of this point is our habituation to the tree as symbol as, for example, in the Feathered Serpent and Flowering Trees murals (fig. 1). Its religious connotation as the cosmic or directional tree is familiar; it is all too easy to overlook the tree simply as vegetation. Perhaps for this reason we have only recently recognized the narrative element in the decoration of several cylinder tripod vessels for what it is, the depiction of kneeling blowgun hunters with their prey, birds already bagged or fluttering in the trees (fig. 2). This failure of perception is all the more surprising in that the theme is familiar: the blowgun hunter appears among the myths of the *Popol Vuh* while he and his prey are celebrated by the Aztecs in the fourteenth sacred song recorded by Sahagún in *The Florentine Codex:*

Let there be rejoicing
By the flowering tree
Hear all the firebirds
The various firebirds
Our God speaks
Pay him heed
His firebird speaks
Is it one of our dead who is piping —
Who'll be felled by a dart from a blow-gun?[6]

It is a good possibility, as these Maya and Aztec analogues suggest, that this scene has a mythic or ritual connotation. However, it also illustrates the way in which narrative content and representational imagery can contribute to the identification of the themes of Teotihuacan art and the interpretation of a form of symbolism that until recently has been somewhat overlooked — the attributive or coded usage of familiar objects to identify persons, animals, and abstractions. A typical example in our own culture is the laurel wreath as a symbol of glory. At Teotihuacan such attributive use of symbols is very common: soldiers are identified by atlatl darts or other items of military equipment, and priests by their ceremonial bags. Nearly a hundred years ago Antonio Peñafiel drew attention to this usage,[7] but two more recent innovative studies, which broke with the fashionable interpretative tradition of their time, provide essential insights into the extent and nature of the practice.

In the first of these studies Hasso von Winning identified a symbol cluster consisting of a bird, a shield with emblazoned hand, and one or more atlatl darts as a martial emblem (see the Small Birds with weapons murals, cat. nos. 48-49, this essay).[8] Following this lead, many other symbols of function, allegiance, and rank have been identified, and the large secular element in Teotihuacan art, particularly the extent of martial and sacrificial imagery, also have come to be recognized. In another pioneering study, Clara Millon placed the Teotihuacan sociopolitical system in a new perspective when she proved that a distinctive tassel worn in Teotihuacan headdresses signified membership in a high-ranking social group having leadership and military

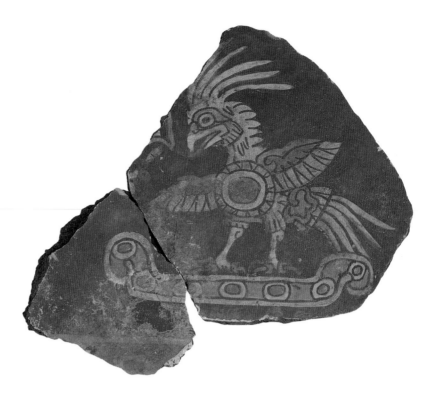

Cat. no. 48
SMALL BIRD IN U-SHAPED FORM
The Fine Arts Museums of San Francisco, Bequest of Harald J. Wagner.

attributes and forming part of the ruling establishment or bureaucracy (cat. nos. 43-45).[9]

As a by-product of these studies in attributive symbolism, attention was first focused on yet another kind of symbol, the notational signs with which this paper is particularly concerned. Notational signs are small, conventional depictions of natural objects or abstract motifs. They are usually associated with other graphic imagery but, unlike the attributive codes, are easily distinguished as incongruous elements in the graphic composition. Pictorially they are out of place, having no obvious naturalistic or decorative functions, but serving rather as symbolic supplements to the imagery. While the existence of such signs at Teotihuacan has been recognized for most of this century, Clara Millon's 1973 article contains the first discussion of their usage in a linear inscription (fig. 3) and as probable name glyphs (the sign clusters at the feet of the processional figures in the Tassel Headdress murals).

Notational signs tend to cluster in patterns that display the sorts of uniformity and variability characteristic of glyphic communication. This tendency is well illustrated in the Flowering Trees murals, of which the most careful analysis so far has been made by Esther Pasztory.[10] In the complete suite of four murals, regrettably incomplete, she identifies nine basic signs or sign compounds (and several distinctive variants). The most common of these signs is eyelike. It appears in several different configurations with a trilobe, trefoil, feathered eyebrow, or rectangular motif. If pattern is a reliable guide to meaning, it is reasonable to assume that each of these clusters expresses some variation on the basic connotation of the eye sign.

In a previous study based on the analysis of some thousand artifacts it was suggested that the Teotihuacan notational corpus consisted of about 120 signs.[11] The discovery of new mural paintings and other decorated artifacts in recent excavations suggests several modifications to this analysis. In the first place it seems useful to note that a few signs — at most ten — rarely if ever occur as main signs in a cluster but typi-

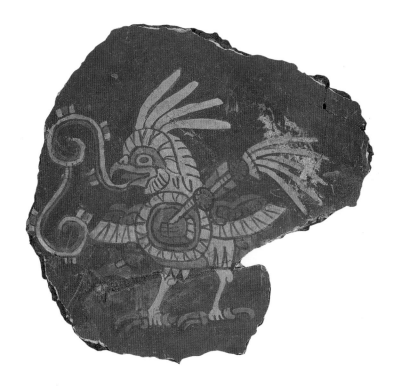

cally adhere to other signs in a way that appears to qualify them. The trilobal blood sign in the clusters of the Flowering Trees mural is an example of such an affix. Second, a more rigorous application of the criteria of notational proof suggests that the number of different signs is about 100 rather than the 120 previously estimated. Third, the evidence for the notational status of signs varies enormously. Some, such as comb and bar (fig. 4a), feathered eye (fig. 4b), trapeze and ray (fig. 4c and cat. no. 143), water lily (fig. 5c), and interlaced bands (fig. 5e), are common and appear in a variety of notational contexts. Others occur much less frequently. However, generalizations about frequency must be treated with caution in part because they involve the accidents of artifact recovery and may not accurately reflect the reality of sign usage at Teotihuacan.

Over two-thirds of the signs of confirmed notational usage at Teotihuacan are pictographs and may therefore also occur in its art as representational or decorative elements, or as attributive codes. The pictorial context is a key element in distinguishing among these four different usages. In particular, certain contexts intrinsically indicate notation, and it may be presumed that the signs associated with them encode some form of communication. The most intuitively convincing of these notational contexts is the sound scroll, the quintessential symbol of oral message. Another symbol, the panel that falls from the hands of elaborately clothed individuals, is often associated with signs (cat. no. 42), and suggests communication in the context of offertory or prophetic ritual. A necessary condition of such communication is, of course, that the configuration of context and sign cluster be compatible with the encoding of verbal messages. Thus, sign scrolls to which a series of identical profile flowers are affixed may, as has been suggested, represent song or chant, but they do not convey specific verbal messages.

Finally, if the context is representational or is part of a narrative

Cat. no. 49
SMALL BIRD CARRYING A SPEAR
The Fine Arts Museums of San Francisco, Bequest of Harald J. Wagner.

133

Fig. 3
Two-part notation. Detail, mural painting, Museum of Art and Archaeology, University of Missouri, Columbia.

Fig. 4
A selection of signs characteristic of Teotihuacan: (a) comb and bar, (b) feathered eye, (c) trapeze and ray, (d) nose pendant G, (e) trefoil E, (f) shield-streamer, (g) interlocking scrolls, (h) reptile eye.

composition, it will provide thematic information relevant to the interpretation of the associated signs. This and the more general relationship of sign and context are well illustrated by the Maguey Figure mural (cat. no. 42). An elaborately dressed profile figure with sound scroll faces a bundle motif in which maguey thorns are implanted. This composition has close parallels with the imagery of penitential bloodletting that is well documented on Aztec monuments in the form of the *zacatapayolli*, or grass ball in which priests stuck their bloody maguey thorns.[12] It seems reasonable to infer a similar theme in the Teotihuacan mural and to deduce that the sign cluster associated with the sound scroll, one of the larger such clusters of a generally linear form at Teotihuacan, encodes a message related to this theme.

In the absence of thematic information, the clues to meaning in a nonnarrative composition are rather more tenuous. For example, the imagery of the Flowering Trees murals lends itself to several possible but inconclusive interpretations. The contextual association of trees and sign clusters led Jorge Angulo to propose that similar clusters in the murals of Tepantitla, Teotihuacan, were phonetic place names,[13] for which there is some analogical evidence in the similar usage of the mountain symbol with affixed signs in other Mesoamerican cultures. An even closer analogy with Mesoamerican symbolic usage is suggested by the composition as a whole, each of four feathered serpents being associated with thirteen trees. This is precisely the format of a basic unit of the Mesoamerican time count, the cycle of fifty-two years subdivided into four quarters of thirteen years each. Unfortunately, given the present state of our knowledge, it is not possible to determine whether either of these interpretative hypotheses is correct.

The ultimate validation of the notational system as a method of graphic communication will, of course, depend on deciphering the messages encoded in its sign clusters. While interpretation of the signs has been a major scholarly interest, several formidable obstacles have inhibited progress. In the first place, our ignorance of the language or languages spoken at Teotihuacan makes it impossible to assign specific readings to signs or, indeed, determine whether their usage is phonetic. Second, the number of sign clusters available for study is still quite

limited. This is especially true of the linear cluster most characteristic of the traditional written text, of which there are only about thirty-five examples in the data sample, mostly short and often partly effaced.

Unlike the epigraphic study of the main Mesoamerican writing systems, the interpretative effort at Teotihuacan has thus been forced to concentrate on the literal meaning of pictographic signs and the metaphorical meanings that can be gleaned from contextual associations and analogies with other Mesoamerican cultures. There is no certainty that these interpretations are precisely what the authors intended. However, the ostensible meanings that result from this approach often seem to elucidate the imagery with which the signs in question are associated and offer some assurance that the sign system is not simply a part of the graphic repertory of Teotihuacan art but is a distinct category of symbol that serves a variety of purposes.

I have already mentioned striking examples of notation associated with sound scrolls and falling panels, but the most frequent use of signs might be described as annotative. Typically, a repetitive pattern of signs in the borders of mural paintings or in the rim and basal bands on pottery vessels supplements and annotates the imagery within the decorative area. To cite two simple examples — footprints indicating movement are featured in the border of the Tassel Headdress processional murals and a band of trilobal blood signs is associated with obsidian knives on a pottery vessel, suggesting sacrificial ritual. A more remarkable instance occurs at Tetitla in a mural painting depicting martial figures and their weapons, whose borders contain footprints and a repetitive sign cluster representing the well-known Mesoamerican metaphor for war — fire and water.[14]

The emblematic usage of notation is also common at Teotihuacan. Its purpose, as mentioned in the discussion of the Tassel Headdress, is to denote official status, rank, or membership in an association with military attributes. The best-known example is the variable cluster of motifs drawn from Storm God imagery found on shields held by warriors (fig. 6b), probably to indicate allegiance to the deity or invoke his protection. However, other common signs were used in a similar way, among them transverse bars, a collared bellshape, and a

Fig. 5
A selection of Teotihuacan signs with counterparts elsewhere in Mesoamerica: (a) bone, (b) serpent head, (c) water lily, (d) twisted cord, (e) interlaced bands, (f) hand B, (g) trefoil A, (h) pinwheel.

Fig. 6
Examples of the emblematic use of signs: (a) feather headdress symbol, (b) Storm God insignia, (c) transverse bars, (d) bellshape, (e) hand.

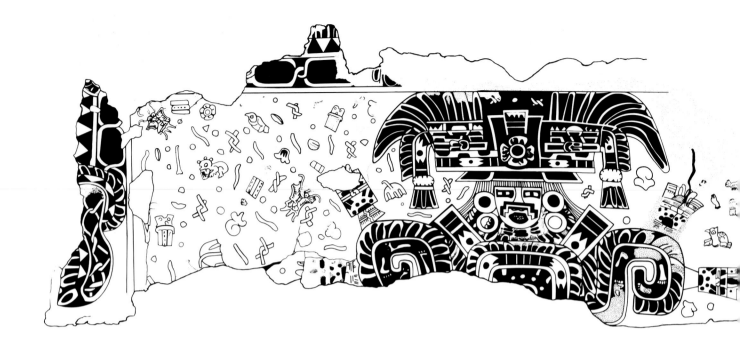

Fig. 8
Los Glifos mural. Found in a structure adjoining the Pyramid of the Sun. This drawing is based on slides taken by Dr. René Millon in 1965 and generously made available by him. The mural is located in the INAH conservation laboratory at Churubusco. © James C. Langley.

hand (fig. 6c-e). It is noteworthy that none of these signs is exclusively emblematic: transverse bars appear in other types of clusters, including a compound in the Flowering Trees mural; in addition to its presence on the hip-shields of the Maguey figures, the bellshape occurs among the signs in falling panels, and the hand is another prominent element in such panels and in the martial bird emblem (see the Small Birds murals).

Contextual evidence is highly suggestive of other forms of notational usage but these remain problematic and can only be briefly mentioned. In addition to the possible place and personal name glyphs referred to above, fairly extensive data exist to suggest the commemorative use of sign clusters on the decorative plaques of ritual incense burners and the use of notation with dynastic and martial connotations on pottery vessels and in mural paintings. Other, rather more puzzling, sign clusters are characterized by the permutation of a small number of signs in stereotyped configurations (the Core cluster, fig. 7) whose significance is obscure.

The most remarkable and puzzling example of sign usage at Teotihuacan occurs in a mural painting from a structure adjoining the Pyramid of the Sun, here published in full for the first time (fig. 8). In addition to a dozen birds, butterflies and other creatures, this mural contains over two hundred symbols, ranging from simple circles and pods to such familiar notational signs as interlaced bands and the triple mountain. The mural has not yet been studied in detail but its symbolism is related to that of the ritual censer and many of the same signs appear in both contexts.

In a broader perspective, Teotihuacan signs fall into one of two main groups. The smaller consists of about twenty-five signs that are either unique to Teotihuacan or are so identified with the metropolis that their usage elsewhere in Mesoamerica implies some form of Teotihuacan influence or presence (for example, the Storm God insignia, fig. 6b, and the signs in fig. 4). The other, larger group consists of signs that have counterparts in one or more of the cultures of Mesoamerica either in a form that closely resembles the Teotihuacan version (fig. 5) or,

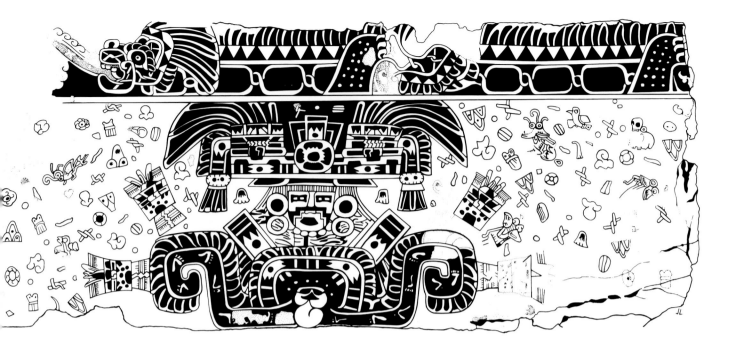

in the case of flowers, shells, and human heads, displays a generic relationship (cat. nos. 42, 47).

Although the parallels are extensive and often striking, the overlap in sign usage between the main Mesoamerican cultures is not consistent enough, nor are the similarities generally close enough, to demonstrate the existence of a pan-Mesoamerican sign system. The similarities do imply, as does evidence from other sources, that a good deal of communication occurred among the societies of Mesoamerica. It seems reasonable to assume a degree of intelligibility among sign systems. What we know of notation at Teotihuacan also implies a two-way diffusion of signs to and from the metropolis during the Late Preclassic and Classic periods. The origins of signs and their subsequent diffusion have not yet attracted much attention but would certainly repay study. The situation following the destruction of Teotihuacan is better documented in that ample evidence suggests the unilateral transmission of elements of Teotihuacan's notation to successors in the Mexican highlands, notably Cacaxtla and Xochicalco, and from them to the later Toltec and Aztec cultures.

The conclusion to be drawn from this evidence is that, while Teotihuacan notation contains many echoes of the sign systems used elsewhere in Mesoamerica and fulfilled a variety of functions, this notation made limited use of the sort of linear sign sequences that are the essence of traditional writing systems. In particular, nothing indicates any interest in emulating Maya or Zapotec literacy. In view of the many contacts between Teotihuacan and its neighbors, students have long puzzled over this apparent disinterest. Even more perplexing is the scant evidence for counting and a calendrical system — two related forms of notation that are almost universal among urban societies and are, in particular, fundamental to the development of writing in Mesoamerica.

Counting is such a basic and practical faculty of humankind that one would expect to find many numbers recorded at Teotihuacan, a society recognized as the hub of a vast trading system. This is not the

Fig. 7
Core cluster. Reconstructed from two fragmentary *adornos*. Museo Diego Rivera de Anahuacali, Mexico City. Drawing by James C. Langley.

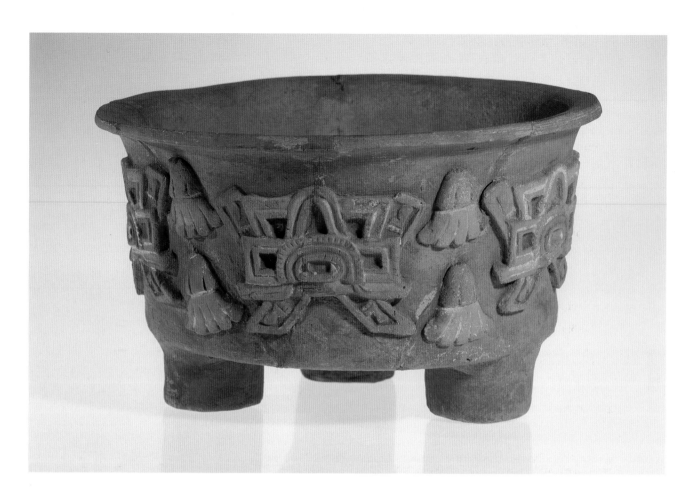

Cat. no. 143
TRIPOD BOWL WITH TRAPEZE-AND-RAY GLYPH
Yale University Art Gallery, Steven
Carlton Clark Fund.

case. The few indisputable numbers found there are either on portable objects or in the Tlalocan mural of Tepantitla where one or two bars are affixed to sound scrolls emanating from the mouths of spectators watching bowlers at play. Thus numerals in the bar-and-dot system were known at Teotihuacan, but the evidence for their use is so scanty as to raise questions about the adequacy of our data or, alternatively, about the nature of a society that could so completely dispense with written numeration.

Similar considerations arise in the case of calendrical notation. The calendar is generally recognized as one of the great intellectual achievements of Mesoamerica. Several scholars, notably including Caso,[15] have sought to show that the Teotihuacanos knew and used it. However, he was able to muster very few plausible examples of calendrical notation (that is, of day signs and numerals) and all were on portable objects. The most convincing are two conch shells bearing painted sign clusters consisting of a trapeze-and-ray motif (a year sign in the Mixtec culture), with infixed feathered eye and a numeral (cat. no. 53). A few other examples of possible calendrical notation exist but they constitute only a fraction of the corpus that might be expected if the calendar was in practical use at Teotihuacan. Not only does the typical Mesoamerican calendar include a vastly greater assortment of day signs and numerals, but one would expect a much greater representation in the data of each sign cluster. The point is well illustrated by the frequency of the emblematic use at Teotihuacan of the trapeze-ray with feathered eye infix and the rarity of this glyph's calendrical use as represented by

the two conch shells mentioned above.

The data on which the study of Teotihuacan notation is based represents the accumulation of over one hundred years of exploration and research at the metropolis and related sites. If the data sample is truly representative, it suggests a society that diverged in remarkable ways from the patterns of culture developed elsewhere in Mesoamerica over many centuries. The unusual forms of its notation and the apparent disinterest in recording numerals and calendrical information imply a sociocultural system so idiosyncratic as to challenge explanation. If, on the other hand, the data sample is not a true reflection of the culture, we may hope that, as in the recent past, new discoveries will produce data that will contribute toward a better understanding of Teotihuacan, its people, and society.

J. C. Langley is Secretary of the Canadian Society for Mesoamerican Studies.

1. R. Millon 1973; R. Millon, Drewitt, and Cowgill 1973.

2. Esther Pasztory, "Feathered Serpents and Flowering Trees with Glyphs," in Berrin 1988, 136-161.

3. Caso 1966, 250.

4. Miller 1973, 26.

5. Kubler 1967.

6. Bernardino de Sahagún, *The Florentine Codex, General History of the Things of New Spain*, book 2, ed. and trans. Charles E. Dibble and Arthur J.O. Anderson, 238-239 (Santa Fe: School of American Research, and Salt Lake City: University of Utah, 1981).

7. Antonio Peñafiel, *Teotihuacan: Estudio histórico y arqueológico* (Mexico: Oficina Topográfica de la Secretaría de Fomento, 1900).

8. Von Winning 1948.

9. C. Millon 1973.

10. Pasztory, "Feathered Serpents."

11. Langley 1986.

12. "Uber Steinkisten, Tepetlacalli, mit Opfer Darstellungen und andere ähnliche Monumente," in Seler 1960-1961, 2:725, fig. 11.

13. Angulo 1972, 51.

14. Séjourné 1969, pl.4.

15. Alfonso Caso, "Tenían los teotihuacanos conocimiento del Tonalpohualli?" *El México Antiguo* 4(1937):131-143.

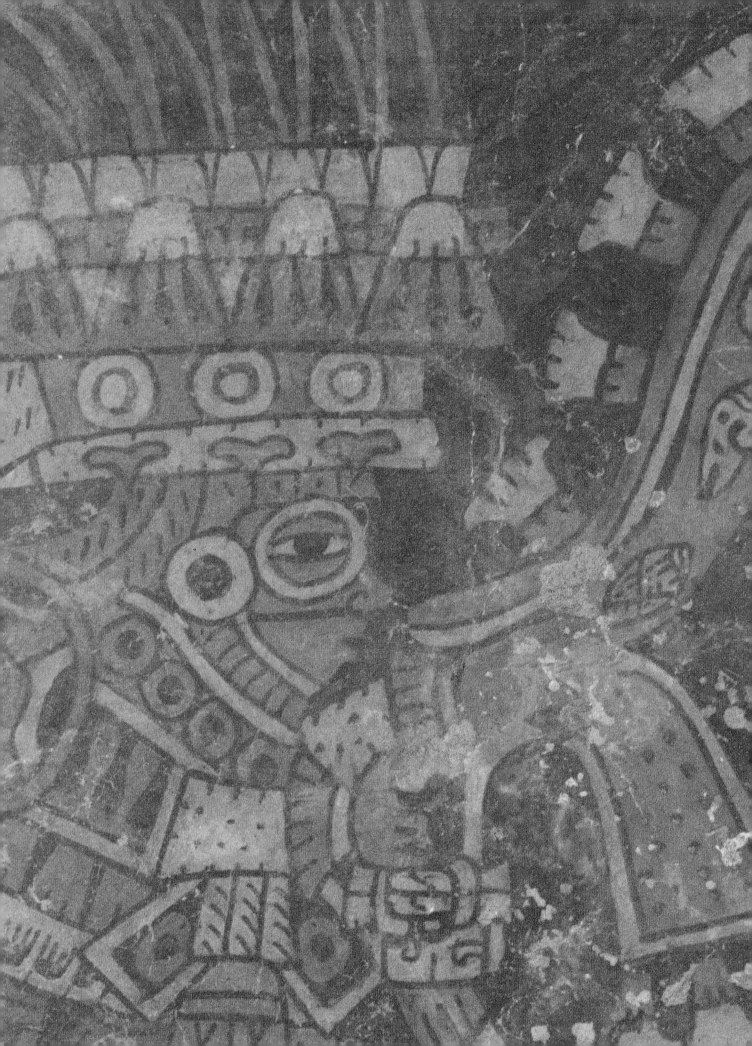

The Age of Teotihuacan and Its Mission Abroad

Clemency Chase Coggins

IN THE THIRD AND FOURTH CENTURIES of our era people traveled over four hundred miles north from Teotihuacan into the highland deserts at the Tropic of Cancer and more than twice as far over mountain ranges south to Copán at the southeastern corner of the region known as Mesoamerica, leaving unmistakable traces of their presence. What were they seeking? For many decades archaeologists have explained these journeys in terms of the production and exchange of essential goods, particularly obsidian, or as evidence of conquest. However, some doubt has been cast on this argument in favor of describing the long-distance trade of Teotihuacan as small in scale and dedicated to specialized elite goods, including the unusual green obsidian characteristic of Teotihuacan.[1] Conquest also seems unlikely because Teotihuacan held no intervening territory, and evidence of warfare is negligible.

The things that signal Teotihuacan presence in far-flung parts of Mesoamerica are distinctive (fig. 1). They represent the ideology of Teotihuacan, its cultural mind-set or *mentalité*; everywhere they have been found they are integrated into the fabric of the receiving culture. This integration is an indication of the success of Teotihuacan's mission abroad, which often involved militant missionaries, or priestly soldiers, who traveled to places where the Age of Teotihuacan and its religion of the Sacred Round, or count of 260 days, might prosper. Where they succeeded we have evidence of their intellectual and military presence. While this essay considers both the geographic and chronological span of the Age of Teotihuacan, in order to understand the great city's mission we must first look at its founding.

Fig. 1
Detail, Elite Figure Wearing
Tassel Headdress (cat. no. 44).

The Beginning

In Middle Preclassic times (ca. 1000 B.C.) the Valley of Teotihuacan was unimportant, but by the first century A.D. the population had expanded to 100,000 as the result of the deliberate resettlement of peoples from the much larger Valley of Mexico.[2] This presumably enforced congregation into the *first* city represents a utopian vision, or at the least a magnificent plan, that defied the fact that until then most people had lived in small villages and farmsteads, and no city had ever existed in Mesoamerica.

Teotihuacan was planned so that its long north-south axis focused on the mountain Cerro Gordo to the north, and the temples on top of the Pyramid of the Sun faced sunset on 12 August, which preceded "the day on which time began."[3] All subsequent buildings at Teotihuacan were constructed in harmony with this geomantic founding principle (see plan of Teotihuacan, Millon, fig. 2).

The Pyramids of the Sun and Moon were built early in the second century, following numerological principles of construction recently identified by Saburo Sugiyama, who has found multiples of an eighty-three-centimeter Teotihuacan measure in the layout of these pyramids that correspond to divisions of the calendar.[4] In the middle of the second century the third-largest pyramid, the Temple of the Feathered Serpent, was built to the southeast, marking the end of megaconstruction at Teotihuacan. The facades of the Temple of the Feathered Serpent (fig. 2) may have the earliest *taludes* and *tableros* at Teotihuacan, and the only monolithic stone ones. These architectural features consist of rectangular frames or *tableros* that project horizontally from the facade of a building, with a sloping talus wall or *talud*, which is visible below. The combined *talud-tablero* is absolutely distinctive, perhaps because it is structurally unstable[5] and thus architectonically arbitrary. The *talud-tablero* characterizes Teotihuacan wherever it is found after the founding of the city.

The rectilinear *talud-tablero* and the analogous ceramic form known as the cylinder tripod are both also emblematic of Teotihuacan and exemplify the Teotihuacan *mentalité*, as did the imposition of a geomantically constrained urban grid upon the undefined expanse of the Valley of Teotihuacan. The vision of the theocratic rulers of Teotihuacan was entirely intellectual — conceptual and theological — as was its message of rectitude. The regular, rational, structured, systematic, and above all the predictable were marshaled there against the natural, formless, idiosyncratic, and unforeseen — all in the name of what I propose to identify as an *Age of Teotihuacan*, which probably started near the beginning of our era. This Age of Teotihuacan consisted of a theologically, probably astronomically, defined number of 260-day cycles, or Sacred Rounds, within the infinitely recurring cycles of time. This religion of the Sacred Round and of the Age of Teotihuacan was spread abroad with the *talud-tablero* and the cylinder tripod. It differed from the calendar religion of contemporary Mesoamerican cultures in its final calculation of the number of sacred rounds, and in its vision of the total span of its own history.

If, as I suggest, Teotihuacan was a city of time dedicated to a religion of the Sacred Round and the Age of Teotihuacan, where is the evidence? No dates are found at the city, virtually no numbers were

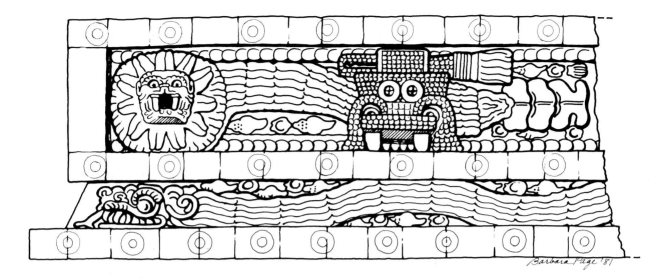

Barbara Page '81

written there, nor can we even be sure they were counting the days, as did every other Mesoamerican culture, using two intermeshed perpetually recycling calendars — the sacred ritual one of 260 days, and a practical solar one of 365 days. But there can be little doubt that they were. The striking orientation of Teotihuacan celebrates the historic day 12 August 3114 B.C., the second solar zenith, and the beginning of the 260-day count used by all Mesoamerican peoples. However, this particular zenith had occurred on this date far to the south at the latitude of Copán, Kaminaljuyú, and Izapa,[6] not at Teotihuacan itself. Furthermore it had occurred three millennia before the founding of the city. Teotihuacan did not invent the 260-day Sacred Round; it had been used by older southern cultures for centuries. But I suggest that Teotihuacan institutionalized it in a new way, constructing the city with geomantic principles involving both time and space that derived from the counts of the days.

Recent work at the Temple of the Feathered Serpent has supplied some new support for the role of Teotihuacan as custodian, if not the founder, of the original calendar. Excavations have revealed that as many as two hundred individuals, many of them captive warriors, were sacrificed in the dedication of the Temple of the Feathered Serpent about A.D. 150.[7] Many of the warriors, their hands tied behind their backs, wore pyrite disks and had obsidian projectile points, while some wore shell collars. Worked-shell platelets were characteristic elements of Teotihuacan military dress for the next six hundred years. This testimony to the massive sacrifice of warriors clarifies the role of the Temple of the Feathered Serpent at Teotihuacan, in that clearly a military element in its inaugural ceremony specifically involved the sacrifice of bound warriors. Dead warriors who may have been the victims of sacrificial ritual are explicitly portrayed at Monte Albán in the Middle Preclassic, as captives are later shown in the Maya Lowlands in the Classic and Postclassic periods, and in Late Postclassic Mixtec and Mexica imagery. The display and sacrifice of captives was a characteristically Mesoamerican practice, and sixteenth-century Spanish descriptions explicitly associate such Mexica ritual with period-ending calendar ceremony, and with the perpetuation of the cycles of the sun.

In its sculptural decoration, however, the Temple of the Feath-

Fig. 2
Facade of the Temple of the Feathered Serpent. Drawing by Barbara Page.

ered Serpent illustrates and commemorates the moment of creation as it was described in the highland Maya *Popol Vuh*, which was written at the southern latitude at which time began. This is the event that is venerated in the orientation of the temple itself. The *Popol Vuh* relates that in the still darkness before the creation only the creator plumed serpent lived in the ocean; then, by its word, the earth and human beings were not so much made as "thought."[8] Alfredo López-Austin, Leonardo López Luján, and Saburo Sugiyama have described the Temple of the Feathered Serpent as "dedicated to the passage of time," and they postulate that in its imagery the plumed serpent, which is depicted in the *tableros* and on the *taludes*, was the creator of "structured time" and thus of the calendar.[9] Furthermore, Sugiyama has made the valuable observation that what is usually read as the rear or tail head of the plumed serpent in the *tableros* is actually the serpent's headdress.[10] He and his coauthors argue that this image represents the earth crocodile Cipactli, patron of the first day of time and of the 260-day calendar.[11] In ancient Mesoamerica headdresses identify and name individuals, which is to say they are their conceptual equivalent. Here the sinuous plumed serpent is named by its rectilinear, unnatural, crocodilian headdress within the rectangular *tablero*, whereas the more natural plumed serpents swimming in the ocean of the *taludes* below have no headdresses. They would correspond to what López-Austin and his colleagues describe as "omnipresent, uncalendarized time."[12] If Teotihuacan was founded as the place to order time within the Age of Teotihuacan, its rulers portrayed and deified the first day, and thus the calendar, within the *tableros* of the Temple of the Feathered Serpent.

Each 260-day cycle is composed of twenty named days (Cipactli is the first) and thirteen numbers. Mesoamerican counting and calendar systems are based on the number twenty. Twenty individuals were sacrificed in the burial excavated beneath the center of the pyramid,[13] and possibly two hundred individuals sacrificed in all. The count of twenty is basic to the calendar, and may have been basic to the organization and naming of the Teotihuacan military as it was for the Maya, whose single word for war and warrior also signified a calendar unit of twenty.[14]

An echo of the ancient role of the Temple of the Feathered Serpent in commemorating the beginning of time, or the first day, is found in sixteenth-century Mexica myths that describe Teotihuacan as the place where the sun first rose.[15] In that primeval darkness light was created after a deity sacrificed himself by leaping into the great fire kindled by the gods. Burning, he became the sun which from that point rose in the east, and with this first sunrise time began at Teotihuacan. Similarly, in the Mexica religion the sacrifice of captive warriors ensured the continued rise of the sun, and the arrival of a new calendar cycle, as well as heavenly reward for the victims. Most important of these Mexica rituals was the drilling of new fire upon the breast of a noble captive every fifty-two years. This midnight ceremony ensured the return of the sun for the next complete cycle of combined 260-day and 365-day rounds. Finally the heart of the captive was thrown into the new fire.[16] Thus, both in the second century A.D. and fifteen hundred years later we have evidence of the sacrifice of warriors for the perpetuation of the calendar. However, Esther Pasztory believes that what the earlier Teotihuacan glorified was heart sacrifice, not conquest

or warfare — that the military symbolism of Teotihuacan had a mythic justification rather than a geopolitical one.[17]

There are indications that the Temple of the Feathered Serpent and its priesthood, which may have been military, were suppressed in the fourth century A.D.[18] when the front facade of the temple was burned (always symbolic of the destruction of a place in Central Mexico) and a pyramidal platform was built partly covering the pyramid. Warriors are not represented at Teotihuacan until late, so if actual sacrificed soldiers were not interred beneath the Temple of the Feathered Serpent in the second century and Teotihuacan warriors were not depicted abroad in the fourth century, we could not be sure any warriors were represented earlier in the site's history.

A revival of militarism may have taken place in the last century of the Age of Teotihuacan when warriors were first represented in wall paintings, most numerously in the Techinantitla compound within the military barrio.[19] Here we find officers wearing later versions of the kinds of uniforms worn abroad, and perhaps by some of the Temple of the Feathered Serpent sacrificial victims. These accoutrements include eye goggles, knots, year signs, coyote tails, and tassel headdresses, associated with projectile points.[20]

TEOTIHUACAN AT TIKAL

From the occurrence of green obsidian, sometimes found associated with fortifications in the third century A.D., we know Teotihuacan may have been pursuing its aims on the Pacific coast of Guatemala at Balberta,[21] and in the lowland Maya regions on the Caribbean coast of Belize at Altún Ha,[22] and at Becán in the Central Lowlands.[23] At the end of the fourth century A.D. a ruler of Tikal named Curl Nose (after his name glyph), who wore a Teotihuacan military headdress on his inaugural stela,[24] introduced a kind of calendar reform at the lowland Maya site.[25] Recent excavation at Tikal has tended to confirm the hypothesis about the calendar goals of Teotihuacanos in the Maya Lowlands, where the *talud-tablero* and cylinder tripod both made their appearance in the fourth century A.D. But the most significant indication of Teotihuacan in its militant role of defender, reformer, or promulgator of the Teotihuacan calendar is that the earliest signs of the foreigners were found at the locus of Tikal's ancient solar calendar ceremony — at the commemorative astronomical complex, which is of the type known as an E group.[26] These specialized architectural complexes marked and celebrated the equinoxes and solstices. They were involved with the calibration of the agricultural year, and had nothing to do with the Maya Long Count, which was a more linear, effectively noncyclic, historic count dedicated to recording the dynastic history of Maya rulers and their places in time.[27]

At Tikal between A.D. 250 and 300 eight *tableros* were added to the facade of Structure 5C-54,[28] which for almost a millennium had been the western radial pyramid of the commemorative astronomical complex. During the next century, as Teotihuacan-connected individuals settled in a group to the south, the whole plaza to the west of Structure 5C-54 was converted into a Teotihuacan plaza with the *talud-tablero* featured on each of the important buildings;[29] the Teotihuacan religion modified, or reformed, the old solar commemorative ritual that was carried out in the opposite, eastern, half of the plaza.

Fig. 3
Stela 31, Tikal. Courtesy of the University Museum, University of Pennsylvania, Tikal Project 69-5-176A. Drawing by William R. Coe.

These changes took almost a century and may have involved foreign men marrying into elite Tikal lineages. For these reasons the excavated Teotihuacan-like ceramic forms and the ritual they reflect were usually locally produced and performed, as was similarly true of the Teotihuacan presence at Monte Albán, Kaminaljuyú, and on the Pacific coast.

Teotihuacan sent their priestly emissaries for the long run, since their effectiveness depended on their becoming a part of the hereditary ruling families of Tikal society; furthermore, they may have had no place else to go because their principal shrine, the Temple of the Feathered Serpent, had been burned and thus destroyed symbolically. The same tactics were followed at Uaxactún, where a Teotihuacan-uniformed officer became ruler of Uaxactún after he, or his cohorts, had modified the Uaxactún commemorative complex and seen to the erection of the first *katun*-celebration monuments in the southern lowlands. These two stelae commemorated the Long Count date 8.16.0.0.0, or A.D. 357, a period-ending date that celebrated the abstract and ideal structure of the Maya Long Count, rather than the stelae's idiosyncratic role as historian of specific dynasties.[30] The Teotihuacan reform imposed the perfect structure of the Sacred Round of 260 days on the Maya Long Count, emphasizing the comple-

146

tion of a cycle of 260 *tuns*, or thirteen twenty-*tun* periods; this would have sacralized Maya time and emphasized its divine, universal, and impersonal structure for the calendar reformers of Teotihuacan. The name for the Long Count period of twenty *tuns*, the *katun*, was the same as the Maya word for soldier and the word for (holy?) war, probably as a result of this Early Classic Teotihuacan incursion.[31]

Curl Nose, the Teotihuacan-uniformed warrior (although perhaps he was some generations from Teotihuacan), became the ruler of Tikal in A.D. 378. After his death his son and successor, Stormy Sky, erected a stela (fig. 3) that portrayed his father twice, from two sides, as a Teotihuacan warrior who carried Teotihuacan weapons and wore shell platelet headdresses, a pyrite hip disk, a whole shell collar, and coyote tails. His father's shield portrays a figure with goggles, whole shell earspools, a nosebar, and the "tassel headdress" that identifies the highest-ranking Teotihuacanos abroad.[32] On this stela Stormy Sky combined traditional Maya practice with the foreign reforms of his father: the stela was erected at the time of a structured period ending, and on the back it detailed dynastic history, although this history was organized by regular *katun* endings, not by irregular human events. Curl Nose's calendar reforms were also symbolized by at least three of the "long-snouted" heads that adorn Stormy Sky's regalia; like the Cipactlis on the Temple of the Feathered Serpent, these represent Imix, the first day of the Maya Sacred Round.

When Stormy Sky died, little in his tomb reflected his father and the preceding period of elite Teotihuacanization at Tikal, except that he had probably died the exemplary death of a warrior. Stormy Sky's body was missing its head, hands, and likely its heart. These may have been taken in sacrifice after a battle and the rest of his body returned for royal burial.

The sixteenth-century Mexica warrior killed in battle or by heart sacrifice went to the blessed heaven of the sun;[33] as in the Islamic jihad, bravery and death in the service of religion were the soldier's supreme reward. Fire and water was the Mexica metaphor for war, and fire, at least, was an important part of Teotihuacan warrior symbolism. This is expressed indirectly in the tomb of the warrior Stormy Sky, whose single Teotihuacan-style grave furnishing was a stuccoed cylinder tripod that portrays on its wall a skull with blood dripping from its jaws, and on the lid a frieze comprising a Maya fire sign as part of the design of butterfly wings next to massed cocoons (fig. 4). This is the only known Early Classic Lowland Maya occurrence of this common Teotihuacan warrior symbolism. In this context, the butterfly denotes the soul of the dead warrior who had been metaphorically transformed in the cocoon (of burial), from which he emerged to sip nectar forevermore.[34] Such warrior imagery may also portray moths, since it is moths that immolate themselves in the flame, as soldiers did in war, and moths would thus epitomize the highest ideals of the warriors of Teotihuacan, who were finally transformed into butterflies after death.

The importance of the regalia of the warrior at Tikal and the associated introduction of "conquest war" into the Maya Lowlands are emphasized in a recent book by Linda Schele and David Freidel, who interpret the presence of Teotihuacan military imagery as indicating a new elite understanding of warfare, as they believe is evident in the conquest of Uaxactún by Tikal.[35] This victorious war, they postulate,

Fig. 4
Stuccoed and painted cylinder tripod. Tikal, Burial 48. Courtesy of the University of Pennsylvania.

147

Fig. 5
Carvings on the edges of stelae
in the four corners of the South
Platform at Monte Albán. Adapted
from Marcus 1984.

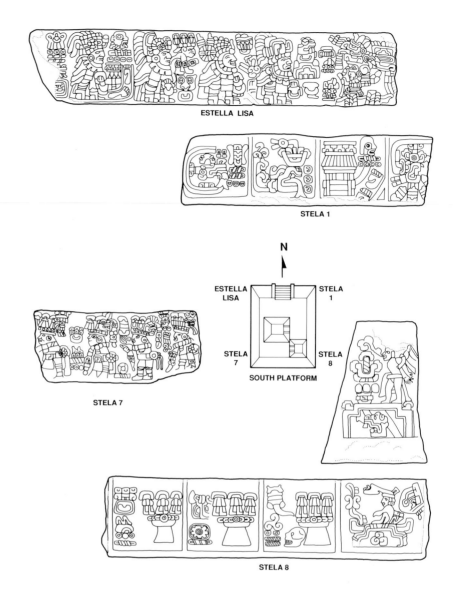

was carried out by the Tikal general Smoking Frog, who was the uncle
of Curl Nose. This interpretation is based on a number of equivocal
Early Classic inscriptions, and in connection with the role of Teotihua-
can I will disagree on one key point. I believe Smoking Frog and Curl
Nose were the same person; Smoking Frog was one of Curl Nose's most
important titles. It referred to his role as inaugurator of the Teotihua-
can calendar ritual of the drilling of new fire at Tikal.[36] A similar fire-
making title was used by the contemporary founder of the Copán rul-
ing dynasty,[37] who is also notable for his Teotihuacan characteristics.[38]
Curl Nose's own name glyph probably represents the Cipactli, or Imix,
serpent that denotes the first day, as it is represented by the serpent's
"headdress" on the facade of the Temple of the Feathered Serpent.
Karl Taube has recently described this as a fire serpent,[39] a characteriza-
tion that would allow us to sum up the two names and the role of Curl
Nose at Tikal as the introducer of the Cipactli/Imix fire-drilling cult of
Teotihuacan.

Schele and Freidel's reconstruction of Maya history acknowledges
the extraordinary significance of the sudden appearance of Teotihua-
can military uniform in the lowlands, and from this they infer the con-
comitant introduction of a new kind of warfare, but they do not attempt to

explain why this might have appeared, or who could have introduced such traits. I propose that the new practices were part of Teotihuacan's expansive religious design, as it was motivated and constrained by the demands of their calendar and the Age of Teotihuacan.

KAMINALJUYU AND COPAN

Along the latitude of the beginning of time, *talud-tablero* architecture was probably built in the Valley of Guatemala as early as the modifications of the Tikal astronomical complex.[40] At Kaminaljuyú, the *talud-tablero* was characteristic of temple buildings placed over rich tombs that, like the tomb of Curl Nose at Tikal, reflected the lives of powerful, cosmopolitan men with clear connections to Teotihuacan.[41] Combined with Maya imagery and iconography, those early fifth-century burials include the pyrite disks, projectile points, and likely remains of shell platelet headdresses found in the second-century burials of the Temple of the Feathered Serpent, as well as the warrior butterfly/moth symbolism so common later immediately to the south on the Pacific coast.

Explanations for the presence of these powerful foreigners at Kaminaljuyú have been offered since 1946 when Alfred Kidder, Jesse Jennings, and Edwin Shook published their excavations.[42] Did Teotihuacan conquer Kaminaljuyú? Were the foreigners warriors, priests, or merchants? Probably they were all of the above, but I suggest the leaders were warrior-priests interested in establishing a religious center at the highland capital that was located on the latitude of the beginning of time. Their calendric reasons may have involved the relationship between the Age of Teotihuacan, the Maya Long Count, and especially the Sacred Round, which began nearby — possibly at Kaminaljuyú. A Mayoid reptilian head depicted on ceramic vessels in these Kaminaljuyú tombs is the Imix "monster," which, like Cipactli, is the sign of the first day for the Maya.[43] Fourteen representations of this same Imix head in the Kaminaljuyú Maya style were carved on two cylinder tripods excavated from a burial in the Xolalpan apartment compound at Teotihuacan,[44] where it is likely they were emblematic of the religious role of Teotihuacan at Kaminaljuyú.

The Teotihuacan calendar elite were intent on introducing their reforms by the end of the Maya *baktun* eight cycle — the critical period ending 9.0.0.0.0 (A.D. 435). At Uaxactún and Tikal they had imposed their structural innovations several *katuns* earlier;[45] while at Copán to the east on the latitude of the beginning of time, where the sun first rises on Mesoamerica, the founder of Copán's Classic period ruling dynasty, Yax Kuk Mo, displayed Teotihuacan traits that he had probably brought from Kaminaljuyú at nearly the same time that Curl Nose was establishing his rule at Tikal.[46]

THE PACIFIC COAST

Teotihuacan-style censers (cat. no. 177) have been found in one or two places on the Pacific coast of Guatemala, although few come from controlled excavations. These were apparently associated with crude carved and molded cylinder tripods (cat. nos. 178-179). Most of the censers, which probably portray dead warriors,[47] employed the butterfly/moth and fire symbolism that glorified the ancestor warrior for whom incense was burned. These censers seem to me to reflect the final centuries of Teotihuacan's history, and the period of military revival evident

in the apartment compounds of Atetelco and Techinantitla, several centuries after the arrival of the Teotihuacanos at Tikal and Kaminaljuyú. The Pacific coast censers combined this late militarism with selected warrior symbolism also evident on late Monte Albán urns and censers, while the cylinder tripods displayed the ball-game imagery of El Tajín and Veracruz — regions from which Teotihuacan directly imported fine-paste ceramics,[48] rather than ideology.

Five or six centuries before Teotihuacan was laid out, Monte Albán was erecting monuments that commemorated conquests with named captives, places, and dates. The earliest clear evidence for the Calendar Round is found on monuments at Monte Albán, yet the day that time began was not commemorated in planning the great plaza of the site. Teotihuacan apparently did not learn the 12 August site orientation from Monte Albán, but it may have learned how to measure the zenith there, and have adopted from Monte Albán the measuring device that denoted the solar year and which came to be known as the Year Sign.[49] By learning how to measure the solar year at Monte Albán, the Teotihuacan calendar priests would have been able to take measurements at home and thus begin their own solar calendar and inaugurate the Age of Teotihuacan. This epoch was symbolized by the Year Sign often worn by the Teotihuacan Storm God at home and abroad. Most Mesoamerican cultural groups had their own calendars that, while all using the same 260-day Sacred Round, varied in the days they chose to begin or end their 365-day solar counts,[50] according to local geographic, ecological, and astronomical determinants.

René Millon has written of a "special relationship" between Teotihuacan and Monte Albán,[51] because some of the Teotihuacanos depicted at Monte Albán wear the military tassel headdress, but they carry strap bags, not weapons. Some also wear shell-platelet headdresses, whole shell collars, and pyrite disks with coyote tails behind. These constitute warrior dress, but they are also priestly attributes, as in this calendar region they were the same. I suggest these Teotihuacan emissaries went to Monte Albán, perhaps as early as the second century A.D.,[52] to acquire esoteric "scientific" knowledge but not to impose their calendar; thus the *talud-tablero* is not found at Monte Albán. As at Tikal, they married into the Monte Albán ruling families and eventually Teotihuacan costume and priestly attributes are found on portraits of the ancestors — in tombs 104 and 105,[53] on sculptural reliefs (cat. no. 176), and worn by the figures on the anthropomorphic ceramic urns that depict ancestors.[54]

When the great South Platform was built at Monte Albán (fig. 5), conquest stelae were erected at its four corners. On their edges, four of these monuments have long, narrow, manuscript-like scenes and compartments with signs that refer to the men portrayed; some wear the shell-platelet headdresses or whole-shell collars. Others wear Teotihuacan tassel headdresses and pyrite disks and all carry strap bags. The ones depicted on the edge of Stela 7 are named again on the edge of Stela 8, where they are conceptualized as incense burners, which is to say as ancestors. The bound captive on the front of Stela 8 is named 8J. Among the various representations of Teotihuacanos at Monte Albán seem to be a disproportionate number of individuals identified by the day signs J and Turquoise. I suggest that these signs denote the names of two interrelated lineages into which the Teotihuacanos had married, rather than the names of individuals. One of these powerful lineages,

designated 8J, was defeated and its leader probably sacrificed, possibly early in the third century A.D., near the beginning of Monte Albán IIIA. This may have signified the major victory of a new ruler of Monte Albán over several influential families that had dangerous ties with the newly threatening Teotihuacan. This conquest was followed by the construction of the South Platform with its victory monuments.

After this defeat the 8J lineage packed up its ancestral urn and moved to Teotihuacan, founding what is now known as the Oaxaca Barrio at the western edge of the city, which was building its earliest apartment compounds. There they lived in genteel poverty, recreating at Teotihuacan the out-of-date Monte Albán pottery of the time of their flight, and venerating the urn of their 8J lineage ancestor, until finally it was ritually broken at the end of the Age of Teotihuacan when the center of the city was destroyed. There is no indication these exiles kept in touch with the motherland; instead they re-created the Monte Albán tombs of their ancestors.[55] In one of these Teotihuacan tombs they used as a door jamb a five-hundred-pound stone that they had dragged all the way from the facade of the Temple of the Feathered Serpent (cat. no. 175, this essay).[56] This act of combined reverence for the Temple of the Feathered Serpent and for the ancestral tomb might perfectly illustrate their role at Teotihuacan as the displaced followers of the old-time Teotihuacan calendar religion that had been carried to Monte Albán in the century after the construction of the Temple of the Feathered Serpent, when its emissary warrior-priests probably first married into the 8J lineage of Monte Albán.

Although the carvings suggest that the defeat of more than one Teotihuacan-affiliated lineage may have been celebrated on the Monte Albán stelae of the South Platform, Teotihuacan signs and costume continued to be used by other lineages whose ancestor urns were made after A.D. 450 in Monte Albán IIIA (cat. no. 174). Some of the enduring Teotihuacan connections with Monte Albán may have involved the specialized, elite-controlled exchange of green obsidian for shell from the Pacific coast of Oaxaca.[57]

Indications of the importation of shell from Oaxaca may be found in the Tetitla apartment compound where wall paintings portray the bust of a frontal figure with crossed arms, flanked by six bearded old men in profile.[58] These are all painted in the style of the murals in Monte Albán tombs 103 and 105 that also include portraits of male members of the J and Turquoise families wearing shell-bedecked Teotihuacan costume. These Monte Albán-style figures at Teotihuacan are found on three walls of an interior room at Tetitla where they are surrounded by images of whole bivalve shells like those worn by Teotihuacanos as collars and placed in their caches. In a nearby portico at Tetitla different wall paintings actually depict divers collecting such shells in the ocean.[59]

Evidence of elite connections with the Maya Lowlands like those exemplified by the carved cylinder tripod from Xolalpan (cat. no. 133) is also found at Tetitla, but in unpublished, fragmentary wall paintings with Mayoid glyphs and figures that include repeated images of the same Maya Imix reptile that, like Cipactli, is the sign of the day that time began.

The early expansion of Teotihuacan abroad appears to have involved a militant priesthood intent on reaching and marking the astro-

nomically defined edges of Mesoamerica. At the sun's northernmost
point they measured the zenith on the summer solstice at the Tropic
of Cancer;[60] while to the southeast at Copán they celebrated where the
sun first rose on 12 August. At Copán, Uaxactún, and Tikal warrior-
priests were evidently dedicated to a calendar reform that involved im-
posing the structure of the Sacred Round on the Maya Long Count
and founding new dynasties in time for the major period-ending of
9.0.0.0.0. At Kaminaljuyú no contemporary writing has survived so only
the dead warrior-priests remain in the tombs accompanied by calendar
symbolism, and the temples with the *talud-tablero* as the signs of the
religion of Teotihuacan. At Monte Albán the military calendar special-
ists may initially have sought astronomical knowledge, but the Teoti-
huacanos stayed to trade.

The great city of Teotihuacan was the sacred facsimile of the place
where time and the calendar began. As the intellectual recreator of its
own calendar and of the Age of Teotihuacan, its religion ordered and
measured time and space, foreseeing the end in the beginning.

In the last century before the prophesied end of the Age of
Teotihuacan the early militant calendar cult was perhaps revived.

Then, inevitably, the calamitous conclusion was engineered on schedule by the keepers of the calendar of Teotihuacan. I suggest they demolished and burned their own religious structures in a systematic campaign of destruction unequaled for its "scale, intensity, duration and sheer excessiveness."[61] Teotihuacan's temples were not renewed, just as San Lorenzo, Izapa, Monte Albán, and Tikal were never revived after the end of their respective cycles.

Clemency Chase Coggins is Professor of Archaeology and Art History at Boston University.

1. Robert D. Drennan, "Long-Distance Movement of Goods in the Mesoamerican Formative and Classic," *American Antiquity* 49, no.1(1984):27-43. John E. Clark, "From Mountains to Molehills: A Critical Review of Teotihuacan's Obsidian Industry," in *Economic Aspects of Prehispanic Highland Mexico*, ed. Barry L. Isaac, 2:23-74 (Greenwich, Conn.: Research in Economic Anthropology Supplement, 1986).

2. R. Millon 1992b, 268-271.

3. Drucker 1977; R. Millon 1981.

4. Saburo Sugiyama, "Worldview and Society at Teotihuacan," paper presented at the 57th annual meeting of the Society for American Archaeology, Pittsburgh, 8-12 April 1992.

5. George Kubler, "Iconographic Aspects of Architectural Profiles at Teotihuacan and in Mesoamerica," in *The Iconography of Middle American Sculpture*, 24-39 (New York: The Metropolitan Museum of Art, 1973), 25-26.

6. Vincent H. Malmström, "Architecture, Astronomy and Calendrics in Pre-Columbian Mesoamerica," in *Archeoastronomy in the Americas*, ed. R.A. Williamson, 249-261 (Los Altos, Calif.: Ballena Press, 1981).

7. Sugiyama 1989a; Cabrera, Sugiyama, and Cowgill 1991, 85-86. Also see Rubén Cabrera and Carlos Serrano, this volume.

8. Munro S. Edmonson, *The Book of Counsel: The Popol Vuh of the Quiché Maya of Guatemala* (New Oreans: Middle America Research Institute, no.35, Tulane University, 1971), 10-11.

9. López-Austin, López, and Sugiyama 1991, 103, 95.

10. Sugiyama 1989b; Taube 1992a.

11. López-Austin, López, and Sugiyama 1991, 96-101.

12. López-Austin, López, and Sugiyama 1991, 99.

13. Cabrera, Sugiyama, and Cowgill 1991, 84-86.

14. Clemency Chase Coggins, "The Shape of Time: Some Political Implications of a Four-part Figure," *American Antiquity* 45, no.4(1980):733.

15. Bernardino de Sahagún, *The Florentine Codex, General History of the Things of New Spain*, book 7, trans. Arthur J.O. Anderson and Charles E. Dibble, Monographs of the School of American Research no.14, pt.8 (Santa Fe: School of American Research and the University of Utah, 1953), ch.2.

16. Sahagún, *The Florentine Codex*, book 7, chs. 10, 12.

17. Esther Pasztory, "El poder militar como realidad y retórica en Teotihuacan," in Cardós de Mendez 1990, 186.

18. R. Millon 1988a, 154.

19. R. Millon 1988b.

20. C. Millon 1988.

21. Frederick J. Bove, "Teotihuacan Impact on the Pacific Coast of Guatemala: Myth or Reality," paper presented at 52nd meeting, Society for American Archaeology, Toronto, May 1987.

22. Pendergast 1971.

23. Irving Rovner, "Implications of the Lithic Analysis at Becán," in *Preliminary Reports on Archaeological Investigations in the Rio Bec Area, Campeche, Mexico*, comp. R.E.W. Adams, 128-132 (New Orleans: Middle American Research Institute, no. 31, Tulane University, 1974), 128-129.

24. Coggins 1979; Clemency Chase Coggins, "A New Order and the Role of the Calendar: Some Characteristics of the Middle Classic Period at Tikal," in *Maya Archaeology and Ethnohistory*, ed. Norman Hammond, 38-50 (Austin: University of Texas Press, 1979).

25. Coggins, "New Order"; Coggins, "Shape of Time."

26. Anthony F. Aveni, Horst Hartung, and J. Charles Kelley, "Alta Vista (Chalchihuites), Astronomical Implications of a Mesoamerican Ceremonial Outpost at the Tropic of Cancer," *American Antiquity* 47, no.2(1982):316-335.

27. Coggins, "New Order"; Coggins, "Shape of Time."

28. Juan Pedro La Porte and Vilma Fialko C., "New Perspectives on Old Problems: Dynastic References for the Early Classic at Tikal," in *Vision and Revision in Maya Studies*, eds. F.S. Clancy and P.D. Harrison, 33-66 (Albuquerque: University of New Mexico Press, 1990), 46.

29. La Porte and Fialko, "New Perspectives," 46.

30. Coggins, "New Order"; Coggins, "Shape of Time."

31. Coggins, "Shape of Time," 733.

32. C. Millon 1973; C. Millon 1988.

33. Bernardino de Sahagún, *The Florentine Codex, General History of the Things of New Spain*, book 3, trans. Arthur J.O. Anderson and Charles E. Dibble, Monographs of the School of American Research no.14, pt.4 (Santa Fe: School of American Research and the University of Utah, 1952), appendix, ch.3.

34. Hermann Beyer, "La mariposa en el simbolísmo Azteca," *El México Antiguo* 10(1965):465-468.

35. Linda Schele and David Freidel, *A Forest of Kings: The Untold Story of the Ancient Maya* (New York: William Morrow, 1990), ch.4.

36. Clemency Chase Coggins, "New Fire at Chichén Itzá," *Memorias del Primero Congreso Internacional de Mayistas* (1987):427-482, Centro de Estudios Mayas, Universidad Autónoma de México, 1987; Clemency Chase Coggins, "The Birth of the Baktun at Tikal and Seibal," in *Vision and Revision in Maya Studies*, eds. F.S. Clancy and P.D. Harrison, 79-97 (Albuquerque: University of New Mexico Press, 1990).

37. Linda Schele, "The Founders of Lineages at Copán and Other Maya Sites," *Ancient Mesoamerica* 3, no.1(1992):135-144, fig. 8.

38. Clemency Chase Coggins, "On the Historical Significance of Decorated Ceramics at Copán and Quirigua and Related Classic Maya Sites," in *The Southeast Classic Maya Zone*, eds. E.H. Boone and G.R. Willey, 95-123 (Washington, D.C.: Dumbarton Oaks, 1988).

39. Taube 1992a.

40. Kenneth L. Brown, "The Valley of Guatemala: A Highland Port of Trade," in Sanders and Michels 1977, 205-396.

41. Kidder, Jennings, and Shook 1946, ch. 8; Charles D. Cheek, "Excavations at the Palangana and the Acropolis, Kaminaljuyú," in Sanders and Michels 1977, 41-158; Coggins, "Teotihuacan"; Coggins, "New Order."

42. Cheek, "Excavations," 159-169.

43. Kidder, Jennings, and Shook 1946, fig. 97.

44. Linné 1934, figs.28-29; Jacinto Quirarte, "Izapan and Mayan Traits in Teotihuacan III Pottery," *Contributions of the University of California Archaeological Facility*, no.18 (1973):11-29.

45. Coggins, "Birth of the Baktun."

46. Coggins, "Historical Significance."

47. Von Winning 1977; Berlo 1984, 105; Berlo 1989a, 154-155.

48. Evelyn C. Rattray, "Los barrios foráneos de Teotihuacan," in *Nuevos datos, nuevas síntesis, nuevos problemas,* ed. E.McClung de Tapia and Evelyn C. Rattray, 243-273. Instituto de Investigaciones Antropológicas, Serie Antropología no.72 (Mexico: Universidad Nacional Autónoma de México, 1987), 259-264.

49. Coggins 1983, 59-63.

50. Munro S. Edmonson, *The Book of the Year: Middle American Calendrical Systems* (Salt Lake City: University of Utah Press, 1988).

51. R. Millon 1973, 42.

52. John Paddock, "The Oaxaca Barrio at Teotihuacan," in *Cloud People*, eds. K.V. Flannery and J. Marcus, 170-175 (New York: Academic Press, 1983), 172-173.

53. Joyce Marcus, "Stone Monuments and Tomb Murals of Monte Albán IIIA," in *The Cloud People: Divergent Evolution of the Zapotec and Mixtec Civilizations*, eds. Kent V. Flannery and Joyce Marcus (New York: Academic Press, 1983), 137-143.

54. Alfonso Caso and Ignacio Bernal, *Las urnas de Oaxaca*, Memorias no.2 (Mexico: INAH, 1952), figs. 178, 346, 507-508; Joyce Marcus, "Rethinking the Zapotec Urn," in Marcus, *Cloud People*, 144-148.

55. Rattray 1987, 244-257; Michael W. Spence, "A Comparative Analysis of Ethnic Enclaves," paper presented at the 57th annual meeting, Society for American Archaeology, Pittsburgh, 8-12 April 1992.

56. Sugiyama 1989a, 104.

57. Drennan, "Long Distance," 38; Robert S. Santley, "Obsidian Trade and Teotihuacan Influence in Mesoamerica," in *Highland-Lowland Interaction in Mesoamerica: Interdisciplinary Approaches*, ed. A.G. Miller, 69-124 (Washington, D.C.: Dumbarton Oaks, 1983), 104; Gary M. Feinman, Linda M. Nicholas, and Scott L. Fedick, "Shell-working in Prehispanic Ejutla, Iaxaca (Mexico): Findings from an Exploratory Field Season," *Mexicon* [Berlin] 13, no.4(1991):69-77.

58. Miller 1973, 268-273.

59. Miller 1973, figs. 274-277.

60. Aveni, Hartung, and Kelley, "Alta Vista."

61. R. Millon 1988a, 156.

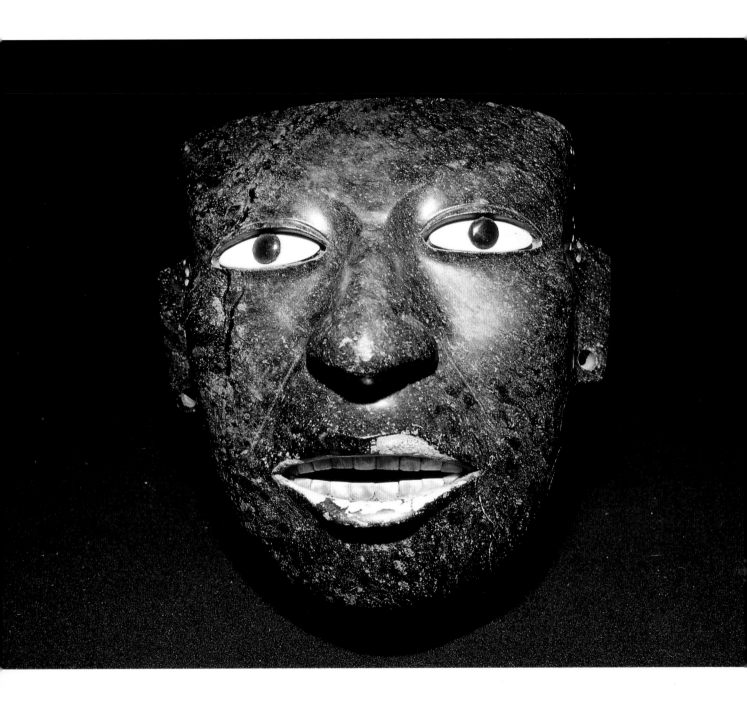

Fig. 1
Teotihuacan-style mask with shell and
stone inlaid eyes and teeth. Offering 82,
Templo Mayor, Tenochtitlan.

Teotihuacan
and Its
Mexica Legacy

Eduardo Matos Moctezuma and Leonardo López Luján

And so they named it Teotihuacan:
because it was the burial place of rulers.
For it is said: When we die,
we do not truly die,
because we are alive,
because we are brought back to life,
because we still live,
because we awaken....
Thus, the elders said:
"He who died became a god."[1]

IN THE YEAR 1502, on the day 9 Deer, Motecuhzoma Xocoyotzin ascended the throne of Mexico-Tenochtitlan in an unprecedented ceremony, and with it he inherited what would be the most powerful empire in Mesoamerica at the time of the arrival of the Europeans. The tumultuous island-city had been decked out as never before for the occasion. Lodged in its palaces were the most distinguished leaders from the allied domains, provinces, and enemy city-states. When the moment arrived and after sumptuous banquets, endless dances, and flowery speeches, Motecuhzoma "the younger" was publicly anointed and crowned. In the following act, at the sacrificial block of the Templo Mayor, the images of the gods were fed, as was customary, with the blood of captives recently caught on the battlefield.

Meanwhile, some forty kilometers (twenty-four miles) to the northeast of Tenochtitlan, at the site known by native peoples of the sixteenth century as Teotihuacan, something very different was happening. Amid silence and desolation rose the majestic ruins of the hegemonic capital of the classical world, which was the first city on the American continent. No fewer than eight hundred years had elapsed since its decline and the disintegration of its age-old tradition that had endured hundreds of years. With the irremissible passage of time, Teotihuacan had been transformed into a true archaeological metropolis stripped of all historical significance. Its ceremonial center was completely abandoned and the silhouettes of many of its buildings could only be vaguely surmised beneath the vegetation.

The Mexicas, now masters of the political scene, never even came to know what language was spoken by its original inhabitants. Knowledge lost of its prior existence, the history of Teotihuacan soon shifted from the real to the mythical. Postclassic peoples did not take long to offer all kinds of explanations about its origins. They believed, for

example, that huge, disproportionate giants had built the pyramids, an idea that undoubtedly arose from Mexica astonishment over the majesty of the ruins.

> And so [the first men] built very large mounds to the Sun and the Moon, as if they were just like mountains. It is unbelievable when they say that these were made by hand; but at that time giants still lived there.[2]

In other accounts, the incomparable undertaking is attributed to people as renowned as the Toltecs and the Totonacs.[3] Nevertheless, according to the most well-known account, what was unquestionably the work of humans was attributed to the gods. Teotihuacan appears from this point of view as the place of origin of the Fifth Sun, the cosmic era in which the Mexicas lived; it was the last era, that of the center, the color green, and of earthquakes or movement. It occurs in no less than the place where the dramatic sacrifice of the gods was consummated so that the new sun would undertake its definitive march. This is the account given by the informants of friar Bernardino de Sahagún:

> It is said that even when it was night, even when there was no light, when dawn had not yet come, they say that they gathered, they called the gods together there at Teotihuacan.[4]

Among the gods who gathered there, Tecuciztecatl and Nanahuatzin were the ones selected; with their penance and death they would restore the sun and life itself. Four days and four nights they fasted and offered their own blood in sacrifice:

> A mountain was made for each one of them, where they stayed doing penance for four nights. Now it is said that these mountains are the pyramids: the Pyramid of the Sun and the Pyramid of the Moon.[5]

At midnight on the appointed day, Nanahuatzin in a surge of bravery leaped into a huge bonfire, and not to be outdone Tecuciztecatl had to do the same. The myth tells us that both reappeared in the east at dawn, transformed into the Sun and the Moon, respectively. This idea, in which Teotihuacan is considered to be the place of rebirth for these divinities, is perhaps the origin of the Nahuatl designation for the city — "Teotihuacan" or "place where one may become a god."

Just as the native sages told Sahagún, once the Sun God was created with the body of Nanahuatzin, the problem arose of the sun's immobility. So the gods met again to discuss this and take extreme measures:

> "How will we live? The sun does not move. Will we perhaps give a new life without order to the *macehuales*, to human beings? May the sun become strong through us! We shall all die!"[6]

It is curious that in addition to this myth Sahagún transmits another native version, very different from the earliest one, about the founders of Teotihuacan. Referring to the migration of a complex of groups originally from the mythical Tamoanchan, the Franciscan notes the following:

> They moved at once; all following the path; the child, the venerable sage, the young woman, the venerable woman elder. Calmly, quietly they advanced toward the place where they went to settle together at Teotihuacan. There they established the government. They were elected rulers — the sage, the *nahuales*, the masters of spells.[7]

And the whole world made mounds there to the Sun and to the Moon; then they made many small mounds. There they said prayers. And rulers were installed there. And when lords died, they buried them there. Then on top of them they built a mound.[8]

In this pair of quotations it is evident that the Mexicas assumed that the two Teotihuacan pyramids of greatest dimensions had been dedicated by its builders to the solar (*Tonatiuh itzacual*) and lunar cults (*Metztli itzacual*). This was probably not the case, because several specialists believe that the colossal constructions, comparable only to the pyramid at Cholula, were raised in honor of aquatic deities. Another totally erroneous idea recorded in these passages has to do with the principal street of the City of the Gods; the Mexicas christened this avenue with the Nahuatl name of Miccaotli (Street of the Dead) based on the false belief that the structures flanking its entire length functioned as funerary mounds of ancient Teotihuacan lords.

By the end of the fifteenth century, Classic Period Teotihuacan (A.D. 250-700) had been converted into a renowned cult and pilgrimage center. Thanks to the sixteenth-century document the "Relación de Tequizistlán y su partido," we know that the towns of the Basin of Mexico attributed the city with a strong sacred character and that they continued venerating the old images (fig. 2):

Fig. 2
Drawing from the map from the "Relación de Tequizistlan y su partido," showing Pyramids of the Sun and Moon and seven other mounds. The Spanish legend reads, "Montecuma's Oracle." From *Relaciónes geográficas del siglo XVI*.

There were other lesser idols [worshipped by the Mexicas] in the town of San Juan, which was the [location of the] temple and oracle attended by nearby towns. In this town they had a very tall temple where there were three landings to ascend to the top: at the summit of it was a stone idol called by the name TONACATEUCTLI, which was made of a single very rough, very hard stone. It was three *brazas* [1 braza = 1.7 meters or 5.6 feet] long and another wide, and another in depth. It faced the west and on a plain that stretched in front of this temple, there was another smaller temple, of three *estados* [1 estado = about 2.1 meters or 7 feet] in height on which was another idol a little smaller than the first one, called MICTLANTEUCTLI, which means "Lord of Hell." This faced the first, set on a large, square boulder, one square *braza* on all sides. A little further, toward the north, was another temple slightly smaller than the first, which was called "the hill of the Moon," on top of which was another idol, almost three *brazas* tall, which was called THE MOON. All around it were many temples, in one of which [the largest of them] there were six other idols, who were called BROTHERS OF THE MOON, [and] the priests of MONTEZUMA, lord of Mexico, came with this MONTEZUMA, every twenty days to [offer] sacrifices to all of them.[9]

Based on the assiduous visits mentioned in this account, it is logical that the Mexicas as well as nearby peoples would have been interested in knowing what was hidden in the ruined mounds of Teotihuacan. With all certainty, curiosity led them to excavate some of its buildings on more than a few occasions. The imitation of Teotihuacan architecture, mural painting, and sculpture that occurred during the Late Postclassic Period (A.D. 1350-1520), as well as the presence of actual materials from the City of the Gods in offerings from the Templo Mayor of Tenochtitlan (in present-day Mexico City) can only be explained by this type of "archaeological" activity. This should not strike

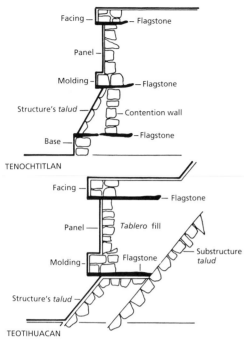

Fig. 3
A comparison of architectural profiles at Tenochtitlan and Teotihuacan.

us as unusual, for other Mesoamerican civilizations were accustomed to removing "antiquities" from sepulchers and offerings belonging to noncontemporary societies. In fact, the Mexicas also carried out premeditated explorations at Olmec and Toltec sites.[10]

Clearly the vestiges of the City of the Gods served as an archetype for Postclassic generations. It is not accidental, for example, that there is a grid plan at Teotihuacan analogous to that of Tenochtitlan, made up of a sacred precinct from which extended two orthogonal axes that divided the city into four parts. In effect, different scholars have noted how the center of Teotihuacan is located at the Ciudadela, at the intersection of the principal avenues — the Street of the Dead, from north to south, and the East-West Avenue.[11] This would have divided Teotihuacan into four sections or quadrants. Similarly, the Tenochca ceremonial precinct, surrounded by alternating walls and stairways delimiting the sacred space, recalls the Ciudadela compound.

Teotihuacan architecture also served as a source of inspiration for Mexica craftsmen, who integrated isolated elements into their work without respecting the internal coherence of old styles, or their proportions and symbolism. In this way, imitations acted more as evocations of the past than as parts of an integral context. What is certain, in several buildings in Tenochtitlan and Tlatelolco (also in present-day Mexico City), is that Teotihuacan architectonic and decorative traits were harmoniously fused with those that were in vogue at the time of their construction.

Up to now, four buildings in marked archaistic style have been exhumed from the lands that occupied the Sacred Precinct of Tenochtitlan. The first was discovered next to the intersection of the present-day streets of Justo Sierra and República de Argentina; the second behind the apse of the Metropolitan Cathedral; and the two remaining (Shrine C and the Red Temple) to the northeast and southeast of the Templo Mayor, respectively.

These buildings share a longitudinal orientation from east to west. Three of them have almost identical dimensions and forms, while the fourth in general resembles them. It is very probable that this similarity indicates the rigorous planning that took place prior to construction of the compound and that their construction was contemporaneous.

Each building is made up of two parts, a massive platform with stairway and a small open space toward the front, like an atrium. Both elements grow out of the same base, which contributes to the harmony and unity of the compound. The massive platform is distinguished by its exterior profile, in which a short, sloped *talud* rests under a projecting *tablero* of vertical panels. The form and proportion of this profile is highly reminiscent of the architectural style disseminated by Teotihuacan between the third and eighth centuries. We should mention that wholly Mexica elements are added to these archaizing ones; for example, balustrades that are inclined at the base of the structure and that end in a small platform at the top are the Mexica version of the continuously sloped balustrade characteristic of Teotihuacan.

It is interesting that construction techniques of Tenochca buildings are quite unlike those regularly used in the City of the Gods (fig. 3). It seems that the Mexicas were solely interested in formal appearances. Although at Teotihuacan the *tablero* rests directly on the *talud*, at Tenochtitlan the latter do not have a structural function; the *talud*

160

only serves as a facade for an interior stone wall that bears the stress of the building nucleus while it sustains the upper *tablero*.

These Mexica buildings have rich polychrome decoration, largely sharing the same characteristics as Teotihuacan mural painting as defined by Arthur Miller — two-dimensionality, visual juxtaposition, technique of manufacture, and utilization of repetitive patterns.[12] Just as red predominates in the mural paintings of Teotihuacan, the major themes relate to frontally represented deities flanked by profile figures in processions, geometric and rectilinear designs, representations of ritual paraphernalia, and zoomorphic images. Also abundant are motifs related to the water cult (Tlaloc mask, cut shells, currents of water, and trilobe motifs that represent water droplets), as well as pairs of bows (fig. 4).

Another building very similar to the ones described above was discovered in the ruins of Mexico-Tlatelolco, twin city to Mexico-Tenochtitlan. The competition between these two Mexica cities had repercussions in the architectural development of their respective sacred precincts; the construction, remodeling, and destruction of these architectural compounds were practically parallel. Both were built on the same plan and consequently their general characteristics are very similar: these quadrangles have similar dimensions; they are confined by a platform with alternating stairways and balustrades; and the main temples are dedicated to Tlaloc and Huitzilopochtli, exhibiting the same number of rebuildings. In this context it is not surprising to find a small Teotihuacanoid-style building at Tlatelolco similar in form, dimensions, and relative position to the so-called Red Temple. Building L was located on the southeast side of the Tlatelolcan Templo Mayor. It is characterized by a low platform that serves as base for a Teotihuacanoid profile body and an "atrium." Just like the Red Temple, it has a repeated decoration of pairs of bows, although these are worked in low relief in stone.

Traits reminiscent of Teotihuacan are also present in Mexica sculptural art. One of the most striking examples is a basalt monolith measuring about seventy-seven centimeters in height (two-and-one-half feet) that dates to the end of the fifteenth century or the beginning of the sixteenth (fig. 5). This sculpture was found in the area of Shrine C, which leads us to believe that it occupied the upper part of this building. It represents an anthropomorphic image seated with crossed legs. It is hunched forward and sustains on its head a great cylindrical vessel decorated on the sides with alternating motifs of pairs of bars and "eyes." The hands rest directly on the knees in different positions: the right hand is extended with the palm up, while the left is completely clenched. These attributes are characteristic of representations of the God of Fire. Although this type of representation goes back to the Formative Period, it is during the Classic — and especially at Teotihuacan — when it acquires its orthodox form and is frequently reproduced. What is really interesting is that in the following period, the Postclassic, its production ceases and the Mexica sculpture found in the Templo Mayor bears attributes atypical of the Teotihuacan style itself — rectangular plaques that cover the eyes and mouth, fangs that emerge from the latter, massive brazier, and lack of facial traits indicating age.

The Mexicas did not only copy Teotihuacan art, they also ex-

Fig. 4
Murals at Teotihuacan and Tenochtitlan: (a) Tetitla, Teotihuacan (Miller 1973, 143); (b) Tetitla, Teotihuacan (Doris Heyden, "Symbolism of Ceramics from the Templo Mayor," in Elizabeth H. Boone, ed., *The Aztec Templo Mayor* [Washington, D.C.: Dumbarton Oaks, 1987], 125); (c) Shrine at Argentina and Justo Sierra, Tenochtitlan (Eduardo Matos Moctezuma, "El adoratorio decorado de las calles de Argentina," in *Anales del INAH*, no. 17 [1965]:135).

Fig. 5
Mexica stone brazier of Masked Fire
God (Huehueteotl). Shrine C, Templo
Mayor, Tenochtitlan.

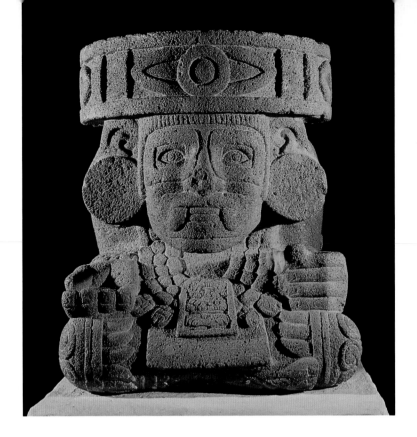

tracted numerous manufactured objects from the ruins of the ancient archaeological city. Although it is feasible that some of these pieces might have been the result of fortuitous finds in the City of the Gods, the vast majority were obtained from specific searches, as mentioned by several colonial texts. We are unaware of the circumstances under which these undertakings were carried out and the type of individuals who ventured to pillage antiquities. Perhaps they were priests or people guided by them who unearthed this type of object.

Surely the high quality of manufacture of Teotihuacan artifacts influenced their overvaluation in the decades prior to the Conquest. But above all, the supposedly magical nature of objects, the creation of which was attributed to giants or gods, made the Mexicas decide to offer them in their sacred precinct. This magical character was not possessed solely by complete pieces, but even by fragments. If this were not the case, it is difficult to imagine why broken objects and simple fragments were included among the rich gifts interred in the Templo Mayor.

The archaeological discovery of Teotihuacan pieces in Mexica contexts in Mexico City may be credited to Leopoldo Batres in 1900,[13] Jordi Gussinyer in 1969,[14] and Eduardo Matos between 1978 and 1982.[15] During the latter excavations, forty-one Teotihuacan-style and twenty-three Teotihuacanoid-style pieces were found, which date to the lapse between A.D. 200 and A.D. 800. Rich primary materials were used and many hours of work were invested in their creation. Carved, polished pieces made of semiprecious stones in green tones constitute the vast majority. Ceramic artifacts, usually fine-paste wares, were destined for religious uses. In accord with their functional characteristics based on the form, the Teotihuacan-style pieces offered in the Templo Mayor may be grouped into three categories — masks and small anthropomorphic heads, anthropomorphic figurine bodies, and stone and ceramic recipients.

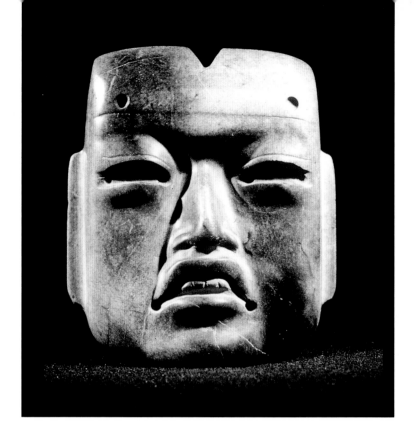

Fig. 6
Olmec-style mask from Guerrero.
Offering 20, Templo Mayor,
Tenochtitlan.

Masks and small anthropomorphic heads were sculpted in dense stones (fig. 1). Stylistically speaking, they present a symmetrical distribution of facial features articulated through a succession of planes and horizontal lines, framed by a contour curved into a U-shape, a manner that was in vogue throughout the time of Teotihuacan splendor. Features are well defined. Two slanted, rectangular plaques simulate ears. The forehead is a flat, smooth, narrow band. Eyebrows are marked by a fine, slightly curved ridge, while eye cavities are elliptical and sometimes have obsidian or shell incrustations that simulate the iris and the white of the eye. The nose has a wide base with perforations for nostrils and a narrow ridge that indicates the space between the eyebrows. The mouth has well-delineated, half-opened lips, and the cheeks and chin are represented by shallow planes.

Full-body, anthropomorphic figures were also made of greenstone. On the one hand, some are small, flat, and geometric in form. Their stylized traits were created by means of a technique of grooves and planes. They display headdresses or bands on the forehead and feminine images wear *huipiles* (unstitched, blouselike garments). On the other hand, there were also pieces of greater dimensions with less schematic facial features that approximate the quality of the masks. They represent individuals wearing a headdress or headband.

Two of the Teotihuacan-style vessels recovered are made of greenstone. One of them has a flat base with walls that flare outward and supports in the form of truncated cones. A fragment of a cylindrical bowl was also found with a narrow band around the edge and a rectangular support. It has a bas-relief decoration on its outer wall that represents a kneeling warrior holding a feathered shield and a *macana* (a club edged with obsidian blades). He faces a beast who wears a feather collar, located on top of a pyramid with *talud-tablero* profile. Also found were two ceramic vessels made of medium-fired brown clay polished with

sticks. Their decoration consists of appliqué, forming highly stylized Tlaloc faces.

Also found were twenty-three Guerrero-Teotihuacanoid-style pieces. All these greenstone sculptures incorporate hybrid traits of Teotihuacan and local figural styles. They try to imitate Teotihuacan, without really succeeding. A technique of carving grooves and planes was used to give form to these figures. They possess well-defined facial features similar to the above-mentioned Teotihuacan mask traits, while the rest of the body is totally flat and schematic. Generally, arms extend beside the body. In the case of female images, slight protuberances indicating breasts and the representation of a *huipil* serve to distinguish gender.

Not all Teotihuacan and Teotihuacanoid objects were offered just as they were found: an important percentage were decorated by the Mexicas prior to their final burial. Thin coats of paint or *chapapote* (a tarlike substance), drawings of human or divine attributes, and glyphs delineated on mask interiors were added by Mexica craftsmen to accentuate old religious meanings of the pieces, or else to confer them with new meanings.

The number of Teotihuacan pieces and Guerrero imitations of this style seem very small if the total number of elements recovered by the Templo Mayor Project (around seven thousand) is considered. Nevertheless, this group of sixty-four pieces is quite impressive when compared with the sole Olmec relic found to date in the Templo Mayor (fig. 6). Furthermore, each Teotihuacan and Teotihuacanoid piece unfailingly occupied a place of preeminence within its corresponding offering. Regarding the location of the ten offerings that contained these materials, the following of a more or less homogeneous spatial pattern is provocative; eight offerings were buried in the principal temple dedicated to Tlaloc and Huitzilopochtli, while the other two offerings were found in adjoining shrines.

Of even greater importance is the fact that all this material was concentrated in deposits belonging to or postdating Stage IV of the Templo Mayor. In fact, the contrast with preceding stages is striking: not a single one of the twenty-two offerings buried prior to this stage included a single Teotihuacan or Olmec artifact. If the tentative chronology proposed by Matos is correct, perhaps the custom of depositing antiquities in the sacred precinct of Tenochtitlan begins or at least escalates during the reign of Motecuhzoma Ilhuicamina (A.D. 1440-1469), when the Mexicas begin to dominate the Central Highlands.

The burial of goods produced by past societies and the building of architectural copies based on old civilizations coincides with the period in which the Mexica state was undergoing a process of integration, consolidation, and expansion. The recuperation of an extinct tradition should perhaps be understood in this historical context as one of many strategies adopted to maintain their new dominant position in the eyes of their own subjects as well as others. It may be supposed that with the passing of centuries, almost all Olmec and Teotihuacan objects, as well as Teotihuacanoid and Toltecoid architecture, had lost its original significance and function. Perhaps, void of specific connotations, they acquired the aura of sacred symbols par excellence, as direct allusions to a life of grandeur.

In this way, the Mexicas were rescuing a past that was never their own. These recent arrivals to the Basin of Mexico thus made their pres-

ence seem less accidental and their place in the cosmos appeared less arbitrary to their neighbors. All in all, the mythical affiliation with the builders of Teotihuacan forever removed them from anonymity, while their indirect descent from Toltec people made them feel that they belonged to a world in which they had become masters. Both in written documents, as well as in archaeological remains, this desire to establish the "historical thread" of legitimacy appears, from the mythical origin of human beings at Tamoanchan, to the great power of Tenochtitlan, passing through Teotihuacan (the place of grandeur) and through Tula (the political foundation). Thus, the Mexicas could instill fear in their enemies and legitimate their hegemony, thanks, among other things, to their authority emanating from the Templo Mayor, the precinct that concentrated the power of deities of war and of water, as well as of the ancestors.

Eduardo Matos Moctezuma is Director of the Museo Templo Mayor, Mexico City, and of the Zona Arqueológica de Teotihuacan. Leonardo López Luján is an archaeologist at the Museo Templo Mayor.

1. Bernardino de Sahagún, *Códice Florentino*, book 10, folio 142v-143.

2. Sahagún, *Códice Florentino*, book 10, folio 142v.

3. Fernando de Alva Ixtlilxóchitl, *Obras históricas* (Mexico: Universidad Nacional Autónoma de México, 1975), 1:272; Juan de Torquemada, *Monarquín Indiana* (Mexico: Porrúa, 1968), 1:278.

4. Bernardino de Sahagún, *Códice Matritense del Real Palacio*, folio 161v and ff.

5. Sahagún, *Códice Matritense*, folio 161v and ff.

6. Sahagún, *Códice Matritense*, folio 161v and ff.

7. Sahagún, *Códice Florentino*, book 10, folio 145v.

8. Sahagún, *Códice Florentino*, book 10, folio 142r-142v.

9. "Relación de Tequizistlán y su partido," *Relaciónes geográficas del siglo XVI: México* (Mexico: Universidad Nacional Autónoma de México, 1986), 6:211-251.

10. Eduardo Matos Moctezuma, "Una máscara olmeca en el Templo Mayor de Tenochtitlan," *Anales de Antropología* 16 (1979):11-19; Umberger 1987; López 1989.

11. Millon, Drewitt, and Cowgill 1973.

12. Miller 1973.

13. *Exploraciones arqueológicas en las calles de las Escalerillas. Año de 1900* (Mexico: La Europea, 1902).

14. "Hallazgos en el Metro, conjunto de adoratorios superpuestos en Pino Suárez," *Boletín INAH*, no.36 (June 1969):33-37; "Un adoratorio dedicado a Tláloc," *Boletín INAH,* no.39 (March 1979):7-12.

15. López 1989. For background information on the discovery of other Teotihuacan motifs see Doris Heyden, "Symbolism of Ceramics from the Templo Mayor," in Elizabeth H. Boone, ed., *The Aztec Templo Mayor* (Washington, D.C.: Dumbarton Oaks, 1987), 109-130; Eduardo Matos Moctezuma, "El adoratorio decorado de las calles de Argentina," in *Anales del Instituto Nacional de Antropología e Historia*, no. 17 (1965):127-138.

CATALOGUE OF
OBJECTS

Introductions to the categories are by
Esther Pasztory unless otherwise specified.

Authors of individual object entries
are designated by initials, as follows:

CLDO - Clara Luz Díaz Oyarzabal
RCC - Rubén Cabrera Castro
EP - Esther Pasztory
ER - Evelyn Rattray
CC - Cynthia Conides
WB - Warren Barbour
MCM - Martha Carmona Macias
LLL - Leonardo López Luján

Other abbreviations used are:
CNCA-INAH-MEX Consejo Nacional para
la Cultura y las Artes - Instituto Nacional de
Antropología e Historia - Mexico
MNA Museo Nacional de Antropología

MNA numbers for objects from Mexico
refer to numbers in the Museo
Nacional de Antropología catalogue.
INAH numbers for these objects
provide inventory identification.

Object dates and periods are as follows:

Tzacualli	A.D. 1-150
Miccaotli	A.D. 150-200
Tlamimilolpa	A.D. 200-400
Xolalpan	A.D. 400-650
Metepec	A.D. 650-750
Epiclassic	A.D. 700-900
Classic	A.D. 200-750
Postclassic	A.D. 900-1519

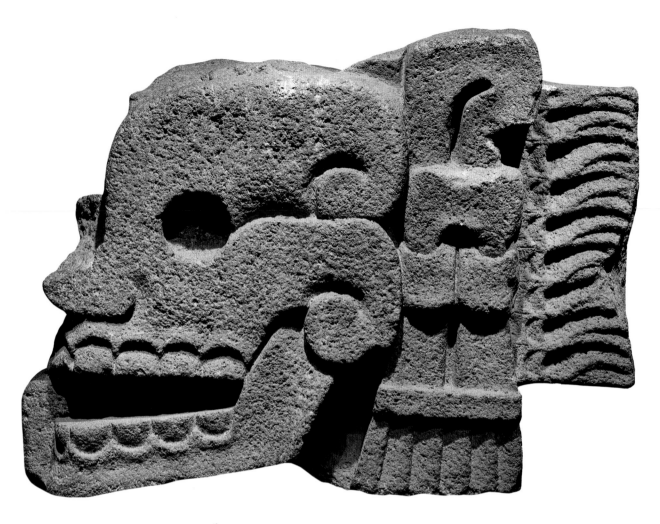

STONE SCULPTURE

TEOTIHUACAN HAD FEW VOLCANIC (as opposed to precious) stone sculptures. Only three colossal statues of deities exist, whose dates are uncertain. Most other sculptures were architectural — attached to balustrades, built into walls, or placed on roofs. The material was buff or gray volcanic stone, which is hard to cut with absolute precision using stone tools.

Teotihuacan sculpture is striking because of the reduction of form into geometric shapes. This does not, however, signify simplicity. Forms are often carved in layers that angle into each other and suggest greater depth than exists in fact. Curving details abound, softening the overall geometric shapes. Images range from the naturalistic to the abstract.

1

SKULL
Tlamimilolpa-Metepec A.D. 200-750
Found in the plaza in front of the Pyramid of the Sun
Volcanic stone
71 x 96 x 37.5 cm (28 x 37 ³/₄ x 14 ³/₄ in.)
MNA 9-2567; INAH 10-958
CNA-INAH-MEX, Museo Nacional de Antropología, Mexico City

The surprising representation of a skull with a tongue may allude to the custom of drawing blood from the tongue with maguey thorns. The vertical knot seems to refer to the knot in a mortuary bundle. At the same time, the knot refers to the tie seen on the bundle of wood or reeds ritually burned at the end of a calendrical cycle, an event perhaps indicated by the flames carved on the right side of the knot. It is therefore possible to interpret the piece as a monument dedicated to blood sacrifice carried out for the ceremonial celebration of the New Fire ceremony marking the end and beginning of a calendrical cycle. CLDO

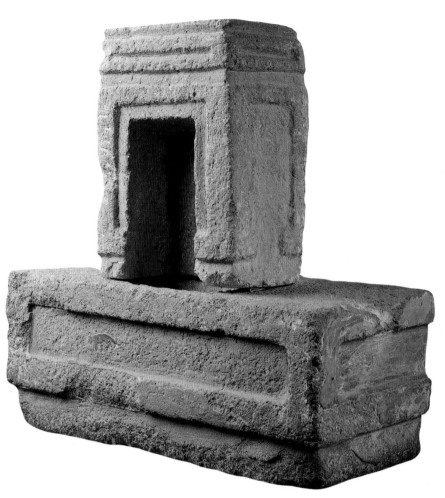

2
ARCHITECTURAL MODEL
Tlamimilolpa-Metepec A.D. 200-750
Provenance unknown
Volcanic stone with traces of stucco
and paint
59 x 58 cm (23 ¼ x 22 ⅚ in.)
MNA 9-3142; INAH 10-81813
CNCA-INAH-MEX, Museo Nacional
de Antropología, Mexico City

Displaying a typical *talud-tablero* plat-
form crowned by a structure with a
single door, this exceptional sculpture
represents an architectural model of a
Teotihuacan temple that may have
served as a prototype for builders of the
period. It still bears traces of stucco and
red paint, the predominant surface
finish for the city's buildings. Its origi-
nal location within the site is not entirely
clear, for it was uncovered accidentally
during construction of the highway that
surrounds the archaeological zone.
CLDO

3
COLOSSAL SERPENT HEAD
Miccaotli-early Tlamimilolpa A.D.
150-200
Found behind the Temple of the Feath-
ered Serpent
Stone, stucco, pigment
70 x 70 x 200 cm (27 ½ x 27 ½ x 80 in.)
INAH 10-411074
CNCA-INAH-MEX, Zona Arqueológica
de Teotihuacan
Illustrated p. 79

The feathered serpent is an icono-
graphic element typical of Teotihuacan,
especially its earlier phases. It is fully
developed on the Temple of the Feath-
ered Serpent, a pyramidal platform that
was completely covered on all four sides
with magnificent serpents, such as this
example, together with other symbolic
elements. This sculpture was originally
tenoned into one of the facades of the
temple, just as were other similar ser-
pent heads framed by feathers that are
still visible on the main facade. In gen-
eral the feathered serpent is accompa-
nied by aquatic signs and its meaning
appears to be related to water and veg-
etation. RCC

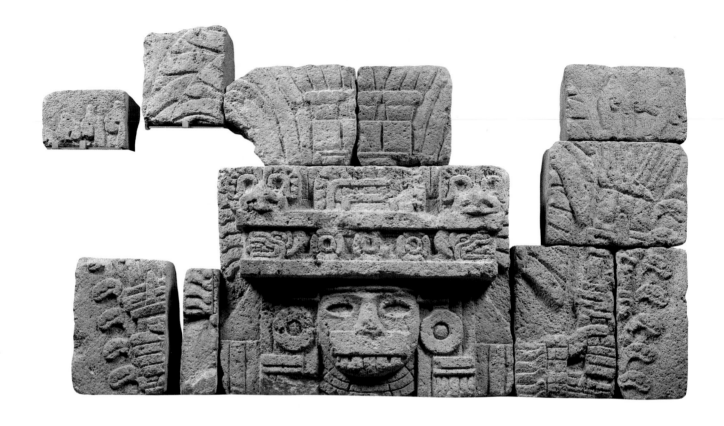

4

FRIEZE REPRESENTING A DEITY
Xolalpan-Metepec A.D. 400-750
West Plaza Complex, Street of the Dead
Complex, 1980-1982 excavations
Pink stone, stucco, pigment
123 x 216 cm (48 1/2 x 86 1/2 in.)
INAH 10-22511590/11
CNCA-INAH-MEX, Zona Arqueológica
de Teotihuacan

When joined together, these numerous stone blocks worked in relief represent an incomplete frontal human figure wearing an elaborate headdress and holding a large staff or scepter in both hands. The presence of the nosebar and the headdress with birds are features of the Goddess and may therefore identify this object as a representation of her. Because the design seems to continue toward the sides, it is believed that this relief formed part of a large frieze that must have covered the facade of the temple where it was found, thereby making it a unique piece at Teotihuacan. RCC

5

STORM GOD RELIEF

Tlamimilolpa-Metepec A.D. 200-750
Found in the early twentieth century in
the building known as "Los Subterraneos"
(Subterranean Rooms), Teotihuacan
Volcanic stone
129 x 104 x 12 cm (50 ¾ x 41 x 4 ¾ in.)
MNA 9-4565; INAH 10-136721
CNCA-INAH-MEX, Museo Nacional
de Antropología, Mexico City

The Storm God was represented so
frequently in Teotihuacan ceramics and
painting that he has been identified as
one of the patron gods of the city and
the focus of greatest veneration. Based
on distinctive traits, two aspects of the
deity have been distinguished, one
related to warriors and the military and
the other associated with the earth,
water, and fertility. This sculpture sche-
matically represents attributes indica-
tive of his warlike aspect — a large
bifurcated tongue, four upper teeth,
and a curled upper lip. The exact func-
tion of these slabs, six of which were
recovered from excavations dating to
the beginning of this century, is un-
known, although some authors believe
that they could have served as architec-
tural elements (*almenas)* decorating
roofs. However, given the weight of
these sculptures, this appears unlikely.
CLDO

6

ABSTRACT SCULPTURE
OF A GODDESS
Xolalpan A.D. 400-600
Found early in this century
by Manuel Gamio
Stone
82 x 76 cm (32 1/2 x 30 in.)
INAH 10-262389
CNCA-INAH-MEX, Museo Arqueológico
de Teotihuacan

This flat, abstract form served as an
almena. The two large circles may be
interpreted as earspools, the horizontal
bar represents a nose ornament, and
the horizontal element at the top indi-
cates a headdress. All are attributes that
are otherwise found on the Goddess.
What is unique about this sculpture is
that it does not have a face, but the
earspools and nosebar vaguely suggest
a face. The perforation in the central
part of the sculpture suggests that the
stone may have been reused for an-
other purpose later in time. RCC

7
STEPPED ARCHITECTURAL ORNAMENT WITH CAVITY
Xolalpan A.D. 400-600
Provenance unknown
Pink stone
81 x 98 x 9 cm (32 x 38 ½ x 3 ½ in.)
INAH 10-411075
CNA-INAH-MEX, Zona Arqueológico
de Teotihuacan

This is another example of an *almena,*
one of many relief sculptures that were
placed one after another on the upper
areas of certain buildings at Teotihua-
can, crowning palace roofs, altars, or
the upper part of dividing walls. Such
ornaments were made in clay, onyx, or
a pinkish stone. They most commonly
represent human figures, calendrical
symbols, stepped forms, and deities.
These roof ornaments are among the
most simple and abstract Teotihuacan
sculptures known. RCC

8
CYLINDRICAL SCULPTURE
Tlamimilolpa-Metepec A.D. 200-750
Found in the early twentieth century near
the Pyramid of the Sun
Volcanic stone
45 x 13.4 cm (17 ¾ x 5 ¼ in.)
MNA 9-6361; INAH 10-393505
CNCA-INAH-MEX, Museo Nacional
de Antropología, Mexico City

The commemoration of fifty-two-year
long calendrical cycles, the pre-His-
panic equivalent of our century, was

commonly practiced by Central Mexi-
can Highland cultures in late periods.
Teotihuacan seems to have shared this
custom, in which a bundle of wood or
reeds was set aflame to honor the end
of the "century." However, we cannot
be certain that the cycle celebrated
would have been exactly fifty-two years.
This sculpture probably represents one
of these bundles because of the cord
near the sides of the sculpture, as well
as the flames schematically carved on
the ends. CLDO

9

OLD GOD BRAZIER

Probably Tlamimilolpa-Metepec
A.D. 200-750
Said to be from Hacienda San Rafael,
Tlaxcala
Volcanic stone
24.5 x 22 cm (9⁵/₈ x 9 in.)
Museum für Völkerkunde, Vienna, 59125

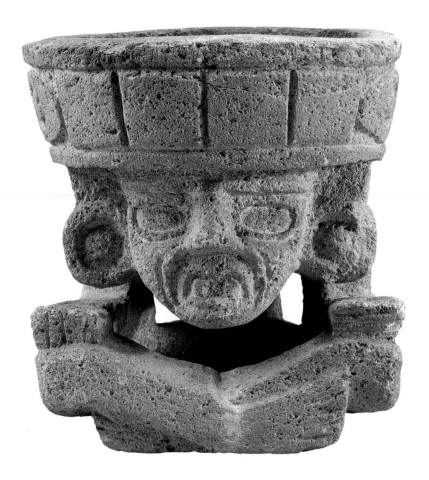

11

OLD GOD BRAZIER

Probably Tlamimilolpa-Metepec
A.D. 200-750
Provenance unknown
Volcanic stone
37.5 x 37 cm (14³/₄ x 14¹/₂ in.)
The Denver Art Museum, Purchase
with Funds Provided by Walt Disney
Imagineering and Harry I. and Edythe
Smookler Memorial, 1990.0070

The subject of a hunched-over old man supporting a round vessel on his head may be very ancient in Mesoamerica and is not unique to Teotihuacan. It was especially common in small clay forms. It is generally believed that the brazier was used to burn incense and that this object is in some way associated with the hearth and household ritual.

Although clay versions were also known at Teotihuacan, after A.D. 250 when the apartment compounds were built stone braziers seem to have been mass produced. When found in archaeological excavations, they have sometimes been located in the central courtyards or near the central shrines of the apartment compounds. They range in size from small to life-sized and fragments exist of what may have been a colossal one. The same format is always followed: the cross-legged, seated figure creates a triangular base. The actual sculpture is openwork. The back of the figure and the head bend forward to support the vessel, but there is nothing solid in the center. These modest household sculptures were thus remarkably conceived as skeletal supports around an open space.

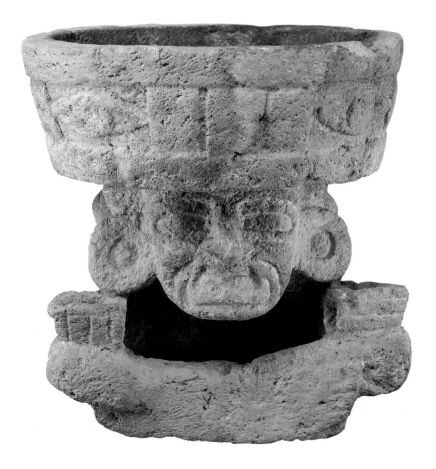

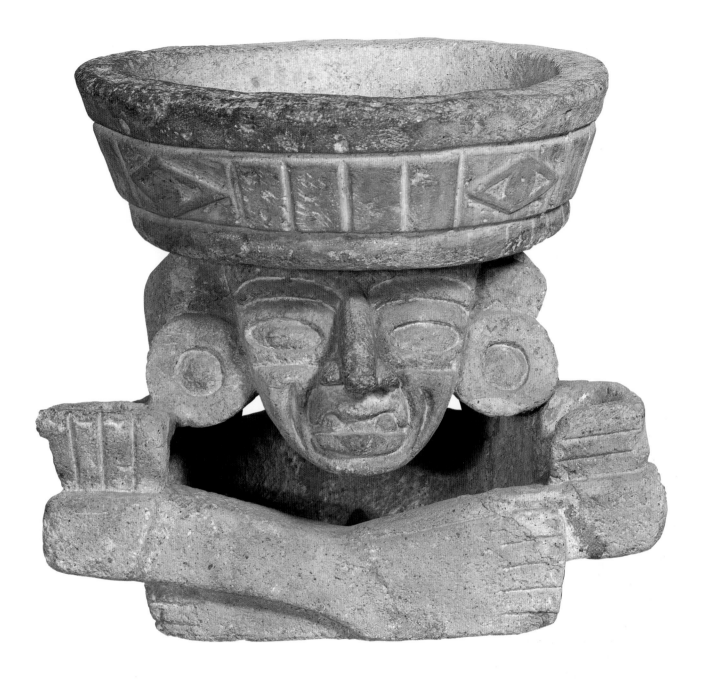

Little in the iconography can be explained fully. The oldness of the figure is indicated by wrinkles on the face and sometimes by two teeth protruding in the corners of the mouth. The figure wears no dress, except for earspools. The intentionality of nakedness is sometimes clear on the backs, which show shoulder blades, ribs, and buttocks. Each of the hands is in a different position, perhaps indicating they served as distinct ritual objects or in different ritual actions. Small asymmetries within an overall symmetrical design are characteristic of Teotihuacan ritual art. The rim of the vessel is usually carved with vertical bars alternating with rhomboid eyes. These eyes are believed to be symbols of fire because they occur on these incense-burning braziers.

The Teotihuacan Old God is similar to old gods found in the Templo Mayor offerings of the Aztecs, but it is not clear if he is a deity. Since he holds the ritual vessel on his head, he could be considered a "supporter" rather than a deity. Oldness can also be associated with the concept of ancestors. It is not possible at this point to select which of these meanings is absolutely correct. EP

10
OLD GOD BRAZIER
Probably Tlamimilolpa-Metepec
A.D. 200-750
Provenance unknown
Volcanic stone
48 x 48 cm (19 x 19 in.)
Natural History Museum of Los Angeles
County, F. A. 644.72-1

12

RECTANGULAR BASIN
Xolalpan A.D. 400-600
Found in the West Plaza Group of the
Street of the Dead Complex
Whitish-green stone
79 x 28 x 62 cm (31 x 11 x 24¹/₂ in.)
INAH 10-261110
CNCA-INAH-MEX, Museo Arqueológico
de Teotihuacan

Tecalli, a white stone like onyx, was an
imported raw material used to make
religious articles or sumptuous domes-
tic objects for families of high social
rank. Consequently, objects made of
this material are quite rare. This ex-
traordinary object has been identified
as a ritual vessel. It was found next to a
drain pipe inside one of the rooms of
the Street of the Dead Complex, an
administrative center at Teotihuacan.
RCC

SEMIPRECIOUS STONE OBJECTS

THIS VERY IMPORTANT CATEGORY of art
works at Teotihuacan were fashioned
from a variety of attractive stones. These
were often very hard stones, such as
greenstone, but included brownish,
grayish, mottled, and striated stones
of a variety of geological classifications.
The aesthetic features of the stones
were apparently their color, texture,
ability to take a high polish, and poten-
tial for dramatic or abstract carving with
crisp detail. The hardness of these
stones makes a certain amount of sim-
plicity necessary. An alabaster-like whit-
ish stone was also used, which ranges
from calcites with greenish or brownish
color to translucent gypsum. These
alabaster-like stones are so soft that they
can almost be scratched by a fingernail;
the forms carved from them tend to be
softer and do not lend themselves to
sharply cut decorative detail.

Excavations since the 1900s have
shown that large stone figures all come
from the temples and habitations near
the Street of the Dead and therefore

were among the most important ritual
objects at Teotihuacan. The figures are
mostly naked or wear minimal indica-
tions of dress and headdress. In some
instances the figures have recognizable
male or female genitals. Judging by the
mural depictions, it would seem that
these figures could have been dressed
in rich feathered textiles and worn
headdresses and earspools. Thus at-
tired, they might have been the major
images in the temples.

Stone figures vary greatly in style,
ranging from flat two-dimensional,
minimal depictions to three-dimension-
ally modeled naturalistic figures. While
over a dozen large figures are known,
many more smaller figures have been
found in a variety of styles. These varied
styles suggest several possibilities — that
not all of these figures were necessarily
of Teotihuacan manufacture, or that
the relatively infrequent production of
them was by workshops that did not
standardize their products, or that indi-
viduality was important. In its day, each
of these figures might have been as
specific as any particular madonna or
saint of a Christian church.

13

Standing Male Figure

Miccaotli-Tlamimilolpa A.D. 150-250
Found at the beginning of this century
at the so-called House of the Priests
(Casa de los Sacerdotes)
Greenstone
71 x 23 cm (28 x 9 in.)
MNA 9-3158; INAH 10-81806
CNCA-INAH-MEX, Museo Nacional
de Antropología, Mexico City

One of the oldest pieces in the history
of the collection of the Museo Nacional
de Antropología, this sculpture comes
from the earliest excavations carried
out at Teotihuacan under the direction
of Leopoldo Batres at the beginning of
this century. Because of the somewhat
atypical style of its rounded, naturalistic
forms, it was believed to date to the
early stages of the city. However, the
description of its discoverer indicates
that it was found in fill from the last
construction stage of a residential
group having a temple pyramid at the
center, and located on an unexcavated
platform surrounding the Pyramid of
the Sun. Numerous fragments of
equally fine pieces were found near the
torso, such as masks and parts of arms
and legs made of a fine lapidary stone.
Because of the remains of mural paint-
ing and other materials of exceptional
quality found there, the apartment
compound probably pertained to an
upper stratum of Teotihuacan society,
so it came to be known as the House of
the Priests, a name still used today.
Aesthetically, the fragmentary state of
the outstanding stone objects found
during this excavation is unfortunate,
but archaeologically this intentional
destruction corroborates recent finds in
other important, centrally located com-
pounds in the city, where similar evi-
dence indicates the Teotihuacan state
came to an abrupt and violent end.
CLDO

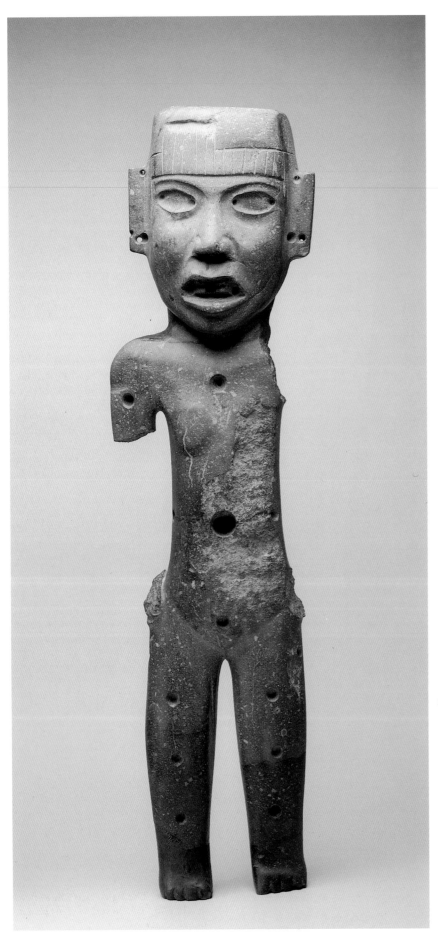

14
ASEXUAL DEITY WITH CIRCULAR PERFORATIONS FOR INLAYS

Xolalpan-Metepec A.D. 400-700
Associated with a pyramidal platform
in the back of the Ciudadela, found in
the 1980-1982 excavations
Serpentine
75 x 18 cm (29 1/2 x 7 in.)
INAH 10-333079
CNCA-INAH-MEX, Museo Arqueológico
de Teotihuacan

This is an asexual human figure with
numerous holes distributed throughout
the body and legs (front and back) for
the addition of inlays made from other
materials, perhaps obsidian or green-
stone. Such applications must have
made this an extraordinarily beautiful
piece. It was found broken into pieces
and scattered around a small temple
base, perhaps where the sculpture was
originally venerated. Because of its size,
fine workmanship, and the number of
cavities made for inlays, it is an excep-
tional and unique piece of Teotihuacan
art. RCC

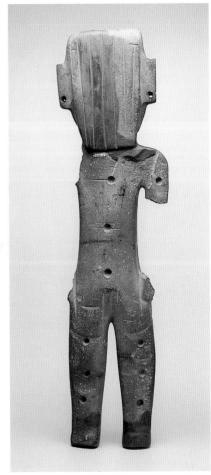

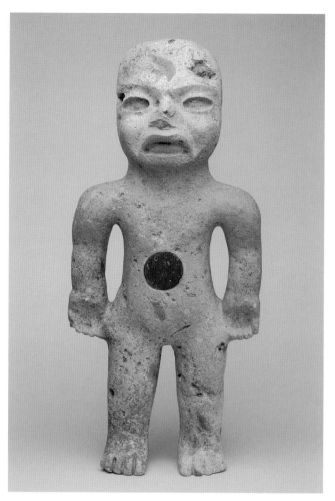

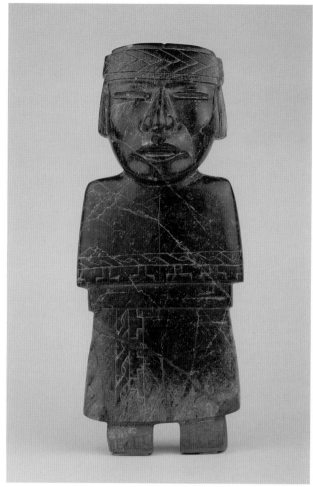

15

OLMECOID FIGURE
Late Xolalpan A.D. 550
Found in a residential context in
the Ciudadela during the 1980-1982
excavations
Sandstone and slate
45.3 x 28.8 x 9.4 cm (18 x 11 ½ x 3 ¾ in.)
Excavations registration no. 17405; INAH
10-336690
CNCA-INAH-MEX, Museo Arqueológico
de Teotihuacan

Naked human sculptures with cavities
for inlays, such as this example, are
quite frequent at Teotihuacan. Repre-
senting a standing figure, possibly male,
this sculpture displays a muscular body,
arms hanging down, with hands cupped
toward the front and held tightly against
the hips, while the feet are slightly
parted. Its face has Olmecoid features
with a flattened nose and thick lips
curled into a feline expression. The
carved, empty eye holes and the round
depression in the center of the figure
must have held inlays made of another
material. RCC

16

**FEMALE FIGURE WITH SKIRT
AND *HUIPIL***
Xolalpan A.D. 400-600
West Plaza Compound, Street of the Dead
Complex, 1980-1982 excavations
Serpentine
45 cm (17 ¾ in.)
INAH 10-213190
CNCA-INAH-MEX, Museo Arqueológico
de Teotihuacan

This exquisitely worked sculpture repre-
sents a female figure with a typical
Teotihuacan face. She wears a skirt and
a *huipil* (an unstitched upper garment),
both decorated with bands of interlaced
and stepped fret motifs drawn by means
of fine incisions. A wide band with a
woven pattern encircles her head, while
her hair falls neatly parted at both sides
of her face. The figure was found near
an altar and is believed to represent a
female deity. RCC

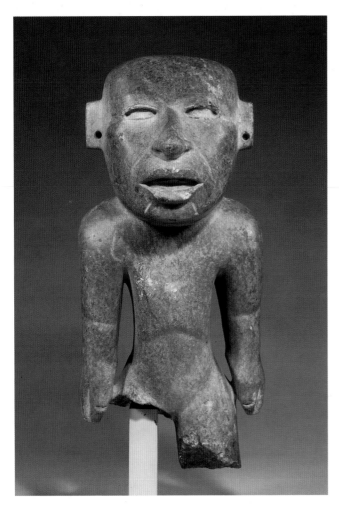

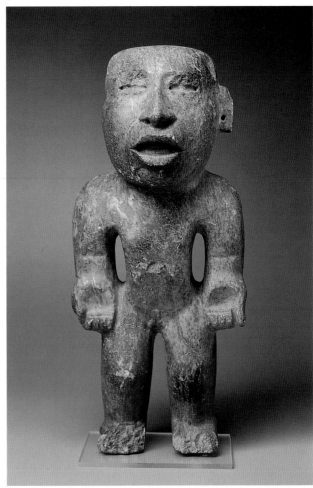

17

STANDING FIGURE
Probably Tlamimilolpa-Metepec
A.D. 200-750
Provenance unknown
Greenstone
40 cm (16 ⅛ in.)
The Metropolitan Museum of Art,
The Michael C. Rockefeller Memorial
Collection, Bequest of Nelson A.
Rockefeller, 1979. 1979.206.585

This figure is one of the most powerful and energetic representations of a human being in Teotihuacan art. It is similar in its dramatic three dimensionality to the figure from Hamburg (cat. no. 18), but its torso and facial features are more finely delineated. The face with its open mouth resembles the large and heavy types of masks such as catalogue number 24. EP

18

STANDING FIGURE
Probably Tlamimilolpa-Metepec
A.D. 200-750
Bought in 1889 from A. Hackmack
Light green metadiorite
42 cm (16 ½ in.)
Hamburgisches Museum für
Völkerkunde, B3627

This figure is almost exactly the height of catalogue number 17 but is slightly less polished and rougher. The hands, palm up at the sides, have their parallels in the Olmecoid figure (cat. no. 15). The roundness of the limbs and the large open mouth project a raw energy seldom associated with the calm ideal of Teotihuacan art. EP

19

FEMALE FIGURE WITH ROSETTES
IN HEADDRESS
Probably Tlamimilolpa-Metepec
A.D. 200-750
Provenance unknown, Bilimek
Collection 1878
Greenstone with remains of pyrite
40.5 x 20 cm (16 x 8 in.)
Museum für Völkerkunde, Vienna, 6270

This is one of two large female figures known in greenstone, the other being catalogue number 16. The figures are alike in that they are both flat and their garments consist of a skirt and a *huipil*. Both have square, abstract "legs." This example has square hands next to the ornamented hem of her *huipil*. The rosette and feather headdress is extraordinary as is the stepped facial marking across her cheeks and nose. Though she is dressed, her spare form could have easily been wrapped in seasonal garments. EP

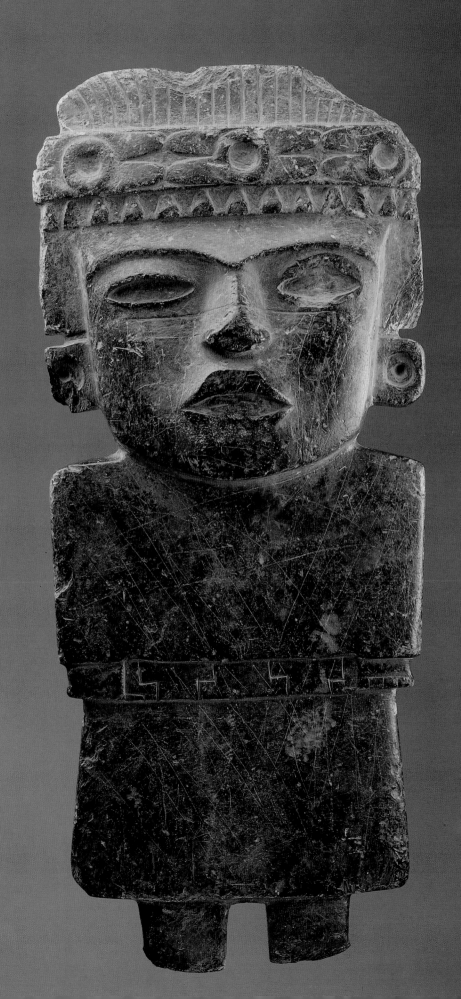

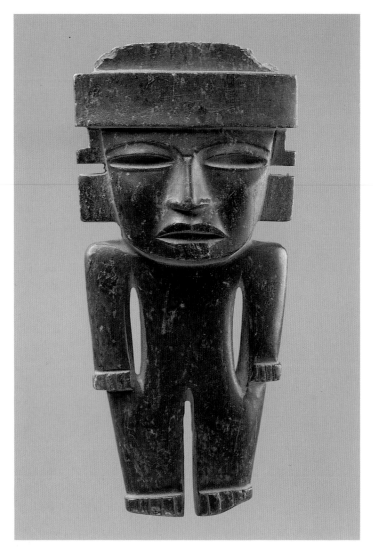

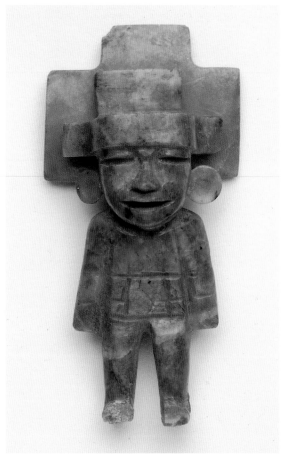

20
SMALL STANDING FIGURE
Probably Tlamimilolpa-Metepec
A.D. 200-750
Provenance unknown, Bilimek Collection
1878
Greenstone
20 x 10 cm (8 x 4 in.)
Museum für Völkerkunde, Vienna, 6279

A number of small figures are known
depicting both males and females. They
look as though they have been cut out
with a cookie-cutter rather than indi-
vidually modeled. The resulting abstrac-
tion of the horizontal headdress and
the flanges is similar to Mexcala-style
figures; their place of manufacture is
unknown. The proportions of this fig-
ure make it an elegant variant on a
theme. The back of the figure is
uncarved. EP

21
STANDING FIGURINE
Miccaotli-Tlamimilolpa A.D. 150-200
Found in 1939 in offerings excavated
at the Temple of the Feathered Serpent
Greenstone
7.4 x 3.9 cm (3 x 1 1/2 in.)
MNA 9-1707; INAH 10-393496
CNCA-INAH-MEX, Museo Nacional
de Antropología, Mexico City

This tiny greenstone figurine is one of
the few examples of this type that has
been found at Teotihuacan. It comes
from the early stages of the city when
construction began on the so-called
Temple of the Feathered Serpent and
lavish offerings were buried to com-
memorate the event. Greenstone itself
was highly prized by pre-Hispanic
peoples as a symbol of something pre-
cious. The figurine additionally has
removable earspools and a removable
stepped plaque behind the head.
CLDO

22

FIGURE SEATED CROSS-LEGGED

Probably Tlamimilolpa-Metepec
A.D. 200-750
Provenance unknown, formerly in
the Miguel Covarrubias Collection
Green-tinged aragonite
26.7 cm (10 ½ in.)
Indiana University Art Museum,
Raymond and Laura Wielgus
Collection, 76.8

This is one of the few examples in
which an alabaster-like stone was used
for a full figure and not a mask or a
container. The sculpture is unusual in
many respects. Its simplified style is
characteristic of the carvings of soft
stones. But the sleek lines of the limbs
and the torso, as well as the breast
bones, are more like those of the
Standing Male Figure (cat. no. 13).
The head is reminiscent of masks and
the cross-legged posture and the hands
resting on them are similar to the Old
God brazier figures. We know too little
of such figures in alabaster to under-
stand how to interpret these parallels.
Weathering has revealed contoured
line reliefs that add to the aesthetic
appeal of the piece. EP

23

LIDDED CONTAINERS ON A STAND

Tlamimilolpa-Metepec A.D. 200-750
Provenance unknown
Yellow-white alabaster-like stone
10 cm (with lid) x 17.5 cm (4 x 7 in.)
The Art Museum, Princeton University,
Lent anonymously, L1974.58

Alabaster-like stones were also used for
making magnificent containers. These
two lidded jars are remarkable for their
preservation, including the lids and
their feet. Their simplicity is in line
with Teotihuacan aesthetic prefer-
ences. Two such jars attached to stands
but lacking the lids were found in the
excavation of the burial of a
Teotihuacan individual of high status
at Kaminaljuyú in Guatemala. (See
Kidder, Jennings and Shook 1946, fig.
154.) EP

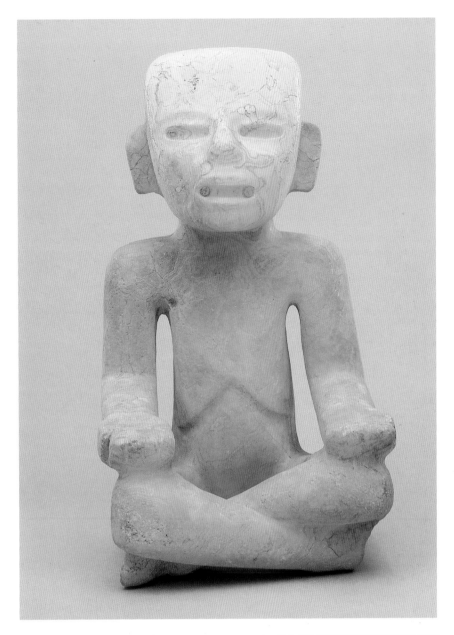

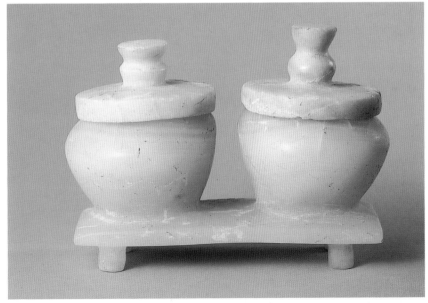

MASKS

THERE ARE MORE stone masks from Teotihuacan than from any other Meso-american culture. It is generally believed they were funerary, but none have been found in burials. The only three that were scientifically excavated of the many hundred that are known come from rooms and corridors in the administrative and temple buildings along the Street of the Dead. Most of the masks are too large and heavy to have been worn and do not have their eyes pierced. There are, however, many holes on the sides and sometimes at the tops, apparently designed for attachment to something. It is likely that the masks were attached to human figures made out of perishable materials that, when dressed, were meant to look like the more costly large stone figures. Only the most elite temples had whole figures of stone, whereas the masked figures, although still restricted to the temples, might have been more widespread. The ceramic Bust with a Mask (cat. no. 60) indicates what these sculptures might have looked like and how the stone masks may have been attached to wooden armatures.

Besides the various holes drilled for attachment to a body and to things like a headdress, masks were further enlivened by inlay and paint. Two excavated masks, one from Teotihuacan and one from the Templo Mayor (cat. nos. 25 and 185) indicate that most had inlaid eyes and teeth, which made them more lifelike. Several masks also have cutout areas, presumably for inlay, and most masks probably once had earspools attached to them.

Teotihuacan stone masks are often thought to be standardized in form, and indeed most of them share a basically similar format — a wide, straight forehead, eyebrows formed by the sharp meeting of two planes in a horizontal line, eyes and mouth in parallel horizontals, and modeling restricted largely to the cheeks and lips. Within this general description are many variations. Some of what seem to be the most important masks are very large and heavy, made from granitic stones. The majority of masks are smaller and fall into vertical, horizontal, and almost-square formats. Many masks are surprisingly three-dimensional from a side view, with the nose and open lips creating a dramatically curving line.

24
MASK

Probably Tlamimilolpa-Xolalpan
A.D. 200-650
Provenance unknown
Stone
22.5 x 28 cm (9 x 11 in.)
MNA 9-1699; INAH 10-9628
CNCA-INAH-MEX, Museo Nacional de Antropología, Mexico City

This large, heavy Teotihuacan mask exhibits the wide forehead, proportions, and schematic facial features characteristic of this lapidary art style in which masks are almost always wider than they are tall. It is unknown if these masks served a funerary function, covering the face of the deceased, or whether they were used to represent the visage of a deity while attached to an armature dressed with associated costume elements. CLDO

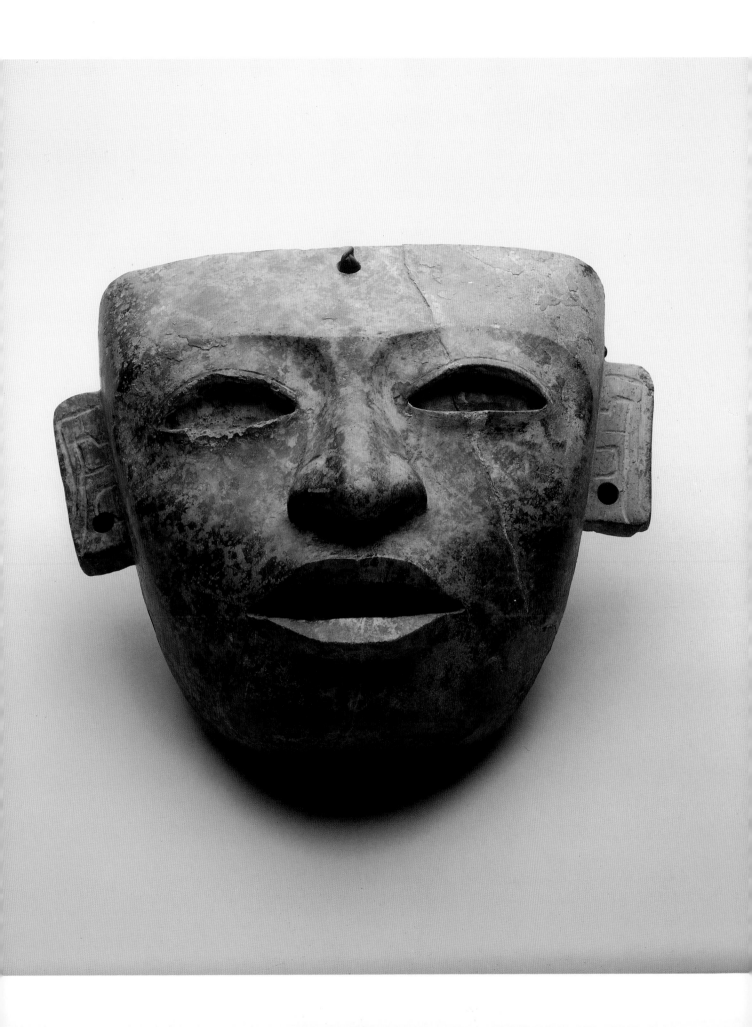

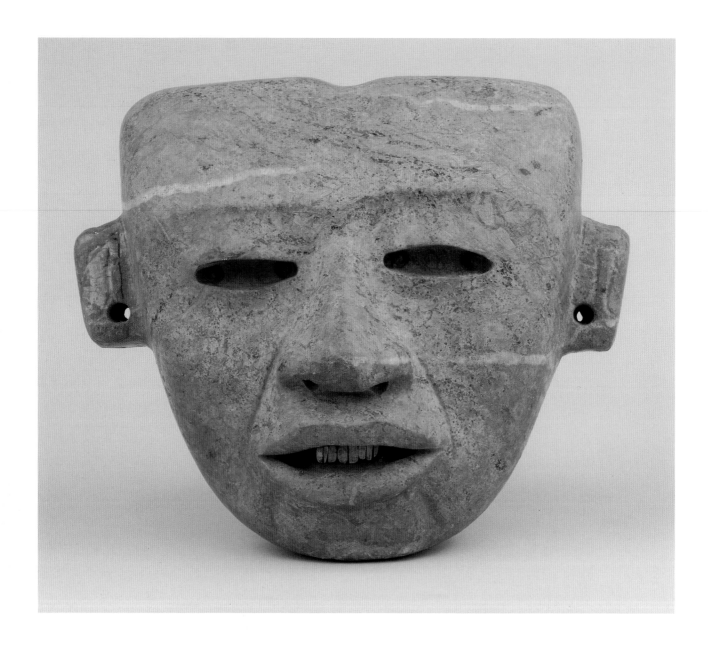

25

MASK WITH SHELL TEETH

Metepec A.D. 600-750

Found in a residential compound directly south of the Street of the Dead Complex, called Conjunto Noroeste del Rio San Juan

Greenstone and shell

25 cm (10 in.)

INAH 10-16880

CNCA-INAH-MEX, Museo Arqueológico de Teotihuacan

This mask, which was complete when found, gives an unexpectedly sensitive expression to a typical Teotihuacan face. Masks from Teotihuacan were sometimes profusely decorated with different precious materials, mainly thin pieces of shell and turquoise. This mask bears simulated teeth made of shell, and some other material must have been added in the hollows of the eyes to make it even more lifelike and expressive. RCC

26

MASK

Probably Tlamimilolpa-Metepec A.D. 200-750

Provenance unknown

Serpentine and remains of iron pyrite

21.6 x 20.5 cm (8 1/2 x 8 1/16 in.)

Dumbarton Oaks Research Library and Collections, Washington, D.C., Robert Woods Bliss Collection, B54 TS

The eyes of masks were inlaid either with a combination of white shell and black obsidian or golden iron pyrite. When it decays, iron pyrite leaves a yellow residue. EP

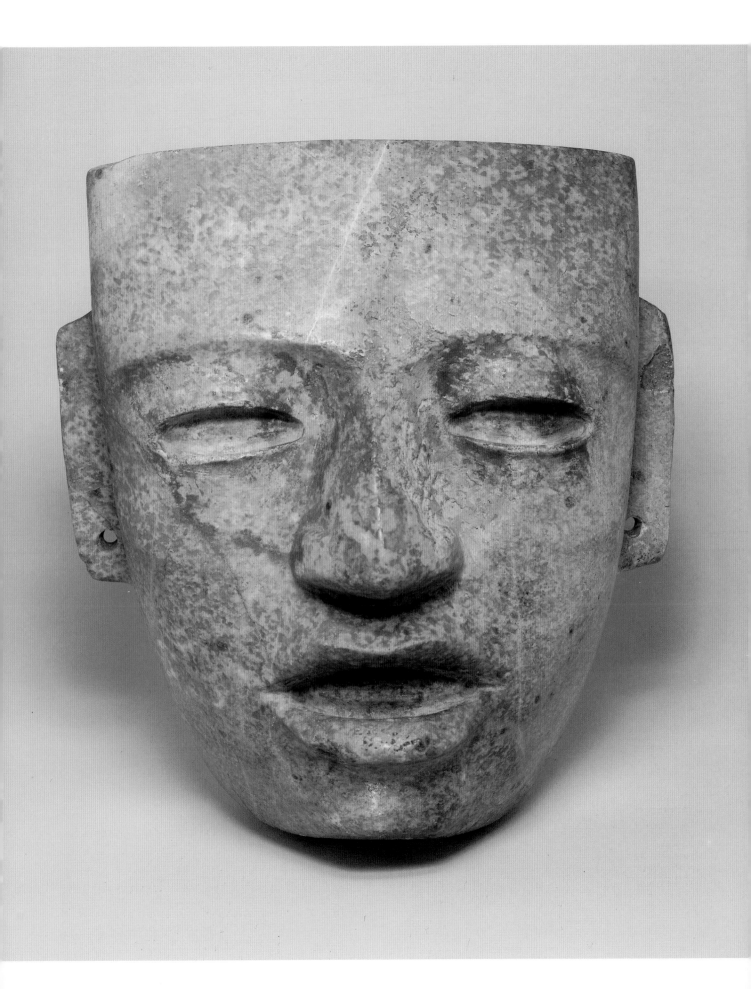

27

MASK

Probably Tlamimilolpa-Metepec
A.D. 200-750
Provenance unknown
Green mottled stone
19 cm (7 ½ in.)
Lent anonymously

This elegant greenstone mask is strik-
ing for its serene expression and its
naturalism. The variations in the
mottled stone, the smooth contour of
facial planes, and the deep inset areas
for inlay in the eyes and mouth give a
great sense of texture to the piece. EP

28

MASK

Tlamimilolpa-Metepec A.D. 200-750
Provenance unknown
Probably calcite with remains of original
pyrite inlay
18 x 17 cm (7 x 6 ¾ in.)
Dumbarton Oaks Research Library and
Collections, Washington, D.C., Robert
Woods Bliss Collection, B55 TS
Illustrated p.14

This mask is especially interesting be-
cause of the translucent quality of the
stone and the precision of cutting. The
original pyrite inlay would have given
it a lifelike yet supernatural quality. EP

30

MASK

Probably Tlamimilolpa-Metepec
A.D. 200-750
Provenance unknown, Bilimek
Collection 1878
Calcite
13 x 12 cm (5 x 4 ¾ in.)
Museum für Völkerkunde, Vienna, 6250

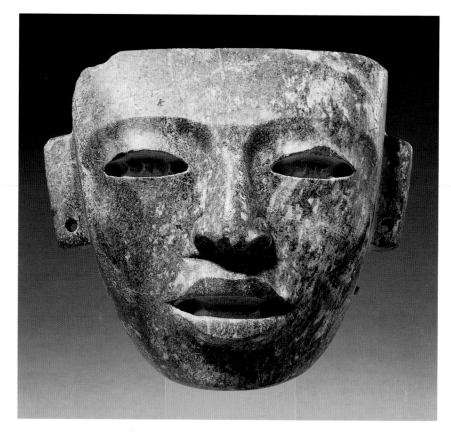

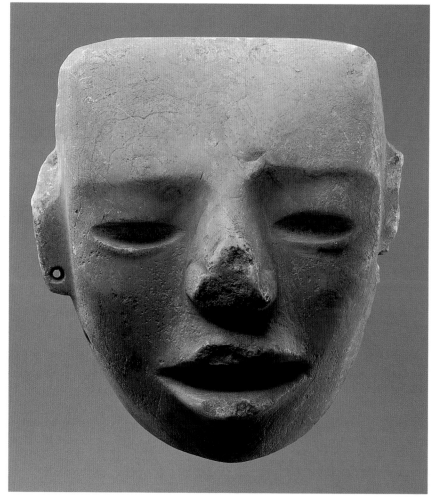

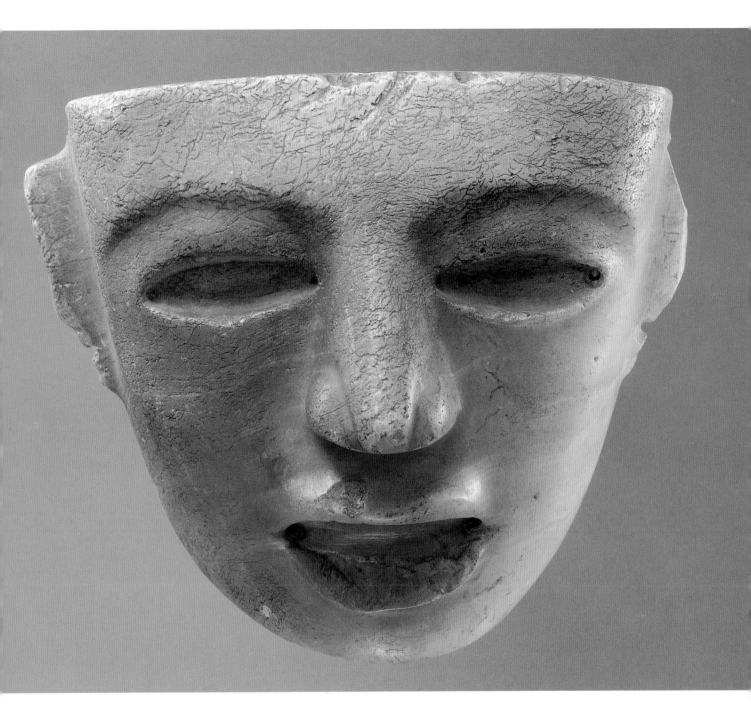

29
MASK
Probably Tlamimilolpa-Metepec
A.D. 200-750
Provenance unknown, Bilimek Collection
1882
Calcite with green-and-white striations
15.5 x 18 cm (6 x 7 in.)
Museum für Völkerkunde, Vienna, 14685

Though part of the lip is broken, this
mask harmoniously uses the horizontal
striations of the calcite in its design. It
is unusual in its trapezoidal facial shape
with very narrow chin. EP

31

MASK

Probably Tlamimilolpa-Metepec
A.D. 200-750
Provenance unknown
Stone
21.5 x 20 cm (8 ³/₄ x 8 in.)
The University Museum, University
of Pennsylvania, 66.27.14

This mask in a soft white stone is un-
usual for the geometric simplicity of its
facial planes and its crisp carving. EP

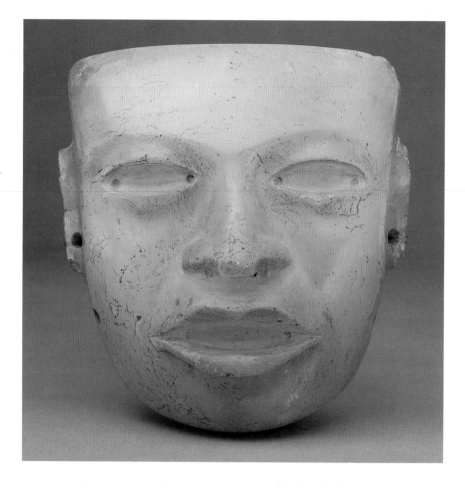

32

MASK

Probably Tlamimilolpa-Metepec
A.D. 200-750
Provenance unknown
Greenish-white stone
17.7 x 16.7 cm (7 x 6 ¹/₂ in.)
Yale University Art Gallery, The Katherine
Ordway Collection, 1980.13.12

Swirling erosion lines are particularly
evident on this simply but finely de-
signed mask. Drilled holes in the eyes,
lips, and nostrils of this and other
masks may have been the result of
manufacturing processes, and perhaps
also useful in the securing of inlays. EP

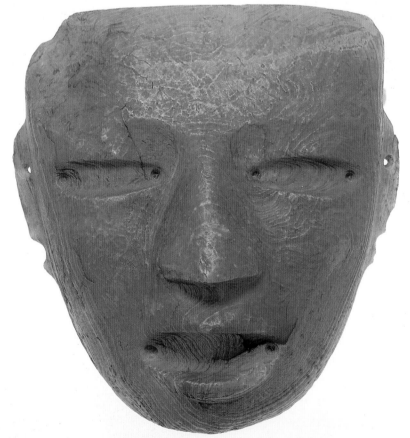

33
MASK

Probably Tlamimilolpa-Metepec
A.D. 200-750
Provenance unknown
Possibly calcite
20.5 cm (8 in.)
The Art Museum, Princeton University.
Lent anonymously, L1970.44

This mask is unusual for its curving
forehead line and for the asymmetri-
cally placed holes in the center and
side of the forehead, which may have
related to natural irregularities in the
stone. EP

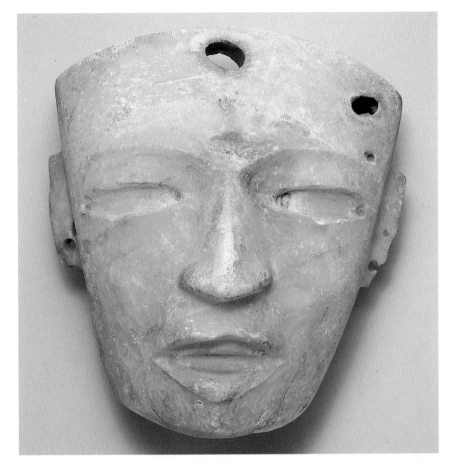

34
MASK WITH FLOWER DESIGNS ON CHEEKS

Probably Tlamimilolpa-Metepec
A.D. 200-750
Provenance unknown, Philipp J. Becker
Collection 1897
Dark gray hornstone
14.5 x 14.5 cm (5 ³/₄ x 5 ³/₄ in.)
Museum für Völkerkunde, Vienna, 59250

This is a mask remarkable for its deli-
cacy in the outlines of the mouth and
the center ridge of the nose and the
eyebrows. The flower shapes in the
cheek were probably inlaid with mosaic.
EP

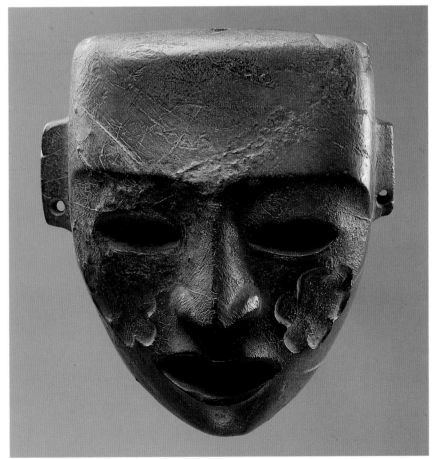

35

MASK WITH HORIZONTAL STRIPES ON CHEEKS

Probably Tlamimilolpa-Metepec
A.D. 200-750
Provenance unknown, Kaiserlich,
Konigliches Münz und Antiken-
cabinete 1881
Dark gray hornstone
16 x 16 cm (6 $^1/_4$ x 6 $^1/_4$ in.)
Museum für Völkerkunde, Vienna, 12416

This mask is very similar to the preced-
ing one in size and carving style. Three
stripes are painted on each cheek. A
bright line of red paint remains on the
inner upper lip. EP

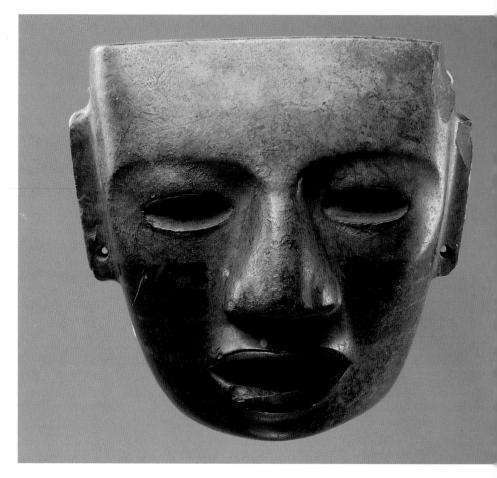

36

MASK WITH A WEATHERING PATTERN

Probably Tlamimilolpa-Metepec
A.D. 200-750
Provenance unknown, Bilimek Collection
1878
Gray stone
19 x 18 cm (7 $^1/_2$ x 7 in.)
Museum für Völkerkunde, Vienna, 6230

The proportions and features of this
mask resemble the Dumbarton Oaks
serpentine mask (cat. no. 26) and to
a lesser extent the University Museum
mask (cat. no. 31). All are vertical in
format and have wide mouths with a
squarish outline. EP

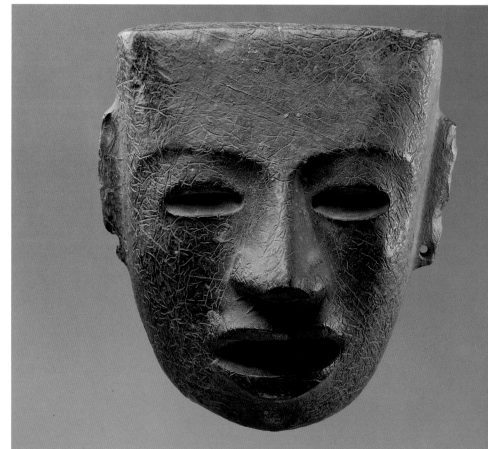

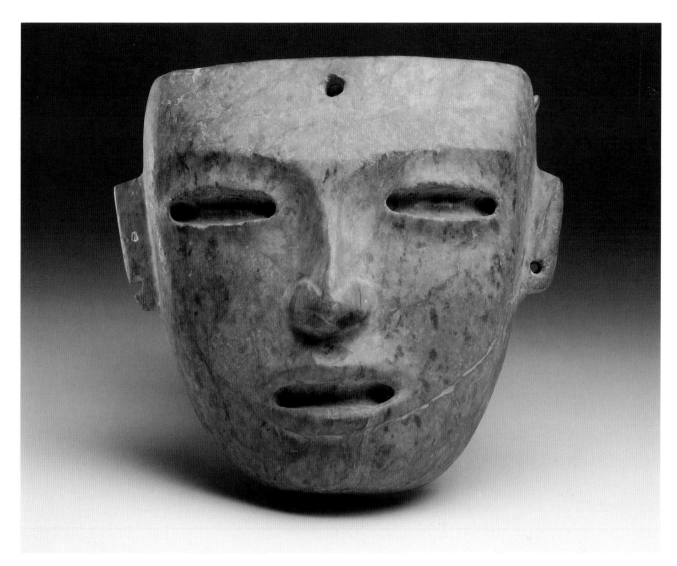

37

MASK

Probably Tlamimilolpa-Metepec
A.D. 200-750
Provenance unknown
Granitic stone
19.8 x 21.5 cm (7 ³/₄ x 8 ¹/₂ in.)
Philadelphia Museum of Art, Louise and
Walter Arensberg Collection, 50.134.233
(Not in exhibition)

The mottled pink-gray granite color
of this mask may have been especially
appreciated by the people of Teotihua-
can. The mask has a hole in the center
of the forehead, similar to catalogue
number 33. EP

38

MINIATURE MASK WITH NECKLACE

Probably Tlamimilolpa-Metepec
A.D. 200-750
Provenance unknown, said to have been
found in Guerrero
Wood, stucco, paint, remains of
iron pyrite
7.5 x 10 cm (3 x 4 in.) mask; 23 cm
(9 in.) diameter of necklace
The Fine Arts Museums of San Francisco.
Purchase, Mrs. Paul L. Wattis Fund,
1980.38a-b
Illustrated p. 84

Wood objects of any sort are rare from
Teotihuacan. This small mask with its
remaining stucco and blue paint (in
stepped design) indicates that wood
sculpture may have been an important
medium at Teotihuacan. Its forms are
quite similar to stone masks, including
the likelihood of inlay. In addition, the
paint, remains of pyrite in the eye sock-
ets, and the associated necklace help to
suggest the stone masks with all their
ornamental additions. EP

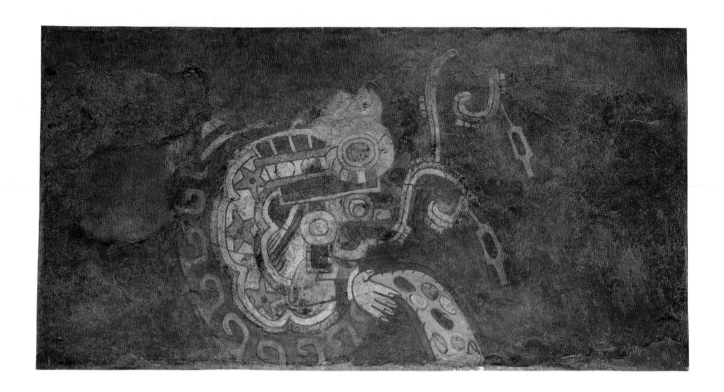

MURAL PAINTINGS

TEOTIHUACAN WAS A PAINTED CITY. Relatively little sculpture in the round or in relief ornamented the buildings. Instead, a large number of temples and habitations were covered with colorful mural paintings. The finds at this point are too sporadic to allow us to be certain why some structures were painted and some were not, but painting was found in apartment compounds of even relatively modest means. While few paintings are known to date to the Tlamimilolpa phase (A.D. 200-400), many more are from the Xolalpan phase (A.D. 400-650), and even more date from the Metepec phase (A.D. 650-750). This is due, in part, to the accidents of preservation: the last layers of murals were the best preserved.

A nineteenth-century French explorer, Désiré Charnay, compared the murals he saw to Aubusson carpets because of their jewellike colors and rich borders. Indeed, the first aspect that strikes the modern viewer is their color and ornamental quality: modern viewers sometimes compare them to wallpaper. The murals were painted in the true fresco technique — on damp plaster — with mineral pigments that included malachite for the splendid greens and hematite mixed with ground mica for the deep red, sparkling backgrounds. The five most common colors — maroon, pink, green, blue, and yellow — are close to each other in value. Although harmonious, they are not high in contrast. White and black, which would have added contrast, were only sparingly used. As a result, the murals require scrutiny to make out what is represented.

Undoubtedly a part of the purpose of the murals was to ornament walls with their rich colors and complex repeating patterns. The subject matter of the murals was full of symbolic meaning we are in the process of analyzing. Regardless of whether the murals were in temples or habitations, the same motifs and subjects were used.

The style of some Teotihuacan murals is one of the most elaborate two-dimensional styles in the world, and compares to Irish medieval manuscripts or Persian miniatures in rendering. Some images are ornamental, some are a form of simple naturalism, while others are abstract diagrams. Any one mural may be a combination of all three. The aspects of some murals are flat while other features are rendered in depth. A study of the signs, which number nearly three hundred, and their relationships, has shown that all of the iconographic themes and glyphs interrelate in a bewildering network. We must assume a sophisticated Teotihuacan public who enjoyed the visual play of color and form, as well as the intellectual game of making sense of them. The puzzlelike qualities of this art that frustrate us may have been a source of delight to them.

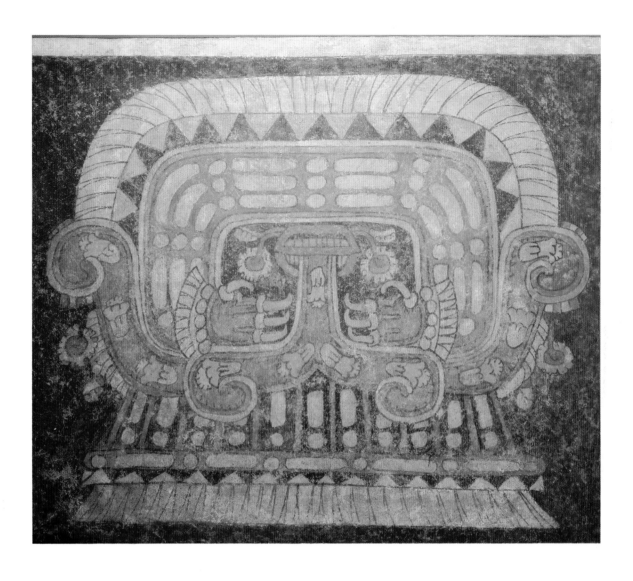

39

STORM GOD

Xolalpan A.D. 400-650
Zacuala
Fresco on wall fragment
75 x 145 cm (31 x 57 in.)
MNA 9-4716; INAH 10-136067
CNCA-INAH-MEX, Museo Nacional
de Antropología, Mexico City

In this painting the Storm God appears
to be casting seeds to the earth in the
act of planting; a speech scroll issues
from his mouth, ending in a quincunx
sign symbolizing water and precious
things. A band of starfish and a fringe
of volutes, representing waves, form a
kind of cloud from which the deity
emerges. Although lost on this particu-
lar fragment, a simple border consisting
of bands of eyes and half-starfish, signs
related to water and fertility, originally
framed the panel. The composition as
a whole refers to the Water God in the
guise of a patron of fertility and abun-
dance. CLDO

40

GODDESS WITH CLAWS

Metepec A.D. 650-750
Probably from Techinantitla
Fresco on wall fragment
66 x 77 cm (26 x 30 ½ in.)
Lent anonymously

This mural is especially important in
that it is the only frontal figure and
most likely the principal deity image of
Techinantitla. The Goddess is identifi-
able by her headdress, consisting of
yellow and red zigzag bands that form
both the headdress, the skirtlike plat-
form, and (in other extant examples)

the border of the design. Otherwise,
she is represented in the form of a dia-
gram, and not as a naturalistic image.
She has no eyes or even a clear face. A
large mouth full of teeth floats on a red
background framed by claws emerging
from jade and feather cuffs. At the
same time, the water lilies bordering
her mouth and the speech or water
scroll with flowers that emerges from it
establish the theme of nature and fertil-
ity over which she has control. She is
both creation and destruction. This is
one of the most haunting murals
known from Teotihuacan. EP

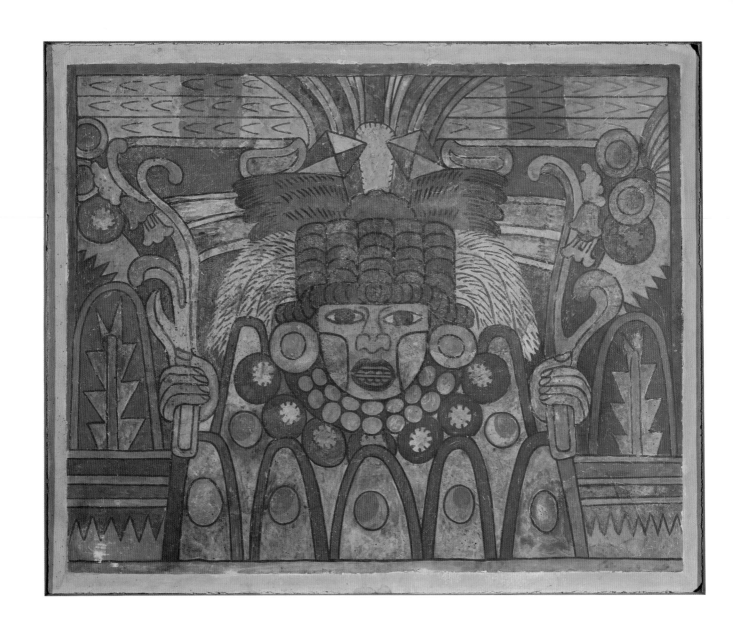

41

Goddess Holding Flowering Branches

Probably Metepec A.D. 650-750
Provenance unknown
Fresco on wall fragment
79 x 104 cm (31 x 41 in.)
The Denver Art Museum, Museum Purchase, 1965.0202

This mural, which has been known from the 1950s, may come from an early mural find such as the apartment compound of Tetitla. Although it is heavily restored, the mural is otherwise within the canon of Teotihuacan art. It represents the Goddess emerging from shapes that suggest mountains, holding what look like stylized flowering branches. Her open mouth full of teeth links her with other Tetitla representations and with Techinantitla representations (cat. no. 40). Although all features of the figure are shown as completely flat, the hands are shown three dimensionally, giving the illusion that she is grasping the branches. Such details of three-dimensionality are rare in Teotihuacan murals, suggesting that the usual flatness is not a lack of skill or knowledge, but a deliberate aesthetic choice. EP

42
Elite Figure with Maguey Leaves
Probably Metepec A.D. 650-750
Probably from Tlacuilapaxco
Fresco on wall fragment
86.5 x 146 cm (34 x 57 ½ in.)
The Fine Arts Museums of San Francisco,
Bequest of Harald J. Wagner, 1985.104.4

Like most representations of the elite
of Teotihuacan, this figure is in profile
and is magnificently dressed in a huge
feathered headdress, a feather back
ornament, and a conch-shell necklace.

A profile supplicant to a deity, the
figure holds a bag for incense and
pours a stream of liquid ornamented
with flowers. A speech scroll enclosing
shells and edged with glyphs issues from
his open mouth. Four thorn-edged
maguey plant leaves are set vertically
in a design of horizontal lines that seem
to be wrapped, three-dimensionally, in
diagonally curving lines. These may be
abstract symbols for agricultural fields,
bundles of tied sticks representing a
fifty-two year cycle, or a grass mat into
which the bloody thorns used in peni-
tential rites were set. Perhaps the image
was meant to be a metaphor for all
three. Serpents are common framing
devices for murals of elite figures.

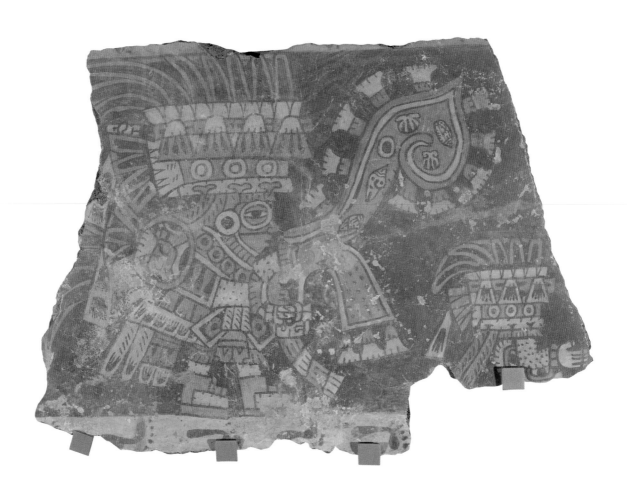
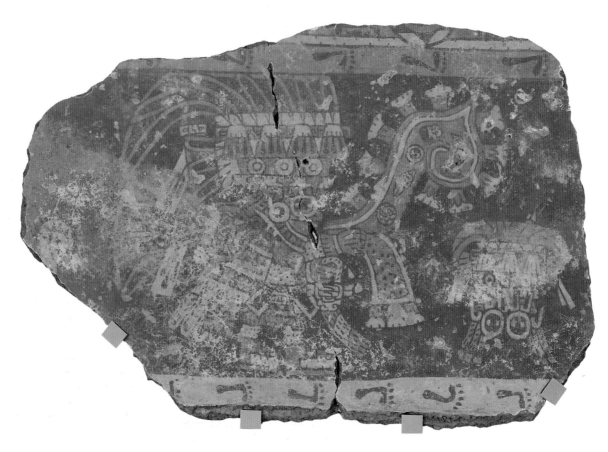

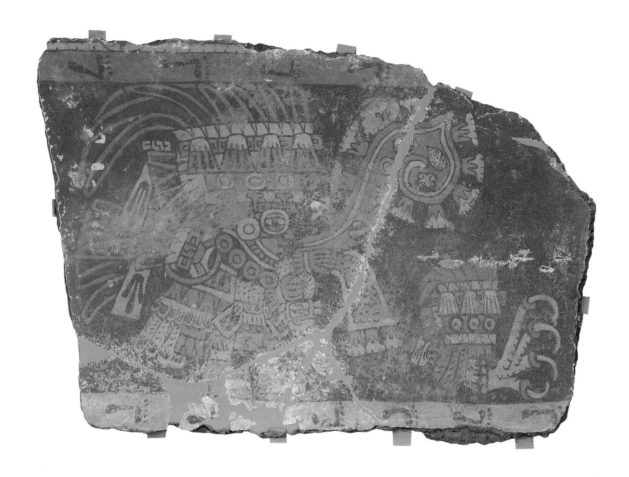

43

ELITE FIGURE WEARING TASSEL
HEADDRESS WITH FEATHERED EYES
ON AN ARM EMBLEM AT HIS FEET
Probably Metepec A.D. 650-750
Probably from Techinantitla
Fresco on wall fragment
97 x 70 cm (38 x 27 ¹/₂ in.)
The Fine Arts Museums of San Francisco,
Gift of Jack Tanzer, 1986.74

44

ELITE FIGURE WEARING TASSEL
HEADDRESS WITH FRONTAL GOGGLE-
FACED EMBLEMS AT HIS FEET
Probably Metepec A.D. 650-750
Probably from Techinantitla
Fresco on wall fragment
79 x 121 cm (31 x 47 ¹/₂ in.)
The Fine Arts Museums of San Francisco,
Bequest of Harald J. Wagner, 1985.104.11

45

ELITE FIGURE WEARING TASSEL
HEADDRESS WITH PROFILE TALON
EMBLEM AT HIS FEET
Probably Metepec A.D.650-750
Probably from Techinantitla
Fresco on wall fragment
77.5 x 110 cm (30 ¹/₂ x 43 ¹/₄ in.)
The Fine Arts Museums of San Francisco,
Bequest of Harald J. Wagner, 1985.104.5

These three continuous murals are
eight of a procession of elite figures
similar to the elite individual with
maguey leaves. Though less refined in
style, the Tassel Headdress paintings
seem much more important in subject.
As Clara Millon has shown, the tassel
headdress identifies these persons as of
the highest rank at Teotihuacan. The
tassel headdress usually consists of three
layers — tassels on top, a row of concen-
tric circles, and spearpoint or thorn
designs below them. The most unusual
aspects of these tassel headdress paint-

ings are the emblems at the feet of the
figures. Although each emblem is simi-
lar in having a tasseled headdress, each
is associated with a different symbol
such as a profile hand with eyes, frontal
goggle eyes, or profile talons. Clara
Millon has suggested that these are the
names of the individuals whose titles
are the tassel headdresses. This is very
likely and makes these murals the only
ones known on which named Teotihua-
can personages were represented. Even
if these figures were thus identified, it is
striking that in their dress, and even in
the insistence on the tassel-headdress
symbol as the most prestigious, the
Teotihuacan artist and patron reinforce
collective ideals of leadership. It may
well be that these figures were "gener-
als" or military leaders. We do not yet
know much about the state organiza-
tion of Teotihuacan, but these persons
had to have been near the very top. EP

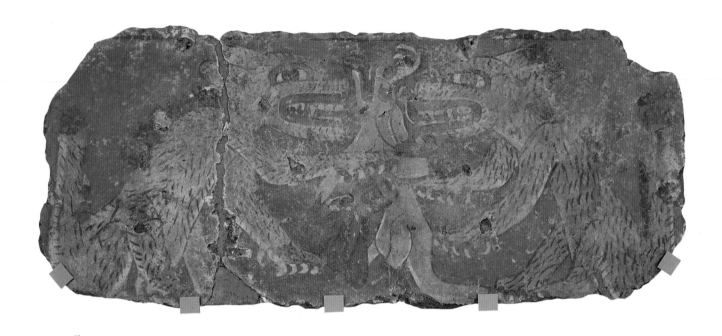

46

46

COYOTES AND DEER
Probably Metepec A.D. 650-750
Techinantitla
Fresco on wall fragment
61 x 147.5 cm (24 x 58 in.)
The Fine Arts Museums of San Francisco,
Bequest of Harald J. Wagner, 1985.104.12

This mural, absolutely unique in subject matter, is also unusual because scenes showing an actual moment of violence are rare in Teotihuacan art. The style of the painting is also unusual, with heavy, thick strokes used to represent the fur of coyotes and their bulky forms, in contrast to the elegant limbs of the deer. A white line outlining one side of the body and limbs makes the figures seem three-dimensional, in a simple form of charoscuro. This demonstrates anew that while Teotihuacan art is usually flat and ornamental, it is also preoccupied with rendering depth.

This image in this mural, so simply depicted without the usual accompanying symbols and ornaments, shows the role of animals in Teotihuacan art. Animals are as frequent a subject as human beings or gods and seem to be allegorical references to both. Unquestionably, this scene refers to the Teotihuacan practice of human sacrifice, with the victim compared to a deer and the sacrificer to a coyote. By selecting animal protagonists for many of their scenes, the artists and patrons of Teotihuacan were claiming that human practices were like those of nature — natural, appropriate, as things are, and perhaps as things ought to be. If we can judge from murals such as this one, the social model for Teotihuacan was presented as the natural world itself.

47

ANTHROPOMORPHIC
FEATHERED FELINE
Probably Metepec A.D. 650-750
Probably from Techinantitla
Fresco on wall fragment
67.5 x 102 cm (26 1/2 x 40 in.)
The Fine Arts Museums of San Francisco,
Bequest of Harald J. Wagner, 1985.104.6

This is another example of a mural in which an animal is represented behaving like a human, but is even more human in form and in dress than the coyotes sacrificing a deer. This feline walks like a human and is dressed in the feather headdress, shell collar, loincloth, hip back-ornament, and sandals of an elite figure. From the big claws of the "hands" emerge ten flames that are related both to aggressive warlike activity or to the lightning created by the Storm God. Most felines at Teotihuacan

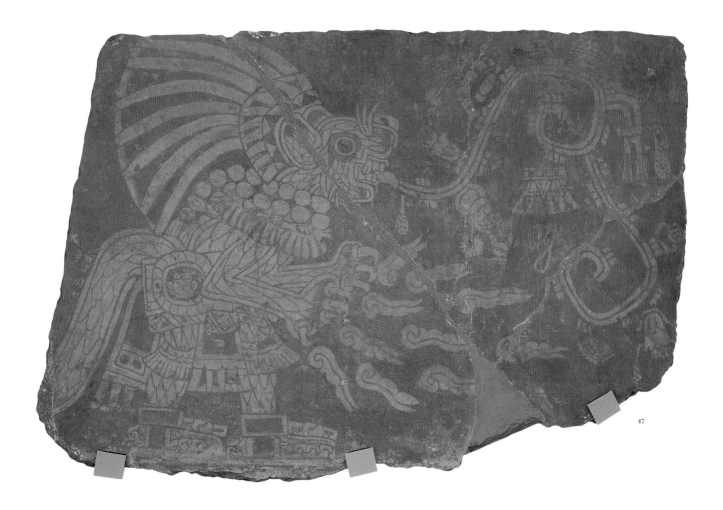

47

are either created out of an interlacing net or from overlapping feathers or possibly scales, suggesting that they are in some sense artificial or mythological beings. They could refer to myths or even be visual puns. This image is complex on several levels because it represents an animal dressed as a human, and yet the animal is not an ordinary animal but a mythological creature. EP

48
SMALL BIRD IN U-SHAPED FORM
Probably Metepec A.D. 650-750
Techinantitla
Fresco on wall fragment
25.5 x 25.5 cm (10 x 10 in.)
The Fine Arts Museums of San Francisco,
Bequest of Harald J. Wagner, 1985.104.7
Illustrated p. 132

49
SMALL BIRD CARRYING A SPEAR
Probably Metepec A.D. 650-750
Techinantitla
Fresco on wall fragment
29.5 x 31.5 cm (11 ¹/₂ x 12 ¹/₂ in.)
The Fine Arts Museums of San Francisco,
Bequest of Harald J. Wagner, 1985.104.9
Illustrated p. 133

These are two of six known fragments of small birds that seem to have been lined up in procession above a border with footprints. Their colors and finely detailed painting style relate them to the Feathered Serpent and Flowering Trees mural (cat. no. 50).

The birds may represent the quetzal, a rare creature from the Guatemala Highlands, or they may be mythical. The birds usually hold shields and/or spears, which suggests that they refer to war. They could represent either hu-

man warriors in animal guise, or deities in animal guise. More pertinently, they could be said to represent a close relationship between the animal and human worlds, a harmony of nature and culture. The U-shaped platform on which catalogue number 48 is standing may be an architectural element or signify a cross-section of a vessel. It looks like an upside-down version of the Storm God's upper lip. That upper lip, all by itself, can be a metaphor for caves and is sometimes shown enclosing seeds and treasure, such as the concentric circles in this mural indicate. EP

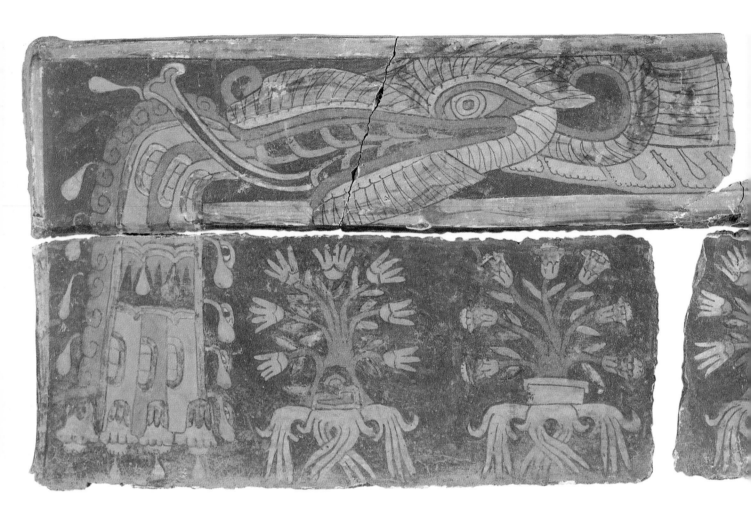

50

FEATHERED SERPENT AND FLOWERING TREES

Probably Metepec A.D. 650-750
Techinantitla
Fresco on wall fragment
56.5 x 407 cm (22 $\frac{1}{4}$ x 160 $\frac{1}{2}$ in.)
The Fine Arts Museums of San Francisco,
Bequest of Harald J. Wagner, 1985.104.1

One of the most beautiful and enigmatic rooms in the large compound of Techinantitla must have been the one with the mural of the Feathered Serpents and Flowering Trees on all four sides. Enough fragments exist to indicate that four serpents once existed with their own sets of trees, and René Millon has suggested two ways in which they could have been arranged — on the four sides of a room or along three sides of a portico. While all four were similar, this

set is by far the best preserved and the only one that is entirely complete.

The painting combines images of an abundant nature with a set of nine glyphs we have not deciphered conclusively. From the mouth of the feathered serpent, an image of verdant nature and life, emerges a stream of water edged in flowers. A curious feature of the stream is the presence of eyes, which are common motifs in Teotihuacan art and are most frequent in representations of water. They are probably the eyes of deities, especially the Goddess, and signify that all water at Teotihuacan was seen as "divine" and literally containing the bodies of the gods.

The delightful little trees contain repeating glyphs at their bases (see Esther Pasztory, "Feathered Serpents," in Berrin 1988). The glyphs are so similar in structure to Mixtec and Aztec

place glyphs that there can be no doubt that this was a form of picture writing. Most likely, some important category such as city districts or the names of clans or families were also the names of plants. This suggests a further use of the metaphor of nature and natural forms for the social and political life of the city. The mural then, as a whole, is not merely a representation of a feathered serpent pouring water over flowering vegetation, because the vegetation stands for human places or social groupings. If the feathered serpent is also symbolic of a title or ruling group in the city, then the message of the entire mural is political but couched in the images of nature. EP

51
A Probable Doorway Border Fragment

Probably Metepec A.D. 650-750
Techinantitla
Fresco on wall fragment
48.5 x 37 cm (19 x 14 $^1/_2$ in.)
The Fine Arts Museums of San Francisco,
Bequest of Harald J. Wagner, 1985.104.13

This beautiful fragment is probably part of a feathered serpent body; serpents were often connecting border motifs in Teotihuacan art. Doorway borders usually related to the subjects of the main murals of a room, but also brought the themes together in new and innovative ways. Perhaps the people of Teotihuacan saw doorways as borderline spaces in which otherwise discreet elements were mixed up. Evidently that is true in this fragment, because a little tree is shown emerging out of the body of the feathered serpent. Teotihuacan art is often thought to be rigid, repetitive, and standardized, but murals like this contradict such first impressions. EP

52
Large Bird in Frame
Probably Metepec A.D. 650-750
Techinantitla
Fresco on wall fragment
86 x 127 cm (34 x 50 ¼ in.)
Duke University Museum of Art, Gift of
Mr. and Mrs. Harry Schaeffer, 1977.38

Large Bird murals such as this example
are remarkable for the hastiness with
which they seem to have been painted
in comparison to the delicacy and
painstaking detail of the Feathered
Serpent and Flowering Trees. This bird
stands heraldically, with its body in
profile and its wings outstretched. A
speech scroll emerges from its mouth.
Human footsteps in different colors are
randomly scattered within the frame,
which might signify a platform. The
identity of the bird is unclear; it com-
bines the features of quetzals, parrots,
and owls. It could be an allegorical
reference either to the gods or to the
elite. The crest and tail feathers are so
similar to elite costumes such as cata-
logue number 42 that one wonders if
the elite might have been thought of
symbolically as "mythical birds." This
bird is unusual in having a large, dra-
matic bunch of tail feathers overhang-
ing the frame. EP

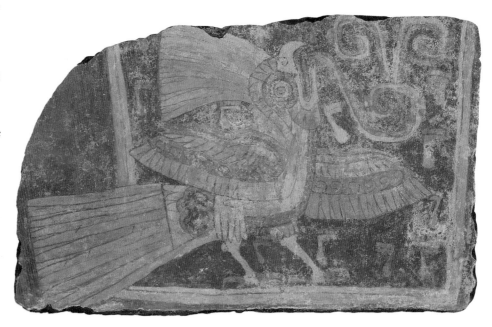

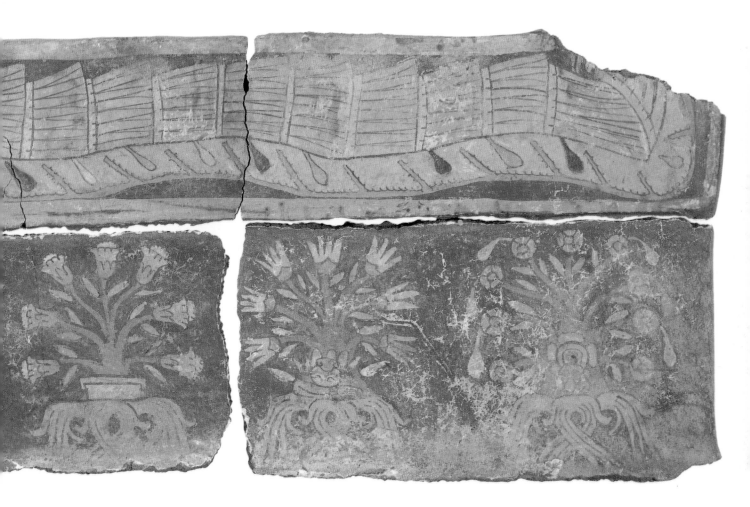

53

Painted Conch Shell
Xolalpan-Metepec A.D. 400-750
Provenance unknown
Shell, stucco, paint
15 x 38 x 20 cm (6 x 15 x 8 in.)
MNA 9-716; INAH 10-223548
CNCA-INAH-MEX, Museo Nacional
de Antropología, Mexico City

This is a frescoed trumpet shell bearing
two representations of the glyph of the
year or calendrical cycle called "eye" or
"turquoise."

The year is expressed by the inter-
laced trapeze and ray with the symbol
for eye or turquoise below, and the
numerals twelve and nine are desig-
nated by means of bars and dots, equi-
valent to the numbers five and one,
respectively. This shell is one of the best
indications that we have concerning the
knowledge and use of the ritual calendar
at Teotihuacan. Although the precise
nature of the calendar used by Teoti-
huacan still remains to be clarified,
later civilizations in the region utilized
both 365-day solar and 260-day ritual
calendars. CLDO

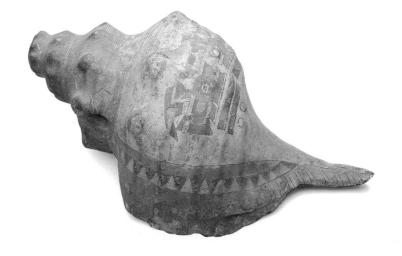

54

WOODEN BOX FRAGMENT (SIDE)

Probably Tlamimilolpa-Metepec
A.D. 200-750
Provenance unknown
Wood, stucco, paint
21.9 cm (9 in.)
The Art Institute of Chicago, Gift
of Mrs. Hanoh Charat, 1971.771
(Not in exhibition)

55

WOODEN BOX FRAGMENT (LID)

Probably Tlamimilolpa-Metepec
A.D. 200-750
Provenance unknown
Wood, stucco, paint
12.5 x 15 cm (5 x 6 in.)
The Denver Art Museum,
Gift of William I. Lee, 1985.0639

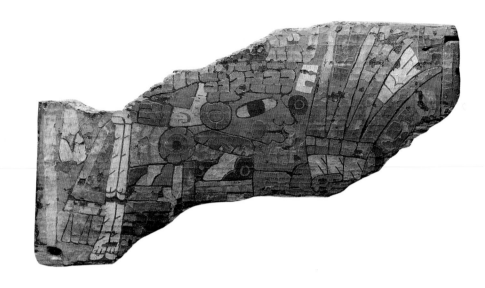

These two fragments were once part of
a rectangular box painted on all sides
with elite profile figures. Outlined with
black, the box is more like the frescoed
vessels in style than the murals and was
perhaps done in related workshops.
Since the headdress, costume, and
bundle held by the figure fill most of
the space with small-scale designs, only
the face, with its large oval eye painted
on the diagonal, is clear. The artist also
emphasized the fleshy nose and lips of
the individual, quite similar to the rep-
resentation of the masks. These box
fragments indicate the importance of
perishable objects in Teotihuacan art
to which we no longer have access. We
do not know what would have been
kept in this box, but it must have be-
longed to a high-status individual. EP

56

PAINTER'S PALETTE

Probably Xolalpan-Metepec A.D. 400-750
Provenance unknown, Collection
of William Spratling
Stone, stucco, paint
10.6 x 35.9 cm (4 1/4 x 15 3/4 in.)
MNA 9-1929; INAH 10-77703
CNCA-INAH-MEX, Museo Nacional
de Antropología, Mexico City

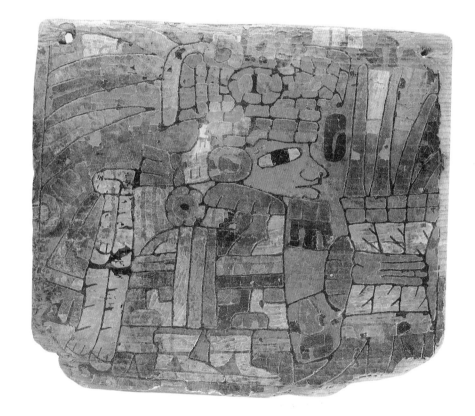

This painter's palette with eight com-
partments for pigment was carved from
a single block of stone. Although it has
lost almost all of its original decoration,
at one time it was totally covered with
stucco and paint. Some of this poly-
chromy may still be seen on the sup-
ports, where busts of profile figures
wearing headdresses with green feath-
ers are shown with speech scrolls issu-
ing from their mouths. CLDO

56

57
MASONRY IMPLEMENT FOR APPLYING
LIME STUCCO
Tlamimilolpa-Metepec A.D. 200-750
Provenance unknown, Sigvald Linné
Collection
7.5 x 9 cm (3 x 3 ¹/₂ in.)
Volcanic stone and lime-stucco remains
Folkens Museum-Etnografiska,
Stockholm, 1932.8.4421
Illustrated p. 123

58
CERAMIC PIGMENT CONTAINER
Probably Tlamimilolpa-Metepec
A.D. 200-750
Buff clay with red-and-white fresco
remains and paint
15 x 20 cm (6 x 8 in.)
The Denver Art Museum, Gift of H.T.
Mulryan and Acquisition Challenge Fund,
1986.0101a-b

58

This frescoed, planar, box-shaped ob-
ject is well within the Teotihuacan aes-
thetic, although no other object like it
is known. The two cylindrical depres-
sions suggest that they were containers
for something such as paint. We have
no explanation for the fanciful format
that combines a house with sloping roof
and a "sedan chair." EP

CLAY SCULPTURE

After A.D. 250, a great many works of art were made in clay at Teotihuacan, including roof ornaments, host figures, and censers. Unlike the greenstone figures and masks that were found in the most elite and ceremonial parts of the city, many of the clay objects were more widely distributed. Unquestionably, clay was a cheaper medium and thus censers, for example, were common in apartment compounds while greenstone masks and figures ere not. The difference is not simply one of cost and status. Because of the malleability of the material it was possible to create more iconographically complex works in ceramic than in stone. What distinguishes this sculpture from that of other parts of Mesoamerica is its fragility, the fact that it is often assembled from pieces, and its intricacy of detail. An exception to this is the bust with separately attached mask (cat. no. 60), which is stark in its simplicity and suggests that it was once dressed. In formal representation it stands half-way between the stone masks and figures and the clay censers. It, too, was made in separate pieces that were then attached to one another.

59

ARCHITECTURAL ELEMENT IN THE
SHAPE OF A BIRD
Metepec A.D. 650-750
Found in the 1960s in Palace 3 of the
Plaza of the Moon
Ceramic, stucco, paint
45 x 47 x 2.5 cm (17 3/4 x 18 1/2 x 1 in.)
MNA 9-3037; INAH 10-80855
CNCA-INAH-MEX, Museo Nacional
de Antropología, Mexico City

This is a ceramic architectural element or *almena* that probably crowned the roof of a building. The sculpted relief represents a bird, probably a quetzal or an eagle, shown with a speech scroll composed of two elements — green beads symbolizing precious substances and volutes alluding to water. These symbols are also associated with birds in the reliefs of the pillars of the Quetzal Butterfly Palace (Serra Puche, fig. 6), a structure located near Palace 3 where this piece was excavated. CLDO

60

BUST WITH A MASK

Tlamimilolpa-Xolalpan A.D. 400-650
Found in a tomb on the north side
of the Ciudadela
Ceramic and pigment
55 cm (21 ³/₄ in.)
PAT 10276, INAH 10-33666-920/2
CNCA-INAH-MEX, Museo Arqueológico
de Teotihuacan

This sculpture is probably a clay repre-
sentation of a funerary bundle, in part
because it was found in a mortuary
offering (together with the remains of
double-cone incense burners and a
specialized potter's workshop). This
unique object consists of two parts — a
solid framework and a detachable mask.
The simple body resembles a human
torso, in which shoulders and the vague
shape of a head are indicated. A typical
Teotihuacan mask was placed over the
flat, completely featureless facial area,
while the rectangular cavity on the
front probably held an object of sacred
significance, such as a pyrite or mica.
The Teotihuacanos buried bodies in
seated position, wrapped with cloth or
mats, with a mask possibly placed on
the face. Archaeological evidence has
indicated that some funerary bundles
were cremated. RCC

209

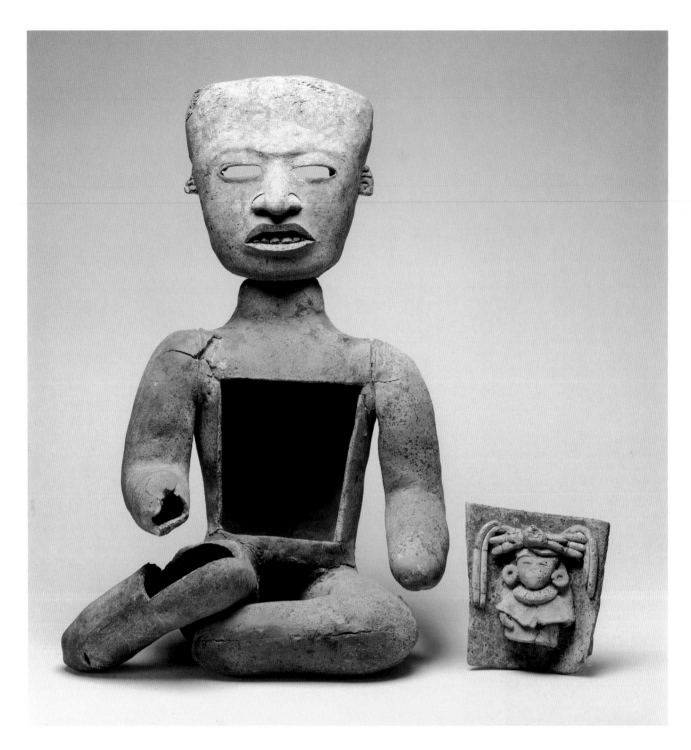

HOST FIGURINES

Two-part, relatively nude figurines that "host" varying numbers of smaller, solid figurines inside of them are aesthetically and symbolically one of the arcane Teotihuacan object types. Found in burials and caches, host figurines commemorated important events for Teotihuacanos within the city and other parts of Mesoamerica. The outer anthropomorphic representation of either a female or male houses groups of smaller figurines that portray a wide variety of status, rank, and divinity in a few cases. Understanding in what context the outer figurine is either male or female may help in understanding the specific meaning of the smaller figurines. Several of the outer figurines show evidence of mica and hematite and other minerals in the eyes and headdresses.

Host figurines are found both within Teotihuacan and as far afield as Guatemala, Michoacán, and the Yucatán. Each host complex is very different and may represent the group consecrating the offering. Some represent only male figures such as soldiers, merchants, or bureaucrats, and still others combine males and females of all ages and perhaps represent significant members or groups in the apartment compound. WB

61

HOST FIGURINE

Terminal Metepec A.D.750
Found at the 33d compound in the area
or barrio called Tlajinga, in a cache be-
hind the residential temple platform
Ceramic and pigment
38 cm (15 in.) for the large figure; two
medium figures are 7.9-9.4 cm (3-4 in.);
tiny figures are 5.2-6.8 cm (2-2 ³/₄ in.)
INAH 10-411079-82
CNCA-INAH-MEX, Centro de
Investigaciones Arqueológicas
de Teotihuacan

The larger outer figure has lower limbs
flexed back with arms resting on legs;
the extremities of both are rounded
and therefore do not display details of
hands and feet. A large hollow head or
mask is a separate piece that may be
balanced on the neck, which has slightly
rounded edges. The face is typically
Teotihuacan with small ears and nose
and well-delineated eyes and mouth. A
lid fits perfectly into the opening made
in the torso. On the inner wall of this
lid is attached a standing figurine with
one of the feet broken. It represents a
richly dressed woman with *quexquemitl*
(triangular mantle), necklace, and
large earspools in addition to a compli-
cated headdress with long feathers and
orange facial paint.

This extraordinary sculpture was
found associated with other objects —
two brown ceramic shallow bowls and
thirteen richly attired clay figurines,
some with appliqué decoration and
brilliant colors in tones of ocher, green,
red, black, and yellow. They represent
both male and female seated individu-
als (in equal numbers), some identical,
which indicates they were made in a
mold. Among these diminutive objects,
two medium-sized figurines stand out
for their elaborate costume, including
earspools, strands of necklaces, a com-
plex headdress, and a large feather
panache. A hunchback male has a very
distinctive headdress. RCC

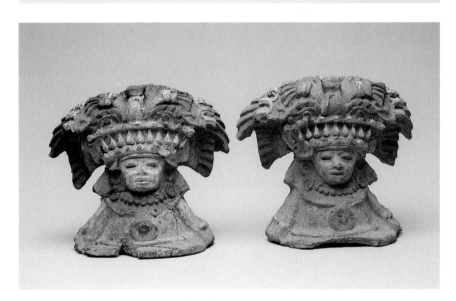

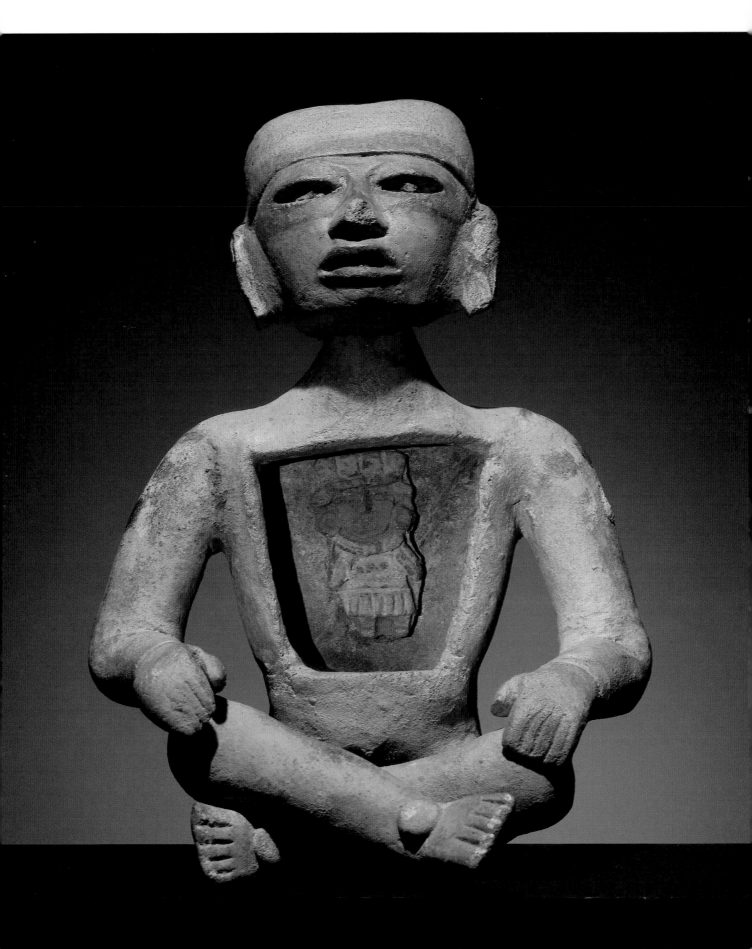

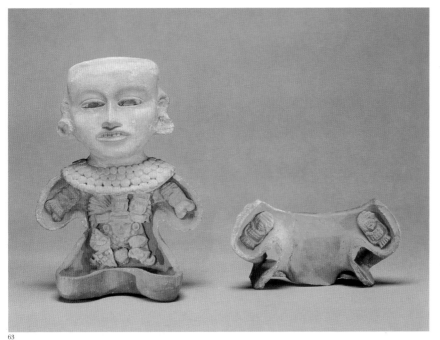

62

HOST FIGURINE
Metepec A.D. 650-750
Provenance unknown
Ceramic and paint
13.9 x 10.4 cm (5 $\frac{1}{2}$ x 4 $\frac{1}{4}$ in.)
MNA 9-3585; INAH 10-223779
CNCA-INAH-MEX, Museo Nacional
de Antropología, Mexico City

Several interpretations have been proposed to explain these figurines; one is that they express the indigenous concept of the *nahual* or the "double that we all possess and into which we may transform ourselves." The other idea is that they represent a goddess of the earth who receives and protects dead warriors. In reality, because of the scarcity of host figurine in the archaeological record and because their smaller figurines vary both in number and gender, it is difficult to offer a unilateral explanation. CLDO

63

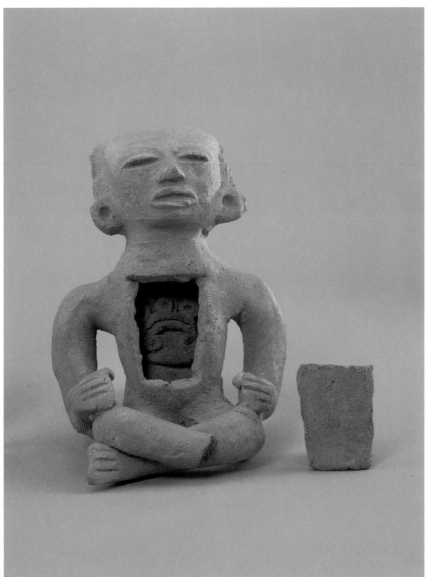

HOST FIGURINE
Metepec A.D. 650-750
Acquired at Ahuexotla by George Vaillant in 1933
Ceramic, mica, pigment
20 cm (8 in.)
American Museum of Natural History, 30.1/9188

This is the first host figurine ever found. It was therefore incorrectly reconstructed, giving the legs the appearance of kneeling; the lower portion was missing that would have indicated that the legs were actually once crossed. A male figurine with butterfly wings, medallion, and unusual headdress sits against the spine. The smaller figurines in the legs and arms are simply dressed females and males. Mica and minerals are encrusted in the eyes. WB

64

HOST FIGURINE
Terminal Metepec ca. A.D. 750
Provenance unknown
Ceramic
13 cm (5 in.)
Natural History Museum of Los Angeles, Gift of Mr. and Mrs. Hasso von Winning, AH-440

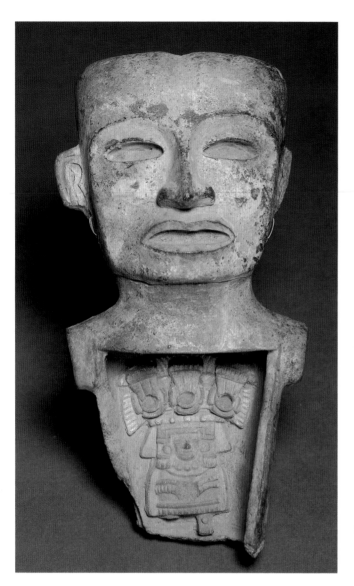

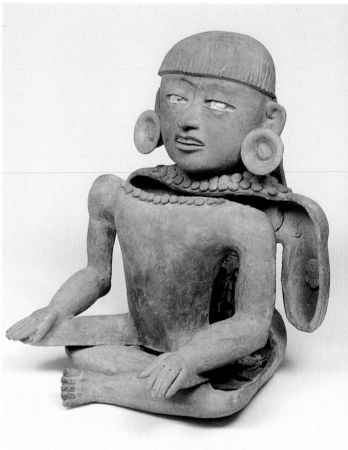

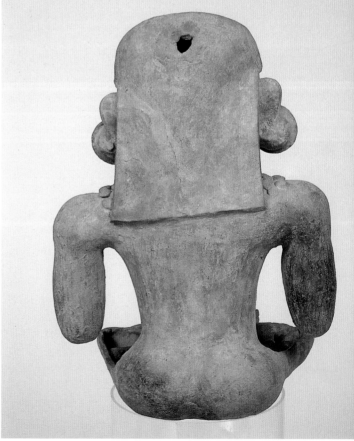

65
HOST FRAGMENT
Metepec A.D. 650-750
Provenance unknown
Ceramic and pigment
20.2 x l0.1 cm (7 ⁷⁄₈ x 4 in.)
The Saint Louis Art Museum, Gift
of Morton D. May, 230.1978

This host fragment is a transitional
piece between the full hosts (which
have multiple interior figures) and the
Early Epiclassic figurines from Tlaxcala
that have an attenuated "niche" form.

This host is female, with articulated
arms; implied moveable arms are ex-
pressed by incisions around the shoul-
der of the Tlajinga 33 host (cat. no. 61).
The smaller, elaborately dressed mold-
made female against the spine is unlike
the full hosts that have males against the
spine and females on the chest plate. WB

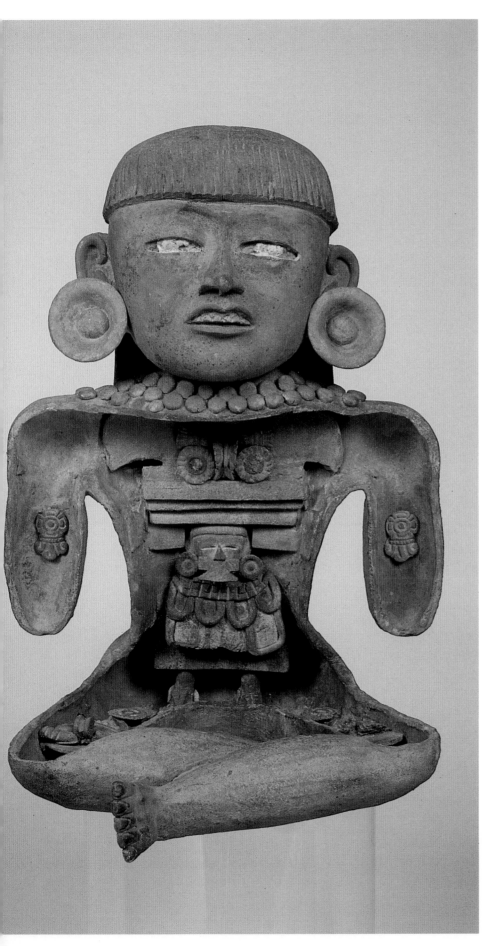

HOST FIGURINE
Late Xolalpan A.D. 650
Escuintla, Guatemala
Ceramic, mica, pigment
38 x 27 cm (14 ³/₈ x 10 ¹/₂ in.)
Lent anonymously

This extraordinary host figurine from
Guatemala was found broken and has
been reconstructed. The exterior figure
is a seated cross-legged male. On the
interior of the chest plate a figure has
been replaced with a head modeled
from the head of the male figure stand-
ing against the spine. In the legs are
small masks or medallions. It is possible
that the chest plate figure had been
originally and purposely removed.
This is clearly what happened to the
spinal figure of the Tlajinga 33 host
(cat. no. 61), where the outline shadow
of the missing figure is still visible in the
cavity. WB

CERAMIC CENSERS

In contrast to the simplicity of Storm God vessels and Old God braziers, ceramic censers are astonishing works of layered complexity in clay. They were apparently invented at the time the apartment compounds were built, around A.D. 250, and continued to be made until the collapse of the city. Several were found either in the burials of important individuals, perhaps even the "founders" of the apartment compounds, or, associated with central patios and their shrines. Evidently they were associated with the rituals of the apartment compound as a whole.

The clay censers were used to burn incense. Copal was placed in the bowl of the flower-pot-shaped vessel which was elevated on another inverted flower-pot-shaped vessel. It was covered by a conical lid; through the back rose a chimney-like tube where the smoke escaped. The emphasis is not on the function of the vessel but on the scene that had been constructed on top and the images and ideas it was meant to convey.

There were a variety of censer burner types at Teotihuacan; sometimes ornaments were added directly to the conical lid, or more infrequently, a standing figure was placed on top. The most common are the so-called theater types, because in them a masked "face" hidden with nose ornament and earspools seems to be looking out from a stage surrounded by a proscenium, completely covered by symbols and signs. A profusion of *adornos* around the mask seem to vie for attention. Flowers, shells, and feathered circles with mica insets are the most common; butterflies, birds' heads, and spear points are also frequent. Rectangular panels called *mantas* often border the top or bottom frame. Though symmetrical in general, the right and left sides of the censer may have different symbols indicating the importance of directions. Janet Berlo and I have argued that the central mask represents the Teotihuacan Goddess because of the butterfly symbolism and the nosebar.

No two censers were alike, and the purpose of the mass-produced *adornos* may have been to make available a lot of symbols put together either for a petition to a deity, at the direction of a diviner, or as some other personal choice. In its lifetime a censer may have been set up with new and different *adornos* several times, and archaeological excavations indicate that censers also were often disassembled and placed in burials and offerings.

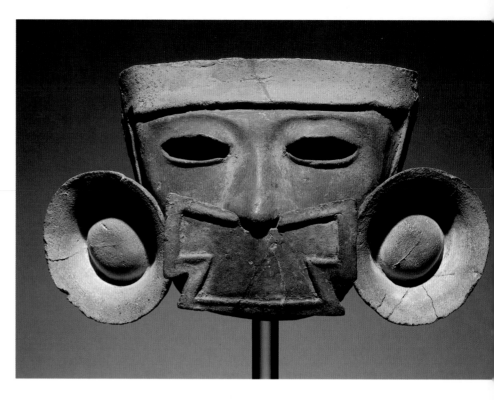

67
POLYCHROME MASK
Late Xolalpan A.D. 500-650
San Miguel Amantla, Azcapotzalco,
Valley of Mexico
Ceramic and pigment
10 x 18 cm (4 x 7 1/4 in.)
MNA 9-2056; INAH 10-373
CNA-INAH-MEX, Museo Nacional
de Antropología, Mexico City

The important role played by masks in Teotihuacan ritual is made clear by the abundance of masks in all media. They are depicted in mural painting, may serve as the face in clay and possibly stone sculpture, and may also have been attached to mortuary bundles containing cadavers wrapped for burial. This particular example displays distinctive elements of rank, such as prominent earspools and a nose ornament. Because of its form this mouth or nose plaque has been interpreted by some authors as the representation of a typical Teotihuacan *talud-tablero* temple; it appears frequently on theater-type censers in association with butterfly symbolism. CLDO

68
THEATER-TYPE CENSER
Late Xolalpan A.D. 500-650
Found in Offering 23 at Tetitla
Ceramic, pigment, mica
68.2 x 41.3 cm (26 7/8 x 16 1/4 in.)
MNA 9-3376; INAH 10-80432
CNCA-INAH-MEX, Museo Nacional
de Antropología, Mexico City

Theater-type censers seem to represent the architecture of Teotihuacan temples in which lateral plaques take the place of jambs while decorations along the upper area refer to pieces crowning a temple's roof. The mask substitutes for the image of the deity within the temple and the rectangular plaques below with repeated designs allude to the cloths that must have covered the altar. This particular censer bears a spiral design on the right lateral plaque that is related to the bundle of burning wood, which was part of the Teotihuacan celebration of cyclic observation. The design encircled in a medallion on the left plaque has been interpreted as a glyph called *reptile eye*, which is related to fertility and abundance, while the *mantas* or rectangular plaques perhaps display designs of calendrical significance. Finally, the butterflies above the mask are related to fire symbolism. CLDO

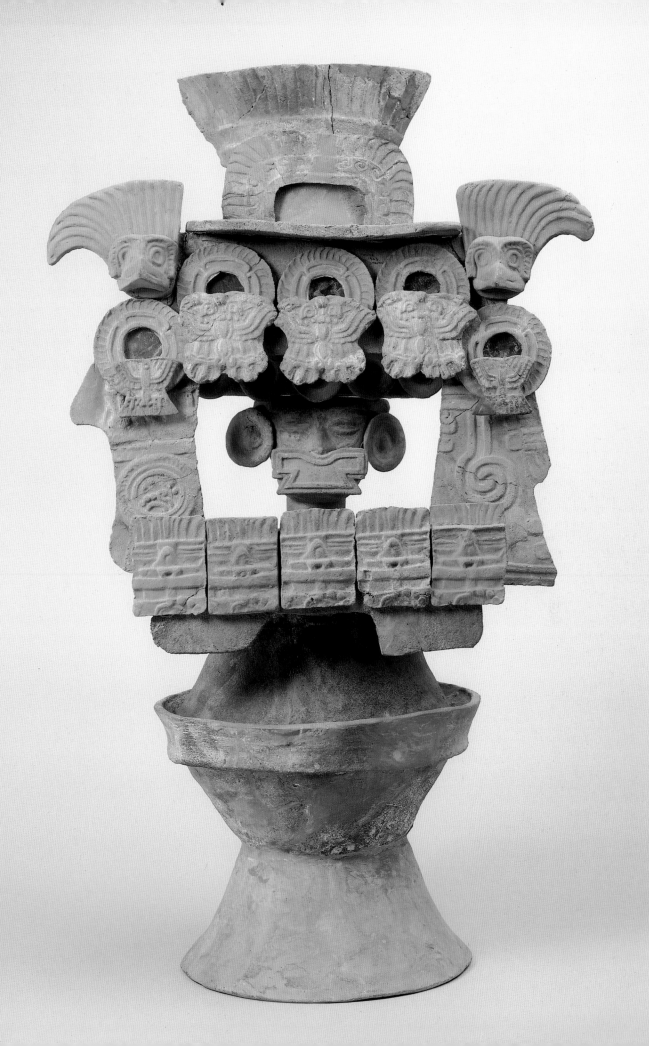

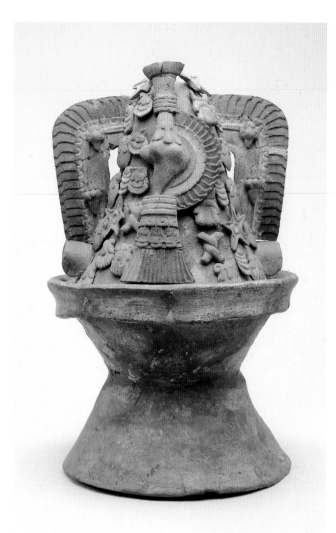

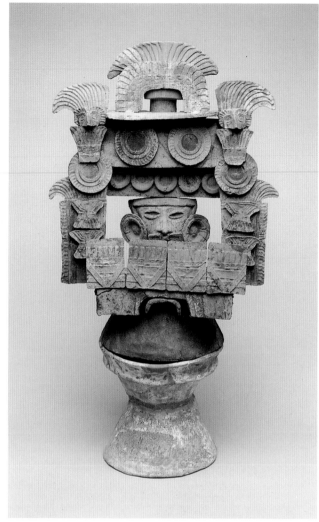

69
COMPOSITE CENSER WITH
WATER MOTIFS
Metepec A.D. 650-750
Found in Offering 16 at Tetitla
Ceramic, stucco, pigment
37 x 22.3 cm (14 $^1/_2$ x 8 $^7/_8$ in.)
MNA 9-2632; INAH 10-80436
CNCA-INAH-MEX, Museo Nacional
de Antropología, Mexico City

This fine ritual censer is noteworthy for
the large number of moldmade decora-
tive elements associated with water. The
upper part is based on a ceramic cone
adorned with molded pieces that were
originally frescoed yellow and green.
The central and largest motif is a trum-
pet shell half surrounded by a feathered
arc. In addition to serving as a musical
instrument, the shell had a ritual func-
tion. Among the smaller pieces decorat-
ing the censer are starfish, twisted cords,
and a variety of different kinds of shells.
CLDO

70
THEATER-TYPE CENSER
Xolalpan A.D. 400-600
Found in the early 1960s at La Ventilla,
Structure 79
Ceramic, pigment, mica
72 x 39 cm (28 $^1/_2$ x 15 $^1/_4$ in.)
INAH 10-262375
CNCA-INAH-MEX, Museo Arqueológico
de Teotihuacan

Almost exclusively associated with the
Teotihuacan culture, these censers are
generally found in isolated offerings
in palaces and residential zones. They
almost always consist of two parts, al-
though frequently only the upper part
survives. The lower part is a conical
receptacle for the hot coals while the
lid is elaborately decorated with a rich
array of thin clay plaques that after
firing were covered with brilliant
pigments. RCC

71
VARIANT OF A THEATER-TYPE CENSER
Xolalpan A.D. 400-650
Oztoyahualco, excavated by Linda
Manzanilla in the late 1980s
Ceramic and pigment
34.5 x 20.5 cm (13 1/2 x 8 in.)
Excavation number 428PJ223
CNCA-INAH-MEX, Museo Arqueológico
de Teotihuacan
Illustrated p. 97

This extraordinary censer was found
completely dismantled in the burial of a
young adult male; it has been accurately
reconstructed by matching the *adorno*
shapes with the residue of lime-stucco
cementing material that once held
them fast. The censer consists solely of
the upper part or lid with chimney shaft
in the back part, while the front portion
is profusely decorated with thin ceramic
plaque appliqués called *adornos*, signify-
ing fruits and flowers. A richly dressed
standing figure is associated with the
representations of plants, food, clouds,
flowers, and butterfly symbols. Two rec-
tangular panels located on both sides of
the figure are fringed with large feath-
ers, echoing the lavish plumes of the
ample headdress worn by the figure.
RCC

72
DISASSEMBLED CERAMIC CENSER
Tlamimilolpa A.D. 200-400
Tlamimilolpa, Burial 1
Ceramic and whitewash
Largest fragment 18-25 cm (7-10 in.)
Folkens Museum-Etnografiska,
Stockholm, 35.8.2383
Illustrated p. 44

The Swedish archaeologist Sigvald
Linné excavated the apartment com-
pound of Tlamimilolpa in 1934-1935.
Tlamimilolpa is one of the less spacious
compounds, with many small rooms
arranged in a labyrinthine plan. Burial
1 was the most lavish burial in the en-
tire history of the compound. It was built
near the time of the foundation of the
structure, three floors under room 16.
Over twelve hundred objects were bur-
ied with this dead man, many of which
were cremated with him. The censer
was found in about thirty fragments.

 This censer is noteworthy because
of its early date and because its various
parts are handmade rather than
moldmade. Unlike most of the later
censers, this was not painted in bright
colors but covered in whitewash. Un-
usual details include the spiral scroll
that emerges from the mask's forehead
and the *mantas* with their fingerlike
projections. EP

73
MASK FOR A CERAMIC CENSER
Tlamimilolpa A.D. 200-400
Tlamimilolpa, Room 1
11 x 16 cm (4 1/2 x 6 1/2 in.)
Terracotta with traces of paint
Folkens Museum-Etnografiska,
Stockholm, 35.8.2773

This censer mask was found three floors
under room 1 along with several other
masks. The stepped facial paint remains
on the cheeks are similar to those of the
censer of Burial 1 (cat. no. 72). A white-
washed nosebar was attached to the
mouth and the eyes still preserve their
pyrite inlay. Linné noted that many
masks seem to have had pyrite inlays
secured with yellowish clay. Though
censer masks are similar in type, they
were individualized by facial paint and
costume. EP

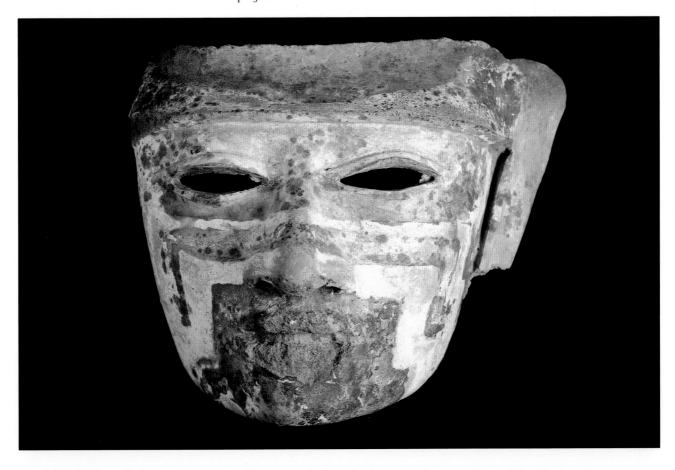

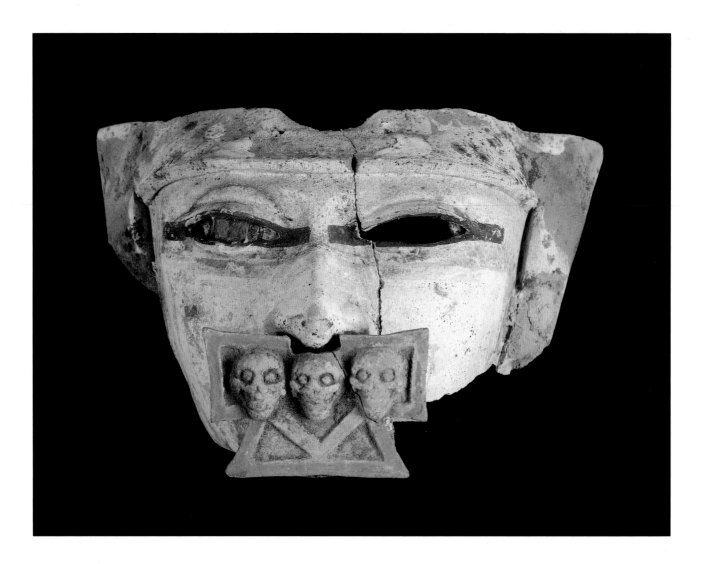

74
MASK FOR A CERAMIC CENSER
Tlamimilolpa A.D. 200-400
Tlamimilolpa
Terracotta with traces of paint
10 cm x 16.3 cm (3 ⁷/₈ x 6 ¹/₄ in.)
Folkens Museum-Etnografiska,
Stockholm, 35.8.2774

This is one of the most dramatic masks
found in room l under the third floor,
next to catalogue number 73. Its pale
face with black-edged eyes has an al-
most "Egyptian" look. In both of these
early masks, the lids are remarkable for
their naturalistic modeling. This mask
is further noteworthy because of its nose-
bar on which three skulls are modeled
in relief. Skulls occur in Teotihuacan
art in all media but they are not as com-
mon a motif as, for example, in Aztec
art. The fine preservation of green and
yellow paint on the nosebar indicates
how colorful these censers must have
once been. EP

75
THEATER-TYPE CENSER
Xolalpan-Metepec A.D. 400-750
Provenance unknown
Terracotta with whitewash and yellow paint
63.5 cm (25 in.)
Natural History Museum of Los Angeles
County, F. A. 462.72-15

Most censers with unknown provenance
have been reassembled and/or restored
to some extent. There is no absolute
certainty as to the correctness of the
adornos and their placement. Since
variability was the essence of the censers
anyway, this does not present a major
problem in interpretation. Birds orna-
ment the sides of the frame, butterflies
hang from the flowers on the roof, and
five *mantas* line the base. The project-
ing nosebar is unusual. The mask and
all the ornaments are moldmade. Be-
cause of its total symmetry, this censer
lacks the liveliness of the one from
Tetitla. EP

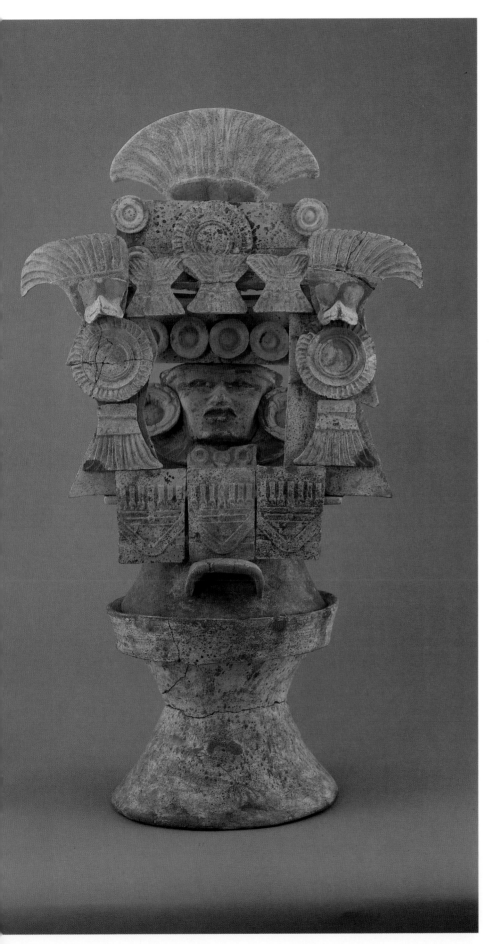

76

THEATER-TYPE CENSER
Xolalpan-Metepec A.D. 400-750
Provenance unknown
Clay with paint
76 cm (30 in.)
Lent anonymously
Illustrated p. 81

This censer is remarkable for the fine
large butterfly image on the top of the
headdress. The other elements, such as
the *mantas*, arrow points, and disks, are
common in censer composition. Since
it is a piece without archaeological prov-
enance it is not certain whether all the
pieces definitely belonged once to this
censer in this arrangement, but since
most censers were disassembled and
rearranged, this is not a major problem.
The base with the ornamentation of the
clay knobs is unusual. EP

77

SELECTION OF MOLDS AND *ADORNOS*
Tlamimilolpa-Xolalpan A.D. 400-650
From a workshop excavated in 1980-1982,
at the northwest corner of the Ciudadela
Ceramic
All under 13 cm (5 in.)
INAH
CNCA-INAH-MEX, Museo Arqueológico
de Teotihuacan
Illustrated p. 120

The use of molds in manufacturing
ceramics represented a major advance
in the process of mass production, and
these are several examples of molds and
adornos found in a ceramic workshop.
This ceramic workshop was found adja-
cent to the Ciudadela. It was surrounded
by high walls and consisted of a very
large patio and small groups of rooms.
In and around these rooms a concen-
tration of molds, *adornos*, censer bases,
masks, and figurines were found in
particularly dense concentrations. Ap-
proximately twenty thousand pieces
were found, including complete objects
as well as fragments. Implements used
in the manufacturing process were also
found, including clay, obsidian, and
other tools. This workshop probably
serviced the Ciudadela because many
of the pieces found in the workshop
also were found in the residential area
in the back part of the Ciudadela. Spe-
cial points of access, including a stair-
way, directly linked the Ciudadela with
this workshop. RCC

78

FIGURINES

THE NUMBERS OF FIGURINES found at Teotihuacan were not exceeded by any other concentration of figurines found elsewhere in Mesoamerica. A tradition that began at Teotihuacan about 150 B.C., figurines were manufactured in the millions and form a significant portion of the total artifactual collection from the ancient city. The sudden appearance of sizable numbers of male figurines in addition to females constituted a major departure from earlier figurine traditions in Mesoamerica.

Because Teotihuacan figurines are found primarily in residential middens and fill and not in the contexts of great temples or burials strongly suggests that they played an important role in daily household rituals at the apartment compounds. The earliest figurines at Teotihuacan were handmade, but around A.D. 250 moldmade figures began to be produced. The mold allowed faster production of figurines for

a growing population that must have felt a continuous need for them. After the fall of Teotihuacan, certain types of figurines (puppets and portraits) completely ceased to be made.

Figurines were used by the majority of ancient Teotihuacanos and represent a wide variety of ranks, positions, or status. They were probably used to help in intercessions with either the state or the pantheon of deities. It is possible to infer from the sheer numbers made that they were even purposely broken, though no direct evidence supports this. WB

78

TWO FIGURINES ON BASE
Xolalpan A.D. 400-650
Found in 1920 on land near the Church of San Miguel Amantla, Azcapotzalco, Valley of Mexico
Ceramic
7.4 x 8.8 cm (3 x 3 1/$_2$ in.)
MNA 9-716; INAH 10-78246
CNCA-INAH-MEX, Museo Nacional de Antropología, Mexico City

Given the great variety of Teotihuacan figurines, this grouping is exceptional both for the physical types represented as well as for the composition that joins two figures on a small tableau or plaque. Both are deformed masculine figures, one of them a hunchback with protuberances on the back and chest, the other knock-kneed. In addition, both have disproportionally large heads. Representations of abnormalities are known, but they are rare, which makes interpretation of this piece difficult. CLDO

79a 79b

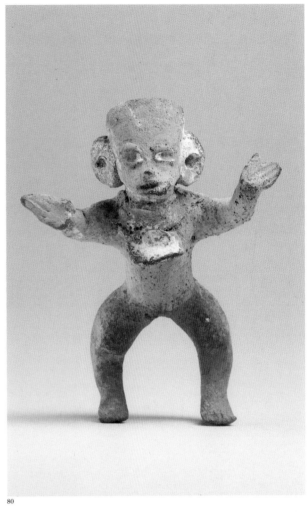

79

(A) SEATED FIGURINE ON TABLEAU, WITH VESSEL

Miccaotli A.D. 150-200
Provenance unknown
Ceramic
6.5 x 4 cm (2 ¹/₂ x 1 ¹/₂ in.)
Los Angeles County Museum of Art, Lent
by Mrs. Constance McCormick Fearing,
L83.11.1

(B) SEATED FIGURINE WITH ASYMMETRICAL BIRD HEADDRESS

Miccaotli-Tlamimilolpa A.D. 150-400
Provenance unknown
Ceramic
9 x 6.5 cm (3 ¹/₂ x 2 ¹/₂ in.)
Los Angeles County Museum of Art, Lent
by Mrs. Constance McCormick Fearing,
L83.11.5

80

STANDING FIGURINE

Late Tzacualli A.D. 150
Provenance unknown
Clay with traces of pigment
6.5 cm (2 ¹/₂ in.)
The Art Museum, Princeton University,
Gift of J. Lionberger Davis, y1968.72

80

81

TWO SEATED FIGURINES

Xolalpan A.D. 400-650
Provenance unknown
Clay and pigment
5 x 3 cm (2 x 1 ¹/₄ in.)
Los Angeles County Museum of Art, Lent
by Mrs. Constance McCormick Fearing,
L83.11.17-.18

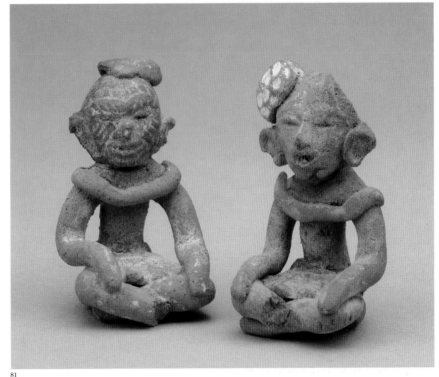

81

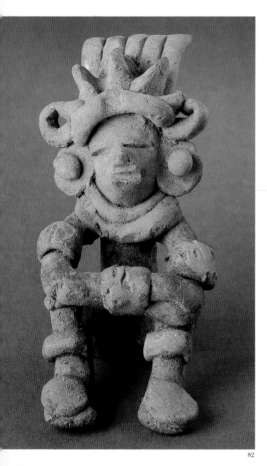

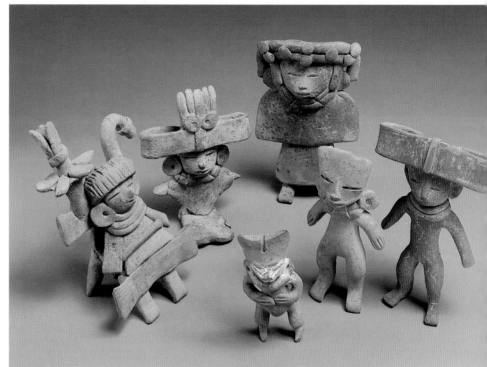

82
SEATED FIGURINE WITH ELABORATE HEADDRESS (FRONT AND SIDE VIEWS)
Tlamimilolpa A.D. 200-400
Provenance unknown
Clay and pigment
11.5 x 12 cm (4 1/2 x 1 3/4 in.)
Los Angeles County Museum of Art, Lent by Mrs. Constance McCormick Fearing, L83.11.16

83
GROUP OF FIGURINES
Tlamimilolpa-Xolalpan A.D. 200-650
Provenance unknown
Clay and pigment
10-14 cm (4 x 5 in.)
The Denver Art Museum, Gifts of the Goodrich Fund and Carolyn and Bill Stark, 1983.0113, 1983.0214, 1983.0215, and 1983.0216

WIDE-BAND HEADDRESS FIGURINES

THE EARLIEST FIGURINES were handmade with elaborate wide-band headdresses. This is the most distinctive of Teotihuacan figurine headdresses, but it does not appear in the mural art of Teotihuacan. On the other hand, it is chronologically one of the longest-lasting headdresses. A number of elaborations of the wide-band headdress appears as early as the Tzacualli phase. These include symmetrical appliqué circles and knots. There are also clear indications that each segment on the sides were painted differently, often with a cross on one side and then either a cross or another motif on the other side, such as a glyph that may mean reed, mat, or field.

The most common representation of wide-band headdress figures are females who frequently stand with cape and skirt and carry a child either over the shoulder or on the hip. In the late moldmade examples of wide-band figurines, children wear the wide-band headdress while the standing women have braids. In late examples, too, the wide-band headdress also appears on representations of throned figures that have all the attributes of males. It is not known what caused the shift in the use of this headdress, which begins in the Late Tlamimilolpa phase, a period of great change and expansion at Teotihuacan. It may signal shifting gender roles or shifts in the status of individuals in Teotihuacan religious and social life, but there is simply not enough evidence at this point to know. WB

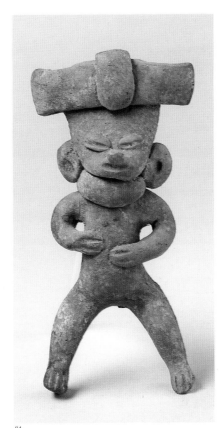

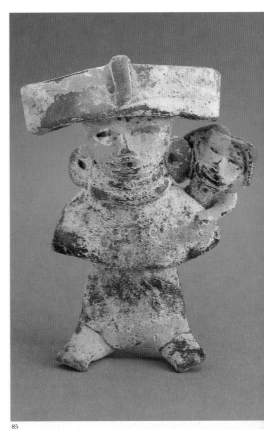

84

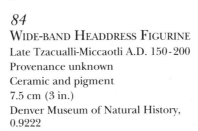

84
WIDE-BAND HEADDRESS FIGURINE
Late Tzacualli-Miccaotli A.D. 150-200
Provenance unknown
Ceramic and pigment
7.5 cm (3 in.)
Denver Museum of Natural History, 0.9222

85
STANDING MOTHER AND CHILD
Miccaotli-Early Tlamimilolpa
A.D. 150-350
Provenance unknown
Ceramic and pigment
11.5 cm (4 1/2 in.)
Los Angeles County Museum of Art, Lent by Mrs. Constance McCormick Fearing, L83.11.3

86
WIDE-BAND HEADDRESS FIGURINE
Miccaotli A.D. 150-200
Provenance unknown
Ceramic and pigment
15.9 cm (6 1/4 in.)
The Art Museum, Princeton University, Lent anonymously, L1966.163

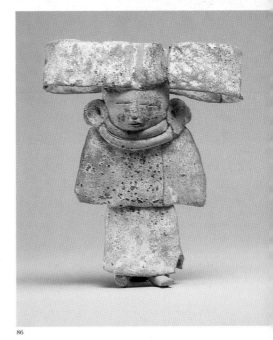

86

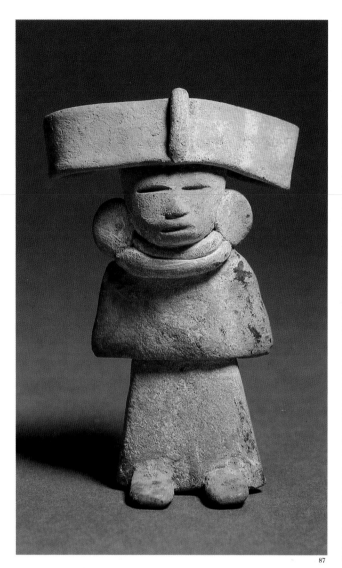

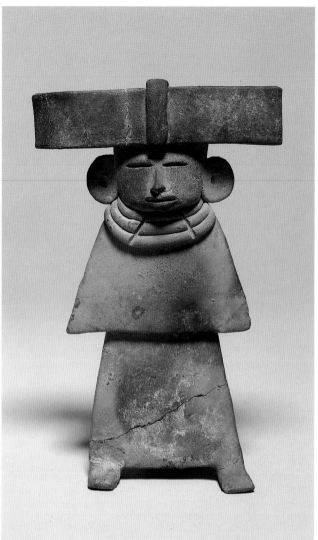

87 88

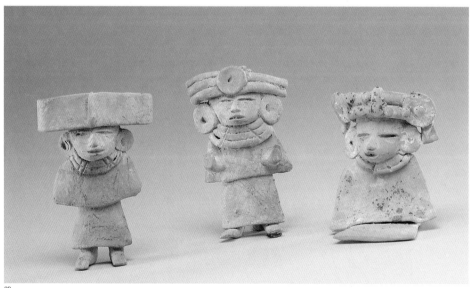

89

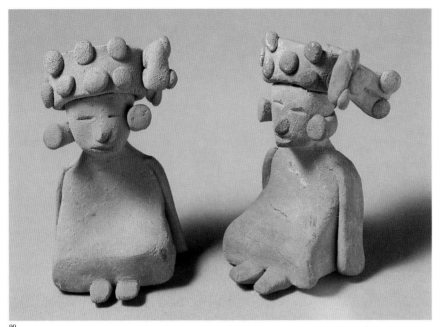

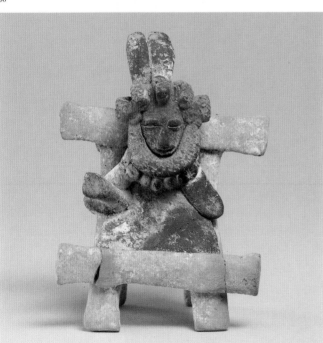

90

91

92

87
WIDE-BAND HEADDRESS FIGURINE
Early Tlamimilolpa A.D. 200
Provenance unknown
Ceramic and pigment
10.3 x 6.4 x 2.9 cm (4 $^1/_4$ x 2 $^1/_2$ x $^3/_4$ in.)
The Saint Louis Art Museum, Gift of
Morton D. May, 233:1978

88
WIDE-BAND HEADDRESS FIGURINE
Early Tlamimilolpa A.D. 200
Provenance unknown
Ceramic and pigment
14.4 x 9.4 x 3.7 cm (5 $^3/_4$ x 3 $^3/_4$ x 1 $^3/_4$ in.)
The Saint Louis Art Museum,
Gift of Morton D. May, 232:1978

89
**THREE WIDE-BAND HEADDRESS
FIGURINES**
Miccaotli-Tlamimilolpa A.D. 150 - 400
Provenance unknown
Ceramic and pigment
Largest 10.2 x 6.4 cm (4 x 2 $^1/_2$ in.)
Yale University Art Gallery, Gift of Fred
Olsen, 1974.36.5, .7, and .8

90
TWO SEATED FIGURINES
Tlamimilolpa A.D. 200 - 400
Provenance unknown
Ceramic and pigment
6.2 cm (2 $^1/_2$ in.)
The Saint Louis Art Museum,
Gift of Morton D. May, 82:1980.1 -.2

91
HEADDRESS FIGURE ON THRONE
Late Tzacualli-Miccaotli A.D. 150 - 200
Provenance unknown
Ceramic and pigment
9.8 cm (3 $^7/_8$ in.)
The Art Museum, Princeton University,
Gift of J. Lionberger Davis, y1968-70a-b

92
CRADLE FIGURINES
Xolalpan-Metepec A.D. 400-750
Provenance unknown
Ceramic and pigment
3.8 x 3.8 cm (1 $^1/_2$ x 1 $^1/_2$ in.)
Los Angeles County Museum of Art, Lent
by Mrs. Constance McCormick Fearing,
L83.11.2a-b

PORTRAIT FIGURINES

PORTRAIT FIGURINES MAY HAVE BEEN one of the most numerous figurine types at Teotihuacan. The bodies of these figurines were handmade until the end of the ancient city, even though the heads became moldmade around the Early Xolalpan ceramic phase. A group of late Metepec figurines found in excavation indicate that the faces may have been painted. The stylized pose of the portrait figurine is an unmistakable trademark. The cupped hands, bent knees and arms, and thrust-forward head have caused some researchers to call them dancers. It is unlikely that they were in fact dancers any more than they were actual portraits of individuals. The term *portrait* comes from the chiseled, clearly anthropomorphic structure and features of the head.

The portrait figurines represent males. Their elongated heads and handmade bodies, sometimes with a distinct loincloth, contrast sharply with the wide faces and flattened bodies of the puppet figurines. While there are questions of human or deity identity for other figurine types at Teotihuacan, researchers seem to agree these represent the people of Teotihuacan. Florencia Müller thought that perishable attire may have clothed these figurines and that the hands may have held miniature shields and spears. She may well have been correct. The portraits seem to represent the Teotihuacan Everyman. The standard posture and simplicity with perishable clothing gives the ultimate flexibility in the representation of status and rank in ceremonies that may have linked the individual to the Teotihuacan state. WB

93
STANDING PORTRAIT FIGURINE
Xolalpan A.D. 400-650
Provenance unknown
Ceramic and pigment
10 cm (4 in.)
Natural History Museum of Los Angeles County, Gift of the Stendahl Gallery, 4964

94
TWO PORTRAIT FIGURINES
Xolalpan A.D. 400-650
Provenance unknown
Ceramic and pigment
5 and 8 cm (2 and 3 1/4 in.)
Los Angeles County Museum of Art, Lent by Mrs. Constance McCormick Fearing, L83.11.1113-.1114

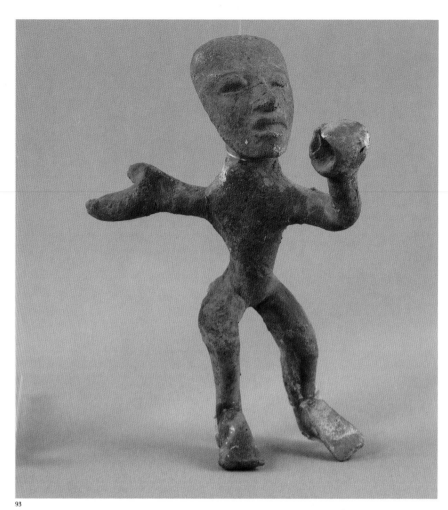

93

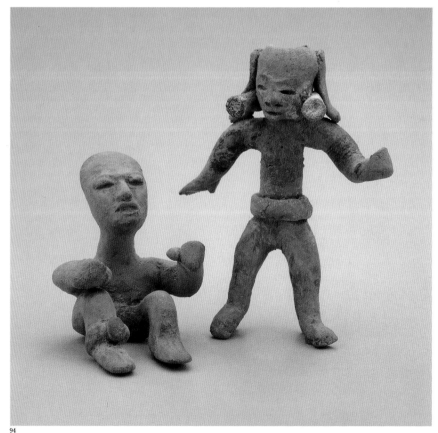

94

228

MOLDMADE FIGURINES

MOLDMADE FIGURINES BEGAN at Teotihuacan sometime toward the end of the Late Tlamimilolpa or the beginning of the Xolalpan ceramic phases. The mold may have been first used in the construction of censer parts and then adapted to figurine manufacture. The mold never completely replaced hand workmanship. The portrait figurines, for example, had moldmade heads but the bodies continued to be made by hand. During the Xolalpan phase one finds a variety of figurines with moldmade faces but elaborate handmade headdresses and body ornaments. The first figurines to be made entirely in molds were the half-conicals and small standing figurines shown in frontal pose, such as the Fat God. The half-conicals, which depict both males and females, represent a move to mass production with little or no finishing handwork needed. From the time the half-conicals were introduced until the collapse of the center of the city, a gradual increase occurs in the use of molds for making at least part of all of the major figurine types. Molds are more widely distributed in Teotihuacan than figurine workshops. There are molds for which clay figurines have not been found, suggesting that the mold may have been used to make bread figurines for temple offerings. WB

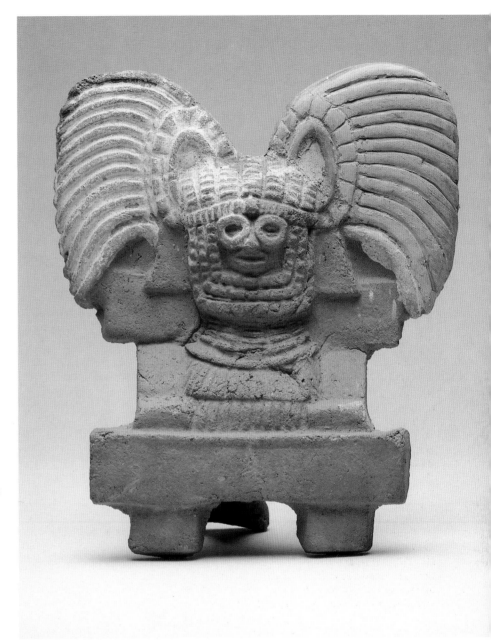

96
ENTHRONED FIGURINE
Metepec A.D. 650-750
Provenance unknown
Ceramic and stucco
12.7 x 11.1 cm (5 x 4 1/2 in.)
MNA 9-2359; INAH 10-393499
CNCA-INAH-MEX, Museo Nacional de Antropología, Mexico City

This figurine is distinctive for its elaborate helmet and for the bench or throne on which it is seated. This type of headdress, which seems to be composed of tiny rectangular plaques fitted together to frame the face and chin, is similar to that used by the armed Teotihuacan warriors on Stela 31 from Tikal. Although at Teotihuacan figurines like this lack weapons, the ears and feathers on the upper part of the headdress are associated with the military in Teotihuacan society, and probably to a feathered feline. Based on the costume as well as the enthroned position, this piece may be interpreted as an individual of military rank. CLDO

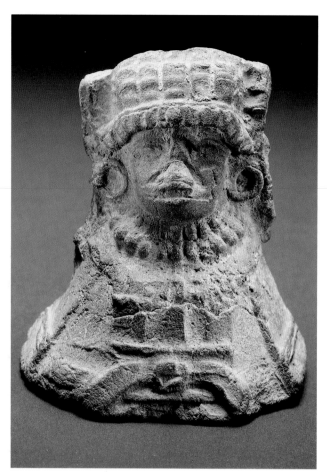

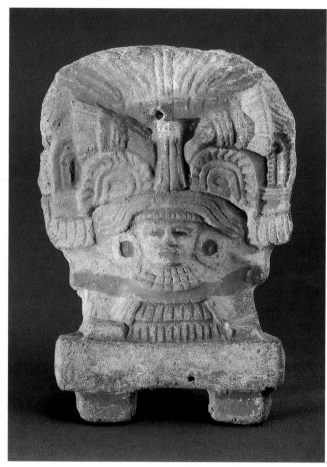

95

HALF-CONICAL MOLDMADE FIGURINE
Late Metepec A.D.650-750
Excavated by Sigvald Linné
Ceramic and pigment
6.2 x 5.5 x 3.5 cm (2 ¹/₂ x 2 ¹/₄ x 1 ¹/₂ in.)
Folkens Museum-Etnografiska,
Stockholm, 1935.8.207

97

ENTHRONED FIGURINE
Metepec A.D. 650-750
Provenance unknown
Ceramic and pigment
Ca. 12 cm (5 in.)
Peabody Museum - Harvard University,
28-1-20/C10086

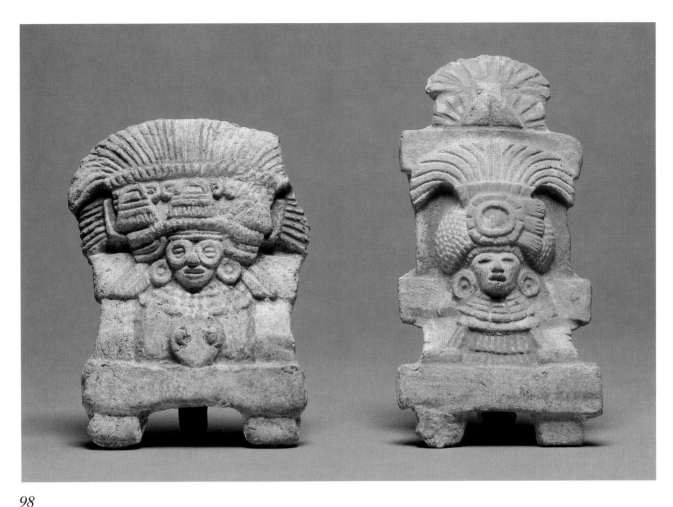

98

Pair of Enthroned Figurines
with Tassel Headdresses
Metepec A.D. 650-750
Figurine on left from general vicinity of El
Corral; G.C. Vaillant AMNH expedition,
1936
Ceramic and pigment
Ca. 15 cm (6 in.)
American Museum of Natural History,
30.1/6894 and 30.2/8945

99

Moldmade Figurine on a Throne
Metepec A.D. 650-750
Provenance unknown
Ceramic and pigment
11 x 10 cm (4 ¹/₂ x 3 ³/₄ in.)
The University Museum, University
of Pennsylvania, 66-27-20

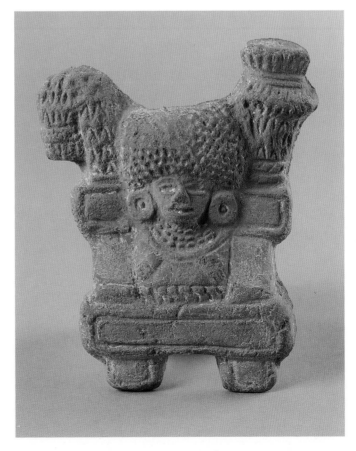

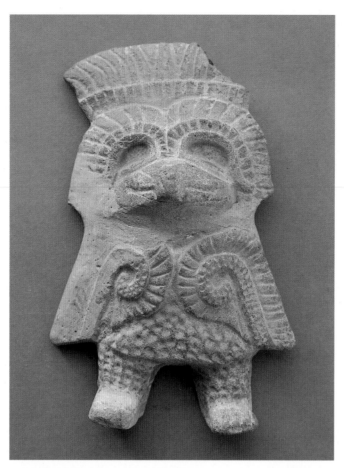

PUPPETS

THE PUPPET FIGURINES of Teotihuacan might better be called articulated figurines, since it is highly doubtful that they were ever used the way we think of puppets in Western culture. The vast majority of these figurines represent females. They share the cleft head, headdresses, and collars often found on standing flat female figurines clothed with capes and skirts, and they often have bracelets and anklets made of applied clay. Lines across the lower abdomen designate a female who has given birth.

The earliest puppet figurines from the Tzacualli phase have only the legs articulated; the arms are fixed. Later, both the arms and legs became articulated. A fascinating question yet to be answered is why the limbs were moveable, allowing for an array of postures. Puppets are one of the few Teotihuacan figurine types found in burials; usually they are found in pairs, so they had some sort of funerary function. They may have also been manipulated for curing ceremonies or possibly they were a precursor of body dismemberment associated with the Mexica female deity Coyoxaulqui. WB

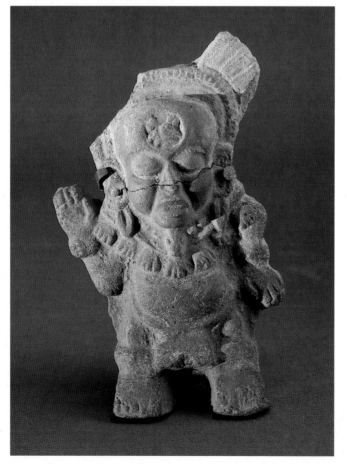

100
MOLDMADE OWL FIGURINE
Xolalpan A.D. 400-650
Provenance unknown
Ceramic and pigment
10 cm (4 in.)
Peabody Museum-Harvard University,
T1497, 21-35-20/C9697

101
MOLDMADE FIGURE OF
FULL-BODIED FAT GOD
Xolalpan A.D. 400-650
Provenance unknown
Ceramic and pigment
10 cm (4 in.)
Peabody Museum-Harvard University,
T1494, 28-1-20-C10088

102
DISASSEMBLED PUPPET FIGURINE
Late Tlamimilolpa-Xolalpan
A.D. 400-650
Excavated by Sigvald Linné
Ceramic and pigment
16 x 14 cm (6 $\frac{1}{4}$ x 5 $\frac{1}{2}$ in.)
Folkens Museum-Etnografiska,
Stockholm, 1935.8.531

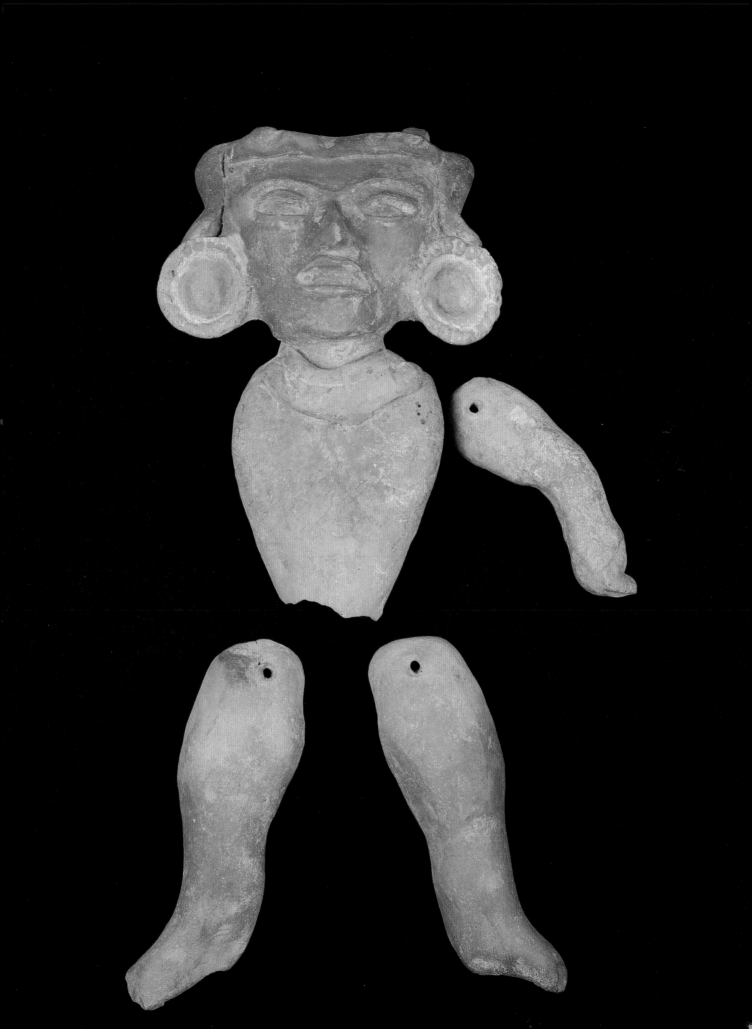

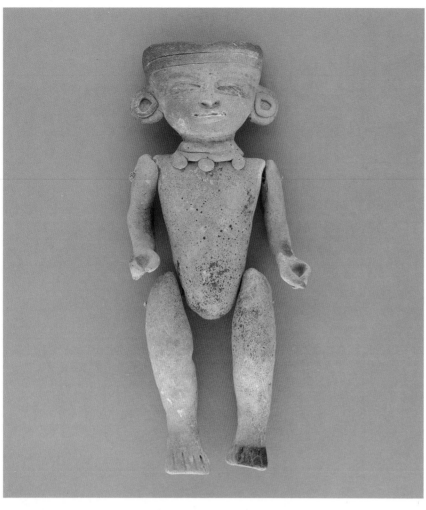

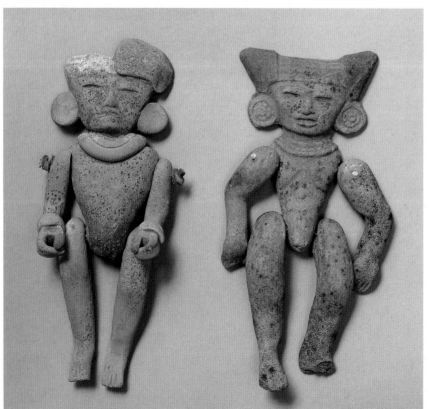

103
PUPPET
Early Xololpan A.D. 400-650
Provenance unknown
Ceramic and pigment
28 cm (11 in.)
Los Angeles County Museum of Art, Lent
by Mrs. Constance McCormick Fearing,
L83.11.24

104
PAIR OF PUPPETS
Xolalpan A.D. 400-650
Provenance unknown
Ceramic and pigment
17 and 16 cm (approximately 6 ¹/₂ in.)
The Saint Louis Art Museum, Gift of
Morton D. May, 308:1978 and 231:1978

105
MINIATURE STANDING PUPPETS
Late Tlamimilolpa-Early Metepec
A.D. 400-650
Provenance unknown
Ceramic and pigment
10 cm (3 ¹/₂ in.)
Los Angeles County Museum of Art, Lent
by Mrs. Constance McCormick Fearing,
L83.11.22-.23.,29

106
MINIATURE SEATED PUPPETS
Xolalpan A.D. 400-650
Provenance unknown
Ceramic and pigment
10 cm (3 ⁵/₈ in.)
Los Angeles County Museum of Art, Lent
by Mrs. Constance McCormick Fearing,
L83.11.35-.36, .38

107
THREE CLAY STAMPS (BIRD HEAD,
STANDING FIGURE BLOWING CONCH,
TRIPARTITE TRILOBE DESIGN)
Tlamimilolpa-Metepec A.D. 200-750
Sigvald Linné Collection
Ceramic
5 x 10 cm (2 x 4 in.)
Folkens Museum-Etnografiska,
Stockholm, 32.8.5541; 32.8.3552;
32.8.3540

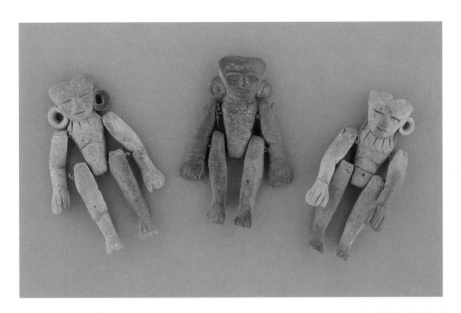

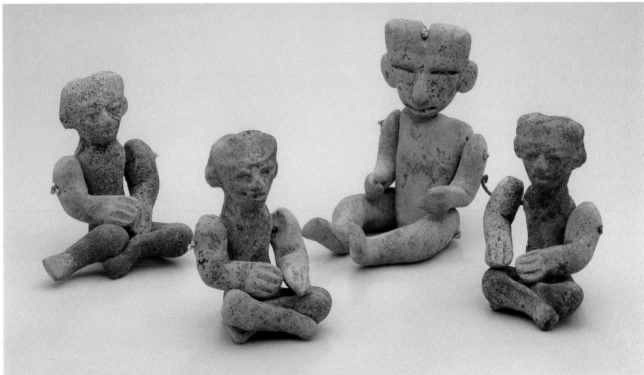

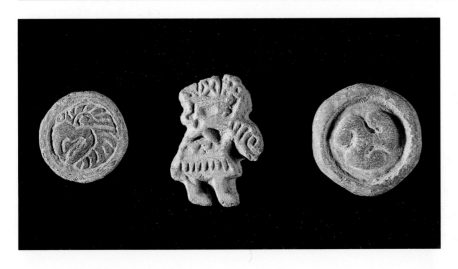

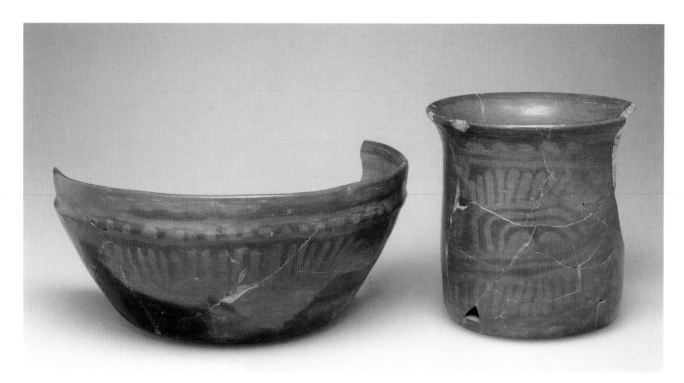

CERAMICS

Teotihuacan ceramics ranged from the minimally simple to complex ornamental forms. Most household pottery was plain black, brown, tan, or orange in color. After about A.D. 150, most pottery had little feet which became, on some vessels, large slab supports, sometimes including openwork with a face peering out from the inside. Raising even simple vessels on feet increases their appearance of importance.

The primary ceremonial vessel form at Teotihuacan was the cylindrical tripod, sometimes, but not always, with a lid. It was frequently plain, incised in a technique known as *plano relief*, and most surprisingly, sometimes covered with fresco and painted with a mural. Cylindrical tripods were the fanciest objects deposited in burials. Recent research indicates that ashes (possibly of ancestors) were kept in them.

We know little about the ritual use of ceramics, except for the obvious one of burial. Vessels with the face of the Storm God may have been used in rituals of pouring water, much as the Storm God is represented pouring water from such jars in murals. Some vessels that we cannot interpret at all hint at mysterious rituals or functions: in some vessels a square object and a shallow round dish are placed in the interior (cat. no. 144). We can appreciate their bold, geometric abstraction but can't say anything more about them.

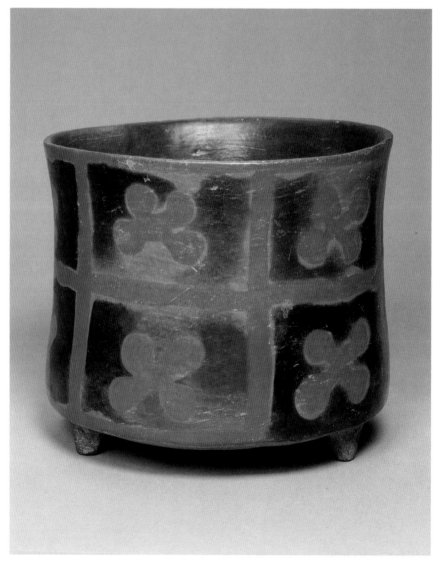

108

RESIST-PAINTED WARES

Early Tzacualli A.D. 1-50

Found at Oztoyahualco in 1957 (Cache 1, vessels 1 and 2)

Rim-shouldered bowl:
Resist on orange-red
14 x 28.5 cm (5 ¼ x 11 ¼ in.)
Marian White Anthropology Research
Museum at the State University
of New York at Buffalo, R 9.4-1 (cache)

Bicurvate vase:
Resist over red on yellow -brown
l6.5 x 11.5 cm (6 ½ x 4 ½ in.)
University of Rochester, Rochester,
New York

109

RESIST-PAINTED BICURVATE
VASE WITH NUBBIN SUPPORTS

Miccaotli A.D. 150 - 200

Provenance unknown

Resist over red and yellow-brown

16.5 x 11.5 cm (6 ½ x 4 ½ in.)

The Denver Art Museum, Gift of Robert
J. Stroessner, 1992.0053

These vessels, called resist-painted or "negative" wares, are magnificent examples of the earliest wares known at Teotihuacan. They characerically bear an indistinct design line, a background color of red-orange or yellow-brown, and a waxy or soapy finish. Because they are made from a coarse paste, they are fragile and usually found only as shards. A unique discovery was made by René Millon and James Bennyhoff in 1957 of seven caches of vessels in a platform on the south side of a three-temple complex at Oztoyahualco in the northeast sector of Teotihuacan, referred to as the "Old City" (cat. no. 108 comes from this excavation). ER

110

RESIST-PAINTED VESSEL WITH
SMALL SUPPORTS

Late Tzacualli-Miccaotli A.D. 100-200

Provenance unknown

Ceramic

19.5 x 23.1 cm (7 ¾ x 9 ¼ in.)

MNA 9-l84; INAH 10-45637

CNCA-INAH-MEX, Museo Nacional
de Antropología, Mexico City

The resist technique developed very early at Teotihuacan. It consisted of covering the space intended for the motif with wax; when the piece was bathed in slip, the motif, in this case a four-petaled flower, would appear in the natural color of the clay. CLDO

111

TWO PAINTED WHITE-ON-RED TRIPOD VASES

Early Tlamimilolpa A.D. 200-300

Provenance unknown

Ceramic

10 x 12.5 cm (4 x 5 in.) and 7.5 x 10 cm
(3 x 4 in.)

The University Museum, University
of Pennsylvania, 66-27-3 and -5

112

POLISHED BLACK *FLORERO* AND MINIATURE TAN *FLORERO*

Late Tlamimilolpa A.D. 300-400

Found at Tlamimilopa, Burial 1,
by Sigvald Linné, 1934-1935

Ceramic

9.9 x 8.1cm (4 x 3 ¼ in.) and
6 x 4 cm (2 ¼ x 1 ½ in.)

Folkens Museum-Etnografiska,
Stockholm, 35.8.2218 and 35.8.2157

113
POLISHED BROWN-BLACK
FLORERO AND **POLISHED BROWN**
OUTCURVING BOWL
Late Tlamimilolpa A.D. 300-400
Provenance unknown
Ceramic
5 x 2 ½ cm (13 x 1 in.) and 5 x 16 cm
(2 x 6 ½ in.)
The University Museum, University
of Pennsylvania, 66.27.9 and .6

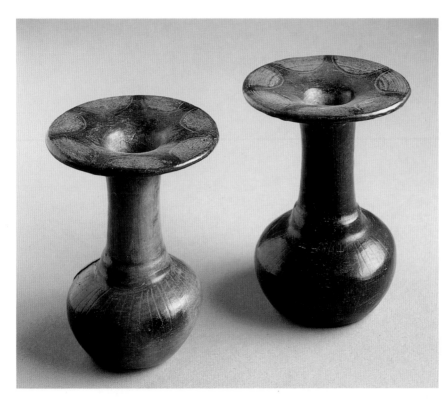

114
PAIR OF MINIATURE BLACKWARE
FLOREROS
Late Tlamimilolpa A.D. 300-400
Provenance unknown
Ceramic
9 x 6.8 cm (3 ¾ x 2 ¾ in.) and
9.2 x 7 cm (3 ½ x 2 ¾ in.)
The Saint Louis Art Museum, Gift
of Morton D. May, 78.1980.1 and 2

Floreros occur at Teotihuacan from A.D.
1-750, and may have been introduced
by peoples from Azcapotzalco as the
earliest ones are found there. In excava-
tions at Pueblo Perdito, Evelyn Rattray
discovered a burial offering accompa-
nied by Tzacualli vessels, including one
florero. It has the long neck terminating
in a flared rim; the body is decorated
with a double row of bosses. The style
of *floreros* continues almost unchanged
from Tlamimilolpa to Xolalpan times.
ER

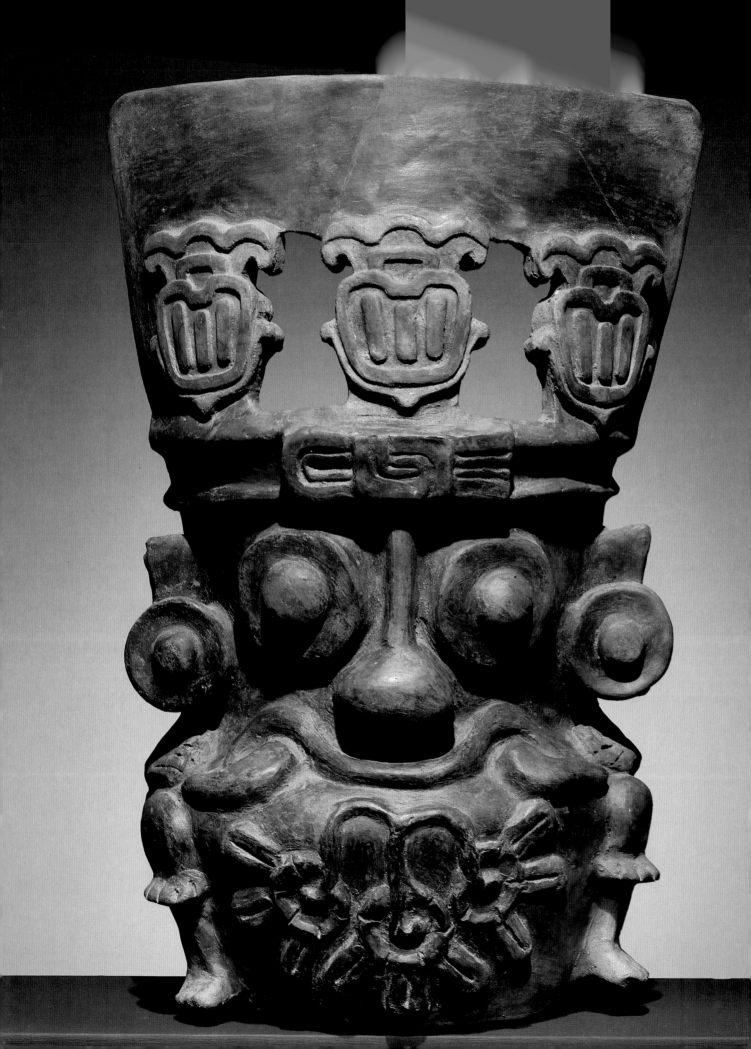

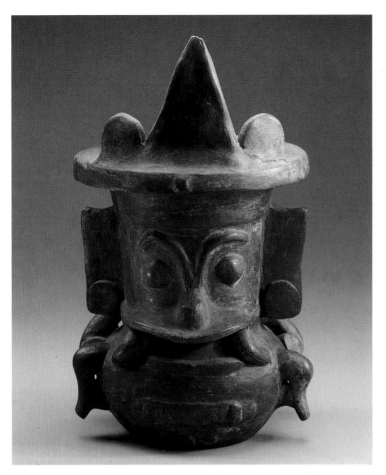

115
VESSEL WITH THE STORM GOD
Metepec A.D. 650-750
Xico Island, Lake Chalco, Valley of
Mexico
Ceramic
45 x 30 cm (17 ³/₄ x 11 ³/₄ in.)
MNA 9-3l02; INAH l0-224372
CNCA-INAH-MEX, Museo Nacional
de Antropología, Mexico City

The body of this large Storm God vessel
prominently displays a water lily, the
deity's most significant attribute in his
manifestation as earth, water, and fertil-
ity god. His other characteristics in-
clude goggled eyes and fangs emerging
from the ends of a curved mouth. Xico,
where this vessel is said to have come,
was the location of a Teotihuacan settle-
ment in the southern Valley of Mexico.
Teotihuacan iconography was repro-
duced in this area, although an inde-
pendent style arose in which unique
motifs were developed, such as the
three floral elements that adorn this
vessel. CLDO

116
STORM GOD VESSEL
Tlamimilolpa-Metepec A.D. 200-750
Provenance unknown, bought in Ham-
burg from Froschel in 1876
Brown ceramic
21 x 13 cm (8 ¹/₄ x 5 in.)
Museum für Völkerkunde, Vienna, L4829

This is an atypical Storm God vessel
because the top is ornamented by a
crown of feathers instead of the trian-
gular element on the lid. Although the
vessel has an animalistic mouth it lacks
the usual broad upper lip. Its eyes and
body position are typical. Such effigy
vessels were probably used in rituals of
pouring water, as the Storm Gods are
represented as doing so on many mural
paintings. EP

117
STORM GOD VESSEL
Tzacualli A.D. 1-150
Pyramid of the Sun, at the juncture
of the *adosada* platform and the pyramid
Ceramic
10 cm (4 in.)
University of Rochester, Rochester,
New York

This is not only the earliest Storm God
vessel we know, but also one of the few
works of art from the Tzacualli phase. It
is striking in its simplicity. It is unusual
in that the vessel has straight sides and
not the usual later bulbous bottom and
flaring neck. A later Storm God jar
looks more anthropomorphic because
the rim is the headdress, the neck of
the vessel the face, and the bulbous
form the "belly." Arms and legs some-
times attached to the sides heighten
this impression. By contrast the
Tzacualli vessel is austere and abstract.
The facial features of the deity are ap-
plied to the side of the cylindrical ves-
sel, which does not look like a person.
The bulging eyes, goggles, and mus-
tache of the Storm God indicate that
already at this early date the features
of this deity were quite stylized. EP

118
Two Miniature Vessels with the Storm God

Tlamimilolpa-Metepec A.D. 200-750
Provenance unknown
Ceramic
6.4 x 6 cm (2 ¹/₂ x 2 ³/₈ in.) and
6.5 x 6.5 cm (2 ¹/₂ x 2 ¹/₂ in.)
MNA 9-2355; INAH 10-393498
CNCA-INAH-MEX, Museo Nacional
de Antropología, Mexico City

The Water God or Storm God (also known as Tlaloc by the Mexicas) was one of the first deities venerated by pre-Hispanic societies in Mesoamerica because of his importance for agriculture and fertility. On these miniature vessels he is shown grasping a curved symbolic lightning bolt and a three-petaled object. These jars may have been ritually "killed" to be deposited in a mortuary offering, for the bases display large circular perforations. CLDO

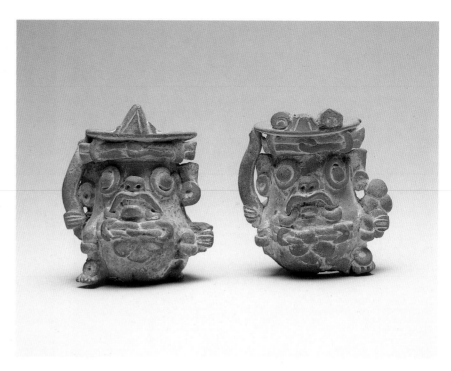

119
Two Miniature Storm God Jar Triads

Tlamimilolpa-Metepec A.D. 200-750
Brownish-black ceramic
7.5 cm (3 in.)
Los Angeles County Museum of Art, Lent by Mrs. Constance McCormick Fearing, L83.11.27-.28

Miniature examples of many types of pottery seem to have existed at Teotihuacan, including Storm God effigy vessels. Such little vessels come either in pairs or as several linked together. These figures not only have arms but also little legs that make them look like dwarfs. In Aztec legends the rain gods were believed to be dwarflike creatures. Whether these were used in ritual we do not know, but they were eventually placed in burials. EP

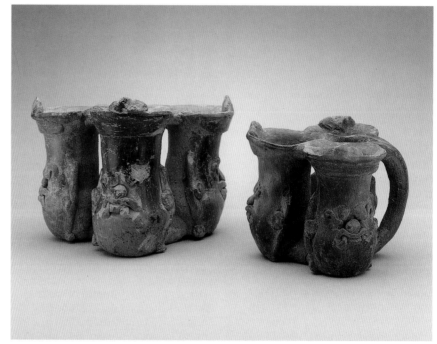

120

BLACKWARE VESSEL
Tlamimilolpa-Metepec A.D. 200-750
Found at Cholula, Puebla
Ceramic
10.5 x 24 cm (4 $^1/_4$ x 9 $^1/_2$ in.)
MNA 9-6-6; INAH 10-45152
CNCA-INAH-MEX, Museo Nacional
de Antropología, Mexico City

This elegant, highly burnished, three-footed vessel was found at Cholula, a site strongly influenced by Teotihuacan during the Classic period, as witnessed by this and other ceramic specimens from there. CLDO

Shiny blackware was the characteristic fancy pottery of the Miccaotli and Tlamimilolpa periods and is remarkable for its elegant shapes and lightly burnished decoration.

This highly polished, lustrous black bowl with incised conch in the interior and parallel lines on the rim (cat. no. 121) is similar to other examples found in burial offerings at La Ventilla and Tetitla. The cylindrical tripod with simple knobbed lid and rounded basal flange (cat. no. 123) is a good example of the early Xolalpan vase. ER

121

**POLISHED BLACK OUTCURVING
BOWL WITH INCISING AND
COVERED BLACKWARE TRIPOD**

Early Tlamimilolpa A.D. 200-300
Provenance unknown
Ceramic
3.5 cm (5 in.) and 10 cm (4 in.)
The Art Museum, Princeton University,
Lent anonymously, L1990.132 and
L1990.14a-b

122

POLISHED BLACKWARE VASE

Tlamimilolpa-Metepec A.D. 200-750
Provenance unknown
Ceramic
21 x 11 cm (8 ¹/₄ x 4 ¹/₂ in.)
The University Museum, University
of Pennsylvania, 66.27.30

123
POLISHED BROWN TRIPOD
VASE WITH LID AND HOLLOW
RECTANGULAR SUPPORTS
Early Xolalpan A.D. 400-550
Provenance unknown
Ceramic
3 $^1/_4$ x 19 cm (8 $^1/_2$ x 7 $^1/_2$ in.)
National Museum of the American In-
dian, Smithsonian Institution, Exchanged
from James Economos, 27.7490a-b

124
POLISHED BROWN VASE
Early Xolalpan A.D. 400
Provenance unknown
Ceramic
20 x 20 cm (8 x 8 in.)
Philadelphia Museum of Art, Louise
and Walter Arensberg Collection,
50-134-45-400
(Not in exhibition)

125

JAR WITH RELIEF DECORATION
Tlamimilolpa-Metepec A.D. 200-750
Provenance unknown
Ceramic
21.1 x 29.6 cm (8 ¹/₄ x 11 ³/₄ in.)
MNA 2182; INAH 10-393497
CNCA-INAH-MEX, Museo Nacional
de Antropología, Mexico City

Although the overall shape of this
vessel is not among the most typical, the
superb burnished surface and the
double incised waves are associated
with Teotihuacan. Undulating
appliqué designs seem to represent
the silhouette of a serpent, an animal
virtually ubiquitous in Teotihuacan
art. CLDO

126

LID WITH OWL

Metepec A.D. 650-750
Provenance unknown
Ceramic
26.4 x 1.4 cm (10 $^{1}/_{2}$ x $^{1}/_{4}$ in.)
MNA 9-3866; INAH 10-393503
CNCA-INAH-MEX, Museo Nacional
de Antropología, Mexico City

This blackware lid displays a typical
Teotihuacan militaristic composition,
consisting of a frontal owl, a shield with
a hand, and crossed arrows. These three
elements appeared repeatedly in figu-
rines and vessels during the last stages
of the city, when militaristic themes are
more explicitly portrayed in its art. The
particular combination of these ele-
ments may have functioned as an em-
blem of the military class. Although
differing in details, comparable images
appear in the murals from Techinan-
titla, where profile birds are associated
with arrows and shields bearing hands.
CLDO

127

Two Copa-ware Cups
Early and Late Xolalpan A.D. 400-650
Provenance unknown
Ceramic
12.8 x 10 cm (5 x 4 in.) and 11.5 x 8.4 cm
(4 ¹/₂ x 3 ¹/₄ in.)
The University Museum, University of
Pennsylvania, 66.27.34-.35

Copa ware is distinguished among
Teotihuacan ceramics for its fine, com-
pact paste, excellent finish, and unifor-
mity of vessel shape. The copa and vase
are the only two shapes made. The copa
shape has upright walls and a pedestal
base and is sometimes equipped with
a small handle at the rim and a spout.
Treasured as personal objects, these
drinking cups were often buried with
the individual. ER

128

Lids with Three Handles
Tlamimilolpa-Xolalpan A.D. 200-600
San Francisco Mazapa and other salvage
excavations
Ceramic
8 x 26.5 cm (3 ¹/₄ x 10 ¹/₂ in.)
INAH 10-10896
CNCA-INAH-MEX, Museo Arqueológico
de Teotihuacan

The exact function of these ceramic
objects that look like lids is poorly un-
derstood. They may have been censers
or they may have served some other
function. In excavations they have
sometimes been found as lids for other
vessels and they have been found in
refuse as well as in burials. Their popu-
larity at Teotihuacan seems to have
increased over time. RCC

129

**Three-Prong Burner with
Molded Portrait Head**
Metepec A.D. 650-750
Provenance unknown
Coarse matte paste
15.8 x 29.2 cm (6¹/₄ x 11¹/₂ in.)
Peabody Museum - Harvard University,
28-1-20/C10323

A utilitarian function has been attrib-
uted to this type of artifact because it is
so common in household debris. Burn-
ers are large flaring vessels with three
prongs on the interior rim. Apparently
the fire was made inside the bowl and a
plate was set on the prongs for heating.
Beginning in the Metepec phase some
prongs were decorated with the molded
heads of deities, typical Teotihuacan
portrait-type heads, or monkey heads.
ER

130
INCISED VESSEL ON NUBBIN FEET
Tlamimilolpa A.D. 200-400
Tlamimilolpa, Room 16
Burnt clay
13 x 13.1 cm (5 $\frac{1}{4}$ x 5 $\frac{1}{4}$ in.)
Folkens Museum-Etnografiska,
Stockholm, 1935.8.2180

This vessel is one of the more than
twelve hundred objects that were found
by Sigvald Linné in the earliest burial
of Tlamimilolpa in room 16 under the
third floor associated with the disas-
sembled ceramic censer (cat. no. 72).
Linné's description of the burial (1942,
126) was as follows: "The body had
been cremated in the grave itself. Round
it quite a number of funerary offerings
had been placed. The clay vessels had
been put together on top of, or inside,
each other. But many more had been
broken up at the edge of the grave and
then thrown into it.... That the heat
must have been considerable is evident
from a number of obsidian knives hav-
ing become bent."

This vessel is one of the ones that
was severely charred and cracked by
the fire, but which remained in one
piece. The rows of incised chevrons,
diagonals, and circles are characteristic
of early Tlamimilolpa pottery. This type
of vessel with nubbin feet and simple
incised decoration antedates the plano-
relief tripods so common in the
Xolalpan period, after A.D. 450. EP

131
TRIPOD WITH MOLDMADE FACE
Xolalpan A.D. 400-650
Tlamimilolpa, Room 3
Brownish clay painted with cinnabar
13 x 13 cm (5 $\frac{1}{8}$ x 5 $\frac{1}{8}$ in.)
Folkens Museum-Etnografiska,
Stockholm, 35.8.2126

This beautifully burnished tripod stands
on intricate slab feet with relief and
openwork decoration. A moldmade
head of the Fat God is attached to one
side. This is one of two identical tripod
vessels found in a cylindrical shaft
chamber that was a place for offerings
in room 3 at Tlamimilolpa. The other
tripod vessel is now part of the collec-
tion of the site museum of Teotihuacan.
EP

132
PLANO-RELIEF TRIPOD WITH
HEADDRESS OVER A FLOWER
Xolalpan A.D. 400-650
Xolalpan, Burial 1, Room 7
11.5 x 13.7 cm (4 $\frac{1}{2}$ x 5 $\frac{3}{8}$ in.)
Brownish clay with cinnabar
Folkens Museum-Etnografiska, Sweden,
1932.8.4198

Burial l at Xolalpan had the finest and
best-preserved offerings, although they
were not numerous. This is one of the
smaller but quite curious plano-relief
vessels. A large headdress such as dei-
ties wear is placed unexpectedly on a
flower instead of a face. Two speech
scrolls emerge from this flower as
though this symbolic substitution for a
deity could talk. A row of flowers at the
base underscores the importance of the
floral theme. Such abstract deity em-
blems were common in the art of Teoti-
huacan. The style of carving on plano-
relief vessels varies from the very precise
to the casual. In this vessel, although
the iconography is fascinating, the ex-
ecution is quite sloppy. EP

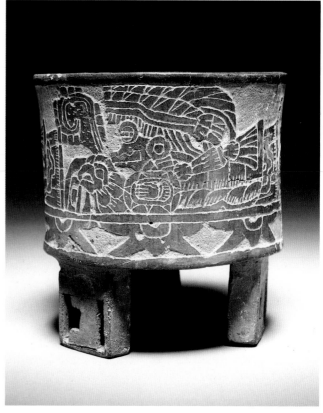

133
PLANO-RELIEF VESSEL
WITH MEDALLIONS
Xolalpan A.D. 400-650
Xolalpan, Burial 4
Brownish clay
18.2 x 23.4 cm (7 ¹/₈ x 9 ¹/₄ in.)
Folkens Museum-Etnografiska, Sweden,
1932.8.4274

Burial 4 was one of the late burials in
the Xolalpan apartment compound,
containing quite a number of Thin
Orange vessels and a Storm God jar
among the forty-five pottery vessels. The
subject of the medallions in this dra-
matically designed vessel can only be
determined in general. The top half
consists of a triangle with a horizontal
element scholars call the trapeze-and-
ray sign. The lower half consists of lines
drawn in perspective, aimed toward a
vanishing point within each medallion
in the border. The trapeze-and-ray sign
sometimes represents a glyph for the
year, but in other cases refers to head-
dresses worn by the gods and the elite.
Teotihuacan preferred composite em-
blems such as these medallions to writ-
ing in the form of glyphs. It may be
because in this way they could often
animate the figures into more sugges-
tive images that had multiple meanings.
EP

134
PLANO-RELIEF VESSEL OF GOGGLED
FIGURE WITH SPEAR AND SHIELD
Xolalpan A.D. 400-650
Xolalpan, Burial 2, Room 15
Brownish ceramic with cinnabar
12.8 x 12.8 cm (5 x 5 in.)
Folkens Museum-Etnografiska,
Stockholm, 1932.8.3985

This delicately incised jar was found in
a burial associated with other very fine
pottery objects, including a vessel with
a lid in a Mayoid style. This vessel is
close in style to the mural paintings
and probably represents an elite figure
wearing Storm God goggles and carry-
ing the shield and spear. A bird appears
to be placed in front of the figure but it
could belong to the weapon emblem. A
speech scroll emerges from the mouth
of the elite figure while a stream of
water pours from the bird beak. The
border series is half a star fish, which
refers either to fertility or warfare. The
vessel has one of the interesting types
of slab legs that have two openings: one
is rectangular and the other is in the
form of a sideways T. Such asymmetries
are common in Teotihuacan art. EP

135
PLANO-RELIEF TRIPOD VESSEL
WITH LID
Tlamimilolpa-Metepec A.D. 400-750
Provenance unknown
Ceramic and pigment
16.7 x 19.6 cm (6 ¹/₂ x 7 ³/₄ in.);
lid: 7.3 x 22 cm (2 ⁷/₈ x 8 ³/₄ in.)
MNA 9-135; INAH 10-56526
CNCA-INAH-MEX, Museo Nacional
de Antropología, Mexico City

The tripod or three-footed vessel was a
hallmark of Teotihuacan ceramics. A
simple but uncommon design is shown
here, composed of a rectangle enclos-
ing an X-shaped cross with a ring in the
center. The background was carved out
and filled with cinnabar, a red mineral
pigment frequently used at Teotihua-
can both in funerary rites as well as on
ceramics. Cinnabar must have been a
precious commodity for it had to be
extracted from mines in the state of
Queretaro, some 120 miles away from
the metropolis of Teotihuacan. CLDO

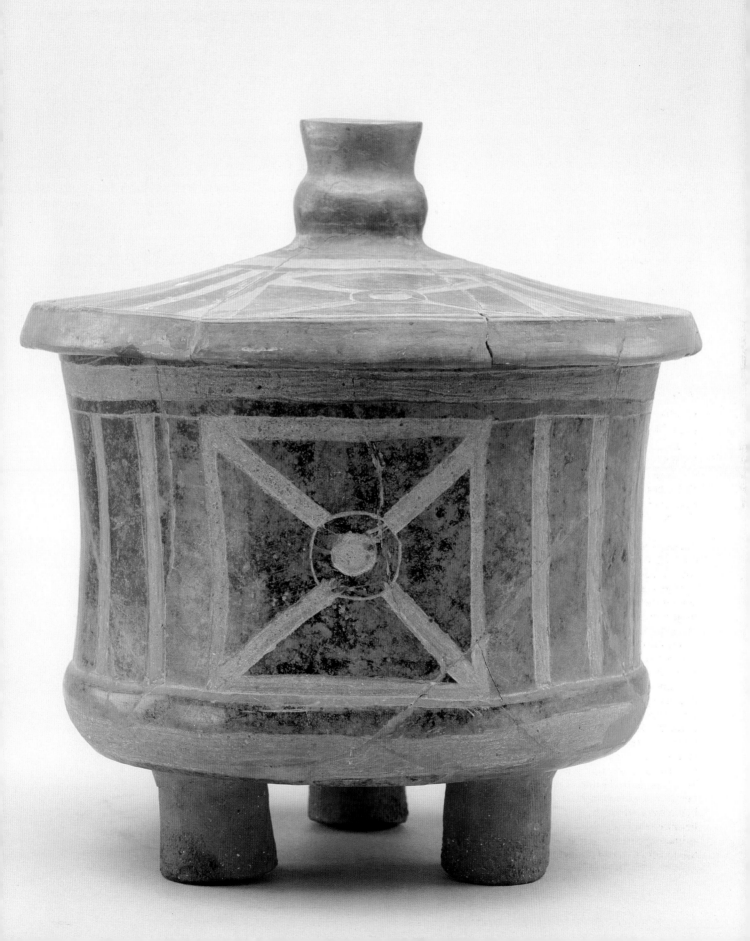

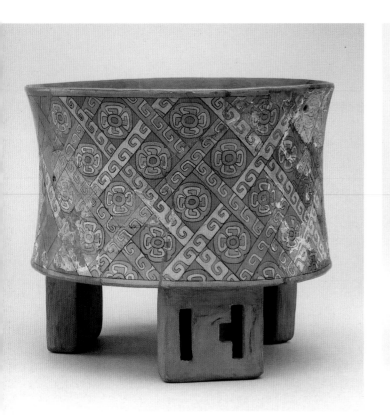
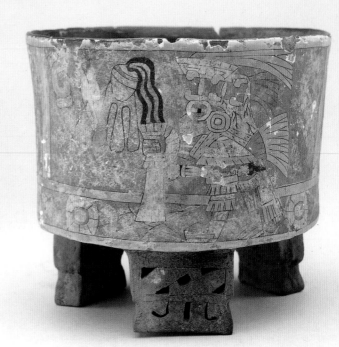

STUCCOED AND PAINTED CYLINDRICAL TRIPODS

STUCCOED AND PAINTED CERAMICS are found throughout Mesoamerica but they reached maximum expression at Teotihuacan. Found on a variety of ceramic forms, stucco painting is most often associated with the low-walled cylindrical tripod with hollow supports. Sloping lids with knob handles, now lost, once accompanied these vessels. The configuration, reminiscent of a house, is affirmed by the architectural references of the supports.

While the term *fresco* is often used to describe the paintings, *stucco painting* is preferable, as the paper-thin stucco surface dries during painting. The bright colors and outlining have been likened to mural painting; it is assumed murals and tripods were painted by the same artists. Tripods were more likely painted by artisans working in the plano-relief technique of ceramic decoration; they display identical themes and compositional formats as stucco-painted ceramics.

These beautiful but fragile painted surfaces are particularly susceptible to the ravages of time; they must have existed in far greater number than are currently known. As the prized personal possessions of high-ranking members of society, the themes reflect the occupations and religious, social, and political affiliations of their owners. Some superb examples of painted tripods have been found in burials and may have contained food or other offertory items. Ancient repair (cracklacing) indicates some stucco-painted tripods were used in other contexts as well, perhaps household rituals. CC

136
TRIPOD VESSEL
Xolalpan-Metepec A.D. 400-750
Provenance unknown; collection of William Spratling
Ceramic, stucco, paint
20.8 x 24.2 cm (8 $^1/_4$ x 9 $^1/_2$ in.)
MNA 9-2029; INAH 10-78079
CNCA-INAH-MEX, Museo Nacional de Antropología, Mexico City

Although plants and flowers were often represented in Teotihuacan art, the four-petaled flower covering this large vessel does not correspond to any species known in nature, but rather seems to be a stylized motif. Its frequent appearance both in decoration as well as in mural painting suggests that it is a sign related to fertility. CLDO

137
TRIPOD VESSEL
Tlamimilolpa-Metepec A.D. 200-750
Found in Burial l4 at Tetitla
Ceramic, stucco, pigment
15 x 16.3 cm (6 x 6 $^1/_2$ in.)
MNA 9-2498; INAH 10-79930
CNCA-INAH-MEX, Museo Nacional de Antropología, Mexico City

The four panels on this vessel, divided by two vertical lines, show alternating motifs — a heart with pendant green sacrificial spines, perhaps from a maguey cactus, and a human figure with elaborate garb and headdress. As a whole, the vessel's imagery is an allegory of sacrifice, both by heart extraction and autosacrifice. The individual carries an arrow, identifying him as a warrior, and a curved obsidian blade piercing a bleeding heart. One of the blood droplets is associated with a scroll, representing a chant, a word, or perhaps in this case a prayer. The human figure might represent a warrior in the act of ritual sacrifice, probably heart sacrifice, a theme of increasing importance in the study of Teotihuacan archaeology and iconography. CLDO

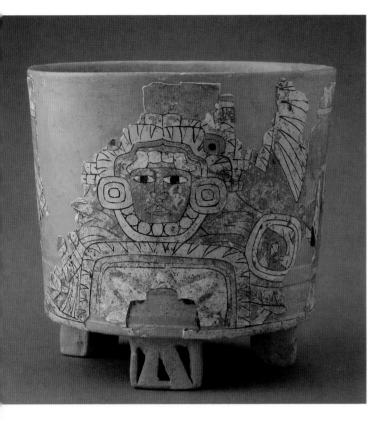

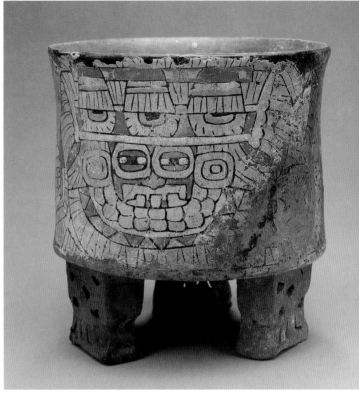

138

TRIPOD VESSEL

Late Xolalpan A.D. 550-650

Provenance unknown

Ceramic, stucco, pigment

13 x 13 cm (5 ¹/₄ x 5 ¹/₄ in.)

The Fine Arts Museums of San Francisco,
Bequest of Harald J. Wagner, 78.95

Illustrated p. 83

Two individuals performing rituals
related to the bird/butterfly cult are
shown in full regalia. Flowering speech
scrolls are visual references to ceremo-
nial verses or chants. Libations falling
from the hands are associated with
plenitude, indicated by flowers and
drops of water scattered throughout the
scene. Bird/butterfly depictions are
common in stucco paintings. Also found
in ceramic figurines and censers, they
are conspicuously absent in murals. CC

139

TRIPOD VESSEL

Late Xolalpan A.D. 550-650

Provenance unknown

Thin Orange ware with stucco and paint

12.6 x 12 cm (5 x 4 ³/₄ in.)

Los Angeles County Museum of Art, Lent
by Mrs. Constance McCormick Fearing,
L83.11.1050

This tripod is reused Thin Orange, a
popular ware made in Puebla and im-
ported into Teotihuacan. Two frontal
depictions of half-figures with masklike
faces wearing coyote headdresses with
bared fangs are shown behind shields
decorated with star or shell motifs.
These motifs indicate martial associa-
tions. The painting may represent a
member of a militaristic order identi-
fied by the headdress. CC

140

TRIPOD VESSEL

Late Xolalpan A.D. 550-650

Provenance unknown

Ceramic, stucco, pigment

l4 x 12.8 cm (5 ¹/₂ x 5 in.)

Los Angeles County Museum of Art, Lent
by Mrs. Constance McCormick Fearing,
L83.11.1054

This vessel is compositionaly similar to
cat. no. 139 but with differing symbol-
ism. Two identical figures wear promi-
nent tassel headdresses, goggles, and
fanged nosebars. Each figure holds a
circular shield with star emblem and
darts in its left hand, and a staff in its
right. Similar figures on other ceramics
have been identified by Clara Millon as
commanders of military units. CC

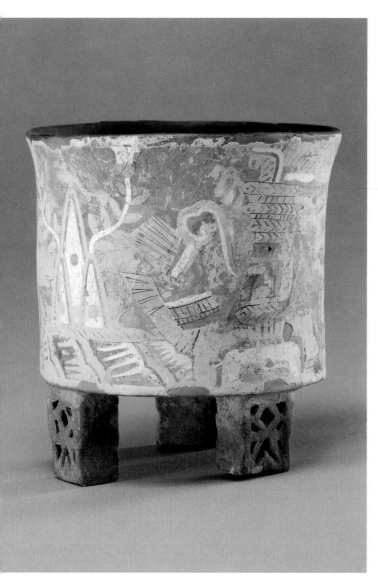

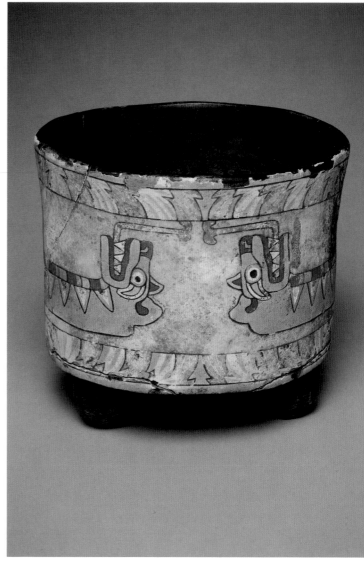

141
TRIPOD VESSEL
Late Xolalpan A.D. 550-650
Provenance unknown
13.7 cm (5 ³/₈ in.)
Ceramic, stucco, pigment
Yale University Art Gallery, Gift of
the Olsen Foundation, 1958.15.2

Worn areas of stucco on this ceramic
reveal roughened walls, suggesting
ceramicists adapted manufacturing
techniques to accomodate stucco paint-
ing. Two profile half-figures behind
shields wear unusual stacked head-
dresses. The step-patterned face paint
resembles designs on clay masks exca-
vated by Séjourné. The tri-mountain
with flowers motifs may be a toponym
identifying a specific location. Some
portions of this painting may have
been reworked. CC

142
TRIPOD VESSEL
Metepec A.D. 650-750
Provenance unknown
Ceramic, stucco, pigment
14 x 15.5 cm (5 ¹/₂ x 6 ¹/₈ in.)
Collection of Mr. and Mrs. Charles
Campbell, San Francisco

After A.D. 650, human figure repre-
sentations were transfered to molded
appliqué and moldmade ceramics as
stucco painting declined in quantity.
Three two-headed serpents are shown
between geometrically designed bands.
Uncluttered compositions and simpli-
fied forms characterize the late painting
style. Unusual features include the black
paint that covers the supports and inte-
rior, and a small orangeware bowl and
bone that are the vessel's contents. CC

143
TRIPOD BOWL WITH TRAPEZE-
AND-RAY GLYPH
Probably Metepec A.D. 650-750
Provenance unknown
Ceramic and paint
15.2 x 26 cm (6 x 10 ¹/₄ in.)
Yale University Art Gallery, Steven Carlton
Clark Fund, 1973.88.41
Illustrated p. 138

Evelyn Rattray believes this thick, un-
usual vessel might have been an incense
burner and could have come from the
nearby site of Azcapotzalco, important
late in the history of Teotihuacan. The
central glyph is widely known in Teoti-
huacan art but is not well understood.
It consists of a trapeze and ray in the
upper part. The entire configuration
looks like the headdresses some deities

and elites wear. At the same time, such glyphs have been found with numbers, leading Alfonso Caso to suggest that they were calendrical signs for the year. What makes the Yale vessel of further interest is that footsteps are shown in the four panels that diagonally intersect the trapeze-and-ray design. These could signify the four directions or some kind of a cosmic crossroads and relate the motif to some ritual activity. Flanking the trapeze-and-ray design are flowers.
EP

144
TRIPOD VESSEL WITH PIECES ADDED TO THE INTERIOR
Tlamimilolpa-Metepec A.D. 200-750
San Miguel Amantla, Valley of Mexico
Ceramic
15 x 29 cm (6 x 11 $^1/_2$ in.)
MNA 9-2634; INAH 10-80438
CNCA-INAH-MEX, Museo Nacional de Antropología, Mexico City

This tripod vessel was published as part of an album of pieces collected in the Valley of Mexico by Franz Boas at the beginning of the century, at a time when the Valley of Mexico chronology was not yet established. "S. Miguel A." was written on the piece, which leads us to believe that it comes from San Miguel Amantla in the area of Azcapotzalco and the location of an important Teotihuacan enclave. However, the piece probably did not come from an excavation but was more likely acquired as a donation or purchase. Its shape, polished surface finish, and the incised, geometric design clearly indicate it belongs to Teotihuacan. The function of the small vessel or cone and quadrangular elements attached to the bottom of the interior are unknown.
CLDO

145

**LUSTROUS-WARE CYLINDRICAL
TRIPOD VESSEL WITH TWO
STYLIZED SERPENTS**

Metepec A.D. 600-750
San Francisco Mazapa, Teotihuacan,
1984 salvage excavations, associated
with a burial
Ceramic
18 cm (7 in.)
INAH 10-213195
CNCA-INAH-MEX, Museo Arqueológico
de Teotihuacan

Lustrous ware is a highly distinctive
Gulf Coast ceramic, compositionally
similar to those from El Tajín. The
ware appears at Teotihuacan in early
Tlamimilolpa times (ca. A.D. 200) and
may be the origin of the Teotihuacan
cylindrical vase with direct rim and
large hollow cylindrical or rectangular
supports. The excellent lustrous fin-
ishes in bright orange, tan, and white,
the elaborate cutout supports and a
decorative style incorporating the "Tajín
Scroll," and anthropomorphic repre-
sentations definitely establish the Gulf

Coast origin of these vases although the
best examples so far come mainly from
burial contexts in Teotihuacan. Evi-
dence of migrations and contacts with
the Gulf Coast were found in Evelyn
Rattray's excavations at the Merchant's
Barrio on the northeast side of Teotihua-
can. The barrio spans Tlamimilolpa
through early Xolalpan times (A.D.
250-550). Other evidences of contacts
throughout Teotihuacan are the ball-
court markers and paraphernalia, archi-
tectural forms, and Classic Veracruz
scroll designs. ER

146

LUSTROUS-WARE CYLINDRICAL VASE WITH MOLDED HEADS

Early Xolalpan A.D. 400-550

Provenance unknown, purchased from Walter Randel

Ceramic

23 x 28 cm (9 x 11 in.)

National Museum of the American Indian, Smithsonian Institution, Gift of Dr. and Mrs. Arthur M. Sackler, 241454

147

CYLINDRICAL TRIPOD VASE WITH DIAGONAL SCROLL DESIGN

A.D. 200-750

Purchased by Sigvald Linné at Teotihuacan in 1942, possibly from the Southern Gulf Coast area (Tuxtlas region)

Ceramic, fine-paste orange

13 x 13 cm (5 ¼ x 5 ¼ in.)

Folkens Museum-Etnografiska, Stockholm, 35.8.2358

THIN ORANGE WARE

THIN ORANGE WARE is a widely distributed Classic Mesoamerican tradeware (A.D. 200-750) closely identified with Teotihuacan for its iconographic content and vessel shapes. Its place of manufacture was in the region of Tepexi de Rodríguez, southern Puebla, according to Evelyn Rattray, who has identified ancient manufacturing sites there. The ware is inextricably tied up with burial customs and religious rites at most sites; at Teotihuacan its contexts are varied, and it can occur in burials, dedicatory offerings, and household middens of apartment compounds. According to Evelyn Rattray, about 20-percent of pot shards found at Teotihuacan have been identified as Thin Orange.

Thin Orange is an unusual type of luxury pottery because it is extremely simple. Evidently what the people of Teotihuacan liked was the relative thinness of the vessels, the slightly gritty surface, and the bright orange color. A wide variety of vessel types were made in Thin Orange, including human and animal effigies. An important part of Teotihuacan aesthetic preference was for elegant but simple forms. ER and EP

148

THIN ORANGE TRIPOD VESSEL WITH RECTANGULAR SLAB SUPPORTS
Probably Xolalpan-Metepec
A.D. 400-750
Tehuacan, Puebla, Tomb 2
Ceramic
16 x 26.5 cm (6 1/4 x 10 1/2 in.)
MNA 9-2149; INAH 10-630
CNCA-INAH-MEX, Museo Nacional de Antropología, Mexico City

Part of a funerary offering, this elegant three-footed Thin Orange vessel was excavated in a tomb at Tehuacan in the state of Puebla. Based on recent work, this region is believed to be the source of Thin Orange ware. A lightweight, easily transported pottery, Thin Orange played a major role in the economy of the Teotihuacan metropolis, for it was traded throughout Mesoamerica in a network controled by Teotihuacan. CLDO

149

Thin Orange Jar with Three-Button Supports and Molded Design

Metepec A.D. 650-750
Found in fill at Tetitla
Ceramic
29.5 x 23.5 cm (11 ³/₄ x 9 ¹/₄ in.)
MNA 9-2765; INAH 10-80576
CNCA-INAH-MEX, Museo Nacional
de Antropología, Mexico City

This jar's molded decoration suggests it dates to the last stages of Teotihuacan. The vessel, with its flaring rim and globular body, is a typical Teotihuacan shape. What is extraordinary are its graceful proportions and extreme simplicity contrasting with the detail of the molded design. CLDO

150

Thin Orange Box with Lid

Late Tlamimilolpa-Xolalpan
A.D. 400-600
Provenance unknown
Ceramic
11 x 6.5 x 5.5 cm (4 ¹/₂ x 2 ¹/₂ x 2 ¹/₄ in.)
INAH 10-336581
CNCA-INAH-MEX, Museo Arqueológico
de Teotihuacan

Small boxes such as this example are uncommon within the corpus of Teotihuacan ceramics. Sometimes they are rectangular, square, or cylindrical, with single or double-chambered interiors. Lids fit over the body to cover the entire box, which has thin, generally orange-colored walls. Such boxes are usually found in tombs and burials along with other sumptuous materials, indicating their use was exclusively for individuals of high status. RCC

151

THIN ORANGE RINGBASE BOWL
WITH INCISED AND PUNCTATED
DECORATION AND S MOTIF

Early Xolalpan A.D. 400-500
Provenance unknown, exchange
from Ralph C. Altman
Ceramic
5 x 15 cm (2 x 6 in.)
National Museum of the American
Indian, Smithsonian Institution, 22-9285

152

THIN ORANGE CYLINDRICAL TRIPOD
VASE WITH LID

Tlamimilolpa-Metepec A.D. 200-750
Provenance unknown
Ceramic
23 x 20 cm (10 x 8 in.)
The Art Museum, Princeton University,
Lent anonymously, L1968.130a-b

Hemispherical bowls with ring bases are
the most frequent form accounting for
over half of the Thin Orange ceramic
forms in Teotihuacan collections. Other
shapes are recurved bowls, vases, *cazuelas*,
jars, effigies, and miniatures. The vases
evolve from the plain cylinder with
simple basal flange and rectangular or
round supports (cat. no. 151) to more
elaborate shapes with appliqué decora-
tions on the basal flange. The rare min-
iatures (cat. no. 156) are good replicas
of regular-sized pots and usually occur
in burials. ER

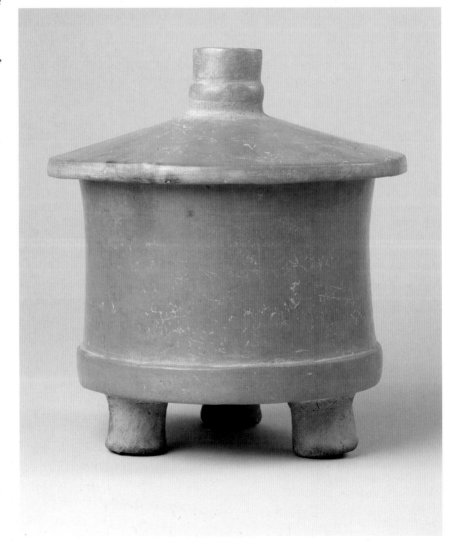

153
THIN ORANGE TRIPOD BOWL
Tlamimilolpa-Metepec A.D. 200-750
Ceramic
7.2 cm (3 in)
The Art Museum, Princeton University,
Lent anonymously, 1990.12

154
THIN ORANGE CYLINDRICAL VASE WITH MOLDED HEAD *ADORNOS*
Late Xolalpan A.D. 550-650
Provenance unknown
Ceramic
12 x 14.5 cm (4 ³/₄ x 5 ³/₄ in.)
Los Angeles County Museum of Art, Gift
of Mrs. Constance McCormick Fearing,
M. 86.311.31

155
THIN ORANGE GLOBULAR JAR WITH GADROONED BODY
Tlamimilolpa-Metepec A.D. 300-700
Provenance unknown
Ceramic
14 x 12.5 cm (5 ¹/₂ x 5 in.)
Los Angeles County Museum of Art, Lent
by Mrs. Constance McCormick Fearing,
M86.311.30
Illustrated p. 108

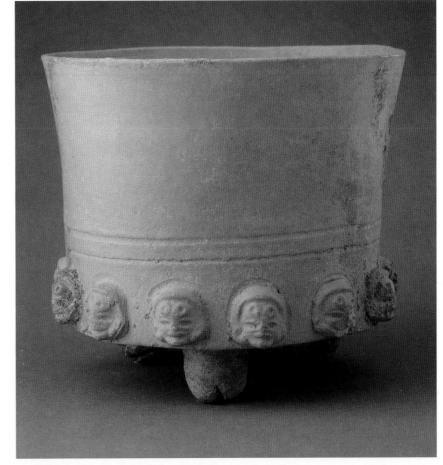

156
GROUP OF THIN ORANGE
MINIATURES
Tlamimilolpa-Metepec A.D. 200-750
Provenance unknown
Ceramic
Ca. 5 cm (2 in.)
Los Angeles County Museum of Art, Gift
of Mrs. Constance McCormick Fearing,
L83.11

157
THIN ORANGE WARE WHISTLING
POT WITH MONKEY
Tlamimilolpa-Xolalpan A.D. 300-600
Provenance unknown
Ceramic
12 x 12.8 cm (4 ³/₄ x 5 in.)
Los Angeles County Museum of Art, Lent
by Mrs. Constance McCormick Fearing,
L83.11.54

This is a rare type of Mesoamerican
vessel that whistles when water is poured
into the aperture. The animal effigy
represented on the lid of this cylindri-
cal vase is a monkey, a creature that is
frequently associated with whistles and
musical instruments. The Teotihuacan
five-petaled flower is incised on the body
of the vessel. Sigvald Linné found a very
similar whistling pot at Las Colinas,
Tlaxcala, Grave 1 (1942, 67). ER

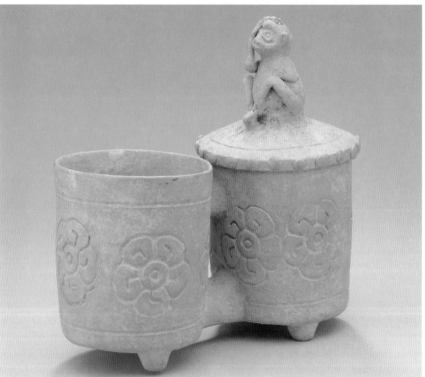

158
THIN ORANGE TRIPOD
WITH RELIEF DECORATION
Probably Xolalpan-Metepec A.D. 400-750
Provenance unknown
Ceramic
12.8 cm (5 in.)
Los Angeles County Museum of Art, Lent
by Mrs. Constance McCormick Fearing,
L83.11.1046

Thin Orange tripod vessels were fre-
quently ornamented with relief panels
usually impressed by molds. In this case,
a handsome half-star and double-key
design also ornament the tripod's slab
feet. The feather-bordered cartouche
encloses a frontal figure typical of deity
representations. The butterfly proboscis

and winglike elements in the head-
dress may identify this personage
as the Goddess. The deity wears an
unusual nosebar with a series of
pendant elements similar to fangs.
An owl head with a trilobe drop,
presumably blood, in its beak is
placed directly beneath the nose-
bar. Two speech scrolls emerge on
either side of the owl head with
the wings of the owl spread out
beneath them. The butterfly is a
frequent symbol in Teotihuacan
art and its meaning has to do with
transformation. The owl is usually
a military symbol and it is fre-
quently found on the chest of hu-
man or deity figures. EP

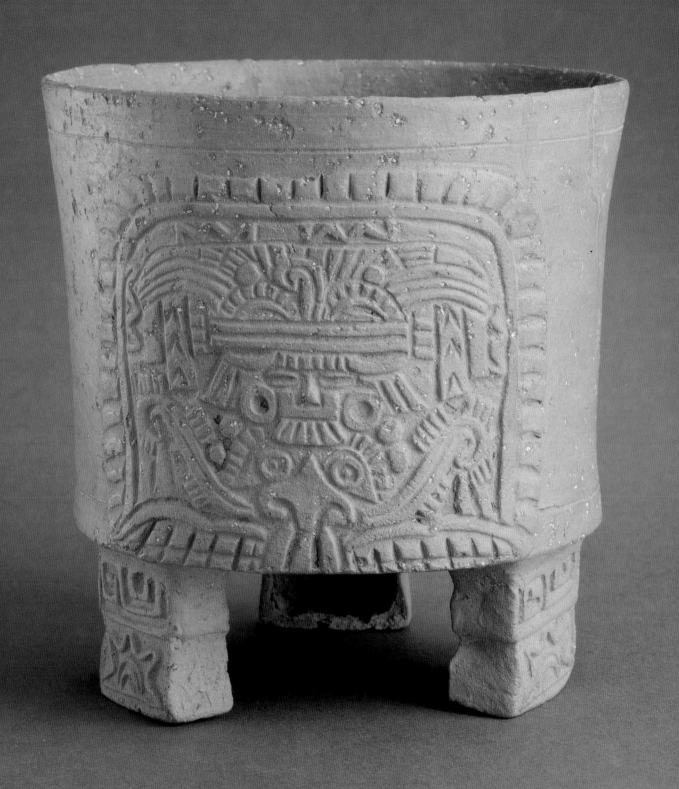

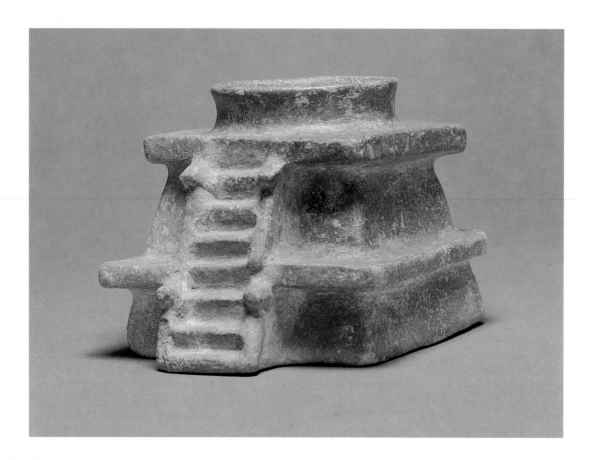

159
ORANGEWARE TEMPLE MODEL
Probably Tlamimilolpa-Metepec
A.D. 200-750
Provenance unknown, said to have been
found at a site near the junction of three
states: Puebla, Oaxaca, and Veracruz
Ceramic
11 cm (4 ¹/₂ in.)
American Museum of Natural History,
30.3/1099

Although a number of temple models
exist in stone (see cat. no. 2), such a
form in ceramic is very unusual. The
round opening of the vessel is harmoni-
ously situated within the rectangular
form of the two-stage pyramid platform.
The platform stages consist of a tall
tablero (or sloping section) to a narrow
cornicelike *talud* (horizontal section).
These are similar to but not identical
with the usual Teotihuacan *talud* and
tablero forms in architecture. The little
projections at the top of the stairway are
quite accurate. The vessel recreates the
aesthetic feeling, if not the exact forms,
of Teotihuacan architecture. EP

160
THIN ORANGE OLD GOD EFFIGY
Probably Tlamimilolpa-Metepec
A.D. 200-750
Provenance unknown, attributed to
Toluca. Purchased in Paris and presented
by Mrs. Thea Heye in 1929.
Ceramic
46 x 30.5 cm (l8 x 12 in.)
National Museum of the American
Indian, Smithsonian Institution, 16.6067
Illustrated p. 88

Many Thin Orange vessels were made
in the form of human or animal effi-
gies. We do not know the purpose of
these effigy vessels; mostly they do not
represent Teotihuacan symbols and
beings. Perhaps they were merely meant
to be pleasing and evocative as funerary
offerings. Since they seem to be free
from the system of Teotihuacan imag-
ery, they have a charm and immediacy
that endears them to the modern viewer.
This vessel of an old man emerging
from the globular shape of the bowl
may refer to the Old God of the stone
braziers (see cat. nos. 9-11) but without
incorporating specific details such as
the position of hands. Like the vessel,
the figure is modeled in simple rounded
forms with a minimum of decoration.
EP

161
THIN ORANGE FELINE EFFIGY VESSEL
Probably Tlamimilolpa-Metepec
A.D. 200-750
Provenance unknown
Ceramic
29.2 x 14 cm (11 ¹/₂ x 5 ¹/₂ in.)
Natural History Museum of Los Angeles,
F.A. 13.75.1931

This effigy is typical of most Thin
Orange effigies in that the head is
three-dimensional but the body is really
the round vessel, the arms and legs only
partly modeled away from it. The Meso-
american connotations of the feline
were many: it is an animal associated
with rulership and with the gods. Be-
cause this figure is so simple — the
creature wears only a necklace — a
more precise interpretation cannot
be made. EP

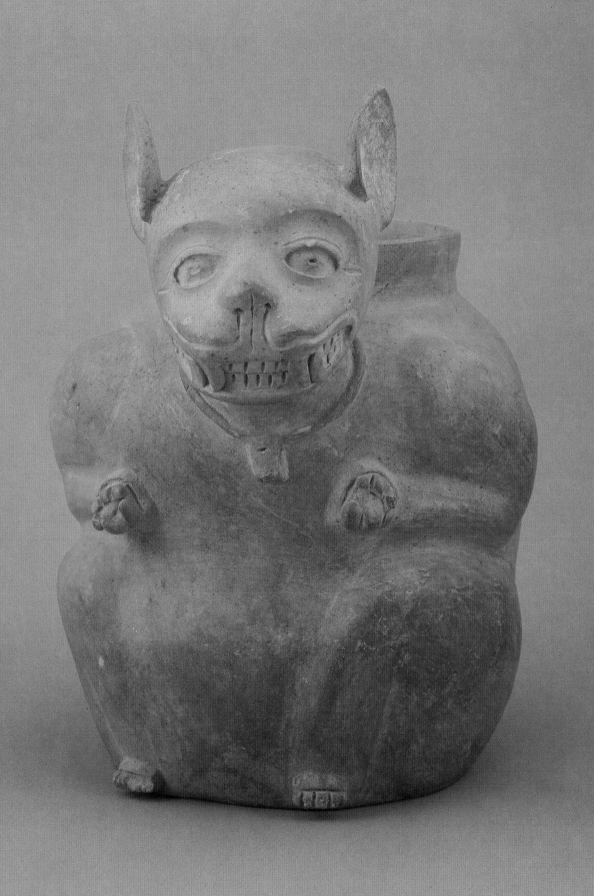

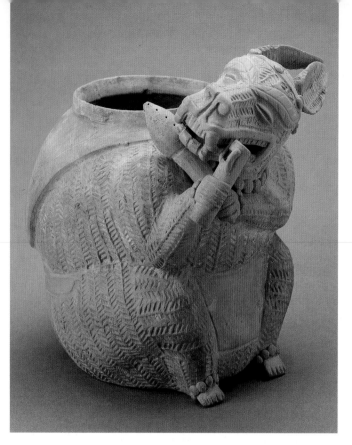

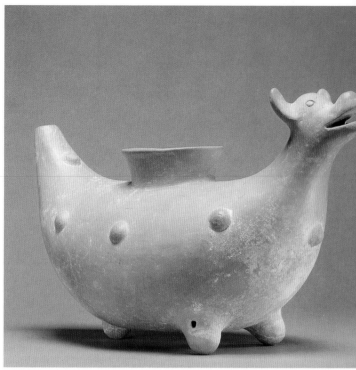

162
THIN ORANGE FURRY ANIMAL EFFIGY
Probably Tlamimilolpa-Metepec
A.D. 200-750
Provenance unknown
Ceramic
23.5 cm (9 1/4 in.)
Los Angeles County Museum of Art, Gift
of Mrs. Constance McCormick Fearing,
85.233.7

This anthropomorphic animal is hard
to identify: it has long ears, a long snout,
and a furry body. It holds two musical
instruments — a rattle and a flute —
to its mouth. While the image has the
potential for ritual interpretation, there
is nothing else quite like it. The figure
is typical in the way the limbs emerge
from the vessel and in the three-dimen-
sional head. It is unusual, however, in
the all-over furry texture indicated by
incision and by the asymmetrical tilt of
the head. These last two features give
the figure a great deal of liveliness. Like
other effigies, it wears a necklace, but
it has matching wristlets and anklets as
well. The directions of the fur texturings
and the contrast of plain and ornate
areas makes this an unusually interest-
ing aesthetic object. EP

163
THIN ORANGE DOG EFFIGY VESSEL
Probably Tlamimilolpa-Metepec
A.D. 200-750
Provenance unknown
Ceramic
9 x 19 cm (3 1/2 x 7 1/2 in.)
The Saint Louis Art Museum, Gift of Mr.
and Mrs. George K. Conant, Jr., 108:1966
Illustrated p. 113

Dogs were one of the most common
subjects on Thin Orange effigy vessels.
They range in size from small creatures
such as this to large vessels over 40.5
centimeters (16 inches) in diameter. In
most cases the dog is shown curled up,
with the round opening of the vessel in
the center of its back. While the crea-
ture is simplified and stylized, the repre-
sentation of its muscles are rendered
with naturalistic sensitivity. Its face, the
parallel lines on the cheeks, and the
eyebrows and the eyelids are reduced to
abstract designs. In Mesoamerica it was
believed that dogs led the dead to the
underworld after death, and either
sculptures of dogs or real dogs were
sometimes placed in burials. This idea
seems to have been especially common
inancient West Mexico. We do not
know the precise connection between
Teotihuacan and West Mexico but
some Thin Orange pottery has been
found in West Mexican tombs. EP

164
THIN ORANGE ANIMAL EFFIGY VESSEL
Probably Tlamimilolpa-Metepec
A.D. 200-750
Provenance unknown, said to have been
found at the juncture of three states:
Puebla, Oaxaca, and Veracruz
Ceramic
18 x 35.5 cm (7 x 14 in.)
American Museum of Natural History,
30.3/2333

This delightful, unidentifiable creature
is a cross between an animal and a cres-
cent-shaped vessel. Head and feet estab-
lish its animal identity. The smooth body
with the enigmatic circular knobs and
the projecting opening of the vessel
make it abstract. EP

266

165
Three *Candeleros*
Xolalpan A.D. 400-650
Provenance unknown
Ceramic
Talud-tablero candelero: 7.5 cm (3 in.)
Effigy *candelero* with twisted face:
7 cm (2 ³/₄ in.)
Hexagonal *candelero*: 7.5 cm (3 in.)
National Museum of the American Indian, Smithsonian Institution,
17-7779, 21-350, 24-2485

166
Candelero in the Shape of a Fish
Tlamimilolpa A.D. 200-400
Found in the clay bed of the floor,
Room 38, Tlamimilolpa
Ceramic
3 x 9 x 5 cm (1¹/₄ x 3 ¹/₂ x 2 in.)
Folkens Museum-Etnografiska,
Stockholm, A35.8.800

167
Four Miniature *Candeleros*
Late Tlamimilolpa to Metepec
A.D. 300-750
Valley of Mexico, probably Teotihuacan
Ceramic
4 x 5.8 cm (1¹/₂ x 2 ¹/₄ in.) and
5 x 7.6 cm (2 x 3 in.)
The University Museum, University of
Pennsylvania, 15138 and 29-41-448

Candeleros, used as small portable incense burners or portable lamps, are a common artifact at Teotihuacan from between A.D. 300-700. Their ceremonial character is often emphasized by symbolic markings or by effigy forms. They began as simple geometric forms with one or two chambers and developed into double-chambered *talud-tablero* configurations with incised borders or overall punctate or gouging designs. The tradition ends with crudely made "thumbed" *candeleros* that often bear rudimentary faces, the two vents serving as eyes. ER

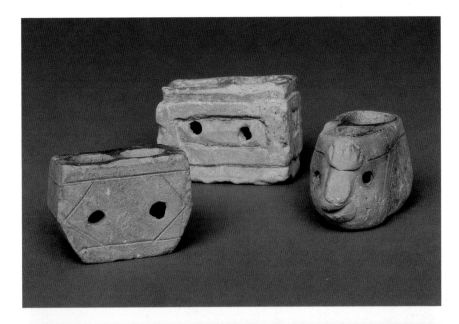

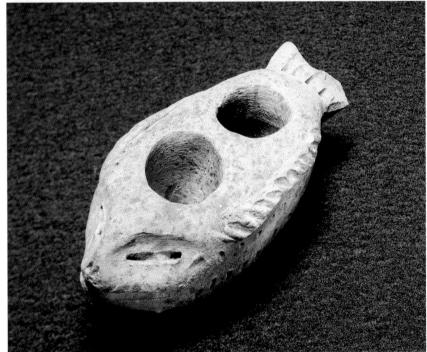

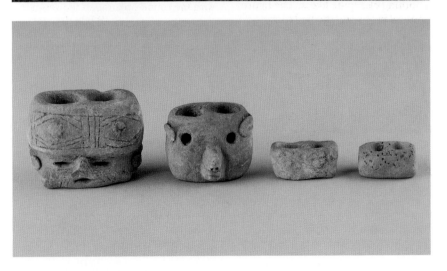

OBSIDIAN

OBSIDIAN OR VOLCANIC GLASS was used for all cutting purposes in Mesoamerica in the absence of metal tools. It is as sharp as steel and is even used for some modern surgical procedures. Teotihuacan is located near two major obsidian sources. A gray obsidian is found near the modern town of Otumba to the east, and a finer olive-green obsidian is found near the site of Tula to the north. In ancient times both areas were under Teotihuacan control. Green obsidian is associated more with ceremonial activity and with trade. An enormous quantity of obsidian debris has been found at the site and archaeologists have defined close to one hundred obsidian workshops.

Aside from the use of tools for everyday purposes and crafts, obsidian was also used for offerings in burials and caches. Sets of arrow heads or long thin blades are common, while little chipped figurines of humans or animals also exist. The most remarkable obsidian objects are oversized weapons or ceremonial staffs. Obsidian cannot be easily cut and is usually worked by chipping, which results in conchoidal fracture, a characteristic uneven surface that Mesoamericans, who had a special liking for stone, found attractive. When it is held up to the light the thin portions are transparent and very beautiful. It is only then that the color, gray or green, is visible.

168
BIFACIAL BLADES

Metepec A.D. 650-750

a) Found in the 1960s in Palace 3, Plaza of the Pyramid of the Moon
b) Found in the 1960s near the road that encircles the archaeological zone of Teotihuacan.

Obsidian

a) 37 x 16 cm (14 $\frac{1}{2}$ x 6 $\frac{1}{8}$ in.);
b) 51 x 23 cm (20 $\frac{1}{2}$ x 9 $\frac{1}{8}$ in.)

a) MNA 9-3742; INAH 10-393502
b) MNA 9-3741; INAH 10-3935301
CNCA-INAH-MEX, Museo Nacional de Antropología, Mexico City

These two huge curved obsidian blades may be identified with depictions of these objects known from Teotihuacan mural paintings and tripod vessels such as catalogue number 137. Although little information survives on their archaeological contexts, there is reason to believe that they were actually or symbolically used in ritual sacrifice involving heart extraction. CLDO

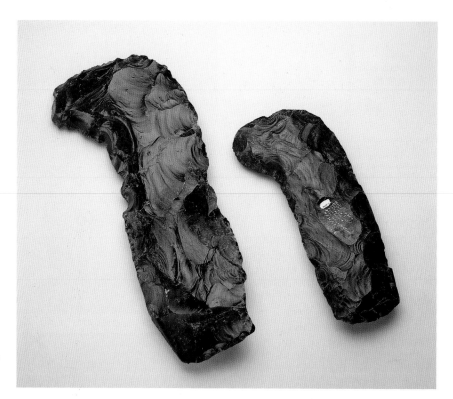

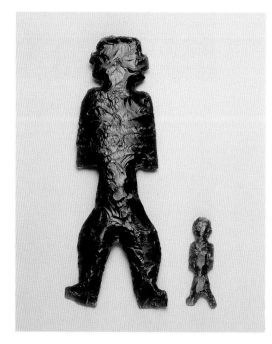

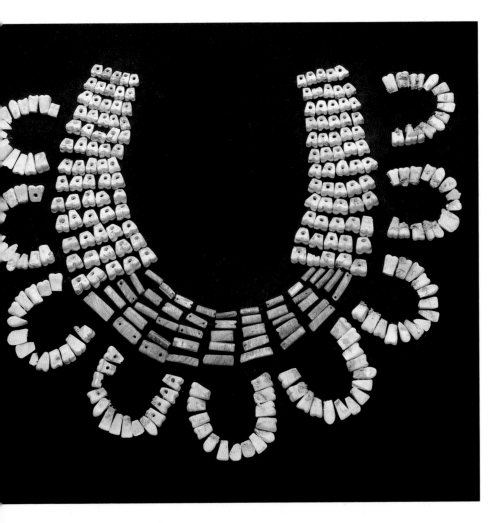

172

(B) NECKLACE

Miccacotli A.D. 150-200
Found in a burial, Temple of the
Feathered Serpent
Shell and human jaw bones
Arranged on a board ca. 8 x 8 cm
(20 x 20 in.)
INAH 10-411076 and l0-411077
CNCA-INAH-MEX, Centro de
Investigaciones Arqueológicas de
Teotihuacan
Cat. no. 172a illustrated p. 100

Composed of carved shell beads that
attest to the artistic abilities of the
Teotihuacanos, these necklaces formed
part of an elaborate costume worn by
male warriors sacrificed at the Temple
of the Feathered Serpent. Tooth-shaped
beads were combined with flat beads
and semicircular pendants of actual or
imitation human maxillaries or jaws.
Close to forty similar necklaces, which
are unique in Mesoamerica, have been
found recently in excavations at the
Ciudadela. RCC

173

CONICAL OBJECTS

Miccaotli A.D. 150-200
Part of an offering in a multiple burial
located on the interior of the Temple of
the Feathered Serpent, l989 excavations
Greenstone
H. 4.7-6.5 cm ($^7/_8$-2 $^5/_8$ in.) with
D. 5-6.5 cm (2-2 $^5/_8$ in.)
INAH 10-411083
CNCA-INAH-MEX, Centro de
Investigaciones Arqueológicas de
Teotihuacan
Illustrated p. 104

These cone-shaped objects have circu-
lar bases and low-relief designs forming
a series of small conical figures around
the entire base. Their function is un-
known as this is the first time these
objects have been reported. A total of
eighteen were found as part of a lavish
offering accompanying a multiple
burial of twenty individuals located at
the center of the Temple of the Feath-
ered Serpent. RCC

169

(A) GROUP OF MINIATURE SERPENTS

Miccaotli-Metepec A.D. 150-750
Temple of the Feathered Serpent
Obsidian
L. 2 .4-3.6 cm (1-1 $^3/_8$ in.)
INAH 10-411085-1
CNCA-INAH-MEX, Centro de
Investigaciones Arqueológicas de
Teotihuacan

(B) LARGE AND SMALL FIGURES

Miccaotli-Metepec A.D. 150-750
Obsidian
4.4 x 1.3 cm (1$^3/_4$x $^1/_2$ in.) and
12.8 x 4.6 cm (5 x 1$^3/_4$ in.)
FOSA 4 9C 2314 and 9C2857 Ent 14
CNCA-INAH-MEX, Centro de
Investigaciones Arqueológicas de
Teotihuacan

170

THREE PRISMATIC BLADES

Miccaotli-Metepec A.D. 150-750
Green obsidian
20 x 1.5 cm (8 x $^3/_8$ in.)
INAH 10-811086/1-3
CNCA-INAH-MEX, Centro de
Investigaciones Arqueológicas
de Teotihuacan
Illustrated p. 27

171

GROUP OF OBSIDIANS

Late Tlamimilolpa A.D. 300-600
Excavated by Sigvald Linné, Xolalpan,
Burial 1
Obsidian
H. 2-12 cm ($^3/_4$ -5 in.)
Folkens Museum-Etnografiska,
Stockholm, 1932.8.4401-9
Illustrated p. 119

TEOTIHUACAN AND ITS CONTEMPORARIES

IT IS KNOWN THAT Teotihuacan was the largest power in Mesoamerica for much of its existence, but everything else about the nature of its relationships to its contemporaries is a problem. Ten years ago it was generally thought that Teotihuacan had a large empire in Mesoamerica, with colonies of its people living in Kaminaljuyú in Guatemala and Matacapan in Veracruz. It was believed that this empire was created by trade and conquest, and obsidian was supposed to have been the material Teotihuacan traded with its neighbors. Current thinking based on a reexamination of the data no longer accepts the empire theory. The contacts seem to have been too sporadic and spread out for an empire.

Nevertheless, it is clear that the people of Teotihuacan traveled far and wide in Mesoamerica. They made astronomical observations near the Tropic of Cancer hundreds of miles to the north. Their elites, deities, and costumes are represented on Maya monuments at Tikal and other places. A Teotihuacan elite figure with a tassel-headdress glyph follows a Monte Albán figure on the Bazan slab in what has been described as the commemoration of a "treaty." Unquestionably, Teotihuacan had important political and dynastic connections throughout Mesoamerica. In two places, Escuintla in Guatemala and Matacapan in Veracruz, objects have been found in a modified Teotihuacan style that were parts of household cults. At Kaminaljuyú, Teotihuacan elites were buried in Teotihuacan-style temples with both Teotihuacan and Maya-style offerings. These examples suggest possible Teotihuacan colonies.

There is also evidence of foreigners at Teotihuacan. The Oaxaca Barrio was found in the western part of the city, where the dead were buried in Oaxaca-style tombs with Oaxaca-style urns and reliefs. The Merchant's Barrio has been excavated in the eastern part of the city, with round houses and pottery imported from Veracruz and even the Maya areas. Teotihuacan was clearly a cosmopolitan place and the visits went in both directions. Long after the demise of Teotihuacan, elements of its art style continued to be fused into the styles of the Postclassic Period.

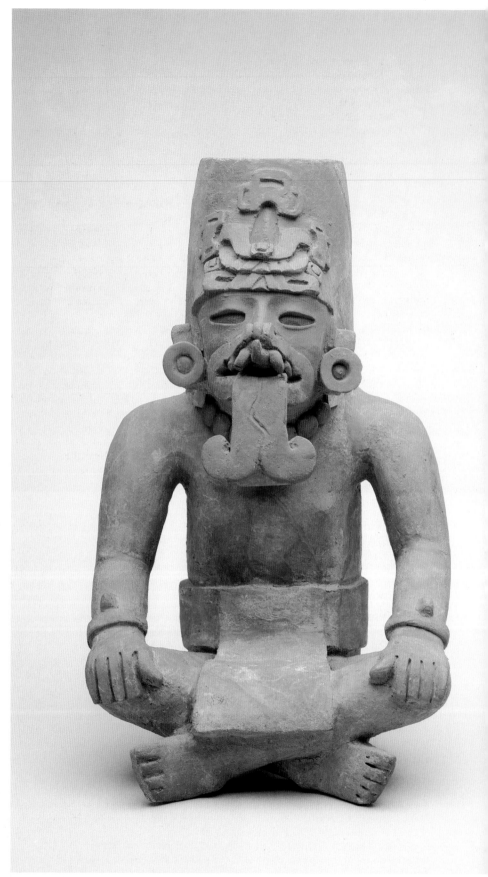

270

174

Zapotec-style Urn

Xolalpan A.D. 400-700
Oaxaca Barrio
Ceramic, shell, greenstone, pigment
34.2 x 21.1 x 22.5 cm (11 ³/₈ x 8 ¹/₄
x 8 ³/₄ in.)
MNA 9-4878; INAH l0-393504
CNCA-INAH-MEX, Museo Nacional
de Antropología, Mexico City

This Zapotec-style funerary urn with
the representation of the God with the
Serpent Mouth-Mask was found, ritually
smashed, in an apartment compound
in a small room adjoining the main
temple. Of exceptional interest are the
rectangular greenstone plaque in the
center and the two squares of cut shell
at the ends of the necklace, as appliqués
in media other than clay are uncom-
mon on urns of this type. The deity's
calendrical name appears in his head-
dress as 8 Flower, the bar indicating the
number 5 and the three dots represent-
ing 3. CLDO

175

Tomb Jamb

Xolalpan-Metepec A.D. 400-700
Found in the Oaxaca Barrio in l966 on
the ledge between a tomb and its ante-
chamber in an apartment compound
Basalt, lime stucco, red pigment
96 x 39 x 28 cm (37 ⁷/₈ x 11 in.)
INAH 10-411078
CNCA-INAH-MEX, Centro de
Investigaciones Arqueológicas de
Teotihuacan
Illustrated p. 152

This tomb jamb is carved from a stone
block removed and reused from the
Temple of the Feathered Serpent. One
of the flat, rectangular sides displays a
glyph with a numeral in Oaxacan style
forming the date 9 movement, which
may indicate the calendrical date of
the interment of the occupants of the
tomb. RCC

176

Bazan Slab

Tlamimilolpa-Xolalpan A.D. 200-650
Found in 1935 at Monte Albán
Stone
49 x 49 x 12 cm (19 ¹/₄ x 19 ¹/₄ x 4 ³/₄ in.)
MNA 6-6048; INAH l0-8651
CNCA-INAH-MEX, Museo Nacional
de Antropología, Mexico City
Drawing in Covarrubias 1957, 153

This scene depicts two richly attired
individuals. To the right is a figure called
3 Turquoise, also the name of the pa-
tron god of Monte Albán, dressed as a
jaguar wearing an elaborate serpent
headdress. Behind him stands another
figure, this time from Teotihuacan,
whose calendrical name is 8 Turquoise,
carrying a copal bag for offerings. Both
are shown standing in profile on plat-
forms that symbolize place and that
contain signs for their calendrical
names. Framing the scene are glyphs,
but whether the content might be
calendrical or political is a subject for
debate. The jaws of a personified sky
with celestial eyes, indicating stars, ap-
pear in the upper part. This and several
other monuments from Monte Albán
are believed to commemorate peaceful
interaction with Teotihuacan through
political emissaries. Near the
bottom of the glyphic col-
umn accompanying the
Teotihuacano is the tassel
headdress, a symbol that
may have served as a
badge of office, per-
haps indicating a
military or com-
mercial rank.
MCM

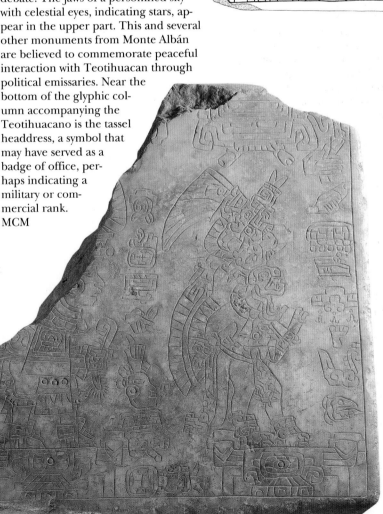

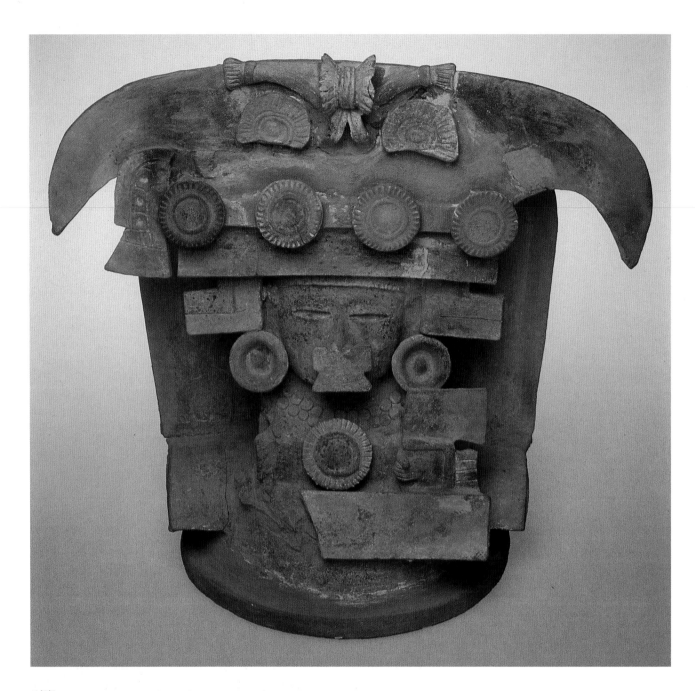

177

ESCUINTLA-STYLE CENSER LID
Tlamimilolpa-Metepec A.D. 300-700
Provenance unknown
Clay with traces of paint
45.5 x 48 cm (18 x 19 in.)
The Fine Arts Museums of San Francisco,
Gift of Dr. and Mrs. Larry M. Ottis,
1981.51.7

Nearly as many censers have come from
the Escuintla region of Guatemala as
from all of Teotihuacan. The nearby
site is Rio Seco, but none of the censers
have been excavated archaeologically.
Because of their overall similarity to
Teotihuacan censers, it is assumed that
this area was inhabited by people of
Teotihuacan origin who brought their
household cults with them. In a defini-
tive study Janet Berlo noted that in
contrast to the Teotihuacan censers,
which look like portable shrines, the
Escuintla censers look more like per-
sons. In comparison to the fragile as-
sembled pieces of Teotihuacan censers,
those from Escuintla are solid and
sturdy. They have stylistic and concep-
tual parallels with the urns of Monte
Albán as well as with the terracotta fig-
ures of Veracruz. This censer lid is a
typical example of a figure with hands
and a butterfly motif in its headdress.
EP

178

Escuintla-style Mold-impressed Tripod Vessel

Xolalpan-Metepec A.D. 400-700
Provenance unknown
Clay
17.8 x 14.6 cm (7 x 5³/₄ in.)
The Denver Art Museum, Gift of Dr.
and Mrs. Larry M. Ottis, 1980.0267

As at Teotihuacan, the favorite ritual vessel of the Escuintla was the cylindrical tripod. Tripods vary greatly in quality at Teotihuacan, but many were finely and delicately made, carved in plano relief or frescoed. The Escuintla tripods are cruder in form and decoration and usually have more vertical proportions. The motifs may copy those of Teotihuacan; in this case a Teotihuacan-style "coffee-bean" row at base and a serpent symbol is employed. EP

179

Escuintla-style Tripod with Mold-impressed Decoration

Xolalpan-Metepec A.D. 400-700
Clay
23 x 33 cm (9 x 13 in.)
The Denver Art Museum, Gift of Dr.
and Mrs. Larry M. Ottis, 1984.0605

The art of the Escuintla region is an eclectic mix of Teotihuacan, Monte Albán, Veracruz, and Maya elements, as well as of innovative local features. In this vessel, the tripod shape recalls the preferred ritual vessel form of Teotihuacan, while the creatures in the medallions have a vague Mayoid appearance. Nicholas Hellmuth named the figure on the legs Curly Face, because of his curly mustache-like lip that is similar in concept but not in form to the Teotihuacan Storm God. He is shown here with hands below his face. The eclectic sources and the rough vitality of rendering are characteristic of this lively provincial style. EP

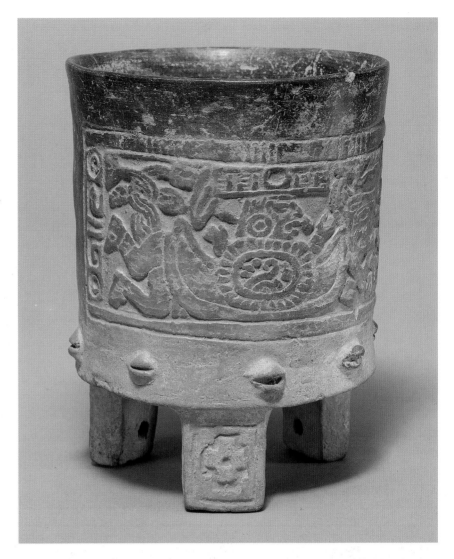

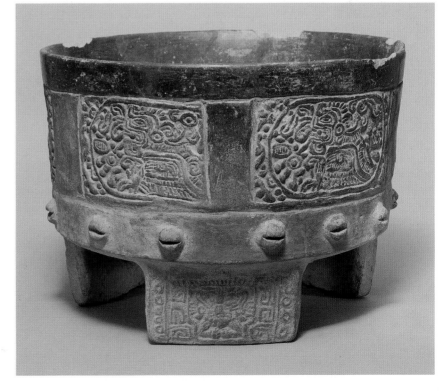

180

MIRROR BACK WITH A FRONTAL FIGURE FLANKED BY PROFILE FIGURES

Probably Xolapan-Metepec A.D. 400-750
Provenance unknown, possibly from Escuintla
Slate, originally inlaid with pyrite on its back
20.1 cm (8 in.)
The Cleveland Museum of Art, James Albert and Mary Gardiner Ford Memorial Fund, 89.65
Illustrated p. 126

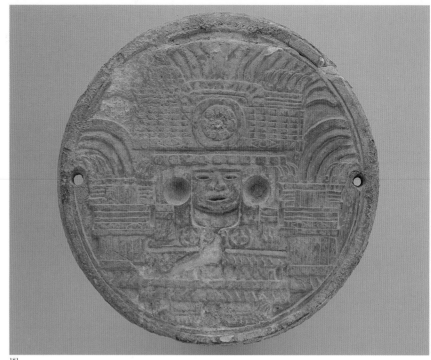

181

Most Teotihuacan-style mirrors seem to have come from Guatemala, in the highlands near Kaminaljuyú or along the coast near Escuintla. Mirrors were used as costume ornaments and very likely used in ritual. Although we do not have specific information on the ritual use of mirrors at Teotihuacan, we know from other Mesoamerican cultures that some mirrors could have been used for starting miraculous-seeming fires, while others could have been consulted in divination, or in some ways for giving access to the world of spirits.

This mirror shows a frontal deity bust flanked by two elite figures in profile with speech scrolls, carrying bunches of flowers and incense bags. They stand above a wavy band of water containing shells. This composition is very similar to the mural from the Tepantitla apartment compound at Teotihuacan. There is even a parallel with the central emblem that encloses a stylized symbol for a cave — a Storm God upper lip with a cross symbol in its interior. The oversized deity with the nosebar, probably a composite ancestor-deity image, wears a huge butterfly headdress and double earspools. EP

181

MIRROR BACK WITH FRONTAL FEMALE FIGURE

Probably Xolalpan-Metepec
A.D. 400-750
Provenance unknown
Slate with cinnabar and pyrite inlay
14 cm (5 1/2 in.)
The Denver Art Museum, Gift of Jan and Frederick R. Mayer, 1990.0080a-b

Because so many Teotihuacan-style mirrors come from Guatemala, it is assumed that this too is not from Teotihuacan. The severe horizontal and vertical grid organization of the figure is, however, in Teotihuacan style, and the figure is reminiscent of the colossal

Goddess sculpture in stone. It is unusual because Teotihuacan frontal figures usually do not have feet but are only busts. The two flanking objects with flames cannot be identified exactly but they are clearly ritual articles. This mirror back is especially striking in its combination of the softly carved face and the hard-edged lines of the headdress, costume, and insignia. The circular holes flanking the face and the depressions of the necklace were intended for inlays. There are few features that identify this personage, but the dress suggests the Goddess. The prominence of flames suggests her more destructive aspect. EP

180

Diagram of mirror-back showing carved design and areas of restoration. Drawing by Ron Garrett. In Young-Sánchez 1990, 327.

182

PLAQUE OF THE GODDESS WITH THE REPTILE-EYE GLYPH

Metepec-Epiclassic A.D. 650-850
Found at Axtapalulca near Chalco, Valley of Mexico, while digging a canal at Axtapalyea, near Chalco; acquired in 1894.
White alabaster-like stone
29 x 16.5 x 3 cm (11 1/2 x 6 1/2 x 1 1/4 in.)
Field Museum of Natural History, Chicago, 23913

This plaque has been known since the nineteenth century. Lightly incised on soft whitish stone, the figure is an eclectic combination of several styles closest to the sculpture of Xochicalco, a site located near the modern-day city of Cuernavaca.

The frontal figure wearing a skirt and nosebar is similar to the Teotihuacan Goddess. The presence of the feet in sandals and the delicate gesture of the hands is reminiscent of the art of Escuintla. Although the reptile-eye glyph, an eye under a curl, is a common Teotihuacan glyph, its presence on the chest of the figure is closer to Oaxaca, Escuintla, and Xochicalco usage. The Goddess on this plaque is similar to that on Xochicalco Stela l. Both of these may be versions of the Teotihuacan Goddess, whose importance lasted beyond the fall of the city. The tassels on the outer borders of the relief are an elegant detail. EP

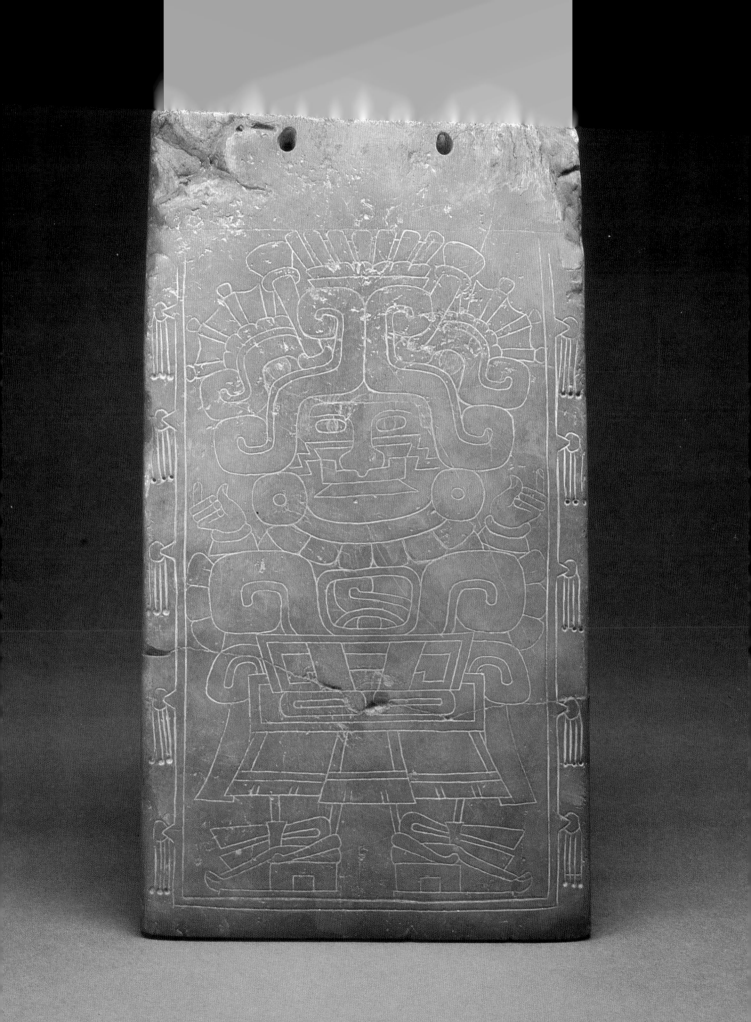

183

TEOTIHUACAN-STYLE FIGURE WITH THREE GLYPHS

Metepec-Epiclassic A.D. 650-850
Provenance unknown, said to be from southern Puebla
Greenstone
30 cm (12 in.)
Peabody Museum of Natural History, Yale University, 8558

This figure indicates the ways in which Teotihuacan stylistic elements were combined with other styles during the end of Teotihuacan hegemony and after its collapse. The style of the figure is close to those from Teotihuacan, although neither this nor many of the other similar stone figures were necessarily made there. The three glyphs with numbers — one on the chest, one on the back, and one on the back of the head — are in Zapotec or Nuiñe style. They represent the day names 5I (Maltese cross), 8 A (Knot), and 8 G (Deer). Javier Urcid (personal communication, 1993) suggests that the glyphs might have a nominative function, perhaps to name some revered ancestors. This could, then, have been a reworked heirloom. EP

184

EARSPOOLS WITH FRONTAL FACES

Probably Xolalpan-Metepec
A.D. 400-750
Provenance unknown
Clay with traces of pigment
3.9 cm (1 1/2 in.)
The Art Museum, Princeton University, Lent anonymously, L1967.206

A small number of clay earspools with ornamental figures exist, although none so far have been excavated at Teotihuacan or in Guatemala; thus we know nothing of their provenance. All deities and elite figures are shown in art wearing impressive earspools, although usually they are of greenstone. The figures inside these clay earspools with their wide-frame headdresses, finely modeled masklike faces, and big earspools evoke all the hallmarks of Teotihuacan style. EP

276

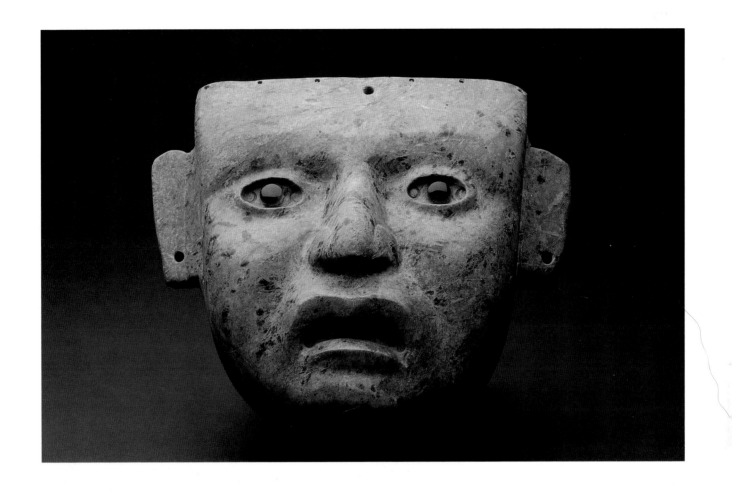

AZTEC VENERATION OF TEOTIHUACAN

TEOTIHUACAN HAD COLLAPSED four hundred years before the Mexica Aztecs founded their capital, Tenochtitlan. They were familiar with the majestic ruins, which they attributed either to the gods or to some great ancient civilization. They made no distinction between Teotihuacan and Tula and considered both to have been "Toltec" and to have existed just prior to the Aztecs. They excavated and looted at both these sites searching for treasures and ancient monuments. Some of these objects found their way into the offerings of the Templo Mayor at Tenochtitlan.

Since the Aztecs saw themselves as barbarian latecomers in the Valley of Mexico, they were insecure in the face of the great monuments of the ancient civilizations. They were extremely conscious of the past and of history. Dates are important in their art. Teotihuacan, by contrast, had no great past to look to, was not interested in history with dates, and seemed to be concerned with an eternal present or perhaps a great future.

185

MASK WITH INLAY

Classic Period A.D. 300-600
Found in 1978 in Offering 20, located at the east (back) facade of the Templo Mayor of Tenochtitlan, Stage IV-B (ca. A.D. 1469-1481)
Greenstone with shell and obsidian inlay
20 x 24.2 x 9 cm (8 x 9 $^1/_2$ x 3 $^1/_2$ in.)
INAH 10-168801
CNCA-INAH-MEX, Museo del Templo Mayor, Mexico City

Several Classic Period Teotihuacan masks were found at the Templo Mayor. Sculpted from dense stone in different shades of green, these masks characteristically display symmetrical facial features framed by a U-shaped contour, while rectangular tabs represent ears. The forehead is a plain band, which displays tiny perforations that perhaps held hair or feathers. Elliptical eye cavities sometimes have inlays — obsidian simulating the iris in this case. The nose is wide at the end and the mouth is essentially realistic. However, this particular mask is unusual because its lips resemble those seen in Olmec sculpture. LLL

186

Quadrapod Vessel

Classic Period A.D. 300-600
Found in 1978 in Offering 20, located at
the east (back) facade of the Templo
Mayor of Tenochtitlan, Stage IV-B (ca.
A.D. 1469-1481)
Greenstone
5.8 x 14.3 cm (2 1/4 x 5 1/2 in.)
INAH 10-168817
CNCA-INAH-MEX, Museo del Templo
Mayor, Mexico City

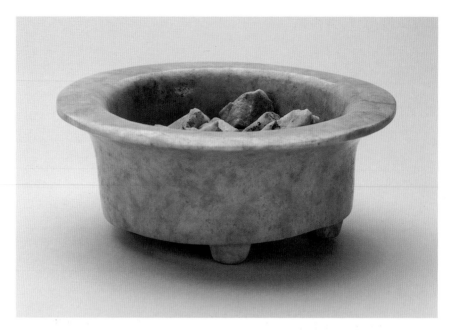

This bowl with flat bottom and slightly
convex, diverging walls has four small
supports in the form of truncated
cones. Covered with a rough, disk-
shaped piece of greenstone, its interior
held twenty small, unworked pieces of
greenstone. This bowl formed part of a
lavish offering that included an Olmec
mask and two Teotihuacan Storm God
vessels. LLL

187

Figure with Aztec Glyphs

Tlamimilolpa-Metepec A.D. 250-750
(figure); A.D. 1400-1521 (glyphs)
Acquired in 1880 from C. W. Lüders
Serpentine
34 cm (13 1/2 in.)
Hamburgisches Museum
für Völkerkunde, B264

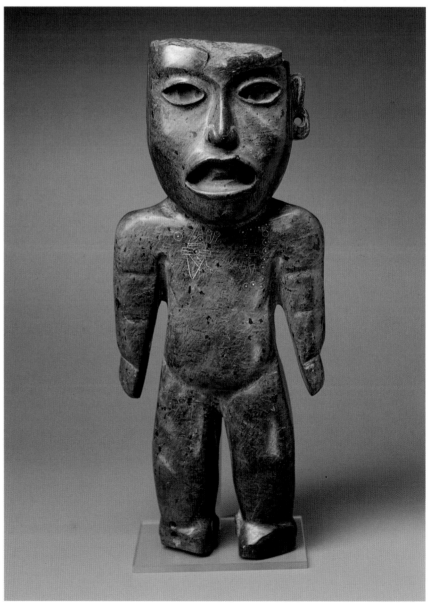

The two glyphs on the figure's chest,
1 Flint and 13 Reed, are two very impor-
tant dates for the Aztecs. The birthdate
of the sun was 13 Reed and thus of the
beginning of time for the Aztecs, an
event they placed at Teotihuacan. The
date of birth of Huitzilopochtli (the
patron god of the Aztecs) was 1 Flint,
the day the Aztecs set out on their mi-
gration, and the date of a decisive vic-
tory over their neighbors that made
their empire a reality.

 Umberger suggests that the two
dates together signified the birth of
the Aztec era and the Aztec political
empire. The placement of these dates
on a Teotihuacan heirloom figure sug-
gests that the Aztecs understood the
antiquity of it and correctly associated
it with Teotihuacan. EP

Bibliography

Acosta, Jorge R. *El Palacio del Quetzalpapalotl.* Memorias no 10. Mexico: INAH, 1964.

Almaraz, R. "Apuntes sobre las pirámides de San Juan Teotihuacan." In *Memoria de los trabajos ejecutados por la Comisión Científica de Pachuca en el año de 1864,* 349-358. 1865.

Angulo Villaseñor, Jorge. "Reconstrucción etnográfica a través de la pintura." In *Teotihuacan: XI Mesa Redonda* 2:43-68. Mexico: Sociedad Mexicana de Antropología, 1972.

_____. *Teotihuacan, la ciudad de los dioses.* Mexico: Panorama Editorial, 1982.

Armillas, Pedro. "La serpiente emplumada, Quetzalcoatl, y Tlaloc."*Cuadernos Americanos* 31(1)(1947):161-178.

_____. "Teotihuacan, Tula, y los Toltecas: Las culturas post-arcaicas y pre-aztecas del centro de México. Excavaciones y estudios, 1922-1950." *Runa* [Buenos Aires] 3, pts.1-2(1950):37-70.

Aveleyra Arroyo de Anda, Luis. *La estela teotihuacana de LaVentilla.* Mexico: INAH, Museo Nacional de Antropología, *Cuadernos* 1, 1963.

Aveni, Anthony F., and Horst Hartung. "New Observations of the Pecked Cross Petroglyph." In *Space and Time in the Cosmovision of Mesoamerica,* ed. F. Tichy, 10:25-42. Vancouver, Canada: 43rd International Congress of Americanists, Latin American Studies, 1982.

Aveni, Anthony F., Horst Hartung, and Beth Buckingham. "The Pecked Cross Symbol in Ancient Mesoamerica." *Science* 202, no. 4365(1978):267-279.

Ball, J.W. "A Teotihuacan-Style Cache from the Maya Lowlands." *Archaeology* 27(1974):2-9.

Barba Pingarón, Luis Alberto, and Linda Manzanilla."Superficie/excavación: Un ensayo de predicción de rasgos arqueológicos en Oztoyahualco." *Antropológicas* no. 1:19-46. Mexico: Universidad Nacional Autónoma de México, 1987.

Barbour, Warren T. D. "The Figurines and Figurine Chronology of Ancient Teotihuacan, Mexico." Ph.D. diss., Department of Anthropology, University of Rochester, 1976.

Barthel, Thomas S. "Veritable 'Texts' in Teotihuacan Art?" *The Masterkey* 56, no. 1(1982):4-12.

Bastien, Auguste Rémy. "La pirámide del sol en Teotihuacan." Thesis, Escuela Nacional de Antropología e Historia, 1947.

Batres, Leopoldo. *Teotihuacan: Memoria que presenta Leopoldo Batres a*l *XV Congreso Internacional de Americanistas, Quebec.* Mexico: Fidencia S. Soria, 1906.

_____. *Teotihuacan: La ciudad sagrada de las Toltecas.* Mexico: Escuela Nacional de Artes y Oficios, 1989.

Bennyhoff, James A. "Chronology and Periodization: Continuity and Change in the Teotihuacan Ceramic Tradition." *XI Mesa Redonda* 1:19-24. Mexico: Sociedad de Antropología, 1966.

Berlo, Janet C. "Artistic Specialization at Teotihuacan: The Ceramic Incense Burner." In *Pre-Columbian Art History: Selected Readings,* ed. A. Cordy-Collins, 83-100. Palo Alto: Peek Publications, 1982.

_____. "The Warrior and the Butterfly: Central Mexican Ideologies of Sacred Warfare and Teotihuacan Iconography." In *Text and Image in Pre-Columbian Art: Essays on the Interrelationship of the Verbal and Visual Arts,* ed. Janet C. Berlo, 79-117. Oxford: B.A.R. International Series 180, 1983.

_____. *Teotihuacan Art Abroad: A Study of Metropolitan Style and Provincial Transformation in Incensario Workshops.* Ph.D. diss., Yale University, 1980. 2 vols. Oxford: B.A.R. International Series 199, parts 1 and 2, 1984.

_____. "Art Historical Approaches to the Study of Teotihuacan-Related Ceramics from Escuintla, Guatemala." In *New Frontiers in the Archaeology of the Pacific Coast of Southern Mesoamerica,* ed. Frederick J. Bove and Lynette Heller, 147-162. Anthropological Research Papers 39. Tempe: Arizona State University, 1989a.

_____. "Early Writing in Central Mexico: *In Tlilli, in Tlapalli* before A.D.1000." In *Mesoamerica after the Decline of Teotihuacan A.D.700-900,* ed. Richard A. Diehl and Janet C. Berlo,19-47. Washington, D.C.: Dumbarton Oaks, 1989b.

_____, ed. *Art, Ideology, and the City of Teotihuacan.* Washington, D.C.: Dumbarton Oaks, 1992a.

_____. "Icons and Ideologies at Teotihuacan: The Great Goddess Reconsidered." In *Art, Ideology, and the City of Teotihuacan,* ed. Janet Berlo 129-168. Washington, D.C.: Dumbarton Oaks, 1992b.

Bernal, Ignacio. *Teotihuacan: Descrimientos, reconstrucciones.* Mexico: INAH, 1963.

Berrin, Kathleen, ed. *Feathered Serpents and Flowering Trees: Reconstructing the Murals of Teotihuacan.* San Francisco: The Fine Arts Museums of San Francisco, 1988.

Brambila, Rosa. *Sala de Teotihuacan.* Mexico: Museo Nacional de Antropología, García Valadés Editores, 1986.

Cabrera Castro, Rubén, George Cowgill, Saburo Sugiyama, and Carlos Serrano. "El proyecto templo de Quetzalcoatl." *Arqueología* 5:51-79. Mexico: INAH, 1989.

Cabrera Castro, Rubén, Ignacio Rodríguez García, and Noel Morelos García, ed. *Memoria del Proyecto Arqueológico Teotihuacan 80-82.* Mexico: INAH, Colección Científica 132, 1982a.

_____.*Teotihuacan 1980-1982: Primeros Resultados.* Mexico: INAH, 1982b.

_____. *Teotihuacan 80-82: Nuevas interpretaciones.* Mexico: INAH, Colección Científica 227, Serie Arqueológica, 1991.

Cabrera Castro, Rubén, Saburo Sugiyama, and George L. Cowgill. "The Templo de Quetzalcoatl Project at Teotihuacan: A Preliminary Report," *Ancient Mesoamerica* 2, no.1 (1991):77-92.

Cardós de Mendez, Amalia, ed. *La época clásica: Nuevos hallazgos, nuevas ideas.* Mexico: INAH, Museo Nacional de Antropología, 1990.

Carlson, John B. *Venus-Regulated Warfare and Ritual Sacrifice in Mesoamerica: Teotihuacan and the Cacaxtla "Star Wars" Connection.* College Park, Md.: Center for Archaeoastronomy Technical Publication 7, 1991.

Caso, Alfonso. "El paraíso terrenal en Teotihuacan." *Cuadernos Americanos* 6, no. 6(1942):127-136.

_____. "Dioses y signos teotihuacanos." In *XI Mesa Redonda* 1: 249-279. Mexico: Sociedad Mexicana de Antropología, 1966.

Castañeda, Francisco de. "Official Reports on the Towns of Tequizistlan, Tepechpan, Acolman, and San Juan Teotihuacan Sent by Francisco de Castañeda to His Majesty, Philip II, and the Council of the Indies in 1580." *Papers of the Peabody Museum of American Archaeology and Ethnology* 11, no. 2, ed. Zelia Nuttall. Cambridge, 1926.

Charlton, Thomas H. "Teotihuacan: Trade Routes of a Multi-tiered Economy." *XV Mesa Redonda* 2:285-292. Mexico: Sociedad Mexicana de Antropología, 1977.

_____. "Influence and Legacy of Teotihuacan on Regional Routes and Urban Planning." *Ancient Road Networks and Settlement Hierarchies in the New World*, ed. Charles D. Trombold, 186-197. Cambridge: Cambridge University Press, 1991.

Charnay, Désiré. *The Ancient Cities of the New World, Being Voyages and Explorations in Mexico and Central America from 1857-1882.* Trans. J. Gonino and Helen S. Conant. London: Chapman, 1887.

Chávez, R. *Estudio geofísico de las cuevas y túneles de Teotihuacan.* Comunicaciones Técnicas, Serie Investigaciones 77, Mexico: Universidad Nacional Autónoma de México, 1988.

Chiu, Bella C., and Philip Morrison. "Astronomical Origin of the Offset Street Grid at Teotihuacan." *Archaeoastronomy,* Suppl. *Journal for the History of Astronomy* 2 (1980): S55-S64.

Coe, William R. "Cultural Contact between the Lowland Maya and Teotihuacan as Seen from Tikal, Petén, Guatemala." *XI Mesa Redonda* 2:257-271. Mexico: Sociedad Mexicana de Antropología, 1972.

Coggins, Clemency Chase. "Teotihuacan at Tikal in the Early Classic Period," *Actes* 8 (1979): 251-269. 42nd International Congress of Americanists, Paris, 1976.

_____. "An Instrument of Expansion: Monte Albán, Teotihuacan, and Tikal." In *Highland-Lowland Interaction in Mesoamerica: Interdisciplinary Approaches,* ed. A. G. Miller, 49-68. Washington, D.C.: Dumbarton Oaks, 1983.

Conides, Cynthia. "Craft Specialization and the Development of the Stuccoed Pottery Painting Tradition at Teotihuacan, Mexico." Paper presented at meeting, Society for American Archaeology, Pittsburgh, 8-12 April 1992.

Cook de Leonard, Carmen. "Ceramics of the Classic Period in Central Mexico." In *Handbook of Middle American Indians,* ed. Robert Wauchope. Vol.10, *Archaeology of Northern Mesoamerica,* ed. Gordon F. Ekholm and Ignacio Bernal, 179-205. Austin: University of Texas Press, 1971.

Covarrubias, Miguel. *Indian Art of Mexico and Central America.* New York: Knopf, 1957.

Cowgill, George L. "Quantitative Studies of Urbanization at Teotihuacan." *Mesoamerican Archaeology: New Approaches,* ed. Norman Hammond, 363-396. Austin: University of Texas Press, 1974.

_____. "Teotihuacan, Internal Militaristic Competition, and the Fall of the Classic Maya." In *Maya Archaeology and Ethnohistory,* 51-62. Cambridge Sympo-sium on Recent Research in Meso-american Archaeology, ed. Norman Hammond and Gordon R. Willey. Austin: University of Texas Press, 1979.

_____. "Rulership and the Ciudadela: Political Inferences from Teotihuacan Architecture." In *Civilization in the Ancient Americas: Essays in Honor of Gordon R. Willey,* ed. Richard M. Leventhal and Alan L. Kolata, 313-343. Cambridge: University of New Mexico Press and Peabody Museum of Archaeology and Ethnology, Harvard University, 1983.

_____. "Teotihuacan: Action and Meaning in Mesoamerica." Paper presented at meeting, Society for American Archaeology, Pittsburgh, 8-12 April 1992.

Crespo Oviedo, Ana María, and Alba Guadalupe Mastache de E. "La presencia en el área de Tula, Hidalgo, de grupos relacionados con el barrio de Oaxaca en Teotihuacan." In *Interaccion Cultural en México Central,* ed. Evelyn Childs Rattray, Jaime Litvak King, and Clara Díaz Oyarzabal, 99-106. Instituto de Investigaciones Antropológicas, Serie Antropológica 41. Mexico: Universidad Nacional Autónoma de México, 1981.

Díaz Oyarzabal, Clara Luz. "Chingú y la expansión teotihuacana." In *Interacción Cultural en México Central,* ed. Evelyn Childs Rattray, Jaime Litvak King, and Clara Díaz Oyarzabal, 107-112. Instituto de Investigaciones Antropológicas, Serie Antropológica 41. Mexico: Universidad Nacional Autónoma de México, 1981.

_____. *Cerámica de sitios con influencía teotihuacana.* Catálogo de las colecciones arqueológicas del Museo Nacional de Antropología. Mexico: INAH, 1991.

Diehl, Richard A. "A Shadow of Its Former Self: Teotihuacan during the Coyotlatelco Period." In *Mesoamerica after the Decline of Teotihuacan A.D. 700-900,* ed. Richard A. Diehl and Janet C. Berlo, 9-18. Washington, D.C.: Dumbarton Oaks, 1989.

Diehl, Richard A., and Janet Catherine Berlo, ed. *Mesoamerica after the Decline of Teotihuacan A.D. 700-900.* Washington, D.C.: Dumbarton Oaks, 1989.

Drennan, Robert D. and Judith H. Nowack. "El posible papel de Tehuacan en el desarrollo clásico del Valle de Teotihuacan." *XV Mesa Redonda* 2:351-358. Mexico: Sociedad Mexicana de Antropología, 1977.

Drennan, Robert D., Philip T. Fitzgibbons, and Heinz Dehn. "Imports and Exports in Classic Mesoamerican Political Economy: The Teotihuacan Valley and the Teotihuacan Obsidian Industry." *Research in Economic Anthropology* 12(1990):177-199.

Drewitt, Bruce. "Planeación en la antigua ciudad de Teotihuacan." *XI Mesa Redonda* 1:79-94. Mexico: Sociedad Mexicana de Antropología, 1966.

Drucker, R. David. "Renovating a Reconstruction: The Ciudadela at Teotihuacan, Mexico: Construction Sequence, Layout, and Possible Uses of the Structure." Ph.D. diss., University of Rochester, 1974.

_____. "A Solar Orientation Framework for Teotihuacan." *XV Mesa Redonda* 2:369-375. Mexico: Sociedad Mexicana de Antropología, 1977.

Edwards, Emily [text] and Manuel Alvarez Bravo [photos]. *Painted Walls of Mexico.* Austin: University of Texas Press, 1966.

Fisher, Leonard Everett. *Pyramid of the Sun, Pyramid of the Moon.* New York: MacMillan, 1988.

Florescano, Enrique. "La serpiente emplumada, Tlaloc, y Quetzalcoatl." *Cuadernos Americanos* 23(1964):121-166.

_____. "Tula-Teotihuacan, Quetzalcoatl y la Toltecayótl." *Historia Mexicana* 13(1963):193-234.

Folan, William J. "The Diffusion of Astronomical Knowledge in Greater Mesoamerica: The Teotihuacan-Cerrito de la Campana-Chalchihuites-Southwest Connection." *Archaeoastronomy Bulletin* 3, no. 3(1980):20-25.

Foncerrada de Molina, Marta. "Mural Painting in Cacaxtla and Teotihuacan Cosmopolitism." In *Third Palenque Round Table, 1978,* pt. 2, 5:183-198. Austin: University of Texas Press, 1980.

Furst, Peter R. "Morning Glory and Mother Goddess at Tepantitla, Teotihuacan: Iconography and Analogy in Pre-Columbian Art." In *Mesoamerican Archaeology: New Approaches,* ed. Norman Hammond, 187-215. London: Duckworth, 1974.

Gamio, Manuel. *La población del Valle de Teotihuacan.* 1922. Reprint. Mexico: Instituto Nacional Indigenista, 1979.

_____. "La dirección de antropología y la investigación en el Valle de Teotihuacan." In *La antropología social aplicada en México: Trayectoría y antología,* ed. Juan Comas, 89-103. Serie Antropología Social 1. Mexico: Instituto Indigenista Interamericana, 1964.

Hagar, Stansbury. *The Celestial Plan of Teotihuacan.* Mexico: Impreso del Museo Nacional de Arqueología, Historia y Etnología, 1912.

Hamy, E.T. "La croix de Teotihuacan au Musée du Trocadero." *Revue d'Ethnographie* 1 [Paris] (1882):410-428.

Harbottle, Garman. "Neutron Activation Analyses: Teotihuacan Trade Ceramics." *XV Mesa Redonda* 2:313-316. Mexico: Sociedad Mexicana de Antropología, 1977.

Hartung, Horst. "Relaciones urbanísticas lineales-visuales en Teotihuacan y su zona de influencia." *XV Mesa Redonda* 2:267-275. Mexico: Sociedad Mexicana de Antropología, 1977.

Hassig, Ross. *War and Society in Ancient Mesoamerica*. Berkeley: University of California Press, 1992.

Heizer, Robert Fleming, and Howel Williams. "Stones Used for Colossal Sculpture at or near Teotihuacan." In *Sources of Stones Used in Prehistoric Mesoamerican Sites*, 55-70. Berkeley: University of California Archaeological Research Facility, 1965.

Hellmuth, Nicholas M. *Teotihuacan Ceramic Art in the Department of Escuintla, Guatemala*. Guatemala City: Foundation for Latin American Anthropological Research, 1973.

_____. "The Escuintla Hoards: Teotihuacan Art at Guatemala." *F.L.A.A.R. Progress Reports* 1, no. 2 (June 1975): 1-58.

Heyden, Doris. "Los espacios sagrados en Teotihuacan." *XIII Mesa Redonda* 5:267-279. Mexico: Sociedad Mexicana de Antropología, 1975a.

_____. "An Interpretation of the Cave underneath the Pyramid of the Sun in Teotihuacan, Mexico." *American Antiquity* 40, no. 2 (1975b): 131-147.

_____. "Caves, Gods, and Myths: World View and Planning in Teotihuacan." In *Mesoamerican Sites and World Views*, ed. Elizabeth P. Benson, 1-39. Washington, D.C.: Dumbarton Oaks, 1981.

Heyden, Doris, and Paul Gendrop. *Pre-Columbian Architecture of Mesoamerica*. New York: Abrams, 1975; New York: Electa/Rizzoli, 1988 (1980).

Jiménez Moreno, Wigberto. "Tula y los Toltecas según las fuentes históricas." *Revista Mexicana de Estudios Antropológicos* 5(1941):2-3, 79-83.

_____. "Mesoamerica before the Toltecs." In *Ancient Oaxaca*, ed. John Paddock, 1-82. Stanford: Stanford University Press, 1966.

Kidder, Alfred V., Jesse D. Jennings, and Edwin M. Shook. *Examinations at Kaminaljuyú, Guatemala*. Carnegie Institution of Washington, no. 561. Washington, D.C., 1946.

Kolb, Charles C. "Marine Shell Trade and Classic Teotihuacan, Mexico." Oxford: B.A.R. International Series 364, 1987.

_____. "The Cultural Ecology of Classic Teotihuacan Period Copoid Ceramics." In *A Pot for all Reasons: Ceramic Ecology Revisited*, ed. Charles C. Kolb and Lewana Lackey, 147-197. Philadelphia: Temple University, Laboratory of Anthropology, 1988.

Kovar, Anton J. "Problems in Radiocarbon Dating at Teotihuacan." *American Antiquity* 31, no. 3, pt. 1 (1966):427-430.

Krotser, Paula Homberger, and Evelyn Rattray. "Manufactura y distribución de tres grupos cerámicos de Teotihuacan." *Anales de Antropología* 17, no. 1, 91-104. Mexico: Universidad Nacional Autónoma de México, 1980.

Kubler, George. *The Art and Architecture of Ancient America: The Mexican, Maya, and Andean Peoples*. Baltimore: Penguin Books, 1962.

_____. "The Iconography of the Art of Teotihuacan." In *Studies in Pre-Columbian Art and Archaeology*, no. 4, Washington, D.C.: Dumbarton Oaks, 1967.

LaGamma, Alisa. "A Visual Sonata at Teotihuacan." *Ancient Mesoamerica* 2, no. 2 (1991): 275-284.

Langley, James C. *Symbolic Notation of Teotihuacan: Elements of Writing in a Mesoamerican Culture of the Classic Period*. Oxford: B.A.R. International Series 313, 1986.

_____. "The Forms and Usage of Notation at Teotihuacan." *Ancient Mesoamerica* 2(1991):285-298.

_____. "Teotihuacan Sign Clusters: Emblem or Articulation?" In *Art, Ideology, and the City of Teotihuacan*, ed. Janet C. Berlo, 247-280. Washington, D.C.: Dumbarton Oaks, 1992.

León-Portilla, Miguel. "De Teotihuacan a los Aztecas: Antología de fuentes e interpretaciones históricas." Mexico: Instituto de Investigaciones Históricas, Universidad Nacional Autónoma de México, Lecturas Universitarias 11, 1971.

Linné, Sigvald. *Archaeological Researches at Teotihuacan, Mexico*. The Ethnographical Museum of Sweden, n.s.1. Stockholm, 1934.

_____. *Mexican Highland Cultures: Archaeological Researches at Teotihuacan, Calpulalpan, and Chalchicomula in 1934-35*. The Ethnographical Museum of Sweden, n.s. 7. Stockholm, 1942.

López-Austin, Alfredo, Leonardo López Luján, and Saburo Sugiyama. "The Temple of Quetzalcoatl at Teotihuacan: Its Possible Ideological Significance." *Ancient Mesoamerica* 2(1991): 93-105.

López Luján, Leonardo. "La recuperación mexica del pasado teotihuacano." *Proyecto Templo Mayor*. Mexico: INAH, 1989.

Lorenzo, José Luis. "Clima y agricultura en Teotihuacan." In *Materials para la arqueología de Teotihuacan, 51-72*.

_____, ed. *Materials para la arqueología de Teotihuacan*. Serie Investigaciones 17. Mexico: INAH, 1968.

Manzanilla, Linda. "Sector noroeste de Teotihuacan: Estudio de un conjunto residencial y rastreo de tuneles y cuevas." In *La epoca clásica: Nuevos hallazgos, nuevas ideas*, ed. Amalia Cardós de Mendez, 81-88. Mexico: INAH, Museo Nacional de Antropología, 1990.

_____. "The Economic Organization of the Teotihuacan Priesthood: Hypotheses and Considerations." In *Art, Ideology, and the City of Teotihuacan*, ed. Janet C. Berlo, 321-338. Washington, D.C.: Dumbarton Oaks, 1993.

Manzanilla, Linda, and Luis Alberto Barba Pingarón. "The Study of Activities in Classic Households: Two Case Studies from Cobá and Teotihuacan." *Ancient Mesoamerica* 1, no.1(1990): 41-49.

Manzanilla, Linda, and Emilie Carreón. "Incensario teotihuacano en contexto doméstico: Restauración e interpretación." *Antropológicas* no. 4:5-18. Mexico: Universidad Nacional Autónoma de México, 1989.

_____. "A Teotihuacan Censer in a Residential Context: An Interpretation." *Ancient Mesoamerica* 2, no. 2 (1991):299-307.

Marcus, Joyce. "Teotihuacan Visitors on Monte Albán Monuments and Murals." In *The Cloud People: Divergent Evolution of the Zapotec and Mixtec Civilizations*, eds. Kent V. Flannery and Joyce Marcus, 175-181. New York: Academic Press, 1983.

Margáin, Carlos R. "Sobre sistemas y materiales de construcción en Teotihuacan." *XI Mesa Redonda* 1:157-211. Mexico: Sociedad Mexicana de Antropología, 1966.

Marquina, Ignacio. *Arquitectura prehispánica*. 2d ed. rev. Mexico: INAH, 1964.

Matos Moctezuma, Eduardo. "Teotihuacan: Excavaciones en la Calle de los Muertos (1964)." *Anales de Antropología* 17, no.1:6-90. Mexico: Universidad Nacional Autónoma de México, 1980.

_____. *Cacaxtla*. Photos, Rafael Doniz. Mexico: Citicorp, 1988.

_____. *Teotihuacan, the City of the Gods*. Trans. Andrew Ellis. New York: Rizzoli, 1990.

_____. *Teotihuacan y Tenochtitlan: Cinco ensayos acerca de los Mexicas*. Mexico: García Valadés Editores, in press.

McBride, Harold W. "Cerámica de estilo teotihuacano en Colima." *Anales de Antropología* 4, no.52:37-44. Mexico: INAH, 1972-1973.

McClung de Tapia, Emily. "Recientes estudios paleoetnobotánicos en Teotihuacan, México." *Anales de Antropología* 14:4-61. Mexico: Universidad Nacional Autónoma de México, 1977.

_____." Plants and Subsistence in the Teotihuacan Valley, A.D. 100-750." Ph.D. diss., Brandeis University, Waltham, Mass., 1979.

McClung de Tapia, Emily, and Evelyn C. Rattray, ed. *Teotihuacan: Nuevos datos, nuevas síntesis, nuevos problemas.* Instituto de Investigaciones Antropológicas. Mexico: Universidad Nacional Autónoma de México, 1987.

Miller, Arthur G. *The Mural Painting of Teotihuacan.* Washington, D.C.: Dumbarton Oaks, 1973.

[Millon], Clara Hall. "A Chronological Study of the Mural Art of Teotihuacan." Ph.D. diss., University of California, Berkeley, 1962.

Millon, Clara. "The History of Mural Art at Teotihuacan." *Teotihuacan: XI Mesa Redonda* 2:1-16. Mexico: Sociedad Mexicana de Antropología, 1972.

_____. "Painting, Writing, and Polity in Teotihuacan, Mexico." *American Antiquity* 38, no. 3(July 1973): 294-314.

_____. "A Reexamination of the Teotihuacan Tassel Headdress Insignia," 114-134. In Berrin, Kathleen, ed. *Feathered Serpents and Flowering Trees: Reconstructing the Murals of Teotihuacan.* San Francisco: The Fine Arts Museum of San Francisco, 1988.

Millon, René. "Irrigation at Teotihuacan." *American Antiquity* 20 (1954):177-180.

_____. "The Northwestern Boundary of Teotihuacan: A Major Urban Zone." *Homenaje a Pablo Martínez del Rio.* INAH (1961):311-318.

_____. "Urna de Monte Albán IIIA encontrada en Teotihuacan." *Boletín* 29:42-44. Mexico: INAH, 1967.

_____. "Teotihuacan: City and Region as Sources of Transformation." *Atti del XL Congreso Internazionale degli Americanisti* 4(1975):119-123.

_____. *Urbanization at Teotihuacan, Mexico.* Vol. 1, *The Teotihuacan Map.* Part 1: *Text.* Austin: University of Texas Press, 1973.

_____. "Social Relations in Ancient Teotihuacan." In *The Valley of Mexico: Studies in Pre-Hispanic Ecology and Society*, ed. Eric R. Wolf, 205-248. Albuquerque: University of New Mexico Press, 1976.

_____. "Teotihuacan: City, State, and Civilization." In *Archaeology, Supplement to the Handbook of Middle American Indians. Vol. 1*, eds. Victoria R. Bricker and Jeremy A. Sabloff, 198-243. Austin: University of Texas Press, 1981.

_____." The Last Years of Teotihuacan Dominance." In *The Collapse of Ancient States and Civilizations*, eds. Norman Yoffee and George L. Cowgill, 102-164. Tucson: University of Arizona Press, 1988a.

_____. "Where *Do* They All Come From? The Provenance of the Wagner Murals from Teotihuacan," 78-113. In Berrin, Kathleen, ed. *Feathered Serpents and Flowering Trees: Reconstructing the Murals of Teotihuacan.* San Francisco: The Fine Arts Museum of San Francisco, 1988b.

_____. "Teotihuacan Residential Architecture." Paper presented at meeting, Society for American Archaeology, Pittsburgh, 8-12, April 1992a.

_____. "Teotihuacan Studies: From 1950 to 1990 and Beyond." In *Art, Ideology, and the City of Teotihuacan*, ed. Janet C. Berlo, 339-429. Washington D. C.: Dumbarton Oaks, 1992b.

Millon, René, and James A. Bennyhoff. "A Long Architectural Sequence at Teotihuacan." *American Antiquity* 26, no. 4(1961):516-523.

Millon, René, and Bruce Drewitt. "Earlier Structures within the Pyramid of the Sun at Teotihuacan." *American Antiquity* 26, no. 3, pt. 1(1961):371-380.

Millon, René, Bruce Drewitt, and James A. Bennyhoff. "The Pyramid of the Sun at Teotihuacan: 1959 Investigations." *Transactions of the American Philosophical Society*, n.s. 55, pt. 6. Philadelphia, 1965.

Millon, René, Bruce Drewitt, and George L. Cowgill. *Urbanization at Teotihuacan, Mexico.* Vol. 1, *The Teotihuacan Map.* Part 2: *Maps.* Austin: University of Texas Press, 1973.

Monzón, Martha. *Casas prehispánicas en Teotihuacan.* Toluca: Instituto Mexiquense de Cultura, 1989.

Moore, Frank W. "An Excavation at Tetitla, Teotihuacan." *Mesoamerican Notes* 7-8(1966):69-85.

Müller, Florencia. "La periodificación del material lítico de Teotihuacan." *XI Mesa Redonda*: 219-223. Mexico: Sociedad Mexicana de Antropología, 1966.

_____. "Secuencia cerámica de Teotihuacan" *XI Mesa Redonda* 1:31-44. Mexico: Sociedad Mexicana de Antropología, 1966.

_____. *La cerámica del centro ceremonial de Teotihuacan.* Mexico: SEP, INAH, 1978.

Nichols, Deborah L., Michael W. Spence and Mark D. Borland. "Watering the Fields of Teotihuacan: Early Irrigation at the Ancient City." *Ancient Mesoamerica* 2, no.1(1991):119-129.

Ostrowitz, Judith. "Second Nature: Concentric Structures and Gravity as Represented in Teotihuacan Art." *Ancient Mesoamerica* 2, no. 2(1991):263-274.

Paddock, John. "Distribución de rasgos teotihuacanos en Mesoamérica." *XI Mesa Redonda* 2: 223-239. Mexico: Sociedad Mexicana de Antropología, 1972.

Parsons, Mary Hrones. "Spindle Whorls from the Teotihuacan Valley." *Anthropological Papers* 45:45-80. Ann Arbor: University of.Michigan Museum of Anthropology, 1972.

Pasztory, Esther. "The Gods of Teotihuacan: A Synthetic Approach in Teotihuacan Iconography." In *Atti del XL Congreso Internazionale degli Americanisti* 1(1973):147-159.

_____. "The Iconography of the Teotihuacan Tlaloc." *Studies in Pre-Columbian Art and Archaeology*, no.15. Washington, D.C.: Dumbarton Oaks, 1974.

_____. *The Murals of Tepantitla, Teotihuacan.* New York: Garland, 1976.

_____, ed. *Middle Classic Mesoamerica: A.D.400-700.* New York: Columbia University Press, 1978.

_____. *Aztec Art.* New York: Abrams, 1983.

_____. "Participation and Hierarchy: The Structure of the Teotihuacan Composite Censer." Paper presented at meeting, Society for American Archaeology, New Orleans, April 1986.

_____. "A Reinterpretation of Teotihuacan and its Mural Painting Tradition," 45-77. In Berrin, Kathleen, ed. *Feathered Serpents and Flowering Trees: Reconstructing the Murals of Teotihuacan.* San Francisco: The Fine Arts Museum of San Francisco, 1988.

_____. "Still Invisible: The Problem of the Aesthetics of Abstraction for Pre-Columbian Art and Its Implications for Other Cultures." *RES: Anthropology and Aesthetics* (1990-1991):105-136.

_____. "Strategies of Organization in Teotihuacan." *Ancient Mesoamerica* 2, no.2(1991):247-248.

_____. "Body Parts: Social and Religious Ideology at Teotihuacan." Paper presented at meeting, Society for American Archaeology, Pittsburgh, 8-12 April 1992a.

_____. "Abstraction and the Rise of a Utopian State at Teotihuacan." In *Art, Ideology, and the City of Teotihuacan*, ed. Janet C. Berlo, 281-320. Washington, D.C.: Dumbarton Oaks, 1992b.

_____. *Teotihuacan: An Experiment in Living.* Norman: University of Oklahoma Press, in press.

Pendergast, David M. "Evidence of Early Teotihuacan-Lowland Maya Contact at Altún Ha." *American Antiquity* 36, no.4(1971):455-460.

Price, Barbara J. "Teotihuacan as World System: Concerning the Applicability of Wallerstein's Model." *Origen y Formación del Estado en Mesoamérica*, ed. Andrés Medina, Alfredo López-Austin, Mari Carmen Serra Puche. Instituto de Investigaciones Antropológicas, Serie Antropológica 66. Mexico: Universidad Nacional Autónoma de México, 1986.

Quirarte, Jacinto. "Izapan and Mayan Traits in Teotihuacan III Pottery." *University of California. Archaeological Research Facility Contributions* 18(1973): 11-29. Berkeley.

_____. "Maya and Teotihuacan Traits in the Classic Maya Vase Painting of the Petén." In *Cultural Continuity in Mesoamerica*, 289-302. The Hague: Mouton, 1978.

Ramírez, José Fernando. *Historia del señorío de Teotihuacan*. Mexico: Vargas Rea, 1948.

Rattray, Evelyn Childs. "The Teotihuacan Ceramic Chronology: Early Tzacualli to Early Tlamimilolpa Phases." Ph.D. diss., University of Missouri, Columbia, 1973.

_____. "Anaranjado delgado: Cerámica de comercio de Teotihuacan." In *Interacción Cultural en México Central*, ed. Evelyn Childs Rattray, Jaime Litvak King, and Clara Díaz Oyarzabal, 55-80. Instituto de Investigaciones Antropológicas, Serie Antropológica 41. Mexico: Universidad Nacional Autónoma de México, 1981.

_____. "Los barrios foráneos de Teotihuacan." In *Nuevos datos, nuevas síntesis, nuevos problemas*, ed. Emily McClung de Tapia and Evelyn C. Rattray. Instituto de Investigaciones Antropológicas, Serie Antropológica 72:243-273. Mexico: Universidad Nacional Autónoma de México, 1987.

_____. "La Cerámica de Teotihuacan: Relaciones externas y cronología." *Anales de Antropología* 15. Mexico: Universidad Nacional Autónoma de México, 1987.

_____. "Nuevas interpretaciones en torno al barrio de los comerciantes." *Anales de Antropología* 25:165-180. Mexico: Univeridad Nacional Autónoma de México, 1988.

_____. "Un taller de cerámica anaranjado San Martín en Teotihuacan." *Ensayos de alfarería prehispánica e histórica de Mesoamérica: Homenaje a Eduardo Noguera Auza*, ed. Mari Carmen Serra Puche and Carlos Navarrete Cáceres, 249-266. Instituto de Investigaciones Antropológicas, Serie Antropológica 82. Mexico: Universidad Nacional Autónoma de Mexico, 1988.

_____. "El barrio de los comerciantes y el conjunto Tlamimilolpa: Un estudio comparativo." *Arqueología* 5(1989):105-129.

_____. "New Findings on the Origins of Thin Orange Ceramics." *Ancient Mesoamerica* (1990): 181-195.

Rattray, Evelyn Childs, and María Elena Ruiz A. "Interpretaciones culturales de La Ventilla, Teotihuacan." *Anales de Antropología* 17, no.1(1980):105-114.

Rubín de la Borbolla, Daniel F. "Teotihuacan: Ofrendas de los Templos de Quetzalcoatl." *Anales del INAH* 6, no. 2(1947):61-72.

Ruiz, Sonia L. de. *La Ciudadela: Ideología y estilo en la arquitectúra del siglo XVIII*. Mexico: INAH, Departamento de Investigaciones Históricas, 1976.

Ruggles, C. L. N. and J. J. Saunders. "Interpretation of the Pecked Cross Symbols at Teotihuacan: A Methodological Note." *Archaeoastronomy* 7 (1984): 101-110.

Salazar Ortegón, Ponciano. "Maqueta prehispánica Teotihuacan." *Boletín* 23:4-11. Mexico: INAH, 1966.

_____. "Interpretación del altar central de Tetitla, Teotihuacan." *Boletín* 24:41-47. Mexico: INAH, 1966.

Sanders, William T. *The Cultural Ecology of the Teotihuacan Valley*. University Park: Pennsylvania State University, Department of Sociology and Anthropology, 1965.

Sanders, William T. and Joseph W. Michels, eds. *Teotihuacan and Kaminaljuyú: A Study in Prehistoric Culture Contact*. Monograph series on Kaminaljuyú. University Park: Pennsylvania State University Press, 1977.

_____. "Ethnographic Analogy and the Teotihuacan Horizon Style." In *Middle Classic Mesoamerica: A.D.400-700*, ed. Esther Pasztory, 35-44. New York: Columbia University Press, 1978.

Sanders, William T., Jeffrey R. Parsons, and Robert S. Santley. *The Basin of Mexico: Ecological Processes in the Evolution of a Civilization*. New York: Academic Press, 1979.

Santley, Robert S. "Obsidian Working, Long Distance Exchange and the Teotihuacan Presence on the South Gulf Coast." In *Mesoamerica after the Decline of Teotihuacan A.D. 700-900*, ed. Richard. A. Diehl and Janet C. Berlo, 131-151. Washington, D.C.: Dumbarton Oaks, 1989.

Sarro, Patricia Jan. "The Role of Architectural Sculpture in Ritual Space at Teotihuacan, Mexico." *Ancient Mesoamerica* 2:(1991): 249-262.

Schávelzon, Daniel. "Primera excavación arqueológica de América: Teotihuacan en 1675." *Anales de Antropología* 20, no.1(1983):121-134.

Séjourné, Laurette. *Un palacio en la ciudad de los dioses, Exploraciones en Teotihuacan 1955-58*. Mexico: INAH, 1959.

_____. *Burning Water: Thought and Religion in Ancient Mexico*. New York: Grove Press, 1960 (London: Thames and Hudson, 1956).

_____. "Interpretación de un jeroglífico teotihuacano." *Cuadernos Americanos* 124, no.5(1962):137-158.

_____. "El Quetzalcoatl en Teotihuacan." *Cuadernos Americanos* 138, no.1(1965): 131-158.

_____. *Arqueología de Teotihuacan: La cerámica*. Mexico: Fondo de Cultura Económica, 1966a. 1984.

_____. *Arquitectura y pintura en Teotihuacan*. Mexico: Siglo XXI Editores, 1966b.

_____. *El lenguaje de las formas en Teotihuacan*. Mexico: Gabriel Mancera 65, 1966c.

_____. *Teotihuacan, métropole de l'Amérique*. Paris: Maspero, 1969.

Seler, Eduard, "Similarity of Design of Some Teotihuacan Frescoes and Certain Mexican Pottery Objects." *Acts of the 18th International Congress of Americanists*. London, 1912.

_____. *Gesammelte Abhandlungen zur Americanische Sprach-und Alterthumskunde*. Facsimile edition, 5 vols. Graz, Austria: Akademische Druck-und Verlangsanstalt, 1960-1961 (1902-1923).

_____. "Die Teotiuacan-Kultur des Hochlandes von Mexiko." In *Gesammelte Abhandlungen*, 5:405-585. Graz, Austria: Akademische Druck-und Verlagsanstalt, 1960-1961.

Senter, Donovan. "Algunas semejanzas entre Xochicalco y Teotihuacan." In *Interacción Cultural en México Central*, ed. Evelyn Childs Rattray, Jaime Litvak King, and Clara Díaz Oyarzabal, 149-158. Instituto de Investigaciones Antropológicas, Serie Antropológica 41. Mexico: Universidad Nacional Autónoma de México, 1981.

Smith, Robert Eliot. *A Ceramic Sequence from the Pyramid of the Sun, Teotihuacan, Mexico*. Papers of the Peabody Museum of Archaeology and Ethnology, Harvard University, vol. 75. 1987.

Soustelle, Jacques. "Observations sur quelques signes de calendrier dans

l'iconographie de Teotihuacan." In *Circumpacifica, Band 1. Mittel und SudAmerika, Festschrift für Thomas S. Barthel*, ed. Bruno Illius and Mattius Laubscher, 397-400. Frankfurt: Peter Lang, 1990.

Spence, Michael W. "The Obsidian Industry of Teotihuacan." *American Antiquity* 32, no.4(1967):507-514.

_____. "Residential Practices and the Distribution of Skeletal Traits in Teotihuacan, Mexico." *Man* [London], n.s.9, no.3(1974):262-272.

_____. "Obsidian Production and the State in Teotihuacan." *American Antiquity* 46, no.4(October 1981):769-788.

_____. "Excavaciones recientes en Tlailotlaca[n]: El barrio oaxaqueño de Teotihuacan." *Arqueología* 5(1989): 81-104.

_____. "Tlailotlacan, Zapotec Enclave at Teotihuacan." In *Art, Ideology, and the City of Teotihuacan*, ed. Janet C. Berlo, 59-88. Washington, D.C.: Dumbarton Oaks, 1992.

Stone, Andrea. "Disconnection, Foreign Insignia and Political Expansion: Teotihuacan and the Warrior Stelae of Piedras Negras." In *Mesoamerica after the Decline of Teotihuacan A.D.700-900*, ed. Richard A. Diehl and Janet C. Berlo, 153-172. Washington D.C.: Dumbarton Oaks, 1989.

Storey, Rebecca. "An Estimate of Mortality in a Pre-Columbian Urban Population." *American Anthropologist* 87, no.3(September 1985):519-535.

_____. "Residential Compound Organization and the Evolution of the Teotihuacan State." *Ancient Mesoamerica* 2, no.1(1991):107-118.

_____. *Life and Death in the Ancient City of Teotihuacan: A Modern Paleodemographic Synthesis.* Tuscaloosa: University of Alabama Press, 1992.

Storey, Rebecca, and Randolph J. Widmer. "Household and Community Structure of a Teotihuacan Apartment Compound: S3W1:33 of the Tlajinga Barrio." In *Households and Communities*, Proceedings of the 21st Annual Chacmool Conference, ed. Scott MacEachern, David J. W. Archer, and Richard D. Garvin, 407-415. Calgary: Archaeological Association of the University of Calgary, 1989.

Sugiyama, Saburo. "Burials Dedicated to the Old Temple of Quetzalcoatl at Teotihuacan, Mexico." *American Antiquity* 54, no.1 (January 1989a): 85-106.

_____. "Iconographic Interpretation of the Temple of Quetzalcoatl at Teotihuacan." *Mexicon* [Berlin] 11, no.4(1989b): 68-74.

_____. "Rulership, Warfare, and Human Sacrifice at the Ciudadela: An Iconographic Study of Feathered Serpent Representations." In *Art, Ideology, and the City of Teotihuacan*, ed. Janet C. Berlo, 205-230. Washington, D.C.: Dumbarton Oaks, 1992.

Taube, Karl A. "The Teotihuacan Spider Woman." *Journal of Latin American Lore* 9, no.2(Spring 1983):107-189.

_____. "The Teotihuacan Cave of Origin: The Iconography and Architecture of Emergence Mythology in Mesoamerica and the American Southwest." *RES: Anthropology and Aesthetics* 12(1986): 51-82.

_____. "The Temple of Quetzalcoatl and the Cult of Sacred War at Teotihuacan," *RES: Anthropology and Aesthetics* 21 (1992a): 53-87.

_____. "The Iconography of Mirrors at Teotihuacan." In *Art, Ideology, and the City of Teotihuacan*, ed. Janet C. Berlo, 169-204. Washington, D.C.: Dumbarton Oaks, 1992b.

Tobriner, Stephen. "The Fertile Mountain: An Investigation of Cerro Gordo's Importance to the Town Plan and Iconography of Teotihuacan." *XI Mesa Redonda* 2:103-115. Mexico: Sociedad Mexicana de Antropología, 1972.

Toscano, S. *Arte precolombino de México y de la América Central.* Mexico: Instituto de Investigaciones Estéticas. Mexico: Universidad Nacional Autónoma de México, 1944. 2d ed., 1951.

Umberger, Emily. "Antiques, Revivals, and References to the Past in Aztec Art." *RES: Anthropology and Aesthetics* 13(1987a):63-106.

_____. "Events Commemorated by Date Plaques at the Templo Mayor: Further Thoughts on the Solar Metaphor." In *The Aztec Templo Mayor*, ed. E. H. Boone, 411-449. Washington, D. C.: Dumbarton Oaks, 1987b.

Villagra Caleti, Agustín. "Mural Painting in Central Mexico," *Handbook of Middle American Indians*, ed. Robert Wauchope. Vol.10, *Archaeology of Northern Mesoamerica*, ed. Gordon F. Ekholm and Ignacio Bernal, 135-156. Austin: University of Texas Press, 1971.

Von Winning, Hasso. "The Teotihuacan Owl-and-Weapon Symbol and Its Association with 'Serpent Head X' at Kaminaljuyú." *American Antiquity* 14, no. 2(October 1948):129-132.

_____. "Los incensarios teotihuacanos y los del litoral pacífico de Guatemala: Su iconografía y función ritual." *XV Mesa Redonda* 2:327-334. Mexico: Sociedad Mexicana de Antropología, 1977.

_____. "Teotihuacan Symbols: The Fire God Complex." 42nd International Congress of Americanists, Paris. *Sociétè des Americanistes* 7 (1979): 425-437.

_____. "An Iconographic Link between Teotihuacan and Palenque." *Mexicon* [Berlin] 3, no. 2 (1981): 30-32.

_____. *La iconografía de Teotihuacan: Los dioses y los signos.* 2 vols. Mexico: Universidad Nacional Autónoma de México, 1987.

Wallrath, Matthew. "The Calle de los Muertos Complex: A Possible Macrocomplex of Structures near the Center of Teotihuacan." *XI Mesa Redonda* 1:113-122. Mexico: Sociedad Mexicana de Antropologia, 1966.

Wicke, C.R. "Los murales de Tepantitla y el arte campesino." *INAH Anales* 8(1954):117-122.

Widmer, Randolph J. "Lapidary Craft Specialization at Teotihuacan: Implications for Community Structure at 33:S3W1 and Economic Organization in the City." *Ancient Mesoamerica* 2, no.1(1991): 131-147.

Wiercinski, Andrzej. "Time and Space in the Sun Pyramid from Teotihuacan." *Polska Akademia Nauk, Komizja Archaeologiczna Prace* [Krakow], no.16(1977):87-104.

_____. "Canon of the Human Body, Mexican Measures of Length and the Pyramid of Quetzalcoatl from Teotihuacan." *Polska Akademia Nauk, Komisja Archaeologiczna Prace* [Krakow] no. 19(1980):103-123.

Winter, Marcus C. "El impacto teotihuacano y procesos de cambio en Oaxaca." *XV Mesa Redonda* 2:359-367. Mexico: Sociedad Mexicana de Antropología, 1977.

Wolfe, Elizabeth Farkas. "Pictorial Traditions of Teotihuacan: Their Code and Meaning." Ph.D. diss., University of California, Berkeley, 1990.

Young-Sánchez, Margaret. "Veneration of the Dead: Religious Ritual on a Pre-Columbian Mirror-Back." *The Bulletin of the Cleveland Museum of Art* 77 (November 1990): 326-361.

Index

Works illustrated are indicated by italic figures

sculpture of, *171* (cat. no. 5), 171

Storm God Mural (cat. no. 39), *194*, 195

vessels, 50, 53, 112, 163-164, 216, 236, *240-242* (cat. nos. 115-119), 241, 242, 250, 278

Street of the Dead, 18, 19, 25, 29, 33, 34ns 4 and 6, *64*, 70, 72, 77, 118, 120, 160, 176, 184

orientation of, 20, 49

name of, 34n4, 66, 159

Street of the Dead Complex, 19, 36n9, 72, 170

political significance of, 38n22

Stuccoed and painted vessels, 82, *83* (cat. no. 138), 84, 86, 112, 129, *130*, 131, *138* (cat. no. 143), 142, 145, *147*, 147, 149, 151, *166* (cat. no. 137), *252-257* (cat. nos. 136-147), 252-256

lustrous ware, *256-257* (cat. nos. 145-146), 256

Talud-tablero, 25, 30, 42n50, 75, 144, 160, 163, *169* (cat. no. 2), 169, *264* (cat. no. 159), 264

as conceptual expression, 23, 59, 142

as distinctive form, 28, 36n11, 145, 149, 150, 152, 160

instability of, 86, 142

represented in art, 216, *267* (cat. nos. 165-167), 267

Tassel headdress

abroad, 39n29, 145, 150

shown worn by deities or people of rank, 39n29, 50, 57-58, 131-132, 147, 199, *249* (cat. no. 132), 249, *253* (cat. no. 140), 253, 270, 271

Tassel Headdress Figure murals, 57, 135, *140* (cat. no. 44), *198-199* (cat. nos. 43-45), 199

Techinantitla, 19, 31, 150

murals in, 55, 196, 199, 200, 202, 203, 247

Temple of the Feathered Serpent, *back cover*, 20, 25, 26, 34n6, 37n14, 41n50, 50, *52*, 101-106, *102*, *103*, *105*, 114, 142, *143*, 143, 144-145, 146, 149, 182, 269, 271 . *See* Architecture, *adosada* platform

sculpture of, 51, 60, 76, *79* (cat. no. 3), 169

burial at, 37n19, 51, *103*, 104

Tenochtitlan (Templo Mayor), 156-165, 184, 277

Teopancaxco, 19, 95

Teotihuacan. *See also* Architecture; Art; Maps

Aztecs, contrast with, 46, 49, 53, 54, 76, 112, 129, 131, 134, 175, 202, 220, 242

Aztec veneration of, 33, 277-278, *277-278* (cat. nos. 185-187). *See* Tenochtitlan

cult of war-and-sacrifice, 17, 25, 27, 28, 31, 34n3, 37n14, 37n17, 41n50

astronomic orientation of, 34n7,

39n31, 45, 49, 107, 142, 152

calendric associations or system, 107, 137, 138, 141-155, 168, 205

counting system, 137, 138, 144

early settlement, 19, 46-47, 124, 142

destruction of, 32-33, 34n3, 62, 137, 153, 177

economy, 17, 26, 32

and contemporaries, 270-276, *270-276* (cat. nos. 174-184): Bécan, 145; Belize, 39n28, 145; Chupícuaro, 70; Cholula (Puebla), 243, 253, 258, 264, 266; Copán, 149, 152; El Tajín, 150, 256; Escuintla, 28; Guanajuato, 70; Guatemala, 210; the Gulf Coast, 68, 123; Jalisco, 70; Kaminaljuyú, 28, 146, 149, 150, 152, 183; the Maya, 17, 68, 118; Michoacán, 70, 210; Monte Albán (Oaxaca), 40n40, 46, 50, 68, 122, 143, 146, *148*, 150, 151, 152, 264, 266; the Pacific Coast, 145, 146; Tikal, 28, 42n52, 145, *146*, 146, 147-148, 149, 150, 152, 229; Uaxactún, 146, 149, 152; Veracruz, 28, 30, 39n28, 118, 150, 264, 266; Yucatán, 28, 210; Zacatecas, 70; the Zapotec, 137. *See also* Merchants' Barrio, Oaxaca Barrio

living conditions in, 30, 62

military, 26, 27, 28, 29, 32, 38n23, 47, 101, 106, 114, 131, 143, 144-145, 147-148, 149, 171, 199, 229

name of, 34n4, 65, 158

origin or creation myth, 17, 23, 24, 34n6, 41n50, 47, 49, 143-144

political activity or system, 26, 28, 52, 114, 202

population concentration in, 18, 24, 32, 38n19, 40n33

religion, 22, 23, 26, 31, 41n50, 42n52, 47, 50, 130, 142, 145, 149, 151. *See* Sacred Round

social organization in, 29, 40n32, 42n52, 47, 52, 53, 62, 112, 114, 123, 124, 199

studies of, 65-73, 117-125, 130. *See* Leopoldo Batres, Manuel Gamio

Toltec veneration of, 33, 137

trade, 28, 32, 34n3, 46, 122, 137, 141, 152, 258, 268, 270

Valley of, 20, 23, 30, 31, 67, 71, 94, 142

writing, lack of, 46, 129, 137, 250

Teotihuacan Archaeological Project, 72, 95, 111

Teotihuacan Mapping Project, 19, 22, 50, 71, 117, 119-120, 121, 123

Tepantitla, 19, 31, 34n6, 91

murals of, 55, *56*, *57*, 72, *78*, 138, 274

Tetitla, 19, 31, 91, 96, 112, 216, 218, 220, 243, 252, 259

murals of, *57*, 71, 91, 110, 135, 151, 196

Textiles, 31, 85, 105, 176, 179, 180, 211, 216. *See also* Crafts and workshops

Thin Orange ware, 28, 59, 82-84, 87n8, *88* (cat. no. 160), *108 113* (cat. no. 163), 111, *112*, 250, *253* (cat. no. 139), 253,

258-266 (cat. nos. 148-164), 258-260, 262, 264, 266

Three-temple complexes. *See* Architecture

Tikal. *See* Teotihuacan and contemporaries

Tlacuilapaxco, 19, 197

Tlajinga, 18, 91, 92, 93, 95, 96, 110, 111, 112, 114, 211, 214, 215

Tlaloc. *See* Storm God

Tlamimilolpa, 91, 96, 98, 219, 220, 249

murals in, 53

Tlaxcala, 174, 214, 262

Toltecs, 76, 158, 160, 164, 277

Tools and implements, 95, *123*, *206-207* (cat. nos. 56-58), 206-207. *See* Molds

Tripod vessels. *See* Stuccoed and painted vessels

La **V**entilla, 19, 71, 76, 91, *110*, 111, 112, 113, 114, 218, 243

Veracruz. *See* Teotihuacan and contemporaries

Water God, 195

Wide-band headdress figurines. *See* Figurines

Wooden objects, *84*, 85, 105, *105*, 193, *206* (cat. nos. 54-55), 206

Xolalapan, 19, 91, *92*, 93, 94, 96, 112, 114, 149, 151, 249, 250

Yayahuala, 19, 71, 110, 112, 123

Yucatán. *See* Teotihuacan and contemporaries

Zacuala Palace or Patios, 19, 31, 71, 91, 110, 195

Zapotec. *See* Teotihuacan and contemporaries

Photography Credits

IN THE CATALOGUE OF OBJECTS:

Michel Zabé photographed the following: 2, 6-8, 12, 14-15, 21, 24, 53, 56, 59, 61, 68-69, 71, 77-78, 96, 110, 118, 125-126, 128, 135-137, 144, 148-150, 168-170, and 172a-176. Lloyd Rule: 11, 41, 55, 58, 109, and 178-180. Mario Carrieri, courtesy Olivetti, the following: 1, 5, 13, 39, 62, 67, 115. Schecter Lee: 17. Gerhard Vesely: 19-20, 29-30, 34-36. Michael Cavanagh and Kevin Montague: 22. Bruce M. White, Photography, N.Y.C.: 23, 33, 80, 86, 91, 121, 152-153, and 184. Sotheby's: 27. F. Schoch: 31. John Bigelow Taylor, N.Y.C.: 40. James Medley: 38, 42-47, 50-51, and 138. Joe McDonald: 48-49, 76, 142, and 177. Butch Usery: 52. Bo Gabrielsson: 57, 72-73, 95, 102, 107, 112, 130-134, 147, 166, 171. Jacklyn Beckett/Alix Michel: 63, 98, 159, and 164. John DeLeon: 75. Bill O'Conner: 83. Rick Wicker: 84. Bob Kolbrener: 90 and 163. Hillel Burger: 97, 100-101, and 129. David Heald: 124 and 160. Karen Furth: 146, 151, and 165. Kathleen Culbert-Aguilar: 182.

Photo Credits

ACCOMPANYING THE ESSAYS:

Enrique Franco Torrijos photographed the following: Millon, fig. 1; Pasztory, fig. 3; Serra Puche, fig. 1, fig. 6; Manzanilla, fig. 1; Cabrera, fig. 3; Cowgill, fig. 1. René Millon: Millon, fig. 6. Kathleen Berrin: Pasztory, fig. 1. F.K.: Serra Puche, figs. 2 a-b. Joe McDonald: Berrin, fig. 1. Dell Upton: Berrin, fig. 2a. T. K. Seligman: Berrin, fig. 2b.

TEOTIHUACAN: ART FROM THE CITY OF THE GODS
was produced by
The Fine Arts Museums
of San Francisco.

The book was designed
and composed by Dana Levy,
Perpetua Press, Los Angeles.
Display type is Weiss and text type is
New Baskerville.
Printed on 128 gsm matte paper by
C & C Offset Printing Co., Ltd,
Hong Kong.